*Selected Letters of*
ANNA HEYWARD TAYLOR

Women's Diaries and Letters of the South
Carol Bleser, Series Editor

# Selected Letters of
# ANNA HEYWARD TAYLOR

## SOUTH CAROLINA ARTIST
## AND WORLD TRAVELER

*Edited by* Edmund R. Taylor and Alexander Moore

THE UNIVERSITY OF SOUTH CAROLINA PRESS

*Published in Cooperation with the South Caroliniana Library with
the Assistance of the Caroline McKissick Dial Publication Fund*

© 2010 Edmund R. Taylor

Published by the University of South Carolina Press
Columbia, South Carolina 29208

www.sc.edu/uscpress

Manufactured in the United States of America

19  18  17  16  15  14  13  12  11  10    10 9 8 7 6 5 4 3 2 1

*Library of Congress Cataloging-in-Publication Data*
Taylor, Anna Heyward, 1879–1956.
  Selected letters of Anna Heyward Taylor : South Carolina artist and
world traveler / edited by Edmund R. Taylor and Alexander Moore.
      p. cm. — (Women's diaries and letters of the South)
  Includes bibliographical references and index.
  ISBN 978-1-57003-945-4 (cloth : alk. paper)
  1. Taylor, Anna Heyward, 1879–1956—Correspondence. 2.
Artists—United States–Correspondence. 3.  Women artists—United
States—Correspondence.  I. Taylor, Edmund R. II. Moore, Alexander,
1948– III. Title.
  N6537.T385A3 2010
  760.092—DC22
  [B]                                                          2010013700

*To the Taylor sisters—*
*Anna, the writer,*
*and*
*Nell, the preserver of these letters*

# CONTENTS

# ILLUSTRATIONS

**Black-and-White Figures** ( *following page 106*)

# SERIES EDITOR'S PREFACE

*Selected Letters of Anna Heyward Taylor: South Carolina Artist and World Traveler* is the twenty-sixth volume in this series, now titled Women's Diaries and Letters of the South. This series includes a number of never-before-published diaries, collections of unpublished correspondence, and a few reprints of published diaries—a wide selection of nineteenth- and twentieth-century southern women's informal writings. The series may be the largest series of published works by and about southern women.

The goal of the series is to enable women to speak for themselves, providing readers with a rarely opened window into southern society before, during, and after the American Civil War and into the twentieth century. The significance of these letters and journals lies not only in the personal revelations and the writing talent of these women authors but also in the range and versatility of the documents' contents. Taken together, these publications will tell us much about the heyday and the fall of the Cotton Kingdom, the mature years of the "peculiar institution," the war years, the adjustment of the South to a new social order following the defeat of the Confederacy, and the New South of the twentieth century. Through these writings the reader will also be presented with firsthand accounts of everyday life and social events, courtships, and marriages, family life and travels, religion and education, and the life-and-death matters that made up the ordinary and extraordinary world of the American South.

Art historians and collectors know Anna Heyward Taylor (1879–1956) as a major artist of the Charleston Renaissance. Her wood- and linoleum-block prints helped define perceptions of the South Carolina lowcountry from the 1920s to the 1950s. Readers will learn much about the ways Taylor the artist perfected and exercised her talent over half a century, but they will also discover that she was an intrepid traveler and seeker of exotic experiences throughout the world. A member of the distinguished Taylor family of Columbia and descendant of the lowcountry rice-baron Heywards, Anna Heyward Taylor struck out on her own at the start of the twentieth century to become a professional artist. She traveled and studied in Great Britain and Europe and was in Japan when World War I interrupted her plans to complete a 'round-the-world tour. She accompanied two expeditions to British Guiana as a scientific illustrator; made Provincetown, Massachusetts, her artistic home; and resided in the Caribbean and Mexico—all the time broadening her horizons and perfecting her powers of artistic expression. The only time we know she put aside paints and palettes was during her service with the American Red Cross in wartime France

and Germany. Otherwise travel and the creation of works of art were inextricably inter-twined.

All the while she wrote remarkable letters—mostly to her sister Nell—that brimmed with the names of people, places, plants, and animals; letters that exploded from their pages with observations, gossip, and tart commentaries upon everything from Kaiser Wilhelm to the archaeology of Pompeii, from the art of Venice and Florence to the "tiger dance" of Mexican Indians. The names of more than one hundred artists fill her letters: from Duc-cio to Blanche Lazzell in Western art and from Utamaro to Tamiji Kitagawa in the art of Japan. Her circle of friends was seemingly boundless. She counted among them "Wild Bill" Donovan, founder of the World War II Office of Strategic Services; naturalist and explorer William Beebe; and Natalie Vivian Scott, the flamboyant leader of an artists' colony in Mexico. Her closest friendships, however, were with her sister Nell and the artist Rachel V. Hartley.

When Taylor settled in Charleston in 1929, she joined the artists and writers who cre-ated the Charleston Renaissance, but her will-to-travel set her apart from her peers Alice Ravenel Huger Smith and Alfred Hutty. The influence of her travels and her wide circle of artist friends distinguished Taylor's artwork.

Taylor traveled the world with an eye to its possibilities for adventure, enlightenment, and inspiration to create works of art equal to the beauty of the world of nature and of human activity. She challenged her own values and those of her generation with respect to artistic expression and social conventions and rejoiced to discover new ways of living in the world. With few exceptions—the greatest being her parroting of contemporary southern racial attitudes—she leaped over convention and crafted an adventurous life that was as original and brightly colored as the Carolina parakeets that adorn the dust jacket of this volume.

The editors' solution to the difficult problem of selecting a single volume's worth of texts from a very large collection has been to exercise what can only be called "informed judgments" in reproducing whole documents and, in some cases, portions of individual Taylor letters. They have performed this task cautiously and with the knowledge that they are presenting an Anna Heyward Taylor to some extent of their making, not her own. By way of amendment, the editors have placed full transcriptions of all of the letters in the large Anna Heyward Taylor Collection at the South Caroliniana Library. There can be lit-tle doubt that *Selected Letters of Anna Heyward Taylor* will lead many students and schol-ars to the original letters to make their own discoveries about this woman's amazing life and art.

The editors have sought to make Taylor's prints, her watercolors, and her travel photo-graphs documents equal to her letters in revealing the artist's life and times. It is no simple task to integrate such widely different media into the story of a life, but I believe that Edmund Taylor and Alexander Moore have succeeded in this endeavor. Taylor herself seemed to have valued her writings nearly as much as she did her artworks. She continu-ally counseled Nell to "keep my letters" for she knew they constituted the written record of her life. Edmund Taylor's preface intimates that she expected her nephew and his sister Mariana Taylor Manning eventually to read all of her letters. She may have subtly hinted

that publication of this or a similar volume might be undertaken. Certainly she knew and expressed her mind with every pen stroke, brush stroke, and line carved in wood and linoleum.

<div align="right">CAROL BLESER</div>

## Other Books in the Series

*A Woman Doctor's Civil War: Esther Hill Hawks' Diary*
Edited by Gerald Schwartz

*A Rebel Came Home: The Diary and Letters of Floride Clemson, 1863–1866*
Edited by Ernest McPherson Lander, Jr., and Charles M. McGee, Jr.

*The Shattered Dream: The Day Book of Margaret Sloan, 1900–1902*
Edited by Harold Woodell

*The Letters of a Victorian Madwoman*
Edited by John S. Hughes

*A Confederate Nurse: The Diary of Ada W. Bacot, 1860–1863*
Edited by Jean V. Berlin

*A Plantation Mistress on the Eve of the Civil War: The Diary of Keziah Goodwyn Hopkins Brevard, 1860–1861*
Edited by John Hammond Moore

*Lucy Breckinridge of Grove Hill: The Journal of a Virginia Girl, 1862–1864*
Edited by Mary D. Robertson

*George Washington's Beautiful Nelly: The Letters of Eleanor Parke Custis Lewis to Elizabeth Bordley Gibson, 1794–1851*
Edited by Patricia Brady

*A Confederate Lady Comes of Age: The Journal of Pauline DeCaradeuc Heyward, 1863–1888*
Edited by Mary D. Robertson

*A Northern Woman in the Plantation South: Letters of Tryphena Blanche Holder Fox, 1856–1876*
Edited by Wilma King

*Best Companions: Letters of Eliza Middleton Fisher and Her Mother, Mary Hering Middleton, from Charleston, Philadelphia, and Newport, 1839–1846*
Edited by Eliza Cope Harrison

*Stateside Soldier: Life in the Women's Army Corps, 1944–1945*
Aileen Kilgore Henderson

*From the Pen of a She-Rebel: The Civil War Diary of Emilie Riley McKinley*
Edited by Gordon A. Cotton

*Between North and South: The Letters of Emily Wharton Sinkler, 1842–1865*
Edited by Anne Sinkler Whaley LeClercq

*A Southern Woman of Letters: The Correspondence of Augusta Jane Evans Wilson*
Edited by Rebecca Grant Sexton

*Southern Women at Vassar: The Poppenheim Family Letters, 1882–1916*
Edited by Joan Marie Johnson

*Live Your Own Life: The Family Papers of Mary Bayard Clarke, 1854–1886*
Edited by Terrell Armistead Crow and Mary Moulton Barden

*The Roman Years of a South Carolina Artist: Caroline Carson's Letters Home, 1872–1892*
Edited with an Introduction by William H. Pease and Jane H. Pease

*Walking by Faith: The Diary of Angelina Grimké, 1828–1835*
Edited by Charles Wilbanks

*Country Women Cope with Hard Times: A Collection of Oral Histories*
Edited by Melissa Walker

*Echoes from a Distant Frontier: The Brown Sisters' Correspondence from Antebellum Florida*
Edited by James M. Denham and Keith L. Huneycutt

*A Faithful Heart: The Journals of Emmala Reed, 1865 and 1866*
Edited by Robert T. Oliver

*Elizabeth Sinkler Coxe's Tales from the Grand Tour, 1890–1910*
Edited by Anne Sinkler Whaley LeClercq

*Looking for the New Deal: Florida Women's Letters during the Great Depression*
Edited by Elna C. Green

*Dearest Hugh: The Courtship Letters of Gabrielle Drake and Hugh McColl, 1900–1901*
Edited by Suzanne Cameron Linder Hurley

## EDITOR'S PREFACE
### *The Steamer Trunk*

Thirty years ago my two sisters, Eliza and Mariana, and I climbed the stairs into the scorching attic of my Columbia home armed with hatchets to break into trunks that held our family's history. The dusty trunks were locked and no keys fit. To discover what was hidden inside, we hacked open a big steamer trunk, one that had been used on ocean voyages. There, neatly organized, were stacks upon stacks of letters from our aunt Anna Heyward Taylor addressed to her sister, Ellen Elmore "Nell" Taylor, my mother. Through Anna's insistence and great diligence, Mother had preserved decades of Anna's letters. These letters had been both Anna's family correspondence and her travel diaries. For Anna was a true adventurer, distinguished for her worldwide travels and for the impact her travels had upon her artistic career. She was among the most intrepid American travelers of her generation and, as her letters reveal, an accomplished travel writer.

The old trunk contained photographs from around the world and hundreds of letters and postcards, close to ten thousand handwritten pages that only a persistent reader could decipher. None of these letters were short; many were ten and twenty pages long. In her later years Anna had advised me to raise my children before tackling the immense task of reading that epistolary history of her life and adventures. I took her advice; my children have their own children, and for the past thirty years I have enjoyed the challenges and rewards of reading and transcribing these records of the life she left behind.

For years I have wanted a book written about Anna because she was the most interesting woman my family had known. Her outlook was so positive, optimistic, and passionate, and her experiences so unusual. Finally I determined to let Anna write her own book by editing her letters and illustrating it generously with her artwork.

Anna's legacy of adventure and artistic expression is found in two abundant sources. The first source is her life's work of watercolor and oil paintings, woodblock and linoleum prints, and batiks. The second is almost as revealing: her personal letters, travel diaries, photographs, and occasional publications that grew from her travels. The two sources complement each other. The letters reveal wonderful information about the inspirations and chronology of her artwork, and her vast artistic production provides visual representations of her life and adventures. Apart, the two sources are intelligible; together they paint a vivid portrait of a unique woman's rich life of artistic expression. Presented together, this

illustrated edition of her letters and diaries offers readers a look into the world of a remarkable South Carolinian, my aunt Anna Heyward Taylor.

My coeditor, Alexander Moore, has been reading Anna's letters for more than twenty years. When he was a graduate student, he transcribed the majority of them, and his unedited transcriptions are on file at the South Caroliniana Library. With respect to this volume, Alex verified transcriptions of all of the letters that appear herein. He supplied the annotations that give Anna's letters such deep historical contexts and reveal the remarkable range of her friends, colleagues, and casual acquaintances. Finally he wrote most of the introduction and chapter headings. Those essays are original works of scholarship and provide, along with the works of others listed in the bibliography, the groundwork for any subsequent study of Anna's life and art.

My family donated Anna's papers to the South Caroliniana Library in Columbia to preserve and make them available to scholars. I estimate that about one-fourth of that collection of Anna's correspondence has been selected for publication. In addition, nearly all of that one-fourth has been selectively edited to provide not full transcriptions but excerpts that the editors deemed most relevant to Anna's life and art. This selectivity is grounded on a realistic need to fit valuable portions of her letters and examples of her artwork into a single volume. I have no idea what percentage of her artwork is represented in the color and black-and-white illustrations reproduced in this book. To discover that aspect of her career is the task of another researcher.

Excisions within the letters have not been marked with punctuation or flagged with editorial devices. The complete collection, including photographs, postcards, and rough transcriptions of all the letters is in the South Caroliniana Library. Scholars and interested readers are encouraged to visit the library to consult the original manuscripts and transcriptions.

Brackets have been used liberally in the texts to flag misspelled, illegible, or missing words and to identify briefly persons, places, or events that Anna mentioned. Parentheses are those that Anna inserted. Notes that provide further information on a subject, especially when bibliographical citations are required, follow the pertinent letter, diary entry, narrative, or section. On a few occasions I have interjected myself into narratives that accompany the letters, mentioning my name or using personal pronouns. I have done this either because I participated in an event reported or because I have some personal knowledge to share with readers. The Gibbes Museum of Art, which provided a number of the images reproduced in this volume, also used brackets for the descriptive titles they supplied for works Anna did not title. We have retained their usage in the captions for these works.

During her lifetime and in her will, Anna made gifts of her artwork and financial bequests to the Gibbes Museum in Charleston, the Charleston Museum, and the Columbia Museum of Art. The Gibbes collection is valuable because it contains many of Anna's carved printing blocks. Students of printmaking can research the techniques she used to create some of her most notable prints. Anna donated seven batiks, her rarest works, to the Charleston Museum in 1955. The museum has the facilities and staff expertise to preserve

and display textile art. The Columbia Museum of Art owns many of her works as well as William Merritt Chase's portraits of Anna's parents.

My late sister, Mariana Taylor Manning, supplemented her aunt's benevolence by donating most of her collection of Anna's work to these institutions. My family holds a small number of her works. Most of these will probably find their way into public institutions.

EDMUND R. TAYLOR, M.D.

# ACKNOWLEDGMENTS

The editors have accumulated many debts of gratitude in preparing this volume. Its combination of letters and documents with many illustrations means that we relied upon not only archivists and manuscript curators but also art historians, museum curators, and family members who have preserved the works and memory of Anna Heyward Taylor. The South Caroliniana Library, University of South Carolina, is the repository of the Anna Heyward Taylor Collection. Its staff, including director Allen H. Stokes Jr., Henry Fulmer, Robin Copp, and Beth Bilderback, curates the Taylor Collection and makes it available for study. The South Caroliniana Library has also provided a generous subvention to the University of South Carolina Press to aid in publishing this book. The Gibbes Museum of Art and Carolina Art Association in Charleston, the Columbia Museum of Art, and the Greenville County Museum of Art preserve and display many of Taylor's works. At the Gibbes, Angela D. Mack, executive director, Sara Arnold, Joyce Baker, and Pamela Wall offered the fullest possible assistance.

Karen Brosius, director, Todd Herman, and Noelle Rice of the Columbia Museum of Art provided images and information from their collections. Martha Severens, Ph.D., curator of the Greenville Museum of Art, is a Taylor scholar and steward of the museum's collections. She and director Tom Styron made images available to the editors. Robert M. Hicklin Jr., owner of the Charleston Renaissance Gallery, is a connoisseur and dealer in the fine art of the South. The gallery's collections, inventory records, and reference library make it a center for research on the art of the American South. Johnson Hagood, owner of Carolina Galleries, Charleston, provided information on Taylor prints that had been in his inventory. Jan Heister, curator at the Charleston Museum, manages the museum's collection of Taylor batiks. The museum provided images from its collection. David Houston, chief curator of the Ogden Museum of Southern Art, University of New Orleans, has been a scholar of Taylor's work for decades. His aid to the volume is noteworthy. Professor Lana A. Burgess of the McKissick Museum and the University of South Carolina Art Department, Roberta M. Sokolitz of Charleston, and Mariea Caudill Dennison have done pioneering work on Taylor's life and art.

The South Carolina Historical Society and the Charleston Library Society hold manuscript collections valuable to this project. Mary Jo Fairchild, Jane Aldrich, and Karen Stokes of the historical society and Carol Jones and former director W. Eric Emerson, Ph.D., of the library society made available the resources of their institutions. Carol Bleser, professor

emerita of history, Clemson University, is editor of the Women's Diaries and Letters of the South publication series. She long championed this project, and her series editor's preface is especially appreciated. Hunter Clarkson created high-quality photographs of artwork reproduced in this book. Gayle Levine transcribed many letters and typed most of the manuscript with great accuracy. Last but not least, Mary Herbert Taylor, Mary Taylor Haque, and Georgia Taylor Brennecke, wife and daughters of Dr. Taylor, worked for decades on this project, from the first day in the hot attic where Anna's letters were found to the last stages of preparing the book manuscript. They improved the volume at every stage by their suggestions.

EDMUND R. TAYLOR
ALEXANDER MOORE

# INTRODUCTION

## Taylor's Artistic Career

Anna Heyward Taylor led a multifaceted life that encompassed the solitary labor of an artist, the public persona of the southern gentry, and the benevolence of a good citizen. In addition, she exhibited a lifelong case of wanderlust. A native of Columbia, born November 13, 1879, she was a member of a family that had been distinguished since before the city and state capital was founded in 1786. So strong were her family ties that, wherever she found herself in the world, and no matter how long absent, she recognized Columbia as her home. When in 1929 she moved to Charleston, the chief metropolis and artistic center of the state, she was always the Columbian among the artists and writers of the Charleston Renaissance.

The Taylor family of South Carolina was distinguished in the American Revolution and was synonymous with the history of Columbia, for Anna Taylor's great-grandfather Thomas Taylor had sold a portion of his plantation to the state to be the site of the new inland capital. His son John was governor of South Carolina. Since that time, each Taylor generation had produced leaders of society, several of whom were notable members of the medical profession. Anna Taylor's father, Dr. Benjamin Walter Taylor, had been a Confederate surgeon and medical officer during the Civil War and was a leader in the postwar medical community. Her brother Julius and her nephew Edmund Rhett Taylor were surgeons. Other Taylors were attorneys, businessmen, and college professors.[1] Among her mother's forebears, the Heyward family stretched back even further than the Taylors. Thomas Heyward Jr. (1746–1809) was a signer of the Declaration of Independence, a jurist, and a political leader. In addition, he was a founder of the Agricultural Society of South Carolina in 1785 and was its president until his death. That connection eventually proved meaningful in Taylor's artistic career. Another forebear, Nathaniel Heyward (1766–1851), was among the foremost rice planters of the nineteenth century. In Taylor's own generation, a cousin, Duncan Clinch Heyward, was governor of South Carolina and author of *Seed from Madagascar* (1937), an important work of South Carolina history.[2]

Taylor traveled much in the United States, migrating between South Carolina, New York, Massachusetts, and Pennsylvania to study modern artistic techniques, to paint and make prints, and to exhibit her works. She was one of only a handful of South Carolinians to sojourn at MacDowell Colony, an artist's retreat at Peterborough, New Hampshire.[3]

Taylor's lifelong love of world travel placed her among the professional vagabonds of the twentieth century. Beginning in 1903, when she was twenty-four years old, and continuing to within weeks of her death in 1956, she ventured across the globe. Her letters whisk readers from the art schools and studios of Europe, through villages in Japan, China, and Korea, to the Red Cross stations and shattered cities of World War I Europe, to jungle campsites in South America, to the wellsprings of Western art and culture—Paris, Rome, and Florence—to the Caribbean islands and Mexico, and to the decks of ocean liners that sailed the Atlantic and Pacific. Everywhere she went, Taylor found a kaleidoscope of friends, fellow artists, and cousins. The number and variety of acquaintances that appear in her letters are astonishing. All of her life she engaged in the quintessential South Carolina pastime of asking, "Whom do you know?" Her letters recorded some amazing answers to that simple question.[4]

On her excursions Taylor wrote constantly to her sister, Nell. Throughout her life she admonished Nell to "keep my letters," calling them her diary as early as 1903 and as late as 1935 (pp. 12, 21). She used her letters as resources when she gave lectures and as the intellectual place of record where she expressed her thoughts on life and art. No reader of her letters can doubt the seriousness with which she approached the task of correspondence. When living overseas she often numbered her letters to keep track of them. A few times she wrote to Nell that she was withholding information that she could only report in person. For example, on October 21, 1935, she wrote Nell from the bohemian artist colony at Taxco, Mexico, that her letters "are my diary in a way but I don't tell you everything" (p. 229). She asked Nell to circulate some but not all of her letters among family members but also instructed her to retrieve and preserve them. The condition of the unprocessed collection revealed that most of the letters were kept within their envelopes; postcards were still bundled as visual props to her letters; and inevitably some letters and documents are missing. When she lived in Columbia and Charleston, near her family she wrote less frequently than when far away. We know more about Anna Taylor the world traveler and artistic experimenter than we know about her conventional life at home.

Taylor's art and artistic legacy have been the subject of some scholarship, but there is still much to discover. In 1994 Lana Burgess of the University of South Carolina Department of Art and the McKissick Museum wrote a master's thesis on Taylor that used the family letters well. Burgess's accounts of William Merritt Chase's instruction, of Taylor's printmaking, and of her connections with Asian art are especially illuminating. She also created a useful chronology of Taylor's travels and the dates of her exhibits, lectures, and publications.[5] Mariea Caudill Dennison collected valuable information on the artist's latter years and explained her place in southern art history.[6] A fine scholar of the rise of regionalism and the history of the Southern States Art League, Dennison concluded that the values and practices of the art movement known as American Regionalism had a strong presence in the South, occasionally earlier than in its traditional source, the American Midwest.[7] In 1987 Martha Severens curated an exhibition of Taylor's prints at the Greenville County Museum of Art and published the exhibition catalog *Anna Heyward Taylor: Printmaker,* which presented valuable information on Taylor's printmaking techniques.[8] Pamela Wall, at the Gibbes Museum of Art, Charleston, wrote "The British Guiana Works

of Anna Heyward Taylor," which illuminated the artist's expeditions to South America and the influence of those trips on her artistic career.[9]

Taylor attended the Presbyterian College for Women in Columbia. (The school later became Chicora College and ultimately Queen's College after moving to Charlotte, North Carolina.) From 1900 through 1901 she resided in New York City, where she studied at the New York School of Art and the Art Students League. At the New York School of Art, she met and was inspired by its director, William Merritt Chase (1849–1916), one of America's foremost artists and teachers.[10] The next year she was awarded a scholarship at the Philadelphia Art School but was unable to accept it because it conflicted with a signal event in her artist's education—having developed a friendship and student loyalty to William Merritt Chase, she traveled with his class to the Netherlands in 1903. Of that first trip to Europe, she wrote, "Am having the time of my life. . . . I could paint all day & all night & never get enough paint!" (p. 14, 19). The following year she attended Chase's class in London and her talents blossomed. While there she and her fellow students met John Singer Sargent (1856–1925), and all of them promptly fell in love with the famous artist. Her work won a prize, a still life by Chase that she later donated to the Gibbes Museum of Art. The Chase classes of 1903 and 1904 were the first great watershed in her life as an artist. She met some of the most famous artists of the era and forged bonds of friendship with youthful artists such as Rachel V. Hartley and Walter Bradley that endured throughout her life. Wherever she went all of her life, Taylor found a community of artists united by the experience of having studied with William Merritt Chase.

Even among her unconventional artist-peers, Anna was an individualist, rarely too "gentile" (as she spelled the word "genteel") to challenge received opinions, especially on occasions when she could make a point and astonish her auditors. Sailing to Europe for the first time in 1903, she informed Nell, "Someone remarked yesterday, to my indignation, that I am a typical American. I hastened to inform them that I am anything but that for I was not at all loyal & only patriotic where the South & my state were concerned. The girl was simply scandalized much to my amusement. I must say that to be a typical American is not my ambition" (p. 12).

In England she immersed herself in Japonism, the turn-of-the-century artistic movement in which European and American artists discovered and adopted a broad range of Oriental aesthetics and artistic techniques. The Japonism movement included painting, printmaking, textile arts, ceramics, gardening, and architecture and owed much to the work of an American, Ernest F. Fenollosa (1853–1908). In addition to promoting the plastic arts of China and Japan, Fenollosa, Lafcadio Hearn (1850–1904), and Arthur David Waley (1889–1966) also introduced Westerners to the Asian literary forms of haiku, Kabuki and Noh theater, and a wealth of Asian literature.[11] Guided by a new friend, former British officer Francis James Norman, Taylor and Chase were thrilled to view Japanese *ukiyo-e* prints from Norman's collection.[12] They also visited the British shrine of Japonism, James A. M. Whistler's "Peacock Room."

Taylor was back in New York in 1906 working with Chase and Fredrick Dumond (1867–1927). In the same year, she studied in Pennsylvania with William Langson Lathrope (1859–1938), who taught landscape painting. She then returned to Columbia and became

an instructor at her alma mater, the Presbyterian College for Women. As she observed them, her students sketched models or from nature. She then critiqued their work. Taylor's students visited her home each Saturday for formal lectures by her or one of her artist friends. Taylor and her friend Minna Meinke, another art teacher, put on an exhibition in April 1908 that included works by Robert Henri, F. Luis Mora, John Sloan, and Charles Rosen. For fifteen years, whether or not she was in town, she used her contacts in the art world to organize exhibitions in Columbia. One exhibition included six of Chase's paintings along with works by Robert Henri (1865–1929), Jonas Lie (1880–1940), and others.[13]

In 1908 and 1909 Taylor and her sister, Nell, took an extended European tour during which Nell took voice lessons in Germany while Anna traveled in Italy. Anna Taylor spent a while in England, in Scotland, and at the Swiss resort Chateau d'Oex, and her letters recorded scenes of mirth and drama among vacationers from all parts of Europe. Her descriptions of the ocean liner trip to Great Britain reveal her cordial high spirits. Shipboard games she described included spoon races, obstacle courses, and pillow fights— "The pillow fight was almost the death of us!" (p. 36)—the stuff of family reunions and church field days transplanted to the deck of the TSS *Potsdam*. Anna was an enthusiastic participant and a cheerful chronicler of these and similarly silly events throughout her life. When at the Swiss resort, she continued her good-humored narratives with an account of a costume party. Her friend Alice Atkinson dressed as Salome "with a huge knife and waiter" while "I went as Elsa from 'Lohengrin' and was arrayed in two of Mrs. Carter's sheets which draped & Florence sewed me in" (p. 44).

Convention and adventurousness warred within her as she anticipated a visit to Pompeii and the Naples museum that housed notorious artworks discovered by archaeologists. "A lady told me the other day about [what] a wonderful place Pompeii is and also how wicked. It seems there are houses in the city which contain mural paintings or some things which are so wicked women aren't taken usually, only men. . . . Well, the amazing thing is that there are some so dreadful that the government has them in Naples under lock & key & not a soul is allowed to see them. I am consumed to know what is too dreadful for a man to see!!" (p. 44). In April she secured a municipal permit to visit and to make studies and copies of the holdings of Italian museums and galleries. Her letters are filled with descriptions of visits to famous sights, especially Pompeii, and she sent picture postcards to complement her verbal descriptions. Because Nell was with her, Anna sent long, enthusiastic letters to her younger brother, Edmund Rhett Taylor, and "Cousin Coley," Sally Coles Goodwyn.

Taylor returned to Presbyterian College, by then Chicora College, and taught from 1911 to 1913. She collaborated with Katherine Bayard Heyward (1886–1974) in teaching and managing a small gallery. Heyward was the daughter of Duncan Clinch Heyward and Taylor's cousin. She later established the art department at the University of South Carolina and was a leading arts educator in the city and state.[14] In the summer of 1912 Taylor probably studied in Provincetown, Massachusetts, at the Cape Cod School of Art run by Charles Webster Hawthorne (1872–1930). Hawthorne had also been a pupil of Chase's and an assistant in Chase's schools. Taylor not only developed skill as a watercolorist but also formed

strong ties to the Provincetown art colony. In many ways Provincetown became her home away from home.

Taylor took off for Asia in 1914, visiting Japan, Korea, and China with plans to circle the globe. However, World War I began while she was in Japan, and she had to cut short her trip. Her letters demonstrated a vast curiosity about all aspects of Asian culture: silkworms, rice, Japanese sumo wrestling, hot communal baths in which men and women simmered together, the cruelly bound feet of Chinese girls, the Great Wall in moonlight, abject poverty, and privileged royalty. She examined shoji screens and joined an art class but seems not to have been producing her own art. Her appreciation of Asian printmaking and textile art, particularly as practiced in Japan, deepened. She was already interested in the subject when she met Helen Hyde (1862–1919), one of the first American artists to master Japanese-style printmaking.

She met other Americans who were actively importing Japanese art and aesthetics to the West, including Florence E. Boynton, Anne Heard Dyer, Louise Norton Brown, and fellow South Carolinians Stanhope and Camilla Sams. Dyer had been Ernest Fenollosa's secretary, and Brown translated a major German-language work on printmaking. Stanhope Sams also wrote articles on Japanese art. The eccentric English potter Bernard Howell Leach and his wife, Muriel, were also among Taylor's acquaintances there.[15] Helen Hyde, Stanhope and Camilla Sams, and Taylor reluctantly returned to America as the conflict spread around the globe in late 1914. Others remained in Japan, including "Flan" Boynton, who wrote Taylor often and operated a modest textile export business with her.

Back in Columbia in 1915, Taylor organized exhibitions that included works of modern printmakers. She also arranged a solo exhibition of Helen Hyde's prints. After the exhibition Hyde stayed in the lowcountry for several months lecturing and collecting print-worthy scenes of African American life. Taylor's letters from this period offered considerable information about the beginnings of printmaking by Charleston artists, among whom was Alice Ravenel Huger Smith. Taylor linked Hyde and Bertha E. Jaques (1863–1941) to the group of lowcountry artists eager to learn printmaking from professionals. As early as April 1916, Hyde visited and taught in Charleston. In an April 28, 1916, letter to Taylor, Hyde reported, "You ought to see Alice Smith's 1st block print & Sabina Wells.' I was as proud as punch of my pupils" (p. 100).[16]

Although she had helped arrange Hyde's 1916 southern trip, Taylor was not there to greet her, for she was on her way to British Guiana. Ever in search of exotic locales and experiences, she joined the staff of the scientist and explorer William Beebe (1877–1962) at Kalacoon, his tropical research station. As a scientific illustrator, Taylor had exciting experiences studying the flora and fauna of the South American jungles. In addition to her scientific illustrations, she made drawings and color studies that she later used in creating prints and batiks. She encountered unexplored jungles, flowering trees, vampire bats, venomous snakes, and monkeys. While there, she once prepared a rustic lunch for and entertained former President Teddy Roosevelt and his wife.

In June 1916 Taylor returned to the United States. Within a few weeks she was back at Provincetown, studying painting and woodblock printing with Bror Julius Olsson

Nordfeldt (1878–1955). That visit taught her valuable printmaking techniques that served her throughout her career. She had, of course, been exposed to Japanese prints in Europe, if not earlier in New York, and had firsthand knowledge from her sojourn in the Far East. During the summer of 1915, just a year before Taylor visited Provincetown, an American revolution occurred in the art of woodblock printing. Nordfeldt, Blanche Lazzell (1878–1956), Charles W. Hawthorne, and others at Provincetown had been experimenting with a printing technique they called white-line printing that allowed an artist to make multi-colored prints from a single carved block. In this method the artist carved heavy lines in a block to separate one color section from another. Different colors were placed on the block in succession as the print paper was lifted and reimposed. Also called the Provincetown print, the new method greatly streamlined printmaking because it eliminated the need to carve separate blocks for each color and then to "register" (align) the print many times on different blocks.[17] Janet Altic Flint, a historian of American printmaking, described this innovative block-cutting technique.

> Nordfeldt became impatient with the mechanical labor of cutting so many blocks of wood (one for each color) before he could express his idea; one day he surprised the others by exhibiting one block, with his complete design on that, instead of parts of it being cut on five or six blocks. He had cut a groove in the wood to separate each color, and, in printing this left a white line which emphasized the design. With his invention he had produced a more beautiful picture and eliminated much work.[18]

The white-line method was not only a revolution in printmaking technique but also exemplified a revolution in aesthetics and the concept of the printmaker as artist. The traditional system of Japanese printmaking, called *hanmoto,* involved a group of artists and craftsmen collaborating to create the myriad prints that are Japan's artistic legacy. The artist drew or painted the scene while carvers fashioned the wooden printing blocks, one for each color in the print. Other artisans inked the blocks and pressed the print paper into each one, registering the print on successive colored blocks. In this assembly-line method the name of the artist was that of the person who created the design. All others were craftsmen whose skills were employed by the artist. Kitagawa Utamaro (ca. 1753–1806), Katsushika Hokusai (1760–1849), and Utagawa Hiroshige (1797–1858), the printmakers most famous in the West, all employed the *hanmoto* method.

The division of labor employed in *hanmoto* was certainly not confined to Japanese printmaking, but it posed both challenges and opportunities for European and American artists of the modern era. In the past, European art had demonstrated this kind of division of labor. Etchers and woodblock printers might create their own plates and blocks, but professional printers operated the presses; sculptors created models and left the carving of marble and casting of metal to professionals; Old Master painters employed apprentices and assistants to help create the great works of Western art. However, a revolution in art and aesthetics was under way, and Taylor was part of it.

During the nineteenth century the rise of a Romantic definition of the artist, the idea that an artist was an individual acting alone to create a work of art that expressed personal values, led artists of all kinds to perform all of the labors involved in creating their works.

Sculptors not only created maquettes of their works but also learned to cut their own blocks of stone and wood and to cast molten metal. Painters insisted on creating their works from start to finish, stretching and sizing their canvases, grinding their own pigments, and applying every brushstroke before signing their names—an innovation itself in many media. Printmakers began to cut their own blocks and operate their own presses. To borrow a description from business history, artists replaced a diversified horizontal model of work with a tight-knit vertical method of production. The modern artist took sole responsibility for the work and did not share credit for the inspiration or the labor that made a work of art. Even the Japanese took up the artist-as-auteur concept and developed a twentieth-century printmaking style called *saku hanga* in which the artist did all the work of printing.

The Provincetown print method was an American style of *saku hanga*. It gave printmakers a quick, efficient way to create prints on their own and to take sole responsibility for their own works. Taylor, Margaret Moffett Law (1871–1956, from Spartanburg), Edna Boies Hopkins (1872–1937), and Blanche Lazzell used the white-line or Provincetown method with great success for much of their careers. Lazzell was the chief practitioner of the technique and accomplished the considerable feat of creating cubist and abstract art prints. Taylor employed the method to create in a new way prints of traditional subjects that interested her.

Taylor personified the Romantic notion of the artist. Even when she used the multiblock method, she carved all of the blocks herself, inked them, registered the paper, and operated the press. To print *Grias Cauliflora,* No. 15 (plate 5), *Grias Cauliflora,* No. 5 (plate 6), and *Marcgraavia,* No. 4, 1924 (plate 9) she cut both sides of one block, and for *Carolina Paroquet,* No. 10, 1935 (plate 19) she carved two separate blocks. For *Flower Girl,* No. 3, 1928 (plate 15) and *Turtle and Wave,* No. 3, 1929 (plate 16) she used a single block and the white-line technique to create color prints from single blocks.[19]

Woodblock printing was a difficult, physically challenging medium, and Taylor eventually had to relinquish the method. In late 1950 she told John R. Craft, director of the Columbia Museum of Art, that "I have done none [woodblock prints] in over 10 years & found it one of the most difficult crafts to master."[20] By about 1940, however, when she had abandoned woodblock printing, Taylor had become an inspired linoleum-block printmaker, the third printmaking method of her career. An intensive study of her printmaking would involve not only investigation of surviving printing blocks but also a wide-ranging survey of her prints in the hands of institutions and also collectors. Such a survey should reveal important information about her work methods and artistic intentions. For example, she used a single block to create both a black-and-white and a color version of *Red Howlers* (fig. 1, plate 11) in 1928, the same two-sided block to create two different-colored versions of *Grias Cauliflora* (plates 5, 6), and a single block to print two different color states of *Golden Lotus* in 1932 and 1933 (plate 18).[21]

Taylor used linoleum blocks to create the striking black-and-white illustrations for Chalmers S. Murray's *This Our Land* (1949) and some other books. She also created color prints from her linoleum blocks. For example, both black-and-white and color states exist of her print *July in Charleston* (1938).[22] She also made a few lithographs that survive today;

this fourth printmaking method did not require the exertion of carving wood or linoleum. Her lithographs are both rare and visually powerful. *Big Nets* (fig. 20) is in the collection of the Columbia Museum of Art, and *Cha Cha Church,* a Virgin Islands scene, was exhibited at the 1928 exhibition of the Print Makers Society of California.[23]

At Provincetown Taylor met William and Marguerite Thompson Zorach, a free-spirited couple whose bohemian demeanors amused her.[24] William Zorach was a Paris academy–trained painter and etcher who embraced the aesthetics of the fauves and brought them back to the United States. His wife, Marguerite, was a textile artist, skilled in embroidery and the Indonesian technique of batik. That distinctive art was created by dying fabric in patterns using a method of wax resistance similar to the way that acid-resistant grounds were employed in etching and tusche in lithography or silk-screening. Pieter Mijer, a Dutch native who had lived in Indonesia, taught her the art of batik.[25] Mijer published *Batiks and How to Make Them* in 1919, having already made batiks and taught the methods during the previous decade.[26] His instruction, plus examples of Marguerite Zorach's works, may have inspired Taylor to transform her Guiana botanical studies into textile art. Certainly by 1920, as she planned her second British Guiana excursion, she knew about batiks and had some plans to take up the art. Her use of organic plant forms to create batiks was something of a revolution in that art form.

An article in a 1922 issue of *Natural History,* "Floral Designs in Textiles: Plant Motifs Based on Studies Made by Miss Anna Heyward Taylor at Kartabo, British Guiana," reproduced some of her most distinctive batiks and provided good background information on her education and jungle experiences. The writer stated that Taylor had learned batik techniques "in the interval between her two visits [to British Guiana in 1916 and 1920] . . . and had conceived the idea of using the tropical flowers as motifs for designs in textiles."[27] Her silk batiks were quite large and provided ample space to capture the exuberance and exotic beauty of the jungle plants and flowers. Although few of her batiks survive today, some scholars and connoisseurs considered them among her most distinctive works. The Charleston Museum has seven batiks. They vary in size and shape, and some are nearly six by eight feet. The Gibbes Museum of Art has two, and the late Mariana Manning also had two.[28] A 1924 exhibition review in the *Berkshire Advocate* observed, "Miss Taylor has designed a very lovely green silk shawl. In effective contrast is a rose silk shawl with batik design of the maw-a-maw blossoms."[29]

As was the case with printmaking, Taylor may have discovered batiks while in Asia. Japanese craftsmen practiced a traditional form of batik, *roketsu-zome* or *rozome.* While there she demonstrated much interest in Japanese textiles and sustained that interest when she returned to the United States. Marguerite Zorach and Pieter Mijer taught batik in Provincetown and New York City, but it is possible that Taylor had seen batiks made in Japan a few years earlier.[30]

When Taylor returned to Columbia in the fall of 1916, she organized an exhibition of Edna Boies Hopkins's woodblock prints, several of which were white-line prints. She also sponsored an exhibition of Nordfeldt's etchings and color block prints. Regarding that exhibition, Nordfeldt wrote to her, "Your commission is all right. . . . I usually pay more & if sales come so much the better; if not, we will have to take it with a bit of philosophy"

(p. 113). On December 17 he added, "I can just see you stirring up your town . . . dragging the poor unwitting public into art when all it wants is to be left alone wallowing in its tea and muffins" (p. 116).

Taylor and Katherine Heyward rented a cottage on College Street half a block from the University of South Carolina. They exhibited Taylor's jungle works and Heyward's textile designs. The cottage was filled with embroideries, wooden objects, etchings, and watercolors by various artists.[31] In March 1917 Taylor exhibited works of E. Ambrose Webster (1869–1935), whom she knew from the Chase class in Holland and Provincetown.

Taylor planned to spend another season with William Beebe in South America, but the expedition was canceled as the United States moved closer to entering the Great War. Her life took a considerably different direction after April 1917. She organized service groups in Columbia but then decided to make a greater commitment to the war effort. At the age of thirty-seven, she volunteered for the American Red Cross and served from October 1917 until June 1919 in France and occupied Germany. From Europe she again inundated Nell with exhortations to "keep my letters." She began numbering them and kept a log to account for them. Her report of crossing the Atlantic amid the threat of submarine attack was hair raising.

Taylor's first job was to prepare surgical dressing packages for wounded troops. Tiring of this, she had the opportunity to switch to canteen duty, which she loved. With a close-knit, congenial group, she greeted soldiers and supplied them with food, drink, and recreation. She gave dances and listened to their tales of war, many of which she recounted in her letters home. She experienced the bombing of Paris by German planes, and after the November 11, 1918, armistice, she toured the battlefields of the western front and was among a select group of women who established Red Cross services in Germany. She wrote Nell about German soldiers' fears of French African troops armed with Bowie knives and the tragic story of Victor Sakarov, an "aristocratic Russian" whose forebears "have been soldiers for 500 years."[32] (p. 144). She and her coworkers were especially conscious of their morale-building roles, both in their canteens and when off work. Her accounts of motor trips, parties, and long conversations with soldiers filled her letters. Although she did not take up a paintbrush or sketchbook while in Europe, she attended concerts and performances at the Paris Opera, activities that enlivened her letters.

The Great War had begun while Taylor was in Japan and concluded while she was in France. That phase of her life was indeed painted upon a canvas as broad as the globe and as intimate as the love and loss of friends and family. Her artistic career became secondary to her sense of duty to her nation. Throughout her life she crossed paths with men and women whom she had met during wartime. Perhaps the most distinctive of them was William "Wild Bill" Donovan, the master spy who would head the Office of Strategic Services during World War II. When they met once again in 1925, she "immediately exclaimed & told him my name & we fell on each other's necks" (p. 199).

Taylor returned to the United States during the summer of 1919 and settled in New York City, her home for much of the next decade. She visited Columbia occasionally and stayed in touch with her friends in Boston, Provincetown, and Philadelphia, but her next big adventure was a return with William Beebe to British Guiana. She had, in fact, revived her

correspondence with Beebe while still in Europe and was already planning to join the next expedition.

She was sailing southward by early February 1920, lingered a while in Trinidad, and was in the South American colony by the end of the month. Her colleagues included Rachel and Inness Hartley, veterans of the first expedition. Taylor was an unpaid volunteer, but still she worked hard as a scientific illustrator, making drawings, watercolors, and gouaches to capture not only the appearances of exotic plants but also the changes of shape and color during a plant's life cycle. The work was satisfying and she was a valued member of the expedition, but she also had personal interests that pressed her to be diligent. She collected many images that she later used to create color prints and batiks. Her prints of red howler monkeys and batiks of shooting star plants and marcgraavia are among her most recognizable works.[33] Irving Widmer Bailey, a botanist from Harvard University, was a member of the 1920 expedition. Taylor based several of her batiks on Bailey's photographs of plant cross sections. Her use of this scientific information to create art was highly original and much discussed by naturalists and artists.[34]

Before leaving Kartabo, Taylor made plans to exhibit her new works. Her watercolors and batiks, and possibly some prints, were exhibited for sale in March 1921 at the Grace Horne Gallery, Dartmouth, Massachusetts, and in March and May 1922 at the American Museum of Natural History and the Brooklyn Botanic Garden, respectively.[35] The chief theme of these two exhibitions was Taylor's use of Bailey's scientific photographs in her artwork. Called "the jungle artist," she often presented lectures to accompany the exhibits. In that way she gained a reputation as an explorer and joined the Society of Women Geographers. She published two articles on British Guiana in 1920 and 1922 issues of the *Christian Science Monitor* that described the ways she combined scientific observation and artistic creativity in her life.[36]

Taylor's exhibition at the American Museum accompanied an article in *Natural History* that demonstrated her use of drawings and photographs of plant stem cross sections as batik patterns. Between her 1916 and 1920 expeditions, Taylor "had learned the process of Batik and had conceived the idea of using the tropical flowers as motifs for designs in textiles." Her orchid studies and studies of *Grias cauliflora,* a cocoa bean, and *Moronobea* were reproduced adjacent to batiks that employed the studies as repetitive patterns. One batik was a shawl that combined portions of the cocoa bean and *Moronobea.* In addition to flora, she made studies of a morpho butterfly wing and a katydid nymph and used them as well. "While emphasis has been laid on the textiles, to which most space was given in the exhibit, many visitors must have been equally impressed by the original paintings of the plants. The fidelity of these paintings, the appreciation of form and tint which they reveal, assure them high rank among Miss Taylor's production."[37]

The possible influence of Nordfeldt upon Taylor's oil and watercolor techniques is a subject that has not been explored by art historians. Publication of illustrations of her oils and watercolors in this work may excite interest in that course of inquiry. Conventional wisdom is that she visited Provincetown in 1916 to study printmaking with Nordfeldt, but perhaps her intentions were broader than that. Her accounts of his criticisms did not specifically refer to printmaking but suggested his attention to her paintings. From his

early years Nordfeldt had painted watercolors and oils and was recognized as a talented painter. By 1920 he had left Provincetown and settled in the American Southwest, where he devoted much energy to depicting scenes of Native American and Hispanic American life.[38] Taylor's British Guiana landscapes suggest familiarity with Nordfeldt's broad painting strokes and his bold use of color (plates 1, 2). Even later, her Caribbean and Mexican landscapes rely on these techniques (plates 4, 29, 31). Her active interest in the domestic lives and religious practices of Latin and Native Americans, demonstrated in her letters and paintings, was similar Nordfeldt's love of the American Southwest.

In the early 1920s Taylor resided in New York City and exhibited her work. The Sail Loft Club at Provincetown hosted an August 1924 show of her block prints, batiks, and decorative designs, and in November the New York Society of Craftsmen exhibited British Guiana batiks and prints.[39] In early 1925 she was one of three painters invited to the Edward MacDowell Colony in Peterborough, New Hampshire, along with poets, writers, and other artists. Among them were Dubose Heyward and his wife, Dorothy Kuhn Heyward, Stephen Vincent Benét and his brother, William Rose Benét, the American composer Aaron Copeland, and Tennessee Mitchell Anderson, former wife of the novelist Sherwood Anderson.[40] The MacDowell Colony group was bohemian and seemingly close knit with few southerners among them. When she was at the artist colony at Taxco, Mexico, in 1935–36, Taylor observed that, as she had been at Peterborough, she was "on the outside looking in" (p. 229).

In July 1925 she was aboard the TSS *Martha Washington* crossing the Atlantic for a three months' grand tour of the Mediterranean and France. The chief reason for her tour was to accompany Susan Greenough Hinckley Bradley (1851–1928) on the elderly woman's final visit to Europe. Bradley was an artist who as a young woman had studied painting in Europe and with William Merritt Chase. She wed Civil War veteran Rev. Leverett Bradley in 1879, and the couple had three sons, Leverett Jr., Walter, and Ralph, and a daughter, Margaret Bradley Swaim. Taylor had met Walter Bradley as early as 1903 when they were Chase's students. Susan Bradley was seventy-four years old and Anna Taylor forty-seven when the group made their tour.

Taylor wrote seven lengthy letters describing her and Bradley's visits to the chief shrines of Western art. Comparing those letters with those she wrote in 1908 provides insights into Taylor's intellectual development and her mature opinions on art. Her letters chronicle extraordinary experiences traveling by ocean liner, train, and automobile across the Atlantic and to cities in Portugal, Italy, Yugoslavia, and France. She and Bradley acted the part of thoroughgoing tourists, seeking adventures that ranged from tobogganing at Madeira to visiting art museums and the homes of wealthy art dealers and American expatriates. Her letters recount the pageantry of the Palio, a centuries-old horse race in Siena's town square. The travelers met the art historian Bernard Berenson (1865–1959) in Florence. They also visited Sicily, the Greek island of Patras, and Yugoslavia. Disembarking at Gravosa, they traveled by train through Italy, where they visited Naples, Perugia, Venice, Siena, Assisi, and Florence. Taylor commented often and at length on Italian art and her evolving aesthetic values. Her grand tour letters reveal more of her opinions on art than any of her other correspondence.

The group traveled to Verny, France, and Lausanne, Switzerland, and was in Paris by the end of August. She and Bradley toured the sights and attended a life drawing class at the Academie de La Grand Chaumiere, an art school known today as the Academie Charpentier. Taylor mentioned in particular visiting a museum in Paris that was exhibiting Japanese prints. The party left France on September 16 and arrived at New York on the twenty-third of the month.

In 1926 Taylor and her friend Rachel Hartley traveled to the U.S. Virgin Islands to enjoy the Caribbean culture and to work hard on their painting. Taylor had visited the Caribbean islands on her way to and from British Guiana in 1916 and 1920 and wished to spend time painting scenes of Caribbean life. The excursion was valuable in terms of subject matter, and it also afforded Taylor considerable educational opportunities, not all of which were to her liking. The multiracial character of the Virgin Islands, especially the French and Danish colonies, strongly challenged her South Carolina racial attitudes. She and Rachel attended a dinner dance that included the Millers, "high yellows," among the chief guests. Mrs. Miller sat at Anna's table while "Vallie" Miller socialized with Rachel. "Rachel and I left early & all the way home were discussing how our different families would take the incident. Of course it means that we will not accept any more invitations there without know[ing] who the party includes." Even as she expressed such prejudice, she found some humor in the encounter. She concluded her account of the evening by stating that Mr. Miller had been more partial to Rachel than to herself, "& I mean to tell her the reason is, I look too much like an English slave owner" (p. 197).

Despite her racial attitudes, Anna was horrified to learn of cruelties practiced upon slaves at Saint Thomas and Saint Johns: "Red hot pincers, cutting off legs & hands, branding them on the forehead, cutting off ears & noses & breaking them on wheels!! Did we practice such barbarities!" (p. 200). She concluded her observations by writing that she planned to do some research to discover the answer to her question.

Whatever the gap between her traditional, unexamined opinions and the reality of life in the Caribbean, she worked hard and greatly enjoyed Hartley's companionship. "We painted a 'Gauguin,' I doing the South Sea landscape & Rachel the naked islanders, signing it with a copy of his own signature. It turned out so snappy that R. wanted to keep it" (p. 196). Taylor exhibited her Caribbean works at the National Arts Club in February 1928 and then at Milch Gallery, New York City. One painting, *Isles of Illusion,* won a prize at the 1927 Southern States Art League Exhibition in Charleston. A lithograph, *Cha Cha Church,* was part of the Ninth International Print Maker's Exhibition in California in March 1928.

According to Mariea Caudill Dennison, the 1927 Southern States Art League Exhibition in Charleston was a turning point in Taylor's career.[41] Before Taylor settled in Charleston in 1929, the South American jungles and Caribbean islands had inspired much of her art. After moving to Charleston, she began to create lowcountry scenes that bore all the attributes of the art movement called southern regionalism: depictions of buildings and locales that evoked nostalgia, local flora and fauna, and, most of all, many images of African Americans. However, she brought to those subjects sophisticated training and a love of color and decorative depiction that linked her version of regionalism to French

Postimpressionism, the Japonism of Paris and London, and eventually the Mexican mural-ists Diego Rivera and David Siquieros.

Working mostly in watercolors and in color and black-and-white prints, Taylor grafted the bright-colored decorative elements of Henri Matisse, Henri Toulouse-Lautrec, and even Paul Gauguin onto the southern regional themes of work, churchgoing, and city life. As a printmaker she combined scientific elements of eighteenth-century artist-botanists with the radical colors of the best Japanese *ukiyo-e* printers.

In 1933 Taylor painted two highly individual watercolors, *The Strike* (plate 24), and *Spiritual Society, Campfire* (plate 25). *The Strike* is a fanciful depiction of African American female textile workers dancing wildly in front of their looms idled by their work stoppage. The painting is unique among Taylor's surviving works because it depicts a political act of which she doubtless disapproved. It appeared much like works of social realism sponsored by the New Deal's Works Progress Administration to adorn post offices and other public buildings throughout the nation. Regionalism and regional art secured the imprimatur of the federal government, and many paintings and sculptures were created during this era. Why Taylor created *The Strike* is unknown, but perhaps she created the work in the name of good political satire as she was hardly a proponent of 1930s social realism. *Spiritual Society, Campfire* depicts an event that Taylor and her nephew Edmund R. Taylor witnessed in 1933. The event featured African Americans standing and dancing around a bonfire, but the background is familiar—a rural church deep in a wood. The ecstatic abandon of the dancers is tame, however, whereas that of the dancers in *The Strike* is unbridled. In 1928 Taylor bought a studio at 4 Atlantic Street, where other artists of the Charleston Renaissance, including Alice R. H. Smith, Elizabeth O'Neill Verner, and Leila Waring, a miniaturist, resided. Elizabeth O'Neill Verner's daughter recounted stories about the hard economic times in 1930s Charleston but also about the comradery that was the hallmark of Atlantic Street.[42]

Taylor was among several artists whose prints and paintings defined the visual arts of the Charleston Renaissance. However, she brought to that cultural rebirth a distinctive view of how to make fine art that connected the local renaissance to worldwide artistic trends.[43] Her color prints included not only local magnolias, azaleas, sea turtles, Carolina parakeets, and boll weevils but also *Marcgraavia, Grias cauliflora,* and howler monkeys. Her linoleum prints and watercolors of African Americans at work and worship are complemented after 1935 by those of Caribbean and Mexican peasants engaged in similar activities. A regionalist in style and subject matter, her "home place" depicted the South Carolina lowcountry, South America, and the Caribbean islands.

Alice Ravenel Huger Smith was the acknowledged leader in creating the Charleston Renaissance, but by then Taylor had been a friend and influence upon her for many years. The companionship of fellow southern artists and the opportunity to apply her talents to local subjects was what Taylor had been seeking. In 1929 she moved permanently to Charleston, making her home at 79 Church Street. For the rest of her life, she participated in the city's cultural life. With Smith, Alfred Hutty, and Elizabeth O'Neill Verner, she created some of the signature artworks of the renaissance. She donated her *Red Howlers* color

print to be the frontispiece for the 1929 *Yearbook* of the Poetry Society of South Carolina. The *Yearbook* contained a commentary on an exhibition of Taylor's recent works: "In January the brilliant oil-paintings and vivid water-colors of Miss Anna Heyward Taylor were for three weeks on exhibit in the lower Gallery of the Gibbes Art Building under the auspices of the South Carolina Art Association. Miss Taylor's work was all done in the Virgin Islands, and is vivid with tropical sunshine."[44]

A newspaper review of a 1930 exhibition of Taylor's works expressed the values of the Charleston artists and of Taylor's place among them.

> There are beautiful watercolors depicting fascinating views of the lowcountry. . . . There are swamp scenes in which herons and lily pads add their bit of beauty. . . . There are scenes of the famous old Medway house and its oaks. Interesting old Goose Creek Church furnishes the theme of another, and there is a lovely picture of the Charleston College gates. Among the most charming things are Miss Taylor's market sketches. . . . There is an interesting group of block prints, many of them depicting Charleston scenes.[45]

As her watercolors achieved success, Taylor made certain that her prints remained in the public eye. *Red Howlers, Red Bandana,* and *Negro Flower Girl* were exhibited at the Tenth International Print Maker's Exhibition in Los Angeles in 1929. This show was a frequent venue for her prints. She had previously exhibited works in the sixth (1925), eighth (1927), and ninth (1928) shows. Ten years later her linoleum print *Lightwood* (fig. 12) was featured in the nineteenth (1938) exhibition, and Argent Galleries of New York City presented a solo exhibition of her prints during November 1938.[46]

*Harvesting Rice* (fig. 17), a linoleum print from 1937, became one of her best-known works. It secured a considerable reputation for Taylor. The print was awarded the 1937 Margaret Boerick Prize of the Philadelphia Print Club. It was exhibited at the 1939 New York World's Fair and published in *American Art Today: Gallery of American Art Today, New York World's Fair* (1939) as one of eight works by South Carolina artists.[47] *Harvesting Rice* achieved near immortality when it was included along with *July in Charleston* in the first edition of the Junior League of Charleston's cookbook *Charleston Receipts* (1950). That book has been in print for more than sixty years. *Harvesting Rice* depicts three sturdy women handling large sheaves of the state's former staple crop. Taylor's oil painting *Cypress Swamp, No. 12* was exhibited at the World's Fair and appeared in *Contemporary Art of the United States* (1940). In the brief tagline for the painting, Taylor was identified as a member of the Society of Women Geographers.[48]

A good example of the ways Charleston artists and writers worked together to create a unified sense of the distinctiveness of the lowcountry can be found in a Medway Plantation print. Taylor's color woodblock print of Medway Plantation, similar to a watercolor version, adorned the dust jacket of *The Carolina Low-Country,* edited by Augustine T. Smythe and published in 1931. That volume was an anthology of essays and poems by Charleston writers Herbert Ravenel Sass, Beatrice Witte Ravenel, Josephine Pinckney, Dubose Heyward, and others. Contributing artists were Taylor, Alice R. H. Smith, Elizabeth O'Neill Verner, John McCrady, and Albert Simons. *The Carolina Low-Country* was

published to raise funds for the Society for the Preservation of Spirituals, an exclusive white organization dedicated to the preservation of lowcountry African American music. In addition to a trade edition, a boxed limited edition with a gold-stamped seal was also issued.[49]

Despite Taylor's quick assimilation into the aesthetic and style of the Charleston Renaissance, her works were never so strictly regional that they lacked admirers throughout the nation. As part of her renovation of the Berkshire Museum in Pittsfield, Massachusetts, Laura Bragg, former director of the Charleston Museum, mounted an exhibition of modern art that included Taylor's prints, watercolors, and batiks. Her works were celebrated for their quality, but they were also for sale as a fund-raiser for the museum. Taylor had also designed the logo for the new museum, which was incorporated into furniture, stationery, and publications.[50] A review of the Taylor's exhibition history at every stage of her career reveals that her works, even those with the most local themes, received nationwide attention.[51]

Taylor made her last artistic jaunt when she lived and worked in Mexico from June 1935 to September 1936. At that time the political conditions in Mexico were unstable with strikes, threats of revolution, and lawlessness, and the country was leaning toward communism. Some of Taylor's friends there carried pistols. Despite the dangers and inconveniences, Mexico had considerable appeal to artists and bohemians. The Great Depression had wrecked the economies of Europe and the United States and the fortunes of people wealthier than hardworking artists and writers. Unrest in Mexico was considerable, but it was also endemic in Europe. Totalitarian governments held power in Italy, Germany, and the Soviet Union. Smaller nations faced internal threats by native Fascist movements as well as external ones from Hitler, Stalin, and Mussolini. The Spanish Civil War erupted in July 1936 and ended in 1939 with the defeat of a republican government by Francisco Franco's Fascist Falange. No wonder Mexico appealed to artists, writers, and bohemians. Taxco de Alarcón, in the state of Guerro, was far south of the capital. It boasted a Native American indigenous culture and an economy based on the creation of traditional textiles, silver, and ceramics. Expatriate Americans Natalie Vivian Scott and William Spratling had established an artist's colony in Taxco that rivaled Europe in the 1920s for its cheapness, vitality, and eccentricity. Natalie Vivian Scott (1890–1957) was an author and hostess of literary and artistic salons in New Orleans and Taxco. She had served in the American Red Cross during World War I and was awarded the French Croix de Guerre. While in New Orleans she and William Spratling (1900–1967), artist, writer, and later silversmith, published *Old Plantation Houses in Louisiana* (1927) and *200 years of New Orleans Cooking* (1931). Scott and Spratling established the Taxco colony in 1930 and, in addition to hosting visiting artists and writers, did much to improve public health and economic opportunities in Taxco. Her pension was called Kitagawa House after the artist Tamiji Kitagawa (1894–1989), a resident of Taxco. William Spratling was born in New York but spent his youth in Auburn, Alabama. While teaching at Tulane University he shared a house with William Faulkner and collaborated with him to publish *Sherwood Anderson and Other Famous Creoles* (1929), a satire of bohemian culture in New Orleans. In Taxco he became a silversmith and introduced Mexican motifs to jewelry making in the United States.[52]

Taylor traveled throughout Mexico but spent most of her time in Taxco. She lodged at Kitagawa House and other cabins nearby, where her friends Rachel Hartley and Alice Jones spent time with her. Her letters and a prodigious number of watercolor and oil paintings offered considerable education and entertainment. In number and length, these Mexican letters rivaled her Great War missives. Taylor wrote about the lives and foibles of her fellow Taxco colonists and also recorded information on Mexican geography and folklife. Her descriptions of the customs of Native and Spanish Americans are so detailed that they may serve well the interests of cultural anthropologists. She was as curious about the "tiger dance" and mock battles between "Moors and Christians" in Mexico as she was about the Palio in Italy and wartime performances at the Paris Opera. She was prolific in painting watercolors (plates 28, 29, 30, 31 and 32), but she also made studies that she later used in creating woodblock and linoleum prints (figs. 13, 15, and 16). Her Mexican works were later exhibited in 1937 at Marie Sterner Gallery in New York City and at the New Orleans Arts and Crafts Society.

Taylor's Mexican letters bore some semblance to Mount Popocapetl, the volcano that was the subject of one of her paintings (plate 32). The letters overflowed with the names of her fellow artists and accounts of her own and their adventures. She met and lived closely with a great variety of writers, visual artists, a one-time Russian ballerina, archaeologists, and entrepreneurs from the United States and Europe. Despite the hijinks and whirlwind travel, the level of intellectual stimulation at Guanajuato and Taxco was intense and Anna reveled in it. An example suggestive of the way Anna viewed her world might be found in a letter to Nell, reporting that she had sent her niece Mariana an anthology of world literature with some suggested reading. "I was particularly interested in her reading the Greek, Indian, Persian & Chinese. Some of the most delightful poetry I ever read were Kalidasa's. His "Sakuntala" is the great Indian drama & he is considered the Shakespeare of Sanskrit. I also want her to read some of Tu Fu & Li Ti Po & see what they were thinking in about the 8th century China. The library must have some of Waley's translations of Chinese" (p. 251).

When World War II began, Taylor was back in Charleston. Ever patriotic, she immersed herself in organizing entertainment and parties for the servicemen at the Charleston Naval Base, much as she had done for the Red Cross in Europe. She was especially active in the local Union Jack Club because of her affection for British soldiers and sailors. Her correspondence contained several letters from British officers and enlisted men thanking her for her hospitality in Charleston.

During the last decade of her life, Taylor remained active and creative. She had accumulated a wealth of friends all over the country with whom she kept in touch and exchanged visits. Her chief artistic accomplishment was the creation of twenty-three original linoleum block prints to illustrate Chalmers S. Murray's *This Our Land: The Story of the Agricultural Society of South Carolina*, published by the Carolina Art Association in 1949. Among those illustrations are some of her best-known images: a loggerhead turtle climbing a beach, Mulberry Plantation, Bennett's Rice Mill, and scenes of African Americans laboring in rice and cotton fields. Her prints of a cutworm, a boll weevil, cotton flowers, and

bolls revealed in 1949 the same attention to scientific accuracy that she had shown in her British Guiana art. Six illustrations from *This Our Land* are reproduced in this volume (figs. 21–26).

When Taylor was past seventy years old, the Columbia Museum of Art and the Gibbes Art Gallery held a retrospective exhibition of her prints, oils, watercolors, screens, and batiks. The exhibition was on view in Columbia during November and December 1950 and Gibbes in December 1950 and January 1951.[53] Taylor received international recognition in March 1955 when Helen McCormack of the Gibbes Art Gallery sent ten of her prints to La Scala Opera House in Milan, Italy, as part of a Green Room exhibition at the opening of George and Ira Gershwin's opera *Porgy and Bess.* Her prints complemented the manuscripts and mementos of her cousin DuBose Heyward's 1924 novel *Porgy* and the play that was adapted for the opera.[54]

On March 4, 1956, almost a year to the day of the opening of the exhibit in Milan, Anna Heyward Taylor died at 3 Lamboll Street, her Charleston home. She was seventy-seven. Taylor was buried near her parents and other family members in Elmwood Cemetery, Columbia.[55] Friends and artistic organizations marked her death as a personal loss and the end of a remarkable career. Taylor's legacy has been that of a hardworking, innovative artist whose wanderlust and perennial curiosity about the world enriched the visual arts of her state and the nation. A pillar of the Charleston Renaissance, she was a regional artist for whom the whole globe was her neighborhood.

Although she was a wholehearted South Carolinian, she was never constrained by conventional definitions of the role of the southern lady. She probably wore too easily the privileges and prejudices of her birthplace and social station, but that criticism might well be made about most of her contemporaries, North and South. In her case, at least with respect to her artistic creations, she seemed to transcend those privileges and prejudices. Even when her African American farm laborers, Mexican peasants, and Caribbean natives are depicted in stereotypical scenes, their vitality and integrity are well defined. An acute observer of people and places, Taylor transformed what she saw into works of art and deft commentaries in her letters. However, she was an artist, not a social critic or political progressive. She was true to her values and mindful all her life of her responsibilities to family and friends. Her torrent of letters coupled with her prodigious artistic achievements delights the senses and stirs the imagination of readers and viewers.

With such a wealth of documents and artworks it might be deemed ungrateful to lament those items that are lost. However, the importance Taylor placed on her correspondence makes understandable such a lament. From statements in the letters, it appear that she occasionally kept rough diaries that she consulted to flesh out her letters. These diaries are lost as are some specific journals and even booklists that she reported keeping. Also missing from her papers are any print logs, journals, or account books containing information about the number, sequence, and sales of her prodigious number of prints. Other printmakers, notably Alice R. H. Smith and Blanche Lazzell, kept meticulous print journals that recorded information about their creation of prints and information about sales.[56] The absence of those records for Taylor makes it difficult to assess the business side of her

career or collect precise information about print runs and variant states of prints. Such information is important to art historians and collectors, but its absence does little to affect our appreciation of Anna Taylor's work.

## Notes

1. See B. F. Taylor, "John Taylor and His Taylor Descendants," *South Carolina Historical and Genealogical Magazine* 8 (January 1907): 95–119, for Taylor genealogy. See also the entries in Walter Edgar and others, *The South Carolina Encyclopedia* (Columbia: University of South Carolina Press, 2006) for Anna Heyward Taylor and John Taylor, as well as family members and other principals herein.

2. For more information on Taylor's Heyward forebears, see the Heyward entries in Edgar and others, *South Carolina Encyclopedia,* and Peter A. Coclanis's introduction to *Seed from Madagascar,* by Duncan Clinch Heyward (1937; repr., Columbia: University of South Carolina Press, 1993).

3. Roster of 1925 MacDowell Colony residents, courtesy of the MacDowell Colony, 163 E. 81st Street, New York, NY 10028. Founded in 1907 by the American composer Edward MacDowell and his wife, Marian MacDowell, the colony catered mostly to composers and musicians, but many writers and visual artists resided there. See also *New Hampshire: A Guide to the Granite State,* American Guide Series (Boston: Houghton Mifflin, 1938), 220–21.

4. See Taylor's comments on the Italian Origo family (pp. 184–85) and Dr. Joseph I. Waring (p. 230).

5. Lana Ann Burgess, "Anna Heyward Taylor: 'Her Work Which Is of Enduring Quality Will Remain to Attest to Her Reputation as an Artist and Her Generosity as a Citizen'" (master's thesis, University of South Carolina, 1994).

6. Mariea Caudill Dennison, "Art of the American South—1915–1945: Picturing the Past, Portending Regionalism" (Ph.D. diss., University of Illinois at Urbana-Champaign, 2000).

7. Ibid., chap. one, "America in Search of Herself: The Discovery of American Folk Art and the Rise of Regionalism," and 90–93.

8. Martha R. Severens, *Anna Heyward Taylor: Printmaker* (Charleston: Greenville County Museum of Art and Gibbes Art Gallery, 1987).

9. Pamela S. Wall, "The British Guiana Works of Anna Heyward Taylor" (unpublished essay, Gibbes Museum of Art, 2007).

10. Various issues of the *Palmetto,* the newsletter of the Presbyterian College for Women, reported on Taylor's art instruction in New York. South Caroliniana Library, Vertical File, Anna Heyward Taylor.

11. Gabriel P. Weisberg and others, *Japonisme: An Annotated Bibliography* (New York: Abrams, 1990); John Walter De Gruchy, *Orienting Arthur Waley* (Honolulu: University of Hawaii Press, 2003); Lynn S. Barron, "Japonisme and Its Influence on the Work of Two South Carolina Artists: Alice Ravenel Huger Smith and Anna Heyward Taylor" (unpublished manuscript, South Caroliniana Library, March 17, 2003).

12. Alex Bennett, "The FJ Norman Saga—the Final Chapter," *Kendo World* 3, no. 3 (2006): 8–15.

13. *Palmetto* (see n. 10), April 1908, 126, in South Caroliniana Library, Vertical File, Anna Heyward Taylor.

14. See Valerie Suzanne Bowen, "Katherine Bayard Heyward, South Carolina Art Educator" (master's thesis, University of South Carolina, 1991).

15. See Bernard Leach, *Beyond East and West: Memoirs, Portraits, and Essays* (London: Faber, 1978); Carol Hogben, ed., *The Art of Bernard Leach* (London: Faber, 1978).

16. Hyde's letters to Taylor and Alice R. H. Smith plus a collection of Bertha Jaques's letters to Smith revealed much about the advent of woodblock printmaking as a noteworthy medium of the Charleston Renaissance. These letters are in collections at the Gibbes Museum of Art and the South Carolina Historical Society. Letters to and from Taylor are in the South Caroliniana Library.

17. David Acton, "The Provincetown Print," in *Blanche Lazzell: The Life and Work of an American Modernist,* ed. Robert Bridges and others (Morgantown: West Virginia University Press, 2004), 169–204; Reva Kern, "History of the Provincetown Print," *Block and Burin: Journal of the Wood Engravers Network* (August 1998); Van Deren Coke, *Nordfeldt, the Painter* (Albuquerque: University of New Mexico Press, 1972), 32, 46–47.

18. Janet Altic Flint, *Provincetown Printers: A Woodcut Tradition* (Smithsonian Institution, 1983), 15.

19. Gibbes Museum of Art, Anna Heyward Taylor Printing Blocks Collection, Accession Number 51991.002. Plate 5, block 17, in box 2; plate 6, block 17, in box 2; plate 9, block 16, in box 2; plate 19, blocks 19, 20 in box 5; plate 15, block 2, in box 1; plate 16, block 42, in box 4.

20. Dennison, "Art of the American South," 422, 428.

21. See plate 18 and inventory of Carolina Galleries, 106 Church Street, Charleston, S.C. 29401.

22. The black-and-white version was published in *Charleston Receipts* (1950), and a color version was in the inventory of Carolina Galleries, 106 Church Street, Charleston, S.C. 29401.

23. Severens, *Anna Heyward Taylor: Printmaker,* 7; *Ninth International Print Makers Exhibition* (Los Angeles: California Society of Print Makers, 1928); Gibbes Museum of Art, Artist Files, Anna Heyward Taylor, folder 4.

24. Marguerite Thompson Zorach, *Clever Fresno Girl: Travel Writings of Marguerite Thompson Zorach (1908–1915),* ed. Efram L. Burk (Newark: University of Delaware Press, 2009); William Zorach, *Art Is My Life* (Cleveland: World Publishing, 1967); Roberta K. Tarbell, *Marguerite Zorach: The Early Years, 1908–1920* (Washington, D.C.: Smithsonian Institution Press, 1973).

25. Gibbes Museum of Art, Artist Files, Anna Heyward Taylor, folder 1.

26. Pieter Mijer, *Batiks and How to Make Them* (New York: Dodd, Mead, 1919). Mijer's father was a Dutch colonial administrator in Indonesia. See also Hazel Clark, "The Textile Art of Marguerite Zorach," *Women's Art Journal* 16 (Spring 1995): 18–25, quote at 19.

27. "Floral Designs in Textiles: Plant Motifs Based on Studies Made by Miss Anna Heyward Taylor at Kartabo, British Guiana," *Natural History* 22 (March–April 1922): 176.

28. Gibbes Museum of Art, Artist Files, Anna Heyward Taylor, folder 4 contains a descriptive list of the Charleston Museum's batiks.

29. *Berkshire (Mass.) Advocate,* August 21, 1924, quoted in Burgess, "Anna Heyward Taylor," 50–51.

30. From Gilbert Archey, October 26, 1919; Mijer, *Batiks and How to Make Them* includes technical information and illustrations of his and others' batiks.

31. Bowen, "Katherine Bayard Heyward," 8–10.

32. To Nell, December 23, 1917; October 20, 1918.

33. Plates 4, 5, 9, 10; Wall, "The British Guiana Works of Anna Heyward Taylor."

34. "Floral Designs in Textiles," 175–78, plates 6, 9.

35. Gibbes Museum of Art, Artist Files, Anna Heyward Taylor, folder 2 contains nineteen photographs of the works exhibited at the Brooklyn Botanic Garden.

36. "British Guiana Jungles," *Christian Science Monitor,* December 22, 1920; "British Guiana Flowers," *Christian Science Monitor,* January 17, 1922. Both articles are reprinted herein; see pages 171–74.

37. "Floral Designs in Textiles," 175, 178.

38. Coke, *Nordfeldt the Painter,* 53–55, 67–69, 73–75.

39. Burgess, "Anna Heyward Taylor," 107; Dennison, "Art of the American South," 418.

40. Roster of 1925 MacDowell Colony residents (see note 3).

41. Dennison, "Art of the American South," 419–20.

42. Elizabeth Verner Hamilton, "Four Artists on One Block and How They Got Along; or, A Partial History of Atlantic Street, 1913–1936," *Carologue* 25 (Summer 2009): 15–19.

43. Other Charleston Renaissance artists included Alfred Heber Hutty, Elizabeth O'Neill Verner, and Alice Ravenel Huger Smith. See their biographies in Edgar and others, *South Carolina Encyclopedia*; Martha R. Severens, *The Charleston Renaissance* (Spartanburg, S.C.: Saraland Press, 1998); *Alice Ravenel Huger Smith: An Artist, a Place, and a Time* (Charleston, S.C.: Gibbes Museum of Art / Carolina Art Association, 1993); and James M. Hutchisson and Harlan Greene, eds., *Renaissance in Charleston: Art and Life in the Carolina Low Country, 1900–1940* (Athens: University of Georgia Press, 2009).

44. Poetry Society of South Carolina, *Yearbook* (Charleston: Poetry Society of South Carolina, 1929), 55.

45. "Exhibit of Anna H. Taylor's Works Large and Varied Columbia Library," *Columbia (S.C.) State*, November 25, 1930, 6.

46. For information on Taylor's exhibitions, see the appendix to Burgess, "Anna Heyward Taylor"; Gibbes Museum of Art, Artist Files, Anna Heyward Taylor, folder 4.

47. National Art Society, *American Art Today: Gallery of American Art Today, New York World's Fair* (1939; repr., Poughkeepsie, N.Y.: Apollo, 1987), 321.

48. International Business Machines Corporation, *Contemporary Art of the United States* (New York, [1940]), unpaginated.

49. A boxed, gold-stamped copy of *The Carolina Low-Country* in the Charleston Library Society's Hinson Collection is labeled "No. 40." See Stephanie Yuhl, *A Golden Haze of Memory: The Making of Historic Charleston* (Chapel Hill: University of North Carolina Press, 2005) for a study of the way a Charleston mystique was created and marketed to encourage tourism. See also Edgar and others, *South Carolina Encyclopedia*, "Society for the Preservation of Spirituals."

50. Louise Anderson Allen, *A Bluestocking in Charleston: The Life and Career of Laura Bragg* (Columbia: University of South Carolina Press, 2001), 168, 192–93.

51. See "Chronology" in Burgess, "Anna Heyward Taylor"; Gibbes Museum of Art, Artist Files, Anna Heyward Taylor, folder 4.

52. See John W. Scott, *Natalie Scott: A Magnificent Life* (Gretna, La.: Pelican, 2008); Taylor D. Littleton, *The Color of Silver: William Spratling, His Life and Art* (Baton Rouge: Louisiana State University Press, 2000).

53. Gibbes Museum of Art, Artist Files, Anna Heyward Taylor, folder 4; Burgess, "Anna Heyward Taylor," 83.

54. The Charleston Library Society has a collection of photographs that depict Taylor's prints on view in the La Scala Green Room. The society also owns drafts of the novel *Porgy*.

55. South Carolina Historical Society, Vertical Files, 30-4, Anna Heyward Taylor, contains clippings from the *Charleston News and Courier* and other publications about her death and obsequies.

56. Acton, "The Provincetown Print," 181–82; Severens, *Alice Ravenel Huger Smith*, 25, 60.

# FAMILY MEMBERS AND OTHER PRINCIPALS

**Parents**

BENJAMIN WALTER TAYLOR, M.D. (1834–1905)

The grandson of Colonel Thomas Taylor, he served in the American Civil War and became medical director of cavalry of the Army of Northern Virginia. After the war he practiced medicine in Columbia.

MARIANA HEYWARD TAYLOR (1844–1907)

Born in Beaufort, she was a cousin of Governor Duncan Clinch Heyward, a rice-planting Heyward of lowcountry South Carolina.

**Siblings**

THOMAS TAYLOR (1886–1938)

A farmer in the cottonseed oil business in Columbia, he married Sue Ames from Boston, Massachusetts.

1. Thomas Jr.
2. Ray

BENJAMIN FRANKLIN TAYLOR (1873–1937)

Historian and businessman, he was married to Elizabeth H. Saul.

1. Thomas
2. Coles

JULIUS HEYWARD TAYLOR, M.D. (1877–1938)

A Columbia surgeon, he wed Margaret Rhett of Charleston.

1. Benjamin Walter (Walter)
2. Helen Whaley
3. Goodwyn Rhett (Goody)
4. Julius Heyward Jr.
5. Edward Coles (Ed)

ELLEN ELMORE "NELL" TAYLOR (1883–1973)

Nell was the recipient of most of Anna's letters. She married a cousin, George Coffin Taylor, Ph.D.

1. Eliza Taylor Shockley

2. Mariana Heyward Taylor Manning

Anna's niece was an artist to whom Anna bequeathed paintings and printing blocks.

3. Edmund Rhett Taylor, M.D.

Anna's nephew and a surgeon in Columbia. Editor of this book, he is married to Mary B. Herbert of Columbia, to whom Anna introduced him.

EDMUND RHETT "BUD" TAYLOR (1885–1920)

**Extended Family**

GEORGE COFFIN TAYLOR, PH.D. (1877–1961)

Anna's brother-in-law, he married his cousin Nell. He was an English professor at the University of North Carolina, a farmer, author, and lawyer.

SALLY COLES GOODWYN (COUSIN COLEY, D. 1915)

Anna's first cousin, daughter of Sally Coles Taylor Goodwyn and John T. Goodwyn. She exchanged many letters with Anna and Nell.

MAJOR THOMAS TAYLOR (1824–1903)

Brother of Benjamin W. Taylor, M.D., and Anna's uncle

SALLY ELMORE TAYLOR

Wife of Major Thomas Taylor

**Artists, Friends, and Associates**

WILLIAM MERRITT CHASE (1849–1916)—An eminent American artist and instructor, he painted portraits of Anna and her parents. Anna studied with him in Holland and England.

BROR JULIUS OLSSON NORDFELDT (1878–1955)—Artist teacher of Anna in Provincetown

MARGARET MOFFETT LAW (1871–1956)—Spartanburg, S.C., native and fellow artist

CHARLES W. HAWTHORNE (1872–1930)—Artist teacher of Anna

HELEN HYDE (1816–1919)—Printmaker and Anna's friend

KATHERINE BAYARD HEYWARD (1886–1974)—Head of the Department of Art at the University of South Carolina and daughter of Governor Duncan Clinch Heyward

CHARLES WILLIAM "WILL" BEEBE (1877–1962)—He was curator of ornithology of the New York Zoological Society when Anna accompanied him on scientific expeditions to British Guiana in 1916 and 1920.

GEORGE INNESS HARTLEY (b. 1887)—Member of Beebe's expedition, biologist

RACHEL V. HARTLEY (1884–1955)—Sister of Inness and granddaughter of famous landscape American painter George Inness. She was Anna's lifelong friend.

CAMILLA AND MILES STANHOPE SAMS—Friends of the Taylors in Columbia, Anna visited them in Japan.

ROBERT BEVERLEY HERBERT—Anna's lawyer in Columbia. Edmund Rhett Taylor, M.D., married Mary Herbert, his daughter.

*Selected Letters of*
ANNA HEYWARD TAYLOR

# I

## The Youthful Artist

ANNA HEYWARD TAYLOR'S FAMILY had a strong influence on her life and character. She was fortunate to have grown up in a large, close-knit family. There are no letters from her father, but we do have a few from her mother. This paucity reflects closeness, not estrangement. Her correspondence was fulsome when she was away from home and diminished when she was near.

Taylor's parents came from prominent families, displaced by the Civil War with their livelihoods in ruins. She was born shortly after the end of Reconstruction, and her early years were marked by her family's struggle to recover from debt and decline. Her mother, Mariana Heyward Taylor (1844–1907), was one of the lowcountry Heywards, a family that had produced statesmen and political leaders in every generation of South Carolina history.

Taylor's father, Dr. Benjamin Walter Taylor (1834–1905), was the grandson of Col. Thomas Taylor, a Whig patriot in the American Revolution, and the son of Benjamin Franklin Taylor (1791–1852). Dr. Taylor's life was governed by his sense of duty and honor. He entered Confederate military service before the state attacked Fort Sumter and battled the army of General William T. Sherman even after General Robert E. Lee had surrendered at Appomattox in April 1865. A battlefield surgeon, he was always found among wounded Union and Confederate soldiers in the tremendous battles in Virginia. It was said of him that for four years, "Where the wounded were, there was Dr. Taylor." At the war's end, Dr. Taylor returned to civilian life and helped rebuild his shattered state. He took the lead in establishing the first Columbia Hospital and in reorganizing the State Mental Hospital. President of the Medical Society of South Carolina, he was also a founder of the Southern Surgical Association. Anna Taylor inherited his energy.

When arguments erupted around the dinner table, Dr. Taylor restored calm by rapping on the table and commanding, "Talk art—talk art!" What that order meant is lost to posterity, but perhaps it is a clue to the way Anna Taylor discovered her life's work.

*Ellen T. Elmore to Dr. Benjamin W. Taylor*
*Columbia Home School, Laurel Street, Columbia, S.C.*
*1886*

You will not deny me one of the greatest pleasures I can know, that of <u>believing</u> I am doing something for the dearest friend I have in the world. It has been a delight to me to feel some-one belonging to you near me, & getting into my heart; & I want to keep her there all the time.

It is needless to say I love you & yours with a love beyond what I can say, & to be of use to you in any way makes me happy. Let me <u>think</u> I can be so in this small matter.

Anna is no trouble to me, & her sweet little pure face goes right home to my heart & makes me feel warm & comforted, when I have cause to be otherwise. You must let her be my own little girl as long as you think I am doing for her all that ought to be done; as long as my ability to teach her lasts. When she requires other teaching, I shall be willing to sur-render my place to one more able.

*From Eliza Rhett*
*June 7, 1894*

I am so very sorry that they are changing Trinity Church. I always like to think of it as being the same as when I left Columbia. You don't know how surprised I was to see that you had received a prize for drawing. I have never seen any of your drawing except what you used to do in school. Don't you remember what ridiculous ones we used to draw! I wish I could draw. The only thing I can draw decently is <u>maps</u> and I like to draw those very much. I expect some day I will see you mentioned in the paper as a celebrated artist.

Taylor's mother had a sharp sense of humor and was sometimes hard on those she loved. She and her upcountry husband, Dr. Benjamin Walter Taylor, were pillars of Trinity Episcopal Church and, on Sundays, filled pew number 52 with their four sons, Anna, and Nell. After church Mrs. Taylor climbed into her buggy and distributed food to the needy in her neighborhood. Portraits of her and her husband, painted by William Merritt Chase, hang in the Columbia Museum of Art.

Summers in Columbia are hot, and a century ago, when these letters were written, were without the respite provided by air conditioning. Cooler by far were the North Carolina mountain towns of Saluda, Flat Rock, and Blowing Rock, so gentry women spent the hot months there, boarding in private homes. ∞

*From Mother*
*Columbia*
*Wednesday Aug. 4, 1897*

If you get tired of Blowing Rock, why not see if you can get in at Saluda & come down there. <u>There is plenty of walking</u> in Saluda, but, the surroundings can not compare with where you are. Did you actually pay six dollars for your staging coach from Lenoir to Blowing Rock? I don't remember what I paid when I carried all of you up, but, I remember paying

only ten dollars to carry all of you & a wagon with our trunks besides, to Brevard from Hendersonville.

P.S. Don't take such long walks in the morning, & never take them twice, you will injure yourself.

*From Mother*
*Monday August 19, 1897*

The only book Ben took out of your box was one on pronunciation, &, according to that author our lower country pronunciation is the most correct. I mispronounced thirteen out of fourteen words, by following you up-country people. I think I shall take the present book cases from up-stairs & have a book case made the whole length of the passage, for the guest room cannot be given up. I cannot have strangers up-stairs, & you know you will want some girls to visit you; now I wish to have Elise Lewis this Fall, &, may be, Julius will want some young man, & where would you put them?

We found a lovely walk, which we want you to enjoy when you come up. Every morning I wish for Edmund [her youngest and disabled child] to play ball with the boys on Helen Coles' lawn.

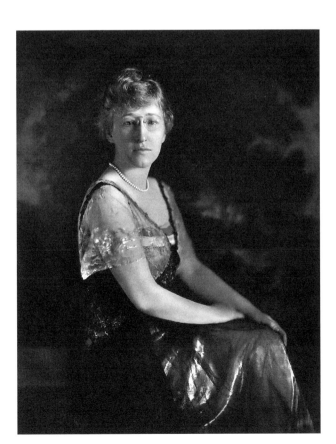

Anna Heyward Taylor, studio photograph. Courtesy of South Caroliniana Library, University of South Carolina, Columbia

It is raining today, & the shed has not been fixed yet, however I am in the nursery, so when your father's nose is mashed flat by the plastering tumbling down, I presume, he will consider the propriety of having it looked after, in the mean time I am "possessing my soul with patience" outside, but very much terrified inside, as, when the weather is good, he will not think of the leaks & when it is bad, it is too late.

TAYLOR NEVER MARRIED, but she attracted and reciprocated the attention of marriageable men throughout her life. Lee Hagood (b. 1877) was one of the first whose eye she caught. Her letters are filled with the names of men who interested her, and she recounted her friendships with men throughout the world. By 1899 Taylor was an art student at the Art Students League and the New York School of Art, where the painter William Merritt Chase taught. ∾

*From Lee Hagood\**
*Fort Preble, Portland, Me.*
*Dec. 31, 1899*

A few weeks ago I received quite a nice surprise in the shape of an express package containing quite a quantity of caramels. A strange part about it was that there was no indication whatever of who the donor of the delightful contents was, further than on the card enclosed was scribed "Should old acquaintance be forgotten." The mystery, however, was cleared up a couple of days ago when Beverley Herbert told me that you had sent them. I can express a most hearty thanks for they were greatly appreciated and enjoyed. Guess you spent a very pleasant Christmas. Julius, I believe, was home wasn't he? Well, I certainly would have liked to have been there too, I know you all had a great time.

* This letter was addressed to Taylor at 153 East 62nd St., New York, N.Y.

*From Mother*
*[1900]*

Poor fare is not conducive of a very rosy complexion, & I neither believe that you are feeling or looking well, & as the Winter advances & the weather becomes severe, & your throat still worried, I don't care for you to stay North. Another winter, like the past one, will reduce you to bones, only, & all the train of evils, belonging to that condition.

It would be well if you went every day to a soup house, or some place where you get a cup of coffee & slice of bread for a few cents. I have heard people talking about those places.

I don't understand what you say about your water paintings. Is it that you are doing so badly in oil that they do not see how you accomplished any thing in water-colours? You must be very discouraged. Do you know whether you have any talent for your work, or can you not find out yet?

*From Lee Hagood*
*Fort Preble, Portland, Me.*
*Nov. 30, 1900*

I am told you are in New York studying art. You mentioned in your letter that you were going there but I wasn't sure as to your purpose. I know you must be delighted for I understand that you are under quite a famous teacher [William Merritt Chase]. Then, to be in New York must be simply elegent [*sic*]. I stopped over for a few days when I passed through and have ever since desired to get back again. No doubt you are taking in all the operas and plays.

How long are you going to be in New York? Do you expect to visit Boston? If so let me know and I will run down to see you. I think we could have lots of fun sight-seeing. And it would be no small pleasure either for me to see some one from home, especially one whom I have so nearly grown up with.

*From Lee Hagood*
*Fort Preble, Portland, Me.*
*Dec. 24th 1900*

I wish you a very happy Xmas! You have my sincere sympathy for having to be away from home on this occasion. This is the second one that I have spent up here so I have a fellow-feeling for you and can realize keenly what it is.

*Dec. 26th*

We have met some nice girls up here whom we on the quiet go to see. They are very much interested in our welfare and treat us royally. I didn't know how much I was dependent on petticoats for a lot of happiness until I got up here. We had a good many opportunities offered to meet some nice girls but we felt that it would be humiliating to meet nice girls while occupying the position in society of a soldier. Finally, a young girl from Maryland sent us word that she would be pleased to meet us, she didn't care whether we were soldiers or not, the fact that we were Southerners alone made her crazy to meet us. Now, who could resist such a temptation as this, and coming from a girl who was as pretty as a peach!

I have made a discovery since I have been up here that I was ignorant of before, and it is this, that Northerners hold Southerners in very high esteem. In the South we always look rather harshly on a Yankee and I thought they would return the compliment but they don't. Instead, they admire them very much, as I guess you have found out yourself. Perhaps, I am in no position to judge, but our men can certainly lay these in the shade when it comes to doing the polite thing towards a woman.

I am awfully glad to learn of your success in your study of art, and you have my deepest interest in your further development. And I know you to be the girl who will make a success of what you go at for you put your heart in it. It is hard indeed to leave home with its happy surroundings to follow up ones ambition. The road to success is generally very bitter and full of stumps. But once the goal is reached you are amply repaid for your suffering.

It seems you have struck your calling, and fame is in store for you if you just continue to work, work, work without ever allowing yourself to loose [*sic*] heart.

*From Lee Hagood*
*Fort Preble, Portland, Me.*
*March 29th 1901*

Your letter arrived O.K. tonight, and to show you how glad I was to hear from you I have answered so you will get this in the return mail. I had a lot of business letters to write tonight and I came very near leaving them all untouched, so much did you get possession of my thoughts.

The thought however of your thinking of me in connection with "the [Art Students] League Fake Dance" has an awakening influence. It is certainly sweet of you and I could k—s well I won't say—for it. "Very disgusting. Learned that forwardness from those Yankee girls." No doubt the above quoted is what you think, but never mind when I get under refining influences I may improve. How much longer will you be in N.Y.? It will be very dreadful if you leave before I pass through. In that case, can't you manage to visit some friend in Boston? I could get a furlough and we could have a great old time.

So you are going to the Commencement after all. Don't you worry about it for I am sure you will have a corking good time. Young lady don't you realize what a stunning woman you have grown to be. Especially when you have on that fifty placket dress. Well, I have to ring off as it is getting late and I might say something foolish like Mr. Reamer if I continue on this subject.

*W[illia]m M. Chase to Thomas M. Taylor*
*The Stratford, Philadelphia*
*Jan. 7th 1902*

Your letter containing a check for $1000—in payment for your Father's portrait—reached me yesterday just as I was taking a train for Philadelphia. I thank you for the same. The frame for the picture will be ready by Saturday of this week when I will have it sent to you. In reply to your inquiry as to my coming south this winter, I will try to do so and if I do I shall take great pleasure in painting your Mother's portrait. I will let you know later when I am likely to go to Charleston.

*William M. Chase to Thomas M. Taylor*
*The Stratford, Philadelphia*
*Jan. 11th 1902*

In reply to your favor of the 9th inst. my price for a copy of your Father's portrait is $800. It goes without saying that I could do it better than anyone else. My work would not be a copy but a replica. If you decide to have me do the work, please notify me as soon as you can conveniently so that I may manage my engagements so as not to interfere with the undertaking. The portrait I have painted of your Father meets with very hearty approval

and is considered one of the very best heads I have painted. The picture is in its frame now and looks very handsome. With kind remembrance to your Sister [Nell] and Father.

*From Marie-Marguerite Frechette*
*315 West 58th St., New York*
*May 19th [1902]*

I rejoiced most heartily to hear of your successes, but it is just what I would have expected you to do. And I was so glad to hear that you hadn't given up art altogether for science. I have simply not thought of anything except work this winter, & it has told. You know I began by getting 3 & 4 in concours [*sic; écorché?*], & every month since in Life class have had a pretty good number, & finally ended the year by getting 1. I was awfully surprised, & of course, delighted. In March I began to paint still-life, & fell hopelessly in love with it. It is so satisfactory. Then I tried portraits & got 5 on my first. I am painting half the day now, & part of the time in the Life class as well. Irving Wiles [1861–1948] criticizes the Portrait class, & I like him immensely. He has been very kind to me.

I wish you could have been here for the S.A.A. this spring. It was better than usual. The other exhibitions have been very good, too. Last Monday I went up to the museum [Metropolitan Museum of Art] to hear Mr. Chase talk of the new pictures. (You know they now have [Peter Paul] Reubens' "Holy Family," "The Sower," several very fine Mesoniers [Jean Louis Ernest Meissonier, 1815–91], & a great many other good ones.) He was very interesting but I liked him best when he went back to the [Franz] Hals' portraits, & spoke of them. It was very amusing to see the way visitors gaped at the long group of students who trailed after the important little man & I heard various funny explanations which they made to each other, of what was being done.

I was so glad to hear of your brother's laurels. [John Mead] Howells, as usual(!) seems to be acquiring them, too.* He has just been reappointed for another year, to his demonstratorship. And he is no. 7 instructor in the surveying class as well. He asked after you in a late letter. I should be most charmed, if I can't be a sister to you, to be a cousin and I hope that fate will arrange it.

Anna, is there any possibility of your being in New York next year? I am coming back, & wish so much that we could be together. I expect to paint all next year, & can hardly wait. You know I am a member of the [Art Students] League now, so there are special inducements to come.

* Architect John Mead Howells (1868–1959) was the son of the writer William Dean Howells. Years later he was active in historic preservation in Charleston, South Carolina.

*From Marie-Marguerite Frechette*
*87 MacKay St., Ottawa*
*June 20th 1902*

You are to be congratulated indeed! And I do, most sincerely. A scholarship is ideal, or would be, should it bring you to New York. But even to Philadelphia, it is fine. Still I was

hoping that perhaps you would be back in New York, & that we might be together. Why don't you try & have it transferred to the [William Merritt] Chase school? Aren't both schools under the same management? Oh, I sympathize with you in the talk of <u>marrying</u> by your family, for mine has been talking to me in just the same vein, & it simply maddens me. I wish one could be left alone about that sort of thing. I shall <u>never</u> marry first because I am told it would be a good thing to do, & it just irritates me. You must have had a <u>lovely</u> time in Charleston. I wish I could have seen the pictures. Did you know that the Mr. [I. N. Phelps] Stokes painted by [John Singer] Sargent, is John's [John Mead Howells's] partner? It is perfectly lovely to hear of your brother's successes. "The Professor" is home for a few days & sends his kindest regards to you.

*From J. D. Pierce*
*Pennsylvania Academy of the Fine Arts, Philadelphia*
*July 16, 1902*

We regret very much that you find it impossible to accept the Scholarship for the coming season as we feel sure that you would be able to make very rapid progress with your work while here.

  I am unable to give you any definite information in regard to the award of a Scholarship after this season. It is probable that the Scholarship to the College for Women will be continued next year but the choice of the candidate would, of course, be left to the authorities of that Institution. I have made a search for your drawings but so far have not been able to find them. I am investigating the matter, however, and if they can be found, I will forward them to you in a few days. It will give me great pleasure to receive you at the Academy Schools whenever you can make it convenient to come, and with best wishes for your success in art.

*From Marie-Marguerite Frechette*
*"The Rockingham," 1748 Broadway, New York*
*October 5th 1902*

Your second letter was waiting for me when I arrived at the League yesterday. I am simply delighted to know that you and Nell are to be here; & what a lively time you will have in Boston. Now Anna, you must let me know just when you are to be here, & where, for you must meet John [Mead Howells] this time; so I can have the South Carolina cousin, (since you won't be a sister to me). When did Miss Morrison expect to be here? Her beloved Du Mond [Frank V. Dumond, 1865–1951] has the morning life classes, but I have seen no sign of her. Walter Appleton Clark [1876–1906] has the Illustration Class & has brought up the attendance tremendously. I am monitor of the Portrait Class, & am only going to work half a day. I am doing some very interesting work beside, that I will tell you about when I see you. I really have not got settled down yet to work for my summer was so glorious that I haven't forgotten it yet. I was in Ottawa until the middle of August and never enjoyed a summer more. Then I went to Jefferson [N.Y.], & had a glimpse of dear old Isabel [Cooper]. She is the same calm old duck, & is settling down quite happily again. She is very busy with

her China-painting, & she has several pupils in drawing. From Jefferson I came to Long Island, where I spent a <u>perfect</u> fortnight with my cousin, Frank Howells. He has a <u>perfectly</u> lovely country place & the house was filled all the time with charming people. Frank is a dear. If I didn't <u>like</u> him so much I might love him.

How lovely that you are to go to Europe next summer. I only wish I could join you. I can't think of anything I would rather do.*

---

* Frechette addressed this letter to Taylor "C/O Mrs. Oliver Ames, 355 Commonwealth Ave., Boston, Mass."

## 2

*With William Merritt Chase
in Holland, 1903*

THE YEAR 1903 WAS SIGNIFICANT in Taylor's artistic career because she took to a high level her study with the American painter and teacher William Merritt Chase. She had begun to study with Chase in 1900 at his New York School of Art and the Art Students League. That acquaintance likely led to Chase's commission to paint portraits of Anna and her parents. Anna enrolled in the first class of students in Chase's summer school in the Netherlands and London. As she arrived in Holland in July 1903, she wrote, "Am having the time of my life" (p. 14). In class she was exuberant. Surrounded by great art and distinguished artists, she asserted, "I could paint all day & all night & never get enough paint" (p. 19).

The adventure began with a smooth voyage on the TSS *Potsdam,* a passenger ship of the Holland America Line, filled with interesting people. Lawton S. Parker (1868–1954), a mature artist who assisted Chase's class, became a close friend. ∽

*From W[illia]m M. Chase*
*May 17th [1903]*

For sometime I have intended to write to you to say how glad I am that you are to be one of the Holland party. It is going to be a great trip. I am fortunate in having a select lot of pupils and I [missing word] make sure you are going to find it all very agreeable and we must get much done. I am exceedingly sorry to have had to disappoint your friend about the sending down those portraits. One thing and another occurred to prevent it for this season if it is still desired I will positively send a collection to Columbia and [the school] next season as early as October if desired.

May I trouble you to send me my paint box, the one I left with brushes at your brothers.

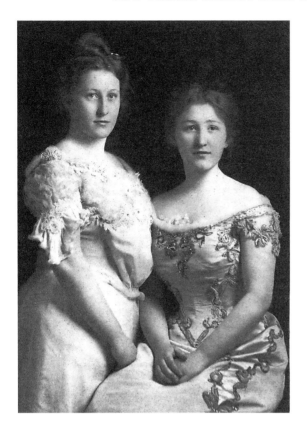

Ellen Elmore Taylor and Anna Hey-
ward Taylor, 1901. Courtesy of South
Caroliniana Library, University of
South Carolina, Columbia

*Holland-America Line, T.S.S. Potsdam*
*June 16th [1903]*

To Nell

We sailed on Tuesday at 10 o'clock & two fool women, regardless of numerous blows of the
whistle to warn people to get off, were left on & had to descend a rope ladder to some lit-
tle tug. They say that people sometimes do it on purpose. It was a beautiful day & the ocean
was like a millpond. Yesterday was the same & today also. Hardly anyone has been sick. The
boat is so steady that there isn't a variation of a half an inch when you get some object on
the horizon.

June 18th. The beautiful weather continues. Very few people seem to have gotten sick,
but among them is one of my roommates. I am with a Miss Kerr & Miss Butts; both being
quite nice looking girls. Among our class is a Mr. Webster [E. Ambrose Webster, 1869–
1935], a nephew of Mark Twain.

I have quite a lively time at the table! Four of the people belong to a German family &
the other two are French! The consequence is I miss the food when it comes around &
nearly go wild in my efforts to understand the conversations. The old German has lots of
fun in him & is now trying to teach me the language. I went to see Mrs. [Alice Gerson]
Chase before leaving N.Y. She must have been a very pretty [woman] when young. She
seems to be a very sweet woman.

We had just gone to bed when we heard quite a noise outside in the passage & soon I saw three men bring that poor little Webster creature, dead drunk, to bed. His state room is just across from ours. After much conversation & row he was finally gotten to bed.

There is a Miss Farrar who is a member of the class–from New Orleans. She knows the people that I know down there. I like her very much. Her hair is the reddest you ever saw.

There are two Barons on board. The Austrian is very tall & consumptive looking & isn't overburdened with sense & the German is short & dark & has only smiled once since I have been on board. They are the most uninteresting people on board.

June 21st. Every one has been remarking on the weather during this voyage. We have been on the ocean exactly one week today & we have hardly seen a white-cap. If one judged from my appetite & my shoes they wouldn't hesitate to place me as a Yankee. Someone remarked yesterday, to my indignation, that I am a typical American. I hastened to inform them that I am anything but that for I was not at all loyal & only patriotic where the South & my state were concerned. The girl was simply scandalized much to my amusement. I must say that to be a typical American is not my ambition.

June 23d. We passed the Scilly Islands last night & this morning the Lizard is in sight. We will get to Boulogne this evening at eight o'clock & to Rotterdam at about 6 in the morning. As there is absolutely nothing to talk about I will close this letter. Please don't hand my letters around the family. Cousin Coley is the only one I want my letters given to unless they ask.

*On board the Potsdam*
*Sunday morning, June 28 [1903]*

To Nell

I was most fortunate in my cabin-mates; neither are sick in the least. One is awfully nice–Miss [Elizabeth H.] Howland from Cambridge.* Miss McEwen is an English girl who has lived in this country for some time. She seems clever but not attractive, rather nice, isn't sick anyhow. One of the girls had a roommate in the berth above who was violently ill so had a most charming time. Every morning I make the maid bring me some tea & toast in my stateroom & then get up & take a hot salt bath which she fixes for me in the bath-room. Then I dress & come on deck & here I stay until 11 o'clock every night.

Have met two men of our party, Mr. [Richard] Tweedy & Mr. Weiss. Mr. Tweedy has a curious history. He studied for several years at the League & then at the Chase School, then three years at a Seminary to be a minister & has gone back to art. So tell Mama that I am not with such a godless set as she thinks. Mr. [Lawton S.] Parker is an artist who is going to Brittany to sketch this summer. He is an old pupil of Mr. Chase's. He is quite a nice fellow.† Mr. Tweedy, Miss Andrews, Mr. Parker & I played Flinch together night before last.

All the officers on board are fascinating looking & all the crew have fine manners, a vast improvement on Americans. The Doctor is really stunning looking.

We have had only one good day, all the rest have been misty. We went 100 miles south of our course in order to escape an iceberg. As it was we came near one which caused a heavy fog.

*Tuesday, June 30th*

I wrote you that I had met a Mr. Parker. He is not a member of the class, but is an old pupil of Mr. Chase's. In fact he was the ringleader among the students who left the League & got Mr. Chase to teach them. That was the beginning of the School & last year they had more students than the League. He won the 5 year scholarship in Philadelphia some years ago. He has studied twice abroad. First, 2 years & then even last year he won the second medal at the Salon. So you see he is something of an artist. In vain he endeavors to cover the bald spot, but alas! six hairs can't do. I seem to have made quite an impression on him. He joined me after dinner yesterday & we were together until eleven when the lights are put out. I laughed so that my face is thankful to have peace this morning.

Wednesday. We had a gorgeous sunset yesterday which Mr. Tweedy & I enjoyed. Alas! Miss Howland had Mr. Parker. Anyhow he walked a long time with me later on. It is a beautiful sunny day & we are fixed on the hurricane deck with our rugs, books, & writing materials.

Thursday. Yesterday was one of the most glorious days I ever saw. It was brilliant sunshine the whole day. Mr. Parker joined us & we read aloud in *Edges* which is by a woman, Alice Woods, who studied at the Chase School.‡ Mr. P. knew her in Paris. It is quite a clever book, illustrated by herself. We nearly dropped dead when we found out Mr. P[arker]'s age. None of us came within 12 years of guessing it. I guessed 33—He is 47!!!!!!!! I nearly fell overboard. He says that no one has ever guessed correctly. Mr. T[weedy] says that he is telling the truth, so we quite venerate him now. Later on we went up on the H[urricane] deck & he & I sat on a coil of ropes & looked at the moonlight while he gave a most interesting dissertation on French & American Art. Tell Mother not to get excited as she sometimes docs over Don & I. That I thought Mr. P. quite safe before but now I am convinced since learning his age. You could no more imagine his being familiar or free than his flying to the moon. Just think of it! He is going to Brittany to sketch all summer. They work from nude models out of doors. Make them pose in the water, grass etc.

Friday. We were in sight of land this morning & may be now but I can't see as I am on the other side of the boat. They are some islands off the coast of England. We get to Boulogne tomorrow morning early & reach Rotterdam sometime that evening. It has been so lovely that I am sorry to land & only wish that I was rounding South America then I would be a month on the sea.

Miss Howland, Mr. P. & I finished *Edges* yesterday & played cards so our day was quite full. At night there was a play gotten up by some boys & girls on board, called "Much ado about nothing doing." Mr. P., Mr. T., Miss Howland & I went & then went up on deck in the moonlight & had lots of fun. Mr. Tweedy says the most dreadfully tactless things & is sometimes beyond the limit even. Mr. P. is going to Rotterdam instead of getting off at Boulogne.

Mr. P., as we thought all along, is not 47 at all.

---

* Elizabeth H. Howland was an artist and Taylor's friend for many years. She studied in Chicago and resided in Provincetown, Massachusetts. She wed Isaac H. Caliga in 1924, and her artwork is often identified as by Elizabeth H. Caliga.

† A Michigan native, Lawton S. Parker (1868–1954) studied art at the Art Institute of Chicago and the Academie Julian in Paris with William Bouguereau. Later he studied with William Merritt Chase and then returned to France and the École de Beaux Artes, which was directed by Jean-Léon Gérôme. Influenced by Claude Monet, Parker was a member of an art group called the Giverny Six.

‡ Alice Woods Ullman (1871–1959) was an Indiana artist and novelist. She studied with Chase at the New York School of Art and Shinnecock Summer School and also attended the Académie Colarossi in Paris. *Edges, a Novel* (Indianapolis: Bowe-Merrill, 1902) was an autobiographical account of her studies in Chase's class. In 1903 she wed another Chase student, Eugene Paul Ullman (1877–1953), but the marriage ended in divorce.

*T.S.S. Potsdam, Haarlem, The Netherlands*
*Sunday July 5 [1903]*

To Nell

We stuck on a sandbank some little distance from the wharf so everybody, except the steerage passengers, were put on a tug & carried to the wharf, then two other tugs carried the baggage. We were all put in a huge barn & told to remain under our initials, where our baggage would be put. I wish you could have seen Mr. Parker & the customs officer over our things. The man came to my case, which was opened, & asked if I had anything. I said nothing but clothes & as the man began to punch I pulled my steamer rug out & with it came shirt waist. There lay my pink wrapper & some other things. I nearly went into convulsions, of course internally, as Mr. P. grabbed them up, punched them back in the funniest way [and] said "Don't, don't" just as though he didn't know what he was going to see next. Saw some of the funniest looking people in <u>wooden shoes</u>, though they aren't as much worn as I expected. Perhaps it is because we are in town. Some of the women wear brass helmets over which are lace caps with frills around the bottom & the remarkable part is that they wear a bonnet on top of all this! The people aren't as foreign looking as I expected. They have absolutely no style, put on their clothes horribly. As to their shoes they are something awful. Look just like those Letty & Maum Lizzie wear.

Our studio & the Gallery are on the Groote Market which is right in the center of the town. We were at the Gallery this morning with Mr. Chase. Franz Hals is stunning. Such glorious painting! Miss Howland is a very attractive girl. She reminds me something of Cousin Rita Pinckney. Is a slight graceful person, blue eyes & lovely curly brown hair, soft voice, in fact awfully nice. We miss Mr. Parker after having seen him every day from almost eleven in the morning until eleven at night, when on board. He is coming down here & I hope that he will continue to be nice to us. Am having the time of my life.

*Haarlem*
*July 12th [1903]*

To Nell

We have found some of the quaintest alleys & places on the canals that I ever saw. At present we are at the foot of our street on a canal, I posing for Miss Howland. Four other students are down here also sketching boats, houses etc. We are all surrounded by at least twenty people a piece.

Dear, adorable Mr. Parker has come! He arrived Tuesday night & we saw him Wednesday when he took dinner with Mr. Townsley [Clarence P. Townsley, 1855–1926] at our Pension. He made an engagement to take us to Bennebrook on Thursday afternoon. We fondly think that we have him guessing about a thing or two also, but of course that is doubtful. Anyhow I know that we are the envy of the rest of the girls, because he is a <u>pretty big artist</u>. Well, he came for us in a <u>carriage</u>. When we got to the village we tried to find some quaint little Inn where some artists had spent the summer some years ago. Mr. Parker knew them all well. One of them, Ulman, [Eugene Paul Ullman] wanted him to engage board for him for he is to do Mr. Chase's portrait this summer. Mr. P. asked us to go to Leydon [*sic*; Leiden] which is on the Zuider Zee. We are going tomorrow. It is a place where lots of artists go & we are to take lunch at a Pension where they all stay. We will leave here at about 10 o'clock, & go to Amsterdam. Then see some exhibit he wants to show us & then go to Leydon. It is on the seacoast. I painted from the model on Thursday morning but it was an awful mess. Yesterday I did ever so much better. Got better color. This afternoon I shall paint Miss Howland. We only have one sketching easel, our others which Mr. P. picked out for us, haven't come yet.

The people are awfully common looking & ugly, though those in national costume are charming to paint. Such colors I never saw. If I saw such cheeks in America I would think that the women were crazy to rouge in this way. Even the old women have fine colors. You hear about how clean the Dutch are. Don't believe it, they aren't any more so than other people. Their houses are dirty inside but the outsides & streets look awfully clean.

I tell you what, Tom [Thomas Taylor] certainly got a cinch when it comes to those portraits Mr. Chase did. Mr. Parker says that Mr. C. is an idiot not to ask more—that he could get anything he wanted. [John Singer] Sargent will not touch a canvas for less than $5,000. Mr. Tweedy told us that Mr. P. himself got more than Mr. Chase, & he isn't near as big a man. Last night we went to a beer garden & listened to the music & <u>drank beer</u>. It was fine.

*Haarlem*
*Sunday July 19th [1903]*

To Nell

We finally did get to Laren & it is a lovely little place. Every summer artists go here to sketch interiors.

Mr. Miller [Kenneth Hayes Miller, 1876–1952], an artist who was staying there, took us all around to see the interiors. We saw a mill which was 500 years old. The houses were rather clean, though some were awfully dirty. The people & their animals all live under one roof. The worst we went in had the big door opening into this large room in which was a pigsty containing several pigs, some goats, cats, dogs, chickens, & place for the cow. The dwelling room opened on this & in there were two dogs, one hen in the corner just setting hatching, another with about 12 chickens & two more grown chickens, a child & all kind of pots & pans thrown around. The bed was a little closet in the wall, with curtains in front. Just outside the only window to this room was another pigsty. This is the place where Mauve [Anton Mauve, 1838–1888] painted a good many of his pictures. Mr. Miller showed

us just where he sat when he did them. I never spent a more delightful day. It's not every man who can take two girls off & make them have a day such as we had, not bored for a single minute. Miss Howland & I have both noticed how different he seems when he gets off with us. He is just as jolly & nice, but just as soon as someone else comes up he changes. <u>Kind of puts on his "famous" air.</u>

Have been working hard this week. Mr. Chase gave me an easel criticism on my first out of doors sketch & told me that it was unusual for a beginner. So I am quite cheerful. Yesterday a party of us went to Marken. It is a little island in the Zuider Zee, near Amsterdam. We took the boat at Amsterdam & went up the canal, stopping at Brock in Waterland & saw them making <u>Edam cheeses</u>—then the boat stopped at some other place but we didn't get out. Every lock we would come to we would rise from 3 to 5 feet until we finally got to the level of the sea. Very often you see a boat sailing along a canal & it looks exactly as though it were sailing across the fields, for you can't see the water. Green isn't the word for the look of everything. We finally got to Marken. From a distance the whole island looks like a forest of fishing smack masts. Most of the island isn't more than 2 or 3 feet above the sea. The houses are built on about five mounds which rise up some distance. The houses are funny old places & the people have on such curious costumes. They wear 5 caps, one over the other & their vests are covered with brilliant embroidery, the skirts are some dark color. They have stiff bangs that stick out straight.* We came back by the Zuider Zee & the boats with their rich dark brown & red sails were exquisite.

I am thinking of not doing much traveling & save my money & go to Spain next year with Mr. Chase.

* Taylor drew a picture of the female costume she described.

*Haarlem*
*July 19th [1903]*

To Nell

Today was criticism & I had four out of doors studies. I got a dandy criticism & Mr. Chase told me to keep the first one I did, he liked it so much. Says that I am going to do all right.

One of the artists, Mr. Miller, took us all around to see the interiors. All the peasants were dressed in national costume. The houses look like large, low, thatched barns, one-half being the yard, stable etc., & the other the room or rooms as the case may be. The dirtiest, therefore most interesting, had a pigsty, goats, dogs, chickens, stall for cow, etc., & on this opened the door of the only room, which was paved with bricks. A little closet in the wall was the bed & outside the only window was another pigsty. I held my breath while inspecting this place.

I am so enthusiastic about painting that I have almost decided not to travel much but save my money for going to Spain with Mr. Chase next summer. I shall have enough to do it, provided all my fillings don't drop out.

Anna Heyward Taylor and William Merritt Chase, 1903. "Me at work! Don't lose."
Courtesy of South Caroliniana Library, University of South Carolina, Columbia

*From Colie Goodwyn*
*Columbia, S.C.*
*July 22nd [1903]*

Your letter from Haarlem was enjoyed by us all, & I must thank you so much for it. Of course I read Nell's letter, & was glad your voyage was such a success. We are quite interested in Mr. Parker but don't think him too charming. I would not approve of your fancying an Artist, unless he was a Star. I lingered in Charleston till the 8th of July—it was so pleasant I found it hard to leave. Uncle Tom [Taylor] is looking better than when I went away—& has a good appetite. He & Aunt Sallie go to White Stone Lithia Springs, near Glenn, the 1st of Aug.—& I will take a trip to Saluda.

Your Uncle Barney [Barnwell Heyward] left last evening for the Clarksons, & I know Nell is rejoicing in having the use of his room. It has been dreadfully hot for some days, the thermometer going up to 95, & I sigh for Saluda breezes.

*July 1903*

To Nell

Tomorrow we are going to Amsterdam to see some more pictures.

Mr. Chase gave me a dandy criticism today. Says I am all right, improving right along, etc. Everyone seems to think that I am doing remarkably well. He made me keep my first outdoor study, it was so good. I suppose that you have seen of [James A. M.] Whistler's death. We sent some flowers to London for the funeral. The German Emperor [Wilhelm II] has just given Sargent [Walter Sargent, 1868–1927] a medal for excellence in painting.

I hope that you will get up an excitement with Lieut. Williams. It would be dandy. I will get up one with Mr. Parker, if I ever see him again. The trouble is that he doesn't know which he likes best, Elizabeth or me. Mr. Tweedy remarked the other day that he never saw three people who seemed to understand each other better.

*Haarlem*
*July 26th [1903]*

To Nell

We found a nice place across the ferry to sketch so went back & got our things, ate lunch & returned to the place. It was a dandy subject but we had hardly gotten fixed before it started to rain, nevertheless we kept on. Finally our main boat pulled away so we gave up in despair. An old man had been nice about giving us chairs & asking us in his house, so we went in & got him to pose. Mr. Chase gave my study the best criticism of the four. Elizabeth & I returned to Haarlem but the others spent the night. Next day they went to the egg-market & heard someone calling "dames, dames" & on turning there was the old man in his Sunday clothes waving a paintbrush I had left! On Tuesday the whole class went down to Schveningen & the Hague. At the Hague we saw some dandy pictures, some of Rembrandt's & others.

*The Hague*
*Aug. 3d [1903]*

To Cousin Coley

To day was criticism & as it seems to be usually, I got a good criticism. Not as good as last week but I had improved. Said some of my painting was "handsome" & pointed to a study of mine as an example of something he wanted to illustrate. I really think that I must be doing remarkably well from what the best students say. Mr. Chase told me last week that he was charmed with the way I was doing. One can't help being inspired with such pictures to see, particularly some I have seen today. After lunch all of us went to The Hague by special invitation from Mr. Mesdag [Hendrick Willem Mesdag, 1831–1915] to see his collection. He is one of the leading painters of Holland in marine subjects. Up to the time he was fifty he was a banker & made lots of money, since then he has devoted himself to Art. He must have done some painting before then. He is now almost seventy, I think. His wife [Sina Mesdag Van Houten, 1834–1909] is also a fine painter & a charming looking "lady," one of the very few I have seen here. She reminds me something of Rosa Bonheur [French painter and sculptor, 1822–99] in the shape of her head & brushing her hair back in such a severe way, but her manners are soft and gentle. This collection Mr. Chase says is the most wonderful he has ever seen. Of course Mesdag knows & has known all the best modern artists & he has from one to eight or ten of their most interesting things, a great many being unfinished sketches. Every picture I could spend hours looking at, instead of doing as one usually does in the galleries, walking by hundreds of uninteresting pictures in order to find one. I almost went crazy with delight. The whole party would run from picture to picture, none knowing which picture they wanted most to see. Honestly I feel as though I could paint a pigpen exactly as Mauve [Anton Mauve, 1838–88] did & I intend hunting up one & doing it. I have never been in such an exalted frame of mind in my life before. I could paint all day & all night & never get enough paint. Mr. Mesdag within the last week has opened this series of galleries to the public, in fact he has given the collection to the state. He took us to his studio which is in the same building. It is a beautiful room hung with old tapestries, stunning still life around, models of all kinds of boats, finished pictures & unfinished pictures around on the easels. On the folding doors were panels done by his friends, Corot [Jean-Baptiste-Camille Corot, 1796–1865], Mauve, Israëls [Jozef Israëls, 1824–1911], Maris [William M. Maris, 1872–1929], & some others. We went up to Madam Mesdag's studio. She is great on still life & had a study put up & was doing it. Mancini [Antonio Mancini, 1852–1930] is an Italian artist who does wonderful things. I have always wanted to see some of his things & I saw at least six in this collection. He puts glass, pieces of cigarettes, etc., in his pictures to get effects & has to put small wire & string across his paintings to make the paint stay on. Such painting I never saw! I am just wild with delight which I can't describe. Enough of this or I may go crazy like Mancini.

Then we started up this glorious beach to walk to Ijmuiden which was six miles away. When entirely out of the way of the people we sat down & ate our lunch. When about halfway to our destination we noticed a very dark cloud which had been hanging over Ijmuiden coming towards us. Soon it began to rain so I gathered up my skirts around my

waist, Mr. S[hamburg] & Miss Pope being way ahead up the beach, & held my umbrella towards the rain, my legs getting soaking wet but dry otherwise. Poor Miss Howland & Miss Niles were under one umbrella! Soon it began to pour cats & dogs. I never saw it rain harder, so we stooped down, I with my clothes around my neck & myself tied in a low knot. You may not believe it but I managed to get in my umbrella in such a way that I hardly got a drop on me. The other two girls didn't fare so well being two to one umbrella. In about 20 minutes the sun came out & by the time we got to Ijmuiden everyone was dry again. The cloud effects during the whole walk were glorious. When we got to Ijmuiden we were so exhausted that we got some beer, then took ourselves to the station & found that we had an hour & 15 minutes to wait. We promptly took ourselves to the 1st class waiting room though we had 3d class tickets.

Our house has the greatest collection of cranks & curiosities you ever saw. Mr. Townsley is something awful. He talks morning noon & night & always on or repeating Mr. Chase. His voice goes spang through one. I never saw anyone who enjoyed being the saterlite [sic] of a big man as much except [James] Boswell in the [John Kendrick Bangs's 1895 novel] "House Boat on the Styx."

I am not only surprised at the children speaking Dutch but the dogs & cats don't understand anything else! If you call them in English they will not come, but simply fly to you if you speak Dutch. Sue & Tom gave me some money so when I get home I shall have almost enough for the trip left over. Why don't you think about going with me. You would have a fine time & living is awfully cheap in Spain, much more so than here. You must get in a Spain frame of mind.

Miss Niles is charming. She is from Ohio but her people are Virginians. Her mother was a Byrd. Those "Westover" Byrds of Revolution fame. She knows loads of people I know & we took to each other from the first. She must be over thirty, is ugly but a perfect lady, just as entertaining as can be. We go around together a lot as we don't find the other people in this Pension very congenial.

*Haarlem, Netherlands*
*Aug. 9th [1903]*

To Nell

I address my letters to you as I know that they can't make them out there. I am counting on your keeping them for me.

Last Wednesday I was in a most exalted humor so determined to try my hand on a head. Such a mess! I don't know why I can't get them for I get good color in still life & landscape. Well I got at a dreadfully low ebb & it was only under protest that I went to Zandroot next day to sketch. I found a fascinating fence corner so concluded that I would do a Mauve. I really made a good study, got sunlight & you could almost hit your nose against the fence. I had just finished & gotten off some little distance to view my masterpiece when a strong gust of wind came along & to my horror I saw easel & sketch go down in the dust. When I picked up my canvass the whole road, stones & all were on it. There was nothing to do but scrape it. I stamped & swore but nothing helped my feelings, so my spirits rose

The painting class in Holland. Courtesy of South Caroliniana Library, University of South Carolina, Columbia

& I finally got some of my enthusiasm back. The next day we went to a little place near here called Heemstede & sketched in a garden. I made a pretty good sketch. As usual the hardest thing in it I got best. If I have three studies worth the freight back I shall be happy.

You would die laughing if you could see Elizabeth scratching flea bites—not only see but to hear her. She is in bed now & such a row as she is making with the sheets. I haven't had a bite to worry me! It makes her furious because fleas don't worry me.

I put up three studies today & as usual got a good criticism. Mr. Chase pointed to my studies three times as illustrating to different students what he wanted them to get. I spoke to him after class about his going to Spain being decided upon certainly. He told me again how well I was doing & said not to mind if my studies didn't look exactly as I wanted them that they were all right, meaning that I had the principal [*sic*] alright & the rest would come later.

*Haarlem, Netherlands*
*Aug. 17th [1903]*

To Nell

I work out of doors whenever the weather permits & my hands are (horrors) getting freckled. I live in hope that a severe course of gloves will soon cure them, when the class is over. Alas! only three more weeks & I am just getting into working. Mr. Chase becomes dearer & dearer. He is so nice to me, the girls all envy me. He certainly likes my work & says I <u>must</u> go on. I can see that my work is ahead of all the rest of the beginners & better than some of those who have studied out of doors before. Don't think that I am doing master-pieces, for all I do are studies & each week all that I put up for criticism are covered with a tone & another study done on the canvas. The service amounts to nothing, the rooms poorly furnished but beds comfortable. Haven't seen a thing but a basin to wash in since I left the Potsdam. One turns her back while the other bathes as there is no screen. There is a bathtub downstairs but you have to wait all night to get a bath & then you have to pay & I prefer being less clean & having more money.

When out sketching as a rule the people are cordial & nice. Nearly always offer us after-noon tea. The poorest people seem to have that. They always lend us chairs.

Israëls has invited the class down to his studio tomorrow at The Hague. We are all going. He is one of the biggest painters in Holland. I will write about it before mailing this letter.

We were about the first people who got there & were asked right up into the studio. The parlors & long hall were hung with quantities of his & other artists' pictures. We entered this large interesting looking studio containing several unfinished pictures on easels. A tiny little old man having white hair & beard & stooping way over came forward to meet us. He had such a charming genial manner & looked thoroughly the artist. He showed us all his pictures & some by other men which he had there. One corner of his studio was fixed up like a regular Dutch interior, the curious window, old table, chair & bible. A door opened out into an out of door studio, a frame work entirely of glass. Most of the pictures he was doing were in watercolor & he used exactly the same brushes as he used in oil. Then we went to see that glorious Mesdag collection again. I certainly drank in knowledge & inspi-ration so I hope to do a Mancini in still life or a Mauve out of doors. I wish you could see the paint Mancini puts on. He has to use fine wires to hold on it. One of his pictures has a piece of tin for a highlight. The paint is sometimes 1½ inches thick. He has crazy spells sometimes & has to be locked up. I wouldn't mind if I could paint like that.

Aug. 19th. Had criticism to day and Mr. Chase said that I was getting along all right. As usual pointed out my studies as being well selected motives. I had more air & daylight in my out of door studies than before. He seemed pretty well pleased.

*Haarlem*
*Aug. 28th [1903]*

To Mother

Nothing much happened last week except that I spent last Friday in Amsterdam with Mary Thompson. I went up on the nine o'clock train & we went to the Gallery where I

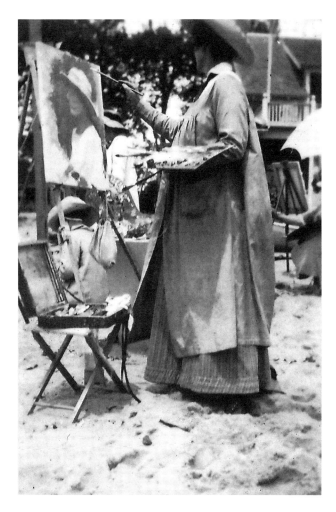

Anna Heyward Taylor painting
en plein air. Courtesy of South
Caroliniana Library, University
of South Carolina, Columbia

enjoyed myself airing Mr. Chase & eased her (a "Miss Wardlaw") much wasted time by only
showing her the fine pictures. Then we got lunch and after that we took a carriage & drove
around. We drove around the Jewish quarter where Rembrandt lived a long time. We went
into the antique shop which is the house where he lived.

Saturday night I received a note from Miss Helen McMaster who was in Amsterdam.
So Monday morning I went over & we went to the Zoo together. I certainly enjoyed seeing
her even if she did say that about our punch last winter. Old Mr. & Mrs. [Charles S.] Ved-
der seem dear old people but they certainly aren't people to go traveling with. They aren't
strong & will not put a foot out on a rainy day. So Miss Helen hopes to leave them very
soon & go on to London. I have arranged to go on there next Monday & stay until the 5th.
Elizabeth has decided to go too so that will be delightful. Miss H. gave us the address. Mon-
day afternoon Miss H. came over with me in order to see Mr. Chase paint a head before
the class. I introduced him to her. I think that she has had some eye openers!

Mr. Chase told me that it was decided that he would go to Spain next year so that settled my plans. They are as follows—

On Monday 1st we go across to London & stay until the 5th, then we come back & join Miss Dunham & Miss Berrett either in Antwerp or The Hague. Then down the Rhine stopping at Brussels, Cologne, Strasburg, Heidelberg, Basel, Lucerne, Interlochen & other places in Switzerland, then across to Paris where we will remain until we sail on the 26th Sept. on the Potsdam. I had some studies up & Mr. Chase gave me a pretty good criticism. As usual pointed out my studies as being good motives to paint. Said that I painted frank impressions of the things I saw & advised Miss Howland to do as I did. Said I got daylight. He told me that I had good ground work enough to work on by myself so I shall do lots of painting this winter. He certainly has been lovely to me in various little ways & seems to take a great deal of interest in me. Mrs. Wadsworth told me that Mrs. [Alison Gerson] Chase seemed very much interested in me too. Everyone remarks on the way I have taken hold of my work.

*From S[ally] C. Goodwyn*
*Saluda, N.C.*
*Sept. 28th [1903]*

Your postal cards have been received and I thank you for them. I know you must have enjoyed London & am so glad you have had the trip down the Rhine. Will want to hear all about Paris. Your father has just returned from Lexington, where he testified in Tillman's case. Of course we all take interest in the trial.*

* On January 15, 1903, James Hammond Tillman, nephew of Senator Benjamin Ryan Tillman, mortally wounded the editor of the *Columbia (S.C.) State* newspaper, Narciso G. Gonzales. In his editorials Gonzales had attacked James Tillman's character and opposed his campaign for the governorship. A jury found Tillman not guilty by reason of self-defense. Taylor's father had likely attended Gonzales before his death.

# 3

*With Chase in London, 1904–1907*

TAYLOR RETURNED TO EUROPE to study with Chase in London the summer following her Holland class. She worked hard, and Chase awarded her a prize. She met John Singer Sargent and, like all her fellow students, became infatuated with him. The year 1907 would be a respite from travels, but the death of her mother in December severed another family tie to Columbia. ∞

*London, T.S.S. Potsdam*
*June 26th [1904]*

To Cousin Coley

We had such a fine passage over that we arrived a day too soon so we had a day in Holland. I didn't know how fond I was of Holland. We all determined to go through to The Hague. We got lunch & then went right to the Gallery. We saw the Mesdag Collection. We went back to the Hook & caught the 11 o'clock boat across the channel that night. We just made the train & got to London about eight o'clock. Mrs. [Isabella] Wilmot is the lady we are staying with. She is just as kind as possible & very agreeable. She calls herself an Anglo-Brazilian because for 20 years she lived on a coffee plantation there. When her five sons became large enough to go to college she came to England & has been here ever since. Most of the houses have bells at the gates, just like Charleston & the funny part, just the same kind of bells. In fact the houses remind me something of C[harleston]. All have gardens in the back.

We found that we couldn't get into the National Gallery until afternoon so reversed our plans & went to church in the morning. We went to West Minster—also in St. James Park, around Parliament House, sat on the banks of the Thames & then went to lunch. After that we went to the Gallery & spent some time. Then we went to Rotten Row in Hyde Park & stared at people and were stared at in turn. The best people aren't out on Sunday. Mr. [Francis James] Norman came to see us this afternoon but missed us. E[lizabeth] had seen him & told him when I was coming. I hope that he will be grand to us.* <u>Keep my letters.</u>

* Francis James Norman (1855–1926) was an India-born British officer who in 1888 taught at the Imperial Naval College at Etajima, Japan. An accomplished European-style fencer, he was a student of the Japanese martial arts of kendo (sword fighting) and jujitsu (wrestling). His book *The Fighting Man of Japan: The Training and Exercises of the Samurai* (London: Archibald Constable, 1905) was one of the first English-language training manuals of Japanese martial arts.

*London*
*July 1st [1904]*

To Nell

On Monday morning we all gathered at the studio & Mr. Chase gave us a talk. Our studio is awfully nice. We have in addition, two other rooms, a pantry with a gas fixture and a place to keep the supplies. You can do what you please in the morning & in the afternoon a model poses. As Miss Murphey has not come yet, I am in charge of the class. I wish that you could see the frights that I have done this week. They looked like wooden dolls which had been on a drunk for a month.

Mrs. Wilmot is just as nice to us as possible. The other night she put a dish of strawberries out for us to eat before going to bed. The men are frightful sticks. I got a note from Mr. Norman saying that he would come tomorrow at 4 o'clock & take us out somewhere. I believe that he is going to prove quite a blessing. Am delighted to hear about Beverley Herbert. I do hope that he will come. I expect Frank [Francis L.] Parker will be in town next week. I hope that he will [not] consider me in too low company to call & take me out to lunch as he promised. I know that I shall fall on his neck with delight. He will not be shocked as I prepared him for it when I was in Charleston. I haven't done much sightseeing as I am working hard & sleep at night.

*T.S.S. Potsdam, London*
*July 5th [1904]*

To Cousin Coley

On Saturday Mr. Norman came & I certainly enjoyed seeing him. He is really charming & he loves to talk, which sits well on a person who has been all over the world. He was born in India & came to England when he was six. He never saw his father until he was 10 when he went to India with his regiment. His mother he saw once when he was 12 years old. He served 12 years, & when his regiment was ordered back to England he resigned. He said that he didn't have the money to stand the expenses of the return, which meant selling everything at a sacrifice & buying a complete outfit here & living in an expensive way, because they were to be stationed near London. He then went to Egypt & served there, then accepted an offer from the Japanese to teach in the University of Tokyo where he was for 16 years. He is now a journalist. He is quite short & a thorough gentleman. He brought some exquisite Japanese paintings to show us. Two that he owns [by Katsushika Hokusai, 1760–1849] are worth their weight in gold. They are by the greatest artist that Japan ever produced. They say that this artist would rent a house & stay in it until it was so filthy the landlord would run him out. They never cleaned up any dirt. This is very uncommon

among Japanese. We invited him to come to the studio today & see Mr. Chase paint. We found our way to the river. It was fascinating. Covered with rowboats, canoes & naptha launches, all having either awnings of some beautiful color or parasols which the women carried. All the women here wear great big hats of the most beautiful colors. We hired a boat & Elizabeth Howland rowed down to Bray, which is a queer old place. We tied our boat, took a walk about the town & bought some lunch which we took to the boat & ate while going back. We got home at about 3:30.

Mr. Chase gave us a criticism on Monday morning & I had some studies up. I haven't quite gotten into the way of working yet.

Today we went to see [James Abbott McNeill] Whistler's famous peacock room. It seems that he painted a portrait of a woman in Japanese costume for a Mr. [Frederick R.] Leyland, a very wealthy man. It hung in the dining room which was particularly designed for it by [Thomas Jeckyll,] a young architect. After everything was completed Whistler came to see how his picture looked. He didn't like it exactly, said that there ought to be some painting around the picture; so he began & before long he had gone all around the room. Then he said that the ceiling would have to be done. About this time he & Mr. Leyland had a huge spat but he insisted on going on in spite of the row. So to avenge himself he put in a panel representing two peacocks fighting! They say that it is one of the very first times that the Japanese mode of decorating was used. The room of course became Whistler's entirely & the young architect was so distressed that he killed himself.*

Tell Nell that she is very English looking. All these women have the most beautiful complections & hair. They wear their hair low & dress in the most beautiful shades. Send this home—I want my letters kept.

* Whistler's Peacock Room is installed at the Freer Gallery of the Smithsonian Institution, Washington, D.C.

*Holland-America Line [London], T.S.S. Potsdam*
*July 9th 1904*

To Nell

There isn't much to say as I have been working hard & not going about. We usually sketch in the mornings & in the afternoon paint from the model at school.

We have had the most ridiculous time with the men in the house. There is one who seems to run everything, all the others seem to move around to suit his whim. Not long ago a sister died & he has been in quite a nervous state. It seems that he is given to these gloomy fits & they last as long as a month. One of the first nights we were here he ate black currant pie, & his mouth & teeth looked as if he had been eating blackberry pie. Well, every now & then he would turn to Mrs. Wilmot & make some remark, then grin & stick his tongue out. I got convulsed but didn't dare smile during the funeral meal. When I got upstairs I told Elizabeth about it & we got into roars. Three nights ago, we had black currant pie again, & as it came on we could not contain ourselves so began to giggle. Mr. Schnlenan[?] looked furious, the other men surprised & Mrs. Wilmot had tears in her eyes,

trying not to join us. It was certainly a relief when we left them. The next evening I nearly went off several times. It seems that the reason Mr. Schnlenan is more glum than ever is because he & the rest of these men have taken a violent dislike to Miss Murphey. Just after dinner we went upstairs & began to stretch two canvasses. In a perfect rage he went to Mrs. Wilmot & asked if he was to have no peace & quiet, pulled his hat on & rushed out. Of course she was furious & came & told us about it & asked us not to hammer any. Mr. Norman took us to Kensington gardens to sketch. We didn't find anything very interesting, but of course had to do something. He certainly is a nice man.

Frank Parker has been in town since Monday & because of various mishaps to notes & heaven knows what else, haven't managed to see each other yet.

*July 14th [1904]*

To Nell

After many attempts to find each other, Frank & I finally saw each other. I had made up my mind to let him alone, but E[lizabeth] persuaded me to try him by phone once again, for she said he must want to see me or he would never have bothered about going to Cook's & leaving a note as soon as he came to London. So Sunday morning I searched all over Hampstead & finally went to a private house nearby & found Frank at the hotel. He had sent a note & two telegrams, & had bought two tickets for the opera and driven way out here to get me. He declares that I wrote the wrong address, but I don't believe it. As I was going out that day, we decided to go out to dinner that night. He came for me & we went to Tricador which is supposed to be very swell. I certainly enjoyed him & I am sure he enjoyed me for he hadn't seemed to have met any congenial people particularly. It seemed to me that we had just begun to enjoy ourselves when 10:30 came & we had to start home, for I live a good ways out from the center. After much persuasion I decided to go to Oxford the next day, with him. I really didn't want to miss criticism as I had a good many studies up, but he seemed to really want me & to think that I could give him a pleasant time. I went & thoroughly enjoyed it. On our way we stopped at "Windsor" which is ideal when it comes to castles. After various mishaps we finally got to Oxford & went to Christ College which is the oldest & most famous. It was built by [Cardinal Thomas] Wolsey & is of gothic style. Frank put on his professional air & asked for the professor of chemistry, but was told that he was out, however his assistant was in the laboratory. I nearly exploded at the air with which he said "Dr. Parker of the Charleston College from the States." The assistant, a youthful looking student, showed us around. Frank says that he didn't seem to know anything about chemistry & the laboratory isn't near as good as ours. I must say, though, that Oxford is a classical college. The church is really beautiful, also the dining hall. We took a drive around & then got dinner. The waiter thought that I was his wife! It certainly amused us. I wouldn't consent to go with him unless he agreed to let me pay my own way so he did, I am thankful to say. He left next day for Holland where Mr. [Harrison?] Randolph is to join him.

To go back a little. On Sunday afternoon we went to Abbey's [Edwin Austin Abbey, 1852–1911] studio for tea & to see his coronation picture [of King Edward VII, 1841–1910]. He lives in Chelsea in a princely house as a great many artists do. He has managed his

subject finely, but of course it had to be more or less conventional so a painting he had of "Hamlet" I found much more interesting. The King & Queen [Alexandra of Denmark, 1844–1925] & all the rest have posed for him. He showed us pastel sketches he had made of the Queen, Prince Edward & others. "I held the King's garter." Also samples of the Queen's dress & robe. Her dress was gold cloth covered with lace embroidered with silk & diamonds. Her robe was plum color instead of royal purple because she thought that it suited her better. Some of the ladies sent a form with their dresses & jewels for him to work from. It represents the King just being crowned & all the men are holding their coronets above their heads. Earl somebody carried the sword held out in front of him & also two pounds in silver on his little finger in a silk purse. At one time during the ceremony the money is put on the altar & he redeems it with the sword. His finger was black before the time came to give up the sword. Mr. Abbey is short with grey hair & moustache. His wife is quite a handsome woman with a lovely complexion & gray hair. He has a huge studio & his dining room is paneled in oak & is a room he bought out of an old country house & had put in this room. The date is 1637! Mrs. Abbey is very gracious. Afterwards we went just across to the "White House" which Whistler built & died in. It is now rented by a young American artist, Peck [Orrin Peck, 1860–1921].

Tuesday afternoon Mr. Chase painted a head before the class & we invited Mr. Norman to come & see it. E[lizabeth's] mother & sister passed through town on their way to Scotland & were there also. Mrs. Howland is very gentile [genteel] looking & Ruth quite pretty. Mr. Norman brought his two Hokusa's [sic; Hokusai prints] & Mr. C. went crazy over them. Mr. Norman is going to take us to some of the very old parts of London & also to see the Horse Guard drill & their barracks.

Now for the best news of all! I have seen "S a r g e n t." We all went to his studio this evening. It is just across from Abbey's. Sargent is just as easy & unaffected as if he were nobody at all. He is almost six feet, wears a beard, blue eyes, & perfectly natural. I was so busy looking at him that I didn't have time to look at the pictures much. He had portraits of the Duke & Duchess of Marlborough, Countess of Warwick, etc. One portrait of a young woman was simply the finest modern painting I know of. He didn't seem to be pleased with any of the portraits we saw & expected to pretty well paint them over. He has two studios. I not only shook hands with him, but conversed with him! These people over here say "thank you" on all occasions. When you tell a cabman you don't want him he says "thank you." If Sargent asked me to marry him, I am sure that for once I would get ahead on the "Thank You." The whole class has been in a gale since leaving his studio & all are ready to die now, and all ready to stop painting. He lives with his mother & sister. One delightful part about him is that he isn't a crank they say.

I am tired so must stop. I live in hopes of seeing Sargent again. I was much amused with Mr. Chase. You know his manner, always self-possessed & never a deferential attitude. Well, he was himself at Abbey's studio but this afternoon his whole manner was that of an inferior, he acknowledged Sargent as his master. He told us while there that we were in the studio of the greatest master living. Mr. Sargent got very much embarrassed. Send this to Cousin Coley.

*Holland-America Line [London], T.S.S. Potsdam*
*Ca., Aug. 4 [1904]*

To Nell

One of the studies I did this summer won a prize! It was a study of fish that Mr. Chase did before the class. It is the best thing that I have ever seen him do before the class & one of his best that I have seen.* Mr. Betts [Louis Betts, 1873–1961] told me that he believed that it would bring $1500. The one he did last summer in Holland brought $1800. I haven't done anything worth bringing home except my prize study. I didn't dream that I would get it, so was charmingly surprised.

I posed last week for an artist, Mr. Betts. I had on my pongee with the peacock ribbons, my blue hat with a long automobile blue veil. It is charming as a color scheme but not much as a portrait. He wants me to pose for a portrait next time we meet. He is going to exhibit it in New York & Chicago. He is to send me a landscape.

We have been to Shannon's [James Jebusa Shannon, 1862–1923]. He is an American artist who lives here. He is very popular & gets loads of artists' orders. His work is interesting but not as much so as at some of the other studios we have been to.

I have been down twice to Miss [Kate] Crawford's since I last wrote. Then on Tuesday I went down & spent the afternoon. Her sister, Mrs. Somebody & her two children had arrived, whom she was very anxious for me to meet. She is rather a fine looking tall woman & the children are very handsome, such beautiful coloring. A cousin of hers was down for the afternoon, an army officer, Capt. Anderson. Miss Crawford has invited me to spend a few days with her in September so that her brother & I can make each other's acquaintance. He returns from Africa the 1st of Sept. Here is my future. Everything that I would ask for! When I am Hon. Mrs. Copland Crawford X.Y.Z., I will have you over to visit me & you step off with Capt. Anderson. The beauty of mine is that I will only see my future [husband] for six months every 15 months.

We have fixed up our trip. We leave tomorrow for the continent, going over a part of our trip of last year as Mrs. Howland & Ruth want to go. We shall go to Paris, Brussels, Cologne up the Rhine, Frankfurt, Heidelberg, Wurzburg, Nuremberg Bay south, Dresden, Berlin to Holland. Then back here, Scotland, walk through English Lake, Ireland, & sail from Liverpool on the Leyland line for Boston.

* Years later Taylor donated Chase's prize painting to the Gibbes Museum of Art, Charleston, S.C.

*Brussels*
*Aug. 12th [1904]*

To Cousin Coley

We came from Paris this morning, much to my delight. The French people are the nastiest people on earth, I do believe. It is a perfect relief to pass an American or an Englishman. How a people can have their sense of the beautiful developed to such a wonderful degree & yet be so degraded morally, I don't understand. It's certainly a wonderfully beautiful city. The long avenues headed & ended by marvelous buildings.

We started out one day to go to Barbazon [*sic*; Barbizon], a little village in the Fontaine-bleau forest where Corot [Jean-Baptiste-Camille Corot, 1796–1875] & the rest of those im-pressionist artists painted & that is how that school got its name.

I saw Mr. & Mrs. Ed Seibels in London. They were staying at a fine hotel. I certainly was glad to see them. I spent one afternoon & then took dinner. Ed had a friend who was com-ing to dinner so we were to go in the big room where everyone wears evening dress. I wore Mrs. Seibels' black dress! The skirt fit as if it were made for me & the body the same, when I finished with it! We went to the theatre after & then back to the hotel. After we finished it was so late & I lived so far that they insisted on my staying, as they had two rooms & a bath. So she & I took one room & Ed the other. Next morning I went home, packed my trunk ready to leave next day, & hurried back to the Savoy. Then we went on an invitation from Ed's friend to the Crystal Palace where we had a fine dinner.

*From Cousin Coley*
*Columbia, S.C.*
*Aug. 14th [1904]*

We have had rains every day for three weeks, which has given us cool, pleasant weather, I have not felt a single warm night. But the planters have suffered, & there has been a freshet in the river. Yesterday evening, your father & Nell drove down to the plantation, fortu-nately he found but little damage had been done to his crop. Hal Green spent last Sunday in Saluda, & brought your letter back to me. We all enjoyed it, & then sent it on to your Mother. I was so glad to hear what a delightful time you are having in London, experiences that you can always remember with pleasure. Your father says it beats Holland all to pieces!

Edmund is a regular baseball fiend, goes every evening to the game.

*From Mother*
*Sunday Sept. 11 [1904]*

It will not be many days before you will be amongst us again, & have our eyes & ears opened to be filled with your anecdotes. I have just seen a picture of Mr. [Francis James] Norman, in one of Kate Crawford's English papers, & we are both anxious to know if it is a good likeness.

I spent the month of August in Hendersonville, with Mrs. Ewart, because Nannie was up there. I improved without much hilarity or sunshine, as it rained almost every day. I found the flat roads delightful to walk on, & I was out as much as possible. Julius came to Hendersonville & brought me back, so I was not with him more than a week. He does not look in first class condition at all. He ought to have a whole year off, when he leaves St. Luke's, & visit California & travel all about. I shall talk it up sure. Lilly Barnwell is visit-ing in Florida, & is a great strong woman, once again. She took the steamer to Charleston & rail from there. I wonder if she could stop here, on her way back, she could sail from Norfolk.

Your father left for Hot Springs, North Carolina a few days ago, but did not tell me for how long. I am afraid he will be back pretty soon, as he left several quite sick patients with

Dr. McIntosh. Dr. Babcock with appendicitis is one & he does not improve very much either. Ed Heise wished to know where your father was stopping & promised, if possible, to take him on to Kentucky to buy a horse. Old Alex [the horse] is so worn out he can scarcely go around.

The crops are very good, except the cotton will be short, that is no top growth. The plant will make no more. I don't [know] whether any of it has been sold yet, but they better hurry up as the price has fallen some already. Little Tom looks very much stronger. Whenever he bathes, he takes a boat & doll baby & plays that Aunt Anna is on the "Potsdam." All boats are "Potsdams" with Aunt Anna on board!

Ben came around yesterday evening, blowing & perspiring, with an empty pitcher, to get the buttermilk that Bessie said could not be gotten, so we filled his arms with the milk & clabber & he took so long to carry the load that his wife phoned after him. I thought of taking meals with Sadie & sending Nell & Edmund to Ben's, but found that they had changed cooks three times, so, I determined to hire Lottie & stay at home.

Two families are in our house, Mr. Wilson a Baptist minister, below, & a family with three children above. No trash has been taken out of the garden as yet, but I hope this is not a forecast of what will be the usual condition of the premises. You & your guests will surely be quieter with a Methodist minister one side & a Baptist the other.

I am deep in stuffed bell peppers & onions & hope to have brandy-peaches. The fruit of all sorts is inferior. We have gotten apples from the farm, but they have to be cooked in different ways.

*From F[rancis] J[ames] Norman*
*186 Edgeware Road [London]*
*14th Jan. 1906*

Thank you all very much indeed for your kind and very thoughtful present and good wishes for the New Year, and please allow me to reciprocate the last toward you all. I most sincerely hope that in the event of any of you coming again to England that you will not be backward in apprizing me of the fact, for I should very much like to renew our somewhat unconventionally made acquaintanceship. As regards news I have none to impart, for London is as it always is at this season of the year, or for the matter of that at any season, as full of people as it can very well be.

Coming from the Far East my hands are just now full of work, newspapers and magazines demanding articles—many of which I cannot supply. Hoping to see you all again some day—if not in England then in America.

* Norman's salutation reads "My dear American Cousins" and was addressed to "Miss [Helen] McMaster, Miss [Elizabeth] Howland and Miss [Anna Heyward] Taylor, Columbia, S.C."

*From F[rancis] W[illiam] Heyward*
*[Oakley Depot, S.C.*
*ca. January 22, 1906]*

Your letter was received yesterday. I have a miniature of my g—Grandfather Nathaniel [Heyward, 1766–1851] done by [Charles] Fraser. Now I would just mention that I know your G—Father [Nathaniel Barnwell Heyward, 1816–1891] had a copy of this same picture & done by this same man. I think your uncle Barney has it, in his possession. If you can't find it, or can't get it I will be glad, to let you have mine. I also have a steel engraving or a lithograph plate, of your G—father's Father [Nathaniel Heyward]; about the size of a playing card. I can send that to you to have copied, or properly, struck off. You will see a great likeness to your g—father's picture, hung in your house—the one Aunt Hatty [Tatty?] gave your mother.

I have a portrait of your G—father's G—father [Daniel Heyward, 1720–77?], given to me last winter by Josephine [Manigault] Jenkins [1863–1932, wife of Hawkins King Jenkins], out of the Manigault House, Charleston. I was delighted; because it represents him quite a young man & I had never seen one of him in his youth. It had always been hung in Cousin Louis' [Manigault, c. 1851–99?] room; & there is not another in existence. I think the best way for you to see these pictures is to come here yourself.

*From Nell*
*[Columbia]*
*Monday [March 1906]*

Evidently from your letter to Cousin Coley, you had too much dinner the night before, or some thing, as you seemed to be in a rage. As to our writing, I think it certainly your place to write home once a week which you don't do. The roses are all dried up from lack of rain, but the dahlias are beginning to bloom & the nasturtiums & corn flowers are in full bloom.

Mr. Weddell & I went out to Hyatt Park & got some beautiful sweet peas for Mama to take to the Cemetery on Saturday.*

* This letter was addressed to Taylor at 140 East 48th Street [New York City], "C/O Miss Margaret Law."

*From Eliza Gary*
*Moultrieville [Sullivan's Island] S.C.*
*June 25, 1905 [sic; 1906]*

As you see I am at Sullivan's Island for at least two more weeks & after that time if Judge Gary goes west I want to join you girls. Nell promised to write me about the place & I hope she will remember to do so. Judge Gary is away & will be off next week also. After he has holiday until the 1st Sept. I can't get him to say whether he is positively going to Hot Springs & so do not know what I will do until I find out his plans.

The island is very quiet though I have seen a great many friends. I go to Charleston nearly every morning & so manage to kill time. The bathing is first rate. Of course you

have heard of Blanche Sally's engagement to [Robert] Goodwyn Rhett [1862–1939]. They are to be married on 8th Aug. in Columbia at Trinity church. I spent yesterday morning at Nellie Elliott Pringle's & we had a fine time talking the affair over. Blanche is fortunate I think for I do not believe the children will bother her. I am staying at Mrs. Gadsden's.

*From Marie-Marguerite Frechette*
*Chateau Frontenac, Quebec*
*Feb. 24th 1907*

Anna dear, I am so disappointed, but I am not going to be able to go south after all, for as things look now I shall be sailing for England very early in the summer & as I have work enough to fill in all my time until then. Since I wrote you I have had four new commissions, two of which are to be copies of portraits in the National gallery, so I will be in London for some time. Can't you give me some introductions there, or if not that, write me what to do, or not to, while there. Of course I am vastly excited over the trip, but am sorry to have to give up my visit to you on its account. Still I must not quarrel with my bread & butter & am thankful to be establishing such a good 'practice' (would one call it?). When I have gone ahead a little further I shall be able to say to my clients that I'll do them at my convenience, but just now I must suit theirs. Is there no prospect of your going across this year? We could have such a good time together.

*From Margaret M. Law\**
*[Spartanburg, S.C.]*
*Dec. 6 [1907]*

The news of Mrs. Taylor's death has just come to me, and I am wishing more than I can ever tell you that I could be of some use to you. If there should be any thing I can do, you will call me won't you, Anna? Had written you a long letter last night but shall not send it now, as you will not be interested.

   * Spartanburg native Margaret Moffett Law (1871–1958) was a Chase student and, like Taylor, a painter, a printmaker, and an advocate for fine arts in South Carolina.

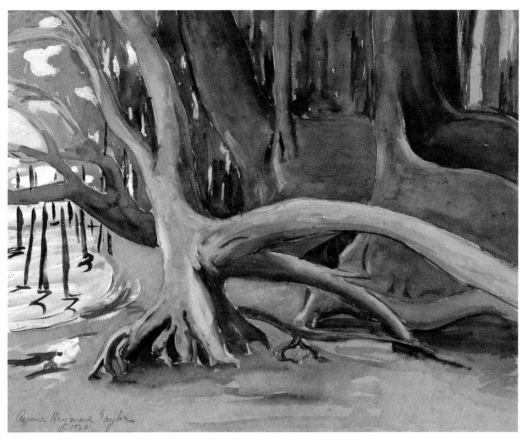

1. [British Guiana Jungle Roots], 1920, by Anna Heyward Taylor (American 1879–1956). Work on paper. © Image Gibbes Museum of Art / Carolina Art Association

2. [Guiana Jungle], 1920, by Anna Heyward Taylor (American 1879–1956). Work on paper. © Image Gibbes Museum of Art / Carolina Art Association

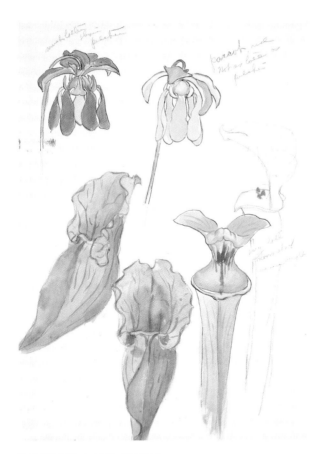

3. Scientific renderings of plants with notations on sizes and colors, by Anna Heyward Taylor (American 1879–1956). Work on paper. © Image Gibbes Museum of Art / Carolina Art Association

4. (*below*) *Demerara*, No. 5, 1924, by Anna Heyward Taylor (American 1879–1956). Work on paper. © Image Gibbes Museum of Art / Carolina Art Association

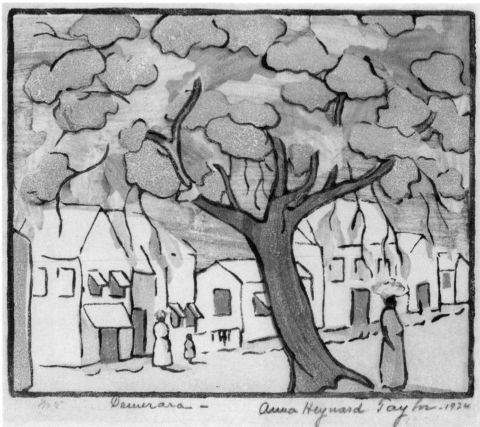

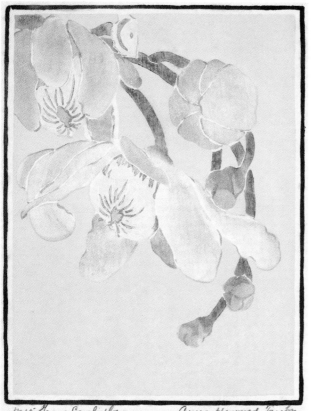

5. *Grias Cauliflora,* No. 15, by Anna Heyward Taylor (American 1879–1956). Work on paper. © Image Gibbes Museum of Art / Carolina Art Association. Plate 6 is another state of this print.

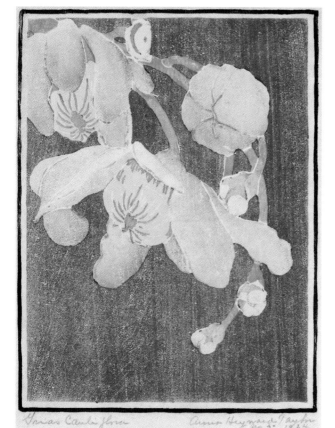

6. *Grias Cauliflora,* No. 5, by Anna Heyward Taylor (American 1879–1956). Work on paper. © Image Gibbes Museum of Art / Carolina Art Association

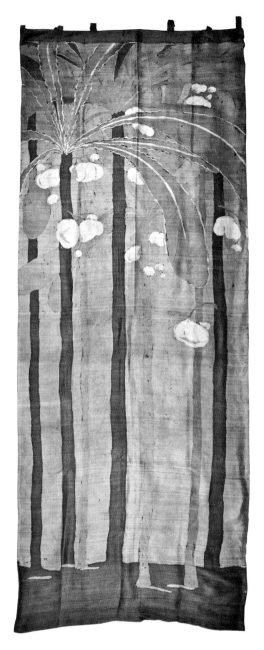

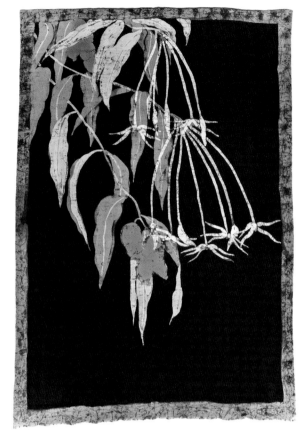

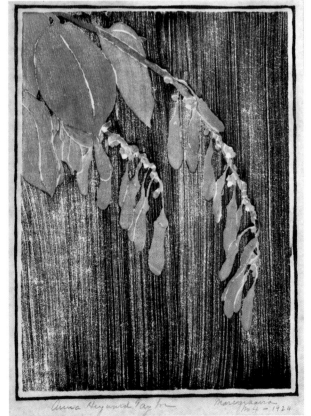

7. (*above*) Grias Cauliflora batik. Courtesy of the Charleston Museum, Charleston, S.C.

8. (*above right*) Shooting Star batik. Courtesy of the Charleston Museum, Charleston, S.C.

9. *Marcgraavia*, No. 4, 1924, by Anna Heyward Taylor (American 1879–1956). Work on paper. © Image Gibbes Museum of Art / Carolina Art Association

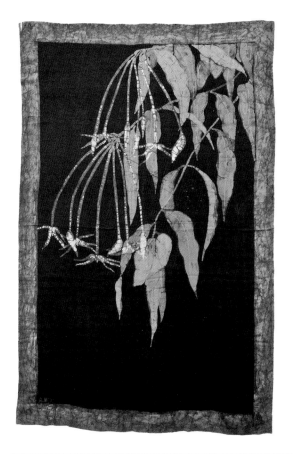

10. Shooting Stars batik.
Courtesy of the Charleston Museum,
Charleston, S.C.

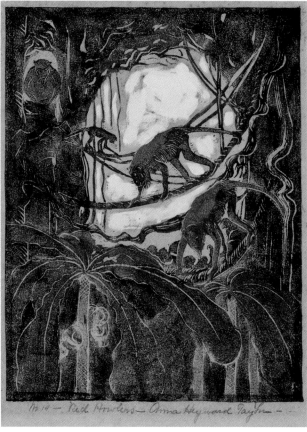

11. *Red Howlers,* No. 14, ca.
1935, by Anna Heyward Taylor
(American 1879–1956). Wood-
block print on paper. Center
may have been retouched.
© Image Gibbes Museum of Art
/ Carolina Art Association

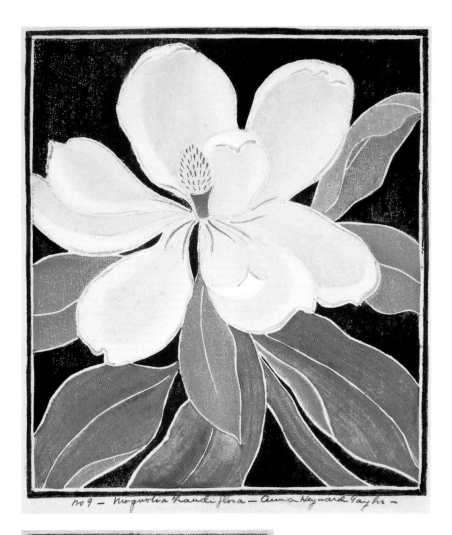

no 9 — Magnolia Grandiflora — Anna Heyward Taylor —

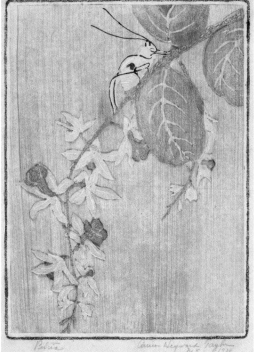

12. (*above*) *Magnolia Grandiflora*, No. 9, by Anna Heyward Taylor (American 1879–1956). Work on paper. © Image Gibbes Museum of Art / Carolina Art Association

13. *Petria*, No. 8, 1924, with a grasshopper, by Anna Heyward Taylor (American 1879–1956). Work on paper. © Image Gibbes Museum of Art / Carolina Art Association

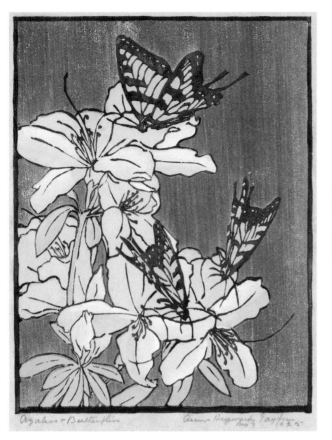

14. *Azalea-Butterflies,* No. 7, 1925, by Anna Heyward Taylor (American 1879–1956). Work on paper. © Image Gibbes Museum of Art / Carolina Art Association

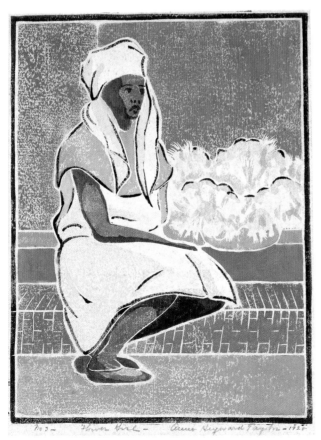

15. *Flower Girl,* No. 3, 1928, by Anna Heyward Taylor (American 1879–1956). Work on paper. © Image Gibbes Museum of Art / Carolina Art Association

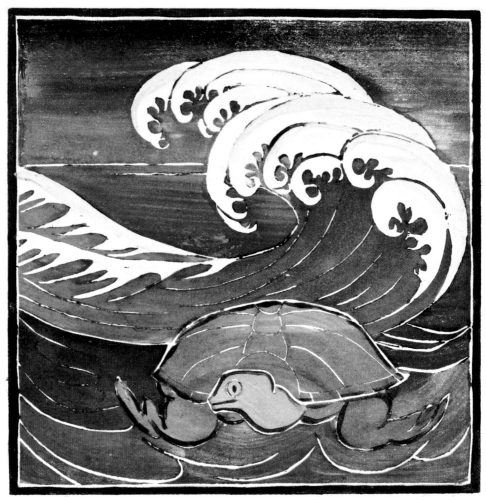

Turtle and Wave

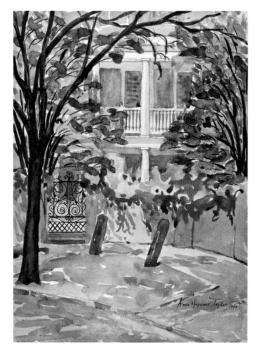

16. (*above*) *Turtle and Wave*, No. 3, 1929, by Anna Heyward Taylor (American 1879–1956). Work on paper. © Image Gibbes Museum of Art / Carolina Art Association

17. *Charleston Pink House on Church Street, 1932*. Courtesy of Anna Taylor Brennecke

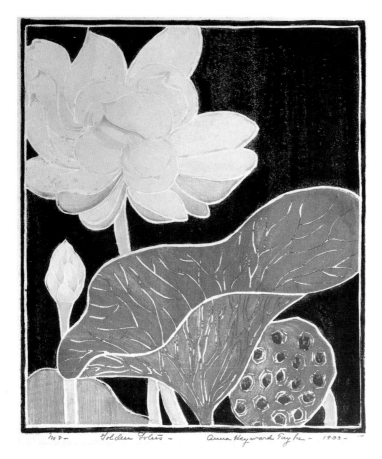

18. *Golden Lotus*, No. 8, 1933, by Anna Heyward Taylor (American 1879–1956). Work on paper. © Image Gibbes Museum of Art / Carolina Art Association

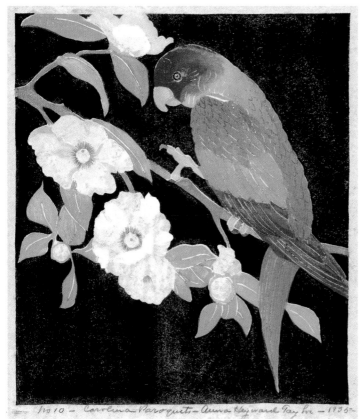

19. *Carolina Paroquet*, No. 10, 1935, by Anna Heyward Taylor (American 1879–1956). Work on paper. © Image Gibbes Museum of Art / Carolina Art Association

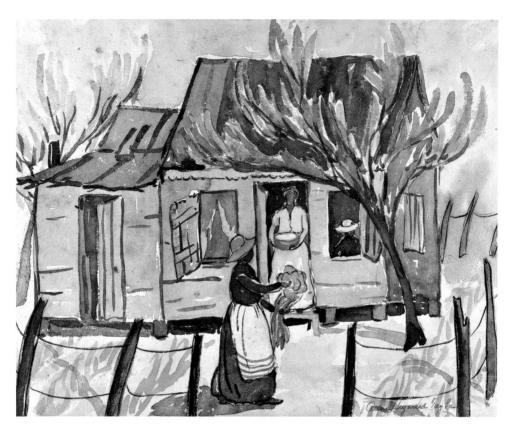

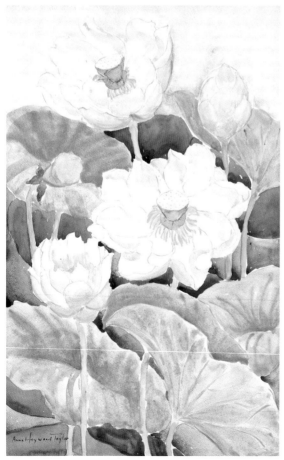

20. (*above*) *Black Cabin with Peach Tree*. Courtesy of Edmund R. Taylor

21. [Waterlilies with Yellow Blossoms], by Anna Heyward Taylor (American 1879–1956). Work on paper. © Image Gibbes Museum of Art / Carolina Art Association

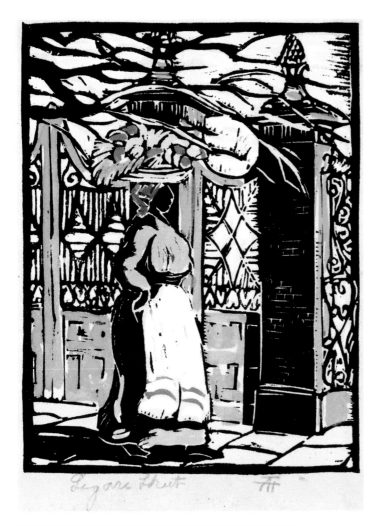

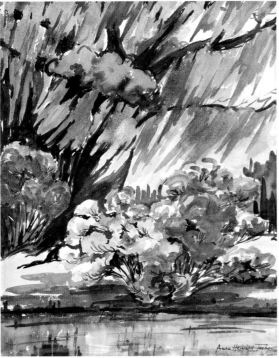

22. (*above*) *Legare Street,* artist's proof, by Anna Heyward Taylor (American 1879–1956). Work on paper. © Image Gibbes Museum of Art / Carolina Art Association

23. [Low Country Moss and Azalea], by Anna Heyward Taylor (American 1879–1956). Work on paper. © Image Gibbes Museum of Art / Carolina Art Association

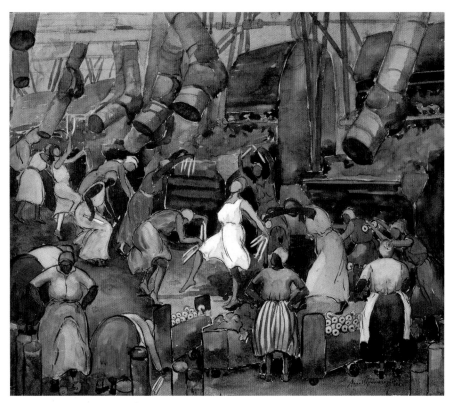

24. Anna Heyward Taylor, 1879–1956; *The Strike*, 1933; watercolor, 21⅞ x 25⅞ inches.
Collection of the Greenville County Museum of Art, museum purchase with funds from
the 1998 Museum Antiques Show

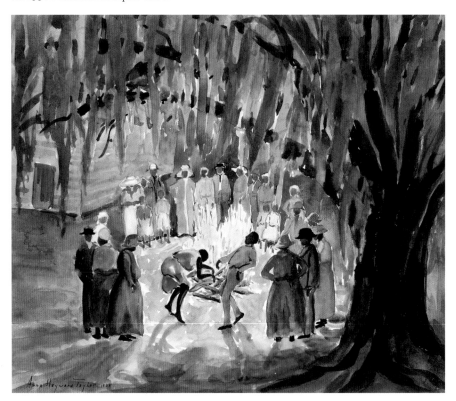

25. *Spiritual Society, Campfire*, 1933. Courtesy of Lisa and Marty Imbler

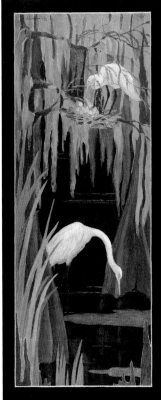
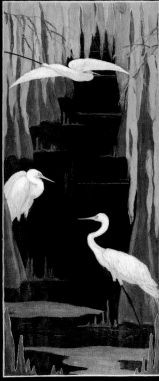
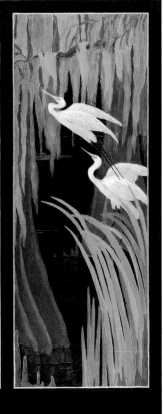

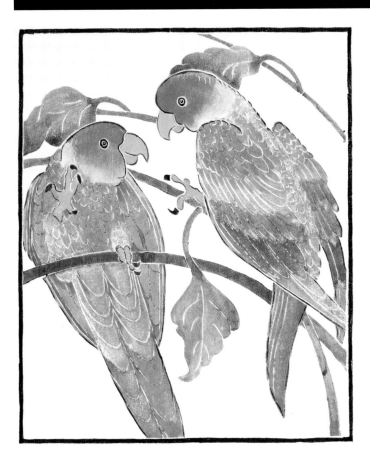

26. Anna Heyward
Taylor, 1879–1956; *Cypress
Swamp and Heron*, 1933;
oil on wood panels,
64 x 76 inches. Collec-
tion of the Greenville
County Museum of Art,
museum purchase

27. (*left*) [Carolina
Parakeets], by Anna
Heyward Taylor (Ameri-
can 1879–1956). Work on
paper. © Image Gibbes
Museum of Art / Colum-
bia Art Association

28. *Mexican Village Rooftops,* 1935, by Anna Heyward Taylor (American 1879–1956). Painting. © Image Gibbes Museum of Art / Carolina Art Association

29. (*below*) *Ruins in Oaxaca,* 1935, by Anna Heyward Taylor (American 1879–1956). Work on paper. © Image Gibbes Museum of Art / Carolina Art Association

30. *Good Neighbors, Mexico,* by Anna Heyward Taylor (American 1879–1956). Work on paper. © Image Gibbes Museum of Art / Carolina Art Association

31. (*below left*) *Taxco, Squatter Sovereignty,* 1936, by Anna Heyward Taylor (American 1879–1956). Work on paper. © Image Gibbes Museum of Art / Carolina Art Association

32. (*below right*) [Homeward Bound and Mt. Popo], 1936, by Anna Heyward Taylor (American 1879–1956). Work on paper. © Image Gibbes Museum of Art / Carolina Art Association

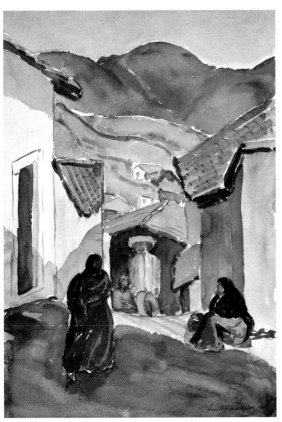

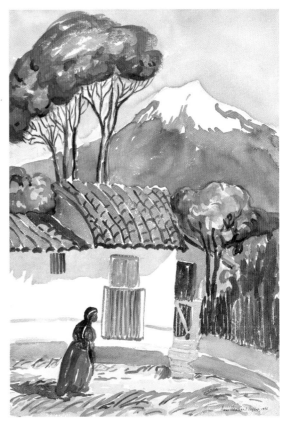

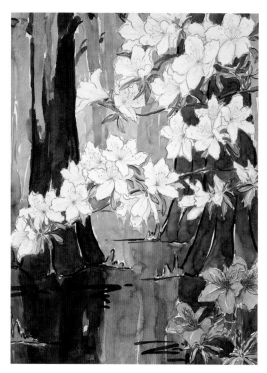

33. *Cypress Swamp and Azaleas,* 1941. Courtesy of the Charleston Renaissance Gallery, Charleston, S.C.

34. (*below*) *Macrophylla,* No. 2, 1938, a magnolia blossom, by Anna Heyward Taylor (American 1879–1956). Work on paper. © Image Gibbes Museum of Art / Carolina Art Association

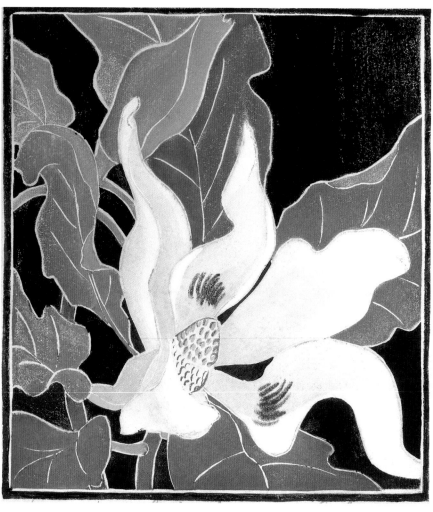

# 4

### ❧

# *In Europe Again, 1908–1912*

Anna Taylor and her sister, Nell, landed in London and then toured Europe. Taylor's letters from Chateau d'Oex, Switzerland, presented her having a grand time ice skating and skiing. In Dresden, Nell took voice lessons. Four years older than her sister, Anna took on the responsibilities of their recently deceased parents. From Switzerland Anna went to Italy, where Nell joined her. From March to May 1909, Anna was in Florence, Naples, Venice, and Rome, and she secured an artist's license to work and study in the museums and galleries of Rome. The two traveled to Vienna and Dresden during May and June and were back in the United States by February 1910.

Despite obtaining her license, there was little evidence that Taylor did much painting or sketching. Regardless, her letters are filled with commentaries on art and culture. With Nell near at hand she sent letters and postcards to her younger brother Edmund instead and filled them with personal observations. Her letters on the art and archaeology of Pompeii and Herculaneum wonderfully revealed her cultural attitudes.

In 1911 Nell wed a cousin, George Coffin Taylor (1877–1961), a professor of English and a scholar of Renaissance literature. With her parents deceased and Nell settled in marriage, Anna Taylor had met her conventional family obligations. For the rest of her life she was footloose and fancy free within the constraints of her finances. She was always careful with money and spent wisely. However, she was always generous to her family, giving them exotic gifts from around the world and aiding them with funds when she could. ❧

*From T[homas] M. Taylor*
*St. Nicholas Club, 7 West 44th Street [New York City]*
*June 15 [19]08*

Allow me to express the hope that you will insist upon returning through this port and will come burdened with genealogical lore—there's no duty.

If you do not care to go to the musty archives and spend hours and days delving in the most hopeless manner, as I know you do not, there remain only a few leads that to me seem worth following. Should you go to the North and visit Carlisle in Cumberland Co., from

which tradition says our first James Taylor came, I hope you will call upon Miss Eva Hulse, 92 Aglionby Street.

At Rochdale, Lancashire, call upon Mr. C. Heape, of Glebe Street who is interested in "Taylors before 1650" so says the International Gen[ealogical] directory 1907; and see if he can tell you any thing about James Taylor who sailed June 10, 1635 in "The True-love" from London for the Bermudas. He was 28 yrs of age and hence born 1607 at Rochdale. I am told James was an unusual name in England at that date.

*July 15 [1908]*

To Bud [Edmund Rhett Taylor]

We sit at the captain's table next to him & find him very jolly & friendly. He paints & really makes good sketches considering. Just across from us sit Mr. & Mrs. Rice from Worchester. She is very attractive looking & married to a man a good deal older than she is. He was quite frisky when young, very fond of actresses & finally became engaged to one. His family rose in arms & the woman broke it off for a fat consideration. This present wife was his stenographer.

July 16th. Our friend Mr. Green certainly is a peach! I wish you could have heard the jokes he was telling at breakfast. Risqué wasn't the word!

July 18th. Thank heavens it has cooled off and one can sleep with comfort in the stateroom. Last night was the first night that I have really gotten a good night's sleep in spite of the foghorn blowing all the time. I don't mean to say that I don't get sleep for I everlastingly knock it on deck. Sometimes the Crockers, ourselves & the four young men are all fast asleep & all our mouths open.

Yesterday afternoon I laughed until I was almost dead. Mr. Falk got up some athletic contests into which all the young men were entered. We younger women were also in some, among them the potatoes race. The potatoes were put in rows & we each had a spoon & had to run to each & pick it up with the spoon & drop it in the box. Another was the thread needle race in which I ran with Mr. Yerxa, & Nell with the younger Swett fellow. We had to take the thread & run to the man who threaded the needle & knotted it. The men's contests were the really funny ones. One was a cock fight. The two men sit on the floor & run two sticks under their knees & clasp their hands under the stick. Then they hop along & try to turn each other over. The first who turns is the winner. George Swett won that one. The pillow fight was almost the death of us! Two men get on a swinging pole & each tries to knock the other off with a pillow. Next was the biscuit eating race. They had two big hard tacks to eat & you never saw such eating in your life. I think a long neck must count in this for the fellow who won had one as long as Uncle Barnie Heyward. Then came the obstacle race which consisted of vaulting poles, getting through hanging life preservers, under a large piece of canvass, under a rope & various things. The Capt. & I are to play a shuffleboard contest against Mr. Falk & Miss Van Dyke.

July 20th. Today is perfectly beautiful, so cool & clear. We have been in sight of Ireland ever since early morning. It's a beautiful coast here along the Killarney district. We have had the greatest quantity of fog & the Capt. has been on deck almost all of every night except our 1st two nights out, but in spite of heat & fog it has been a charming trip.

*Ambleside [England]*
*Aug. 23d [1908]*

To Cousin Coley

Friday morning we spent in the Rows, which are the shops, very curiously arranged. There are shops on the ground floor, entered from the street & above are the swell stores having a piazza running all along in front, over head rise the people. I was looking for an etching or good photo of Caernovan Castle but couldn't find it. I shall try again in London. Then we went into an Antique Shop, which is the most beautiful I have ever seen, so huge & everything beautifully arranged. I was looking for a Sheffield Plate tea pot.

He [the owner] says that our china is very valuable, that a few years ago they gave away Mason [*sic;* Meissen] china, but now he is only too glad to buy & sell at a profit. My old incised teapot is a treasure.

We had agreed to meet two awfully nice women, we had met in Wales, who were also going up into the Lake District. There is no R.R. to this place which is at the head of Lake Windermere so we coached down here. Ambleside is described by William Wordsworth, the poet, as a place where

> "Fairy hills ring with liquid lullaby,
> And shadows play upon the riven mountains."

The town is certainly beautifully situated. It stands on the border of a wooded valley which is watered by several streams that flow into Lake Windermere. From every point magnificent views are obtained of the picturesque surroundings. Near here is the Knoll, which was the residence of the late Miss Harriet Martineau, who was a great friend of Wordsworth. Right nearby is where Dr. [Matthew] Arnold lived—"Fox Hall." Rydal Mount is within a short walk, and this is where Wordsworth lived from 1813 to the time of his death in 1850. You can't go in as it is private.

*Keswick*
*August 30th [1908]*

To Cousin Coley

Wednesday being a beautiful day we decided to go to Grasmere so started off with a little net bag, lent by Miss Walmsley, containing our [missing text] coach & expected to walk back (5 miles) taking a short cut commanding a beautiful view. On our way through the village we noticed a new cottage having a sign at the gate marked "Flax House Industry" so we decided to go in & have a look, particularly because there were such beautiful linen curtains worked in a Greek pattern at the windows. This kind of lace was introduced by [John] Ruskin who became very much interested in this industry when in Italy.* It proved a very charming place so attractively finished & furnished. In a few minutes the lady came down & proved to be the very same woman who four years ago was at the Prince of Wales Hotel in Grasmere & had a quantity of hand woven linen, Greek lace etc. & was much interested in the revival of hand industries among the cottagers. Miss Butterwith is a person of independent means, devoting herself to this work. She had some beautiful work,

particularly a table cloth. The industry is now on a pretty good footing, most of the work being done by delicate girls & women who can't go out to service, or in between times by others.

From there we went to Dove Cottage where Dorothy & William Wordsworth lived so many years. It is filled with souvenirs of them both. In the garden are the apple trees Wordsworth planted. We bought a charming photo of him. It was raining a little when we came out but we went on to see the "Wishing Gate" which was on our way home. Nell was very much disgusted because it was just an ordinary meadow gate. The old gate either wore out from constant initials being cut in it or rotted, anyhow this one is not it really.

Thursday morning we took a walk to see some lovely Falls & across some hills & then left at 3 o'clock for Keswick. It is 16 miles from Ambleside to Keswick. To my mind Keswick is by far the best center for trips. There is a very fine church here in the yard of which [the Romantic poet] Robert Southey [1774–1843] is buried. He lived at Greta Hall for 40 years 1803–1843. Keswick is on Lake Derwentwater, of it Southey says "I have visited the Scotch lakes, & the remembrance of them will ever be cherished among my most delighted reminiscences of natural scenery. I have seen also the finest of the Alpine lakes, & felt on every return from both countries that if Derwentwater had neither the severe grandeur of the highland waters nor the luxuriance & sublimity & the glory of the Swiss, it has enough to fill the imagination & satisfy the heart."

There are 3 islands in the lake, Derwent Is. containing 6 acres, Lords Is. & St. Herbert's Isle. Lord Isle was formerly the island of the Earls of Derwentwater. The last Earl joined the Jacobites & was captured & beheaded in 1716. The tale goes that the family plate with other valuables is in the bottom of the lake. St. Herbert's Isle is so called from having been the retreat of a saintly monk of that name who died about 687. The remains of his oratory & cell are still pointed out to visitors. This afternoon Miss Cross, Miss Ely & I walked to the [eighteenth-century-built] Druid Circle, which is a circle formed by 38 stones, the largest upwards of seven feet in height, & several tons in weight, the recess being by ten stones of inferior size. The whole place enclosed measures 108 ft. by 100 in diameter.

* John Ruskin (1819–1900) was an influential Victorian writer and art critic. His *Modern Painters* (1843–60) criticized classical art and espoused Victorian and Pre-Raphaelite aesthetics. *Unto This Last* (1860) and *Fors Clavigera* (1871–80) attacked industrialization and capitalism. These works shaped the political and aesthetic ideals of guild socialism and the arts and crafts movement of the nineteenth and twentieth centuries.

*Carlisle*
*Sept 6th [1908]*
To Bud
From a geological standpoint this country is very interesting. I tried to find a pamphlet on the subject but the one I got hold of was mostly on the minerals found & not on the construction. All this country was covered with glaciers & I think most of the lakes are caused by terminal moraines. You find rocks everywhere marked with the characteristic glacial marks. I wanted some book to go into details about this but haven't found one. The stores are filled with beautiful precious stones.

Nell wrote to Mrs. Harvey in Glasgow, to whom Cousin Jennie gave us letters. She is not there now but at their summer home five miles from Stirling, which is one of the most beautiful parts of Scotland. She has invited us for two days & nights & will meet us in Stirling with her car!! She expects to show us the country all around them, probably Loch Kabine & Loch Lomond. Nell & I expect to buy two fancy night dresses as we don't care about a maid seeing these old ones we have. We will also buy some silk stockings & handkerchiefs. This is about all we can spend on this visit! I hope they don't wear evening dress for dinner, for we have only our short skirts, but very pretty waists. We only expected to be invited to lunch. I only hope that we can make ourselves so charming that they will not notice our dress.

*182 Haverstock Hill, Hampstead, N.W.*
*Sept. 21st [1908]*

To Cousin Coley

Many, many Happy returns! A great many hugs & kisses dear Cousin Coley! May you live long & prosper, but above all make your will so that I will be sure of getting all those things you promised me, & which I am now allowing you to use, silver, furniture, jewelry, house, etc.!!!

So off we started with our remarkable bags, one a huge knotty brown one which is a kind of bottomless well, one more thing can always be added, it is really fearful looking, then the overflow which is a small brown one with a shoulder strap, & lastly the straw one on which one of us has to sit in order to make it shut. Our baggage wasn't stylish but we were as we had on our new suits & American hats.

They live in a typical English or Scottish cottage. Mrs. Stewart is a joy! She has a very fine head, so full of character & kindliness. She speaks a very broad Scotch & always Gaelic when alone with her children. She is very amusing but doesn't know it as she can't see a joke to save her life—the consequence is Hugh & Daisy are always in roars of laughter. She is just as simple & natural as possible & so hospitable. As for Hugh, I was never so agreeably surprised in a person in my life. When he called at home that night I thought him very quiet but on the contrary, he is just as jolly & full of fun as possible. The truth is he was sick the whole time he was in Columbia. You ought to hear him on the heat down there! Archie Stewart is a big fellow of over six feet, who runs a large sheep farm about 10 miles above Pitlochry. It is leased from the Duke of Athol who owns about ¾ of the whole county. Archie is just an ordinary fellow in the ordinary dress, but put the kilt on him & he is really a very handsome fellow. He wears his kilt most of the time during the summer as a good many men do in the Highlands, & this is in the midst of that region. He wears the Athol kilt, which is the "Hunting Stewart" which the Athols adopted as theirs. The Duke's is the only clan which is intact, as you may say, just as it was in feudal times. All these men are his retainers, consisting of farmers, servants, stewards, etc., & they have a "Meet" every year, which we succeeded in just missing. All his retainers gather, dressed in kilts, & dance the "Highland Fling," drill, & last, but not least, eat! Archie tells me that the Duke's household consumes 300 sheep, alone, in one month, not counting the beef & other game & fish!!!!

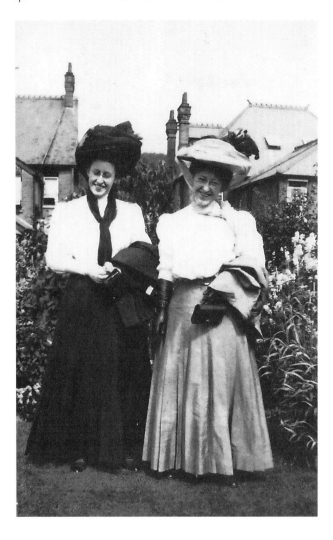

Nell and Anna in Europe.
Courtesy of South Caroliniana
Library, University of South
Carolina, Columbia

I was crazy to see the sheep dogs. They tell me that the dogs are never the beautiful full-blooded collies I had pictured but absolute curs, however usually all collie blood, but a mixture of breeds. The pure haven't half as much sense. The full dress suit of the Athol Clan is the Royal Stewart, which has good deal of red & must be very beautiful when on. Archie showed us his which he wears to dances & the like.

Miss Furguson, & everyone had full sets of false teeth, the brother included!!! I have never seen so many false teeth in my life as the people have over here. The dominee's son and daughter were there, the son being a medical student & a frisky bird so they told us. We sat around & talked, I to the older Miss Furguson & between the false teeth, Scotch accent, and general talking I didn't catch much what she said so I adopted Julius' plan & company manners, which is taking all the talking on yourself.

We left Pitlochry Friday afternoon for Durham. The cathedral is very beautiful, being late Norman & Early English. We left for York Saturday afternoon & went to service Sunday

in the cathedral. As usual we struck a poor sermon & one directed to some young deacons who were being ordained.

It is a wonderfully beautiful building! They are really miracles in stone. I can't write you any thing much about the history this time as Nell has all the books & I can't remember the dates. I will send that later. Nell is doing Lincoln, Beverley, Selby, Peterborough, Ely and Cambridge, arriving here about Saturday. I am delighted to say that she seems deeply interested in architecture.

*London*
*Oct. 4th [1908]*

To Cousin Coley

We went to see Beerbo[h]m Tree [1852–1917] in "Faust." It was the best staged play I ever saw except "Darling of the Gods." It opened with a scene in the clouds between two angels & the devil, Mr. Tree. He was superb in green scales, wings, tail, etc. Then the scene in Faust's study Mephisto being in red now. The witches kitchen was this huge rocky place with lost spirits & apes running around & the witch stirring a huge pot of fire. Margaret was just my idea of the character, lovely young & innocent. The representation of a German town was beautiful. The Summit of the Brocken is a scene representing Mephis. & Faust on a high mountain & below the witch calling up various women which appear in the clouds, Mephis. trying to make Faust forget Marguerite, last of all [to] appear with her baby & Faust is over come. The prison scene is where Faust has done penance & at last meets Marg. in space attended by angels & Mephis. is defeated. The house was roasting and no ventilation as far as I could see.

Our plans have changed. I am going to Switzerland & will be there some months. It isn't very cold high up so expect to get some interesting studies. Nell is going to Dresden as she does not wish to lose so much time. Annie writes that she thinks that she can make very good terms with one of the finest voice teachers in Europe. Nell will stay near Annie & Alice, so will know someone. We leave on Friday with Mrs. W[ilmot] for Paris. I will be here several days but Nell will be there as long as Mrs. W. stays. We have seen Julia [Dill] several times & enjoyed it so much.

*London*
*Nov. 3d [1908]*

To Nell

I am crazy to get another letter from you but they give me awful spells of Dresden-itis. I have a fine "Swiss" spell just now but your letter tonight or tomorrow will kill that! You needn't think you are the only one who is hearing fine music! First, we went Tuesday afternoon & heard "Wood" [Sir Henry Joseph Wood, 1869–1944] conduct, & he is the finest in England. Some of the selections were fine, from Die Walkure, Parsifal, Mignon, etc. A man sang also two beautiful songs, Shuman & Shubert [*sic*; Robert Schumann and Franz Schubert]. Do learn some of Shubert's beautiful songs even if your teacher doesn't give them to you. Are you playing "No One to Love" yet? I am simply consumed with laughter when I think of great fat you playing "No One to Love" & "The Jolly Farmer"! I don't see how I

can wait until March because by that time you will be expert. I am keeping my hand in on the playing question by accompanying Mrs. W. She thinks I am a performer because I rattled off "Sing Me to Sleep" & "Dry those Tears." I didn't say I knew them by heart.

We are going to hear Patti [Adelina Patti, 1843–1919] tomorrow. Have seen several of the good plays.

*London*
*Nov. 10th [1908]*

To Bud

On Monday night we went to see "The Duke's Motto" which is a play [1860s melodrama] which must have been founded on some of [Alexander] Dumas' books "nine men lay dying on the stage" at one time. So you can picture what a thrilling play it was. We sat in the gallery where the seats had no backs!

Then we went to Albert Hall to stand in line to get tickets for Patti. She gave another farewell concert for the 100th time. It was for poor children this time. A. Hall is a perfectly huge place & we were in the gallery which was about six stories up. However we could see & hear splendidly. Patti is about 65 now & is really a fine looking woman in spite of her golden hair. Her diamonds alone are worth 100,000£ if not more. Her present husband is a man of about 25, named Baron [Olof Rudolf] Cederstrom, a Swede. She has several living from whom she has been divorced. Her voice is something wonderful when you think of her age, but of course she only sang in middle range. One was her old favorite—"Oh, Angels ever bright & fair" by [George Frederick] Handel. If Father could only have heard her sing some thing from the "Barber of Seville"! You remember how he used to say "Figero, Figero, la."

Watling Street is all that remains in London of the old Roman road running from Ramsgate across England to Is[land] Ainsley, off the coast of Wales. Near here is also the stone marking the number of miles from the Roman Forum. It was a glorious fall day, like our winter ones, & it was a relief to get out in a country village. We took a walk all around & wound up at Miss Seton-Kerr's [*sic*; Seton-Karr] where we were to have tea & dinner. Miss A[glionby] is staying there & Miss S-K had invited me to be with her. The Seton-Kerrs are kind of high muck a mucks the brother [Sir Henry Seton-Karr, 1853–1919] is a "Sir" & her other brother [Heywood Walter Seton-Karr, 1859–1938] is a well known explorer & scientist. The house is filled with the most wonderful water color sketches he has made all over the world, China, India, Africa, N. America etc. Also tiger heads, deer heads etc. & all kinds of other curious things.

*Chateau d'Oex, Pension Gumpluk [Switzerland]*
*Nov. 22d [1908]*

To Nell

Well, my journey began Tuesday morning, when I began the day by doing very little washing, as you know Mr. Goesler hears every sound, & I usually waited until he went downstairs. Mrs. [Isabella] Wilmot & I took a taxicab as we decided it was the best way to get

ourselves and my "English" luggage to the station. My passage across was lovely, smooth & clear, so I was on the upper deck.

I was in the compartment with a nice looking English girl who was the maid of some English people in the next 1st class compartment. She told me that they were at Chateau d'Oex last winter & expected to be there in a few weeks. She said it was lovely up there. I got to Montreux at about 7:30. The ride up is one of the most beautiful I have ever taken. The train is a little larger than the train in Wales & run by electricity. It winds up the mountains, with the lake first on one side & then the other, perfectly glorious views. It had started to snow about 2 o'clock Thursday & had kept it up all night so everything was covered with snow whiter & whiter the higher we climbed. I spent my time rushing madly from one side to the other & talking French with the guard. We seemed to follow valley after valley, reaching them by means of a tunnel sometimes long & sometimes short, finally the largest & loveliest of all proved to be Le Chateau d'Oex. It is said to be one of the sunniest valleys in all Switzerland.

Miss Seton-Kerr invited me to come out Saturday Nov. 13th and spend the weekend with Miss Aglionby. She had expected to be away but found that she wouldn't so I saw something of her. She was so kind and polite in every way. Miss S-K is going to write to some relatives in Italy when I go there next Spring, some in Rome, Florence & Nice. One is a Mr. Oliver Heywood, who is very much interested in pictures & knows a lot about them. Strange to relate their family name is Nat. Heywood. Miss Seton-Kerr asked me about my middle name.

*Chateau d'Oex*
*Dec. 15 [1908]*

To Bud

I think of you every night & wish that you could be here. Alice plays charmingly & seems always ready to please anyone. She is going to get up a fine repertoire next summer so that she can have a lot to play to you boys when she comes to visit us next year. Speaking of that, I don't see how Nell is going to get out of spending another winter in Germany. Alice says these big teachers never tell you anything but the truth. She went to Frau Ottomann to see if she had a voice & Frau Ottomann told her she had none, but by hard work & years she might be able to produce a little voice! Naturally she never studied vocal! Just think Nell will not take a song this year! You see what a prophet I am, for I knew that Nell had one of the most important requisites, that is physique & a big mouth! After studying with Nell a while you will be singing like Caruso!

If you could only be here to see my learning how to skate! The first day Alice took me out in the middle of the patinage & left me. I couldn't do a thing but yell & everybody around was laughing. I was kind of like George Minnegarode, "It may be awful funny for you but not so damn funny for me." If you could have seen my violent efforts to stand—I was most of the time either sitting on the ice or hanging around someone's neck. We form long rows, one behind the other, & I am put in the middle & expected only to keep my balance, which I do until we strike a bump & down I go with about four men & girls on top,

speed being such that we scud along for about 30 ft. We also form long rows holding each other's hands, then I skate a little.

*Chateau d'Oex*
*Feb. 15th [1909]*

To Bud

We had great fun one night last week. Every one dressed up in some character & then we all voted for the various prizes, there being four. Alice [Atkinson] went as Salome & was arrayed in an old white over pink dress she had. The waist was made to go way up to shorten the dress; my red shawl was tied around her hips & knotted to one side; from a belt she had about a dozen veils of all colors she had borrowed from every one she knew; her hair was in two plaits rolled on each ear, my topaz necklace on her forehead and all the bracelets, chains, etc. she could beg. Of course she walked around with a huge knife & waiter. Her companion was a Swiss who is a missionary to Africa. He was killing as John the Baptist with a grey shawl for a turban & draped in a blanket, he carried dates & a piece of paper with Hebrew written on it. I went as Elsa from "Lohengrin" and was arrayed in two of Mrs. Carter's sheets which I draped & Florence sewed me in. Everyone seemed to think I had been unusually successful in draping them. I will send you some photos Mr. Veleff took of us but as it was taken the next night I wasn't so successful in fixing up the sheets, to begin with they were only pinned & I was expected to fall to pieces every minute.

A lady told me the other day about [what] a wonderful place Pompeii is and also how wicked. It seems there are houses in the city which contain mural paintings or some things which are so wicked women aren't taken usually, only men. Well a French lady said she was certainly old enough & wanted to, her curiosity being more than she could stand so went but seemed to regret it. Well, the amazing thing is that there are some so dreadful that the government has them in Naples under lock & key & not a soul is allowed to see them. I am consumed to know what is too dreadful for a man to see!!* I am getting crazy to get to Italy, it is so beautiful every one says.

* Explicit erotic and pornographic murals and wall paintings at Pompeii were removed to the Naples Museum in the nineteenth century. See Antonio Varone, *Eroticism in Pompeii* (Los Angeles: J. Paul Getty Museum, 2001) for a study of the images and the sexual mores they depict.

*Florence, Italy*
*March 5th [1909]*

To Nell

If you want to strike real Swiss–North Pole–Antarctica weather come to "Sunny Italy." I really haven't been perfectly comfortable since I left Chateau d'Oex on Feb. 22. I didn't know how I hated to leave until the last two days, & I really hated to think I might never come back again. Our last week was glorious as we had fine snow and went out every day. We had great fun going down a very steep hill, Mr. Veleff in the middle & Alice & I on either side.

After leaving Montreux it began to snow & continued to do so until we got almost to Florence. The snow in some places in Italy was deeper than what we had in Chateau d'Oex. I stopped one night at Milan & saw the Cathedral which certainly is a beauty. Started next morning for Florence & when almost 1½ hours run from Bologna, nearly to Florence, what should we run into but an avalanche! Just as our train ran into a tunnel, the snow fell on our rear car, not doing much damage but blocking the way. At the same time quite a large avalanche fell over the front entrance to the tunnel so we were dug out from the rear & returned to Bologna after being 12 hours on the train. I was all day in the compartment with Italians, but fortunately one spoke English, said he had a brother in New York. I really would have enjoyed talking to him but he was too fresh, so contented myself with sleeping. Actually asked me to have dinner with him in Bologna! He thought I was crazy, I'm sure. Thank goodness when we got out at Bologna I saw two American girls so fell on their neck. By-the-way his saying that he & his brother couldn't understand each other's English reminds me of a sign in Geneva, "English spoken, American understood."!!

We left next morning for Florence & took a tour over almost the whole of Italy en route! Poor Miss Menike [*sic;* Minna Meinke]* had waited almost four hours in the cold windy station, the evening before. It was a delight to see her & of course she has a pack of brothers & we both agreed that we would never spend another winter away from home & that Art wasn't worth it. She has really had an awful time, says if she thought she would ever get to Europe again she would have gone home long ago. After the earthquake she went to Rome & had melancholia from which she is just recovering. You know it must have been awful to upset Miss Menike so much.

To begin with they had rain continually in Taormina [Sicily] so she couldn't get much work done, then the earthquake. Mrs. Glover & herself are wakened about 5:30 in the morning by the violent shaking which only lasted three minutes, & in a few minutes more the whole town was in the streets. No great damage was done there, only a few chimneys & ceilings falling, but the little village on the coast just below Taormina, which is on a cliff, was inundated by a tidal wave which came up to the second stories, only a few people being killed however.

They heard how dreadful things were in Messina & trains began to arrive with the wounded. She says that the Sicilians reminded her a lot of Negroes, for they lost their heads immediately & you couldn't get them to do a thing, they stood around as if stunned & the people who did anything were the foreigners who organized & took turns staying at the station & helping. She says the suffering was dreadful but she never saw such patience in her life. Most of the poor creatures had absolutely nothing on, the cars would come in loaded with the nude wounded & what is more they couldn't find enough to cover them. Everyone gave as much as they possibly could.

Florence is perfectly beautiful & in a way is considered even more interesting than Rome. Miss Menike says Rome is one-half absolutely modern & the other absolute ruins, but here it all looks old & delightful. We have lovely rooms, mine being quite good size & over looking the Arno, very near Ponte Vecchio & on the sunny side. It is a good thing because I have been in bed two days with La Grippe.

* Minna Meinke (d. 1965) married into the Bigoney family and was the mother of Helen Meinke Bigoney (b. 1911), a painter. Minna Meinke was a friend from New York City and Europe. She had also taught art and china painting at the Presbyterian College for Women in Columbia.

*From C[harles] P. Townley, Director*
*The London School of Art, Stratford Studios Stratford Road, Kensington London W[est]*
*March 23rd 1909*

This is to certify that Miss Anna Heyward Taylor has been a member of the New York School of Art, New York, U.S.A. and also a member of our Summer School for several sessions. She is now engaged in the serious study of art.*

* An endorsement by Taylor reads, "Please return to A. H. Taylor, 13 Piazza Pitti, Florence."

*Florence, Italy*
*March 23d [1909]*

To Bud

Florence is certainly a lovely city in spite of the fact that we have had steady bad weather since I arrived, only two whole days of good weather, but there is really so much to see that it doesn't seem to make so much difference. I have joined the library and am getting my head so full of information that I will never be able to come down to cows & cotton. I have a red note book in which I put down all kinds of information which I am collecting for family culture; Nell will teach you music & discourse on what she had heard one evening & the next I will lecture on Art with Swiss winter thrown in!

Miss Moody & I moved to this pension which is right opposite to Pitti Palace and on the Piazza Pitti, really a lovely location. I have a nice large room with two huge windows in which the sun is supposed to pour but rain is just now. There are always loads of people passing so I hang out the window most of my spare time. The Palace is in the Boboli so I can run over any time it is open, which is only Sunday & Thursday afternoons & it always rains then! I am going to see if I can't get a permit for sketching.

The Tuscans were here before the Romans & Fiesole was the town they the Romans found here & a time they had subduing it for the Tuscans were very warlike. Fiesole is a lovely suburb now situated on one of the high hills near the city, and is composed mostly of lovely villas, gardens, olive groves & vineyards. Well, the Romans about finished the place & out of spite began a city in the valley on the banks of the Arno which is Florence. One reason for the constant fighting in Florence between the different parties is supposed to be this mixture of two unlike bloods. You know the Guelphs & Ghibellines were at each others throats for centuries.

I shall send a package of post cards & write about each place, which I will send in this letter, in that way you can get such a good idea of Florence.*

* Taylor enclosed numbered postcards and wrote corresponding paragraphs describing each of the cards. They included views of Ponte Vecchio, the Duomo, Giotto's campanile, the Ghiberti doors of the Baptistry, the Bargello, the Church of St. Croce, where Michelangelo and Galileo were buried, the Church of St. Maria Novella, and a portrait of Dante Alighieri.

*From Susan F. Bissell, Secretary*
*The New York School of Art, 2237 and 2239 Broadway, New York City*
*March twenty ninth [1909]*

To whom it may concern———Miss Anna Heyward Taylor was a student in this school for two years, and is thoroughly qualified to appreciate the courtesies that may be extended to her.

*Ministerio Della Pubblica Instruzione*
*Roma, 13 Aprile 1909*
*Direzione Generale per la Antichita e Belle Arti*

Tessera personale de libero ingresso nei musei, nelle gallere, negli scavi di antichita e nei monumenti nazionali, concessa alla Signora Anna Taylor, pittrice. Vale del ——— 190 al 30 Guigno 1909. N. 2797*

  * Taylor's photograph is affixed to the back of this card authorizing her to work in Italian museums and galleries.

*Capri, Italy*
*April 30th [19]09*

To Bud
The family seem to think Leila Waring is taking a long time to do Ray's [Ray Taylor] miniature but they forget that you can't paint them as you do oil portraits. It would take certainly 2 weeks, I should think.*

   Well, we left Florence on the 23d at 7 A.M. which almost killed us, arising at such an early hour. Our trip down was frightfully dirty and tiresome but fortunately the Italians were very polite; we arrived in Naples at 6.30 P.M.

   You must get out your map & look up the places we mention in our letters, also read my [copy of] "Naples, Past & Present" [1901] which is a charming book. Naples is in a huge bay the most beautiful in the world. On your left hand is Vesuvius, Castellammare [*sic*] & Sorrento, just beyond the latter is Capri, where we are now staying for 3 days. On the other side of Naples is Capo Posilipo, & the islands of Procida & Ischia. Naples is right on the coast & on the sides of the surrounding hills, quite a pull I tell you, our pension being quite a good way up. The Museum is simply wonderful & that made so because of the wonderful collection of Greek, Roman, Pompeiian, & Herculaneum things. There are also some fine pictures. The Aquarium is one of the finest in the world & so interesting. They have all kinds of coral growing there.

   Vesuvius of course is the predominating point in the landscape from every side. It is not a simple cone but seems to be two mountains, one Mt. Somma, the name indicating that it must once have been larger than Vesuvius & Vesuvius which is now the larger. At one time it was a single mountain & when on Vesuvius you see that Somma is the remains of a crater, the dotted line shows what it once was probably just as it looked in 79 when it destroyed Pompeii. Before 79 there had been no eruption within the memory of man for ages, but there was an old legend to the effect that once in the dim ages, fire had come from

Vesuvius. It was covered with grass & the top was more or less flat. Only once since then has the mountain looked something as it did then & that was in 1631, just preceding the eruption, when it had been at rest for about 5 centuries. Abbe Braccini ascended the mountain in 1612 & he found a crater on top surrounded by a bulwark of stones, the chasm being a mile in circuit [&] after he crossed this barren rim he came to a little plain, after a short descent where plants grew in profusion. Immediately before this [1631] eruption some peasants went up to the mountain & found the cavern filled to the brim with lava. This eruption differed from that of Pompeii in the fact that the country was covered with lava, whereas in the one of 79 only ashes & mud formed from the down pour of rain. When this great eruption ended, the relative heights of Vesuvius & Somma were reversed & the eruptive cone, which had risen 50 ft above its neighbor stood nearly 200 ft below it. It is usually the rule that in great eruptions Vesuvius suffers loss of height while the cone is piled up by smaller ones. In the eruption of 79 only about 2000 people perished in Pompeii but a good many perished in this eruption. If the people would only take notice of the warnings all could escape. The afterfruits of the eruption are of great value to the people for the soil is so fertile created by the disintegrating lava.

*[April 8, 1909]*

After lunch we drove to Salerno, about a 3 hrs. trip, where we spent the night at a most miserable hotel, taking the train next day for Paestum. The latter is now only the remains of some wonderful Greek temples, which are the finest in existence except Athens. The temple of Neptune was built about 600 B.C. & is of the most beautiful creamy limestone (just the color of the cards I am sending) the imperfections of which were covered by white stucco most of which has tumbled off during the ages. There are 3 of them & in the most deserted looking malarial flats, just here & a peasant's house & there being for our first time in our travels in Italy, stretches of uncultivated land. The malaria was the reason for its being deserted.

* Leila Waring (1876–1976) was the sister of Thomas Richard Waring (1871–1935). She was a miniature painter and a member of the Charleston Etchers Club.

*Rome*
*May 10th 1909*

To Edmund

We left Naples this morning at 10 A.M. arriving here at 2.30. We spent two days at Pompeii & certainly enjoyed ourselves to the utmost. Pompeii is on exactly the opposite side of Vesuvius from Naples & Herculaneum is just between the two, on the coast. The people were a mixture of Greeks & natives from the mountains then were later conquered by the Romans & were Romanized. The earlier forms of architecture are beautiful & simple just as the Greek architecture is, later it became very ornate & the Art just before the destruction of the city wasn't in the best taste too flaming in color & over done. Now Herculaneum was buried in mud entirely, consequently all the things found there are in a much better state

of preservation. After things had quieted down a great many people returned & tunneled into the city & took out a great many treasures & most of the marble friezes particularly that in the Forum. The chief center of Pompeian life was in the Forum where all the city met on any public occasion. It was a rectangle with the Temple of Jupiter on the north, on the east, a market called Marcellum, the Temple of Vespasian, & the Fullers' market erected by a woman named Eumacleia—on the west was the Temple of Apollo & the Basilica, & on the south were three halls for municipal business. In the Forum were statues of the imperial family, and various prominent people of the city.

It was very interesting to take the houses in their architectural order & see how the mural decorations developed & also the plan of the house. It would probably lose you if I went into detail. The first mural decorations were simply imitation blocks of marble & colored stone, then the walls were divided in spaces for painting, the buildings & rooms in perspective which became very complicated. The House of the Faun is one of the earliest & largest houses yet excavated. It was so called from the very beautiful statue of a Faun found in the atrium. Mural paintings hadn't come in yet but here were found the most beautiful mosaics of antiquity, the most famous being a huge one of a battle between Alexander & Darius. All these mosaics have been moved to the Museum in Naples, however, in the houses that have been recently excavated every thing has been left that could be, they being roofed over & the paintings that were exposed have glass over them. The later houses have so much black & red paint. In all the peristyles flowers are planted that must have been growing there in 79. The House of the Velii is very lovely. The House of Glaucus is here & it is the House described in [Edward Bulwer-Lytton's novel] The Last Days of Pompeii as his house. Of course they don't know who owned the house & Glaucus is fictitious. On most of the houses are quotations from the old authors, greetings, municipal notices, election notices, theatre notices, names etc. & on one house in red letters of about a foot high is painted "Sodom & Gomorrah"! which must have been painted by some Jew as there isn't much probability of there being any Christians there at that time. There is very certain proof that Jews were here & evidently some one was shocked at the wickedness of the city. We saw the words! One of the frescoes found is undoubtedly representing the trial of Solomon of the two women, claiming the one baby. That we saw in the Museum. In the city is the house containing the very dreadful [erotic] frescoes.

Herculaneum was the first place in which excavations were made but they haven't been carried on. The first place discovered was a villa owned by Piso. In it were found wonderful treasures & a fine library of some extent for those days. All the world was much excited & expected to find some of the lost books of the great latin writers. A very ingenious way was discovered of unrolling the charred manuscripts by means of silk threads & onion skins. The savants were disgusted to find them to consist of all the works notes, etc. of a very second rate man whose works they didn't care about. Now it is known that this author was a great friend of Piso's & lived with him so it was proved that this must have been Piso's villa. P. was accused by some of the ancient writers with being a looter of the first rank, for when he was on some mission in Greece he quietly took a lot of Art treasures & these are the very ones found here. If he had been very moral they would have been lost like most of the other

things of antiquity. A large number of beautiful bronzes were taken from this villa among them the "Hermes at Rest" which is exquisite. I have sent the book we bought, home to Julius & in it you will find pictures of all these places & things I mention.*

* The book was August Mau, *Pompeii, Its Life and Art* (New York: Macmillan, 1899).

*Vienna*
*May 28th 1909*

To Cousin Coley

Our trip to Venice was much more comfortable & the city perfectly ideal. It is the only city which has really come up to my expectations. You can't imagine anything more romantic than to be rowed around at night in and out the little canals & up & down the Grand Canal. There isn't much to see in Venice in the way of sight seeing but it's a lovely city in which to dream away your time.

Venice is named after an ancient tribe of Northern Italy who were forced by the ravages of the Barbarians to take refuge on the islands of the lagoons so the city is built on piles on 117 small islands & is intersected by 150 canals in which there is a rise & fall of tide which prevents malaria but not mosquitos & smells!

Venice was always closely in touch with the east so her art bears quite a Bazantine [*sic*] stamp. St. Mark's is really beautiful, so much beautiful mosaic & carving. The square or Piazza St. Mark is by far the loveliest & most complete I have seen. In 1902 the campanile collapsed but a new one, exactly like the old one, is being erected with money left for that purpose by an Italian who made a lot of money in the States. Of course St. Marks contains the bones of that saint!! Over the door are the famous horses which were first on an arch of Nero in Rome then brought here, taken by Napoleon to Paris & finally returned. The famous clock is on the square & we saw the procession of the Magii & the last is a negro! The Doge's palace is stunning & the ceilings are heavily decorated with 21 caret gold!! The wall paintings in place there are wonderful, by Titian, Tintoretto, Veronese etc. The Bridge of Sighs connects the palace with the [Bargello] prison. There are some other fine churches & picture galleries. There were loads of artists working on all sides.

*Dresden*
*June 13th 1909*

To Dr. Julius Heyward Taylor

I was very much disgusted because Miss Meinke has decided to go home instead of staying & working with me. It's so hard to work all by yourself & if it weren't for Nell's music I would go to some regular artists haunt. Nell & I both thought that her two months of ease had made her lose all she had learnt but Fraulein Ottoman says she hasn't lost any thing.

I came from Vienna on Thursday & though I arrived in time to go to the Ring[strasse] I was too dirty & tired after my 9½ hour trip. We stayed at a most charming pension & Fraulein Speiss was so nice to us.

I also hear very different accounts of the Crown Prince Rudolph [Hapsburg]. The Austrians were devoted to him & think that he would have made a splendid emperor as he was so brilliant & tactful. Before his marriage he was a perfectly correct fellow, unusually so for royalty, then he married a narrow minded, spitfire who was very jealous! She started by getting into rages if he spoke to any woman even just in a social manner. He had a high temper & was high strung so you can picture the result. Once there was a very attractive actress that every body was crazy about & he wanted to meet her so one evening took his private drosche & drove there with a brother officer. In some way Stephanie had found out where he had gone so she took the court carriage, liveries & all, drove to the ladies house, got out the court carriage, ordered it to remain there & took his drosche & drove home. What would you have done? I would have wrung her neck! Well things got from bad to worse between them & he got gay but no worse than the usual run of men & the story about his wife's killing him is untrue! Finally he met Marie Vetsera who was a lovely, lively girl of about 20 years. She was perfectly correct herself there never having been a word against her but her mother was a notorious woman. Finally Rudolph wrote to the pope, without his father's knowledge, asking to be divorced & for permission to marry Marie. The pope sent the letter immediately to the emperor & you know the rest. He spoke 11 languages fluently & was a great ornithologist, wrote several very interesting books on his hunting & travelling.*

Vienna is the most beautiful modern city I have ever seen & without doubt the handsomest & best dressed women in the world are in Vienna. The city has more beautiful parks & woods than you ever saw, also lovely parked streets & small squares. There are 600 cafes in the city! Such coffee! My mouth waters just to think of it.

* In the Mayerling Incident, Crown Prince Rudolph, heir to the throne of the Austro-Hungarian Empire, and his lover, Maria Vetsera, were found dead on January 30, 1889, at Mayerling, the crown prince's hunting lodge. The lovers' apparent murder-suicide has been a perennial source of scandal and conspiratorial speculation.

*Dresden*
*June 27th [19]09*

To Edmund

Well, I am charmed with Dresden & the Opera and am so sorry that I couldn't spend the winter here. I have been to about seven already and go to night to hear "Tannhauser" which is the last of the season. Nell's two teachers leave July 3d so there is no use in our staying near Dresden when I am uncertain about getting what I want & no artistic atmosphere so I have decided to go to Etaple[s] in France. I have heard from Margaret Law's friend, Mrs. Turner & she says that I can get a lovely studio in a garden for six dollars a month & very nice board for $27 so we think we will have a nice quiet cheap time.

Dresden is a lovely homelike city. All the places have lovely gardens & look as if the families lived there & really loved their homes, but I certainly miss the handsome beautifully dressed Viennese. In the Grosser Garten near there is an International Exhi[bition] of Photos.

TAYLOR WAS BACK IN THE UNITED STATES and settled in Columbia by February 1910, but there is a gap in her correspondence, from June 1909 to January 1910. Her papers from early 1910 contain invoices and receipts from Columbia merchants, including A. G. Douglas Co., "High Class Dry Goods, Novelties, and Millinery"; Mrs. J. M. Eison, "Commercial and Cut Flower Florist"; M. Ehrlich, "Fine Footwear"; Webb's Art Store; and James L. Tapp's Department Store. ∽

*From Minna Meinke*
*Waiting Room, John Wanamaker, New York*
*April 1, 1910*

My house is framed. The roof's on piazzas being put up and outside shingling. The brick fireplace in the living room is also furnished. I'm superintending and must say everything goes along quite smoothly.

I'm having eight rooms and bath, a fine cellar and lovely garret. Studio is next to the kitchen so since our town is such a poor place to secure help, maybe by this arrangement I will have more time in the studio. Mr. Bigoney, my brothers and myself are going to make most of the lighting fixtures and door hardware. We will do the interior painting and decorating too. My oldest brother is installing the electric work. It's to be heated with hot water and will be very pra[c]tical and comfortable.

As soon as I get to painting I'm going to paint you a vase and finish the one I owe in Columbia. You must give me one of your sketches for my living room. Of course painting is far behind, one's family do not help one to paint but G[od] I love them so.*

   * At this time Taylor resided at 1620 College Street, Columbia.

*From Frederick Keppel*
*Frederick Keppel & Co., New York, New York*
*April 19, 1912*

Beg to acknowledge receipt of your postal card of the 17th, and in reply, would say we are sending by this mail under separate cover, a copy of the Print-Collector's Bulletin on [Anders] Zorn, together with catalog of etchings by Zorn now being held in our Gallery, together with the prices marked opposite each print. The prices marked in the Bulletin are no longer correct as it was issued several years ago. Mr. Zorn has since advanced the prices in many cases.

We do not know of any books on Swedish artists.

After looking over the catalogues, should you care to see any of the etchings themselves, we should be most happy to send them by express for your inspection. We pay express charges both ways and we would only ask for New York reference.*

   * The Keppel Company's letterhead advertised "Rare Engravings and Etchings, Artists' Drawings: Fine Picture Framing." Anders Zorn (1860–1920), a Swedish artist, was famous for his portraits and engravings.

*From B. Lucas Webb*
*Webb's Art Store, Columbia, S.C.*
*[ca. May 1912]*

I am enclosing herewith letter [of May 8, 1912] received from the [Roessler & Hasslacher Chemical] factory [in New York City] regarding the material ordered for you and which you wish to have returned. As the most of these articles are in the small packages I would ask that if possible you make use of the goods and we will make you a special price on them of the cost plus freight or $7.90, and if you have no use for the material will hold some of it here for you until next year. However, if you wish us to return the part they will accept kindly return the letter which we are enclosing.

   I am also sending you a circular with reference to Crucible Gold for china painting and will be glad to have you look over same. The firm making this gold will be glad to send a sample for trial if you so desire, and will be glad to hear from you along this line.*

* Webb enclosed a letter concerning purchases of small packages of artist's materials and twenty-five pound lots of feldspar, kaolin, lead white, and whiting.

# 5

*Trip to the Orient, March–October 1914*

IN HER THIRTIES Taylor undertook a trip around the world. However, the Great War interrupted her travels and those of thousands of Americans abroad. She was in Japan in August 1914 with a cordial group of American and English artists, writers, and journalists but reluctantly canceled the rest of her tour and returned home. Her proposed itinerary in India offered tantalizing prospects for her to comment on the life and art of that ancient culture.

From Tokyo she wrote Nell in April 1914 admonishing her to "keep up with all my letters because they are my diary so don't let any of the family have them" (p. 57). She described vividly Japan, Korea, and China as they were a century ago: their people, customs and costumes, art, and architecture. She complemented her letters with photographs of everyday life and the famous places she and her friends visited. In Japan she joined an art study group that met every two weeks. She also described seeing shoji screens, a decorative art medium that she later employed with success. ∽

*Honolulu*
*Saturday, March 29th [1914]*

To Nell

Mr. Barrett is from West Virginia but what he does I don't know. I don't believe he can be just an aimless globetrotter for he doesn't look like it, but he will not tell me what he does. I told him about Dr. Philpot's brother & said I believed he was either like him a smuggler or a Y.M.C.A. Sec[retary]. After I had known him about two days he struck me as being more like the [protagonist of Owen Wister's] "Virginian" than anyone I had ever met. He is tall & slight, slow moving & talking, but says clever and amusing things just like the Virginian.

Got a wireless from the [Camilla Johnson Sams and Miles Stanhope] Sams Saturday night saying they would meet the boat. We have had rough weather so will not dock before ten tonight so there is some question as to my being met tonight. Japan has been in sight since 4 o'clock but we couldn't see Fuji as it's not clear enough. Keep my letters.

## Japan Diary

Taylor met her friends Camilla and Stanhope Sams. Stanhope was a South Carolina native, a journalist with the *New York Times,* and editor of the *Japan Times,* the English-language newspaper in Tokyo. In the 1920s he was an editor of Columbia's *State* newspaper, and the couple were Taylor family neighbors. Camilla Johnson Sams was the daughter of Rev. John Johnson, a historian and the rector of St. Philip's Episcopal Church in Charleston. ❧

*Tokyo*
*April 8th [1914]*

To Nell

Think of really being in Japan! I just can't believe that I am myself! It is absolutely what I anticipated and more. Our boat was delayed in getting on as we didn't dock until 10:30 Monday night. I had received a wireless Saturday saying Camilla & Stanhope would meet the boat so packed all my things & put on shore clothes. It was wonderful as we came up to the wharf, really seemed like fairyland. Way off you see lanterns of all colors coming & when we got near enough we could hear the weird sound of the wooden shoes as they came running up. The wharf was crowded with people and I am charmed to say that nearly everyone was in native dress. I waited until everyone came aboard who could possibly be Stanhope and finally gave up hope of seeing them that night & resigned myself to staying on the ship. Mr. Thomson suggested that I look on the wharf for them—when we saw no signs of either he proposed a rickshaw ride about Yokohama & getting some supper at the Grand Hotel. It was wonderful! Just like another world! All homes, lovely lanterns, & many little smiling people. Camilla said that Stanhope & she would come for me at about nine in the morning. Of course they missed their trains so didn't turn up until 10 o'clock. We fairly fell over each other & had a general kissing all around. We had a lovely ride, all in a rick, all around Yokohama. Camilla talked steadily & hasn't drawn a breath yet & says that I can never remember half she says & anyhow that only about half is what I need remember. Today twice I have told her to break & let me get in a word edgeways. I fairly listened & looked on in gaping astonishment. Stanhope says she speaks coolie Japanese but as she says, she gets what she wants & he doesn't for he will not talk unless he uses classical language. He really knows a lot about the language but will not talk much. You never saw such polite smiling people & Camilla is screamingly funny. Such bowing & scraping, she fairly out Japaneses the Japanese!! At one time it looked as if they were going to give up their dress & wear the little bows turned the other way. You would be amazed to see how little brilliant color there is everywhere. The native homes are all of weather-stained wood & the tile are all grey. The kimonos are all of grey, dark or brown, the only colors being in the obi which the women wear. The obi is a very wide sash. The school girls wear bright colored kimonos, also the babies, but no grown woman of good character wears anything but dark sober colors. The married woman fixes her hair a certain way, something like one big puff & the unmarried ones in two or just an ordinary coil. The babies are strapped on

the backs of children hardly much bigger than their arm & frequently on the mothers' backs. They never seem to cry. I have passed hundreds of them & have only heard one cry.

When we got to Tokyo, Stanhope left us to go to the office so Camilla had a grand time arranging about my luggage, which only cost .25 counting the tip. It consisted of my two trunks. We live in a compound which is nothing but a little empty square surrounded by houses. The house is simply charming, a real Japanese house & two real Japanese servants!! The servants are enchanted with me & I with them. They think my hair something marvelous & the little daughter wept with delight. They are Keyo, the mother, & Yulai, the daughter. Yulai is jolly & pretty & wept with delight over me. You have never seen people move with such grace & charm & their voices are so sweet. Every time they enter the room they ought to get on their knees, bow their head to the ground, go through with some graceful movements of the hands, etc., but it takes so long that foreigners get them to dispense with that & content themselves with frequent bows from the waist. Camilla's house is charming & just about the size I thought. I will draw a plan of it.

Camilla says that Stanhope was so keen about Japanese food that he made himself ill. I don't want to do that. I shall eat everything from bird nests to rats but I can't go live fish.

Yesterday was rainy but it didn't seem to dampen my ardor for things Japanese. The businessmen wear European clothes good days but native ones bad ones. They don't wear stockings but cloth shoes made the shape of the foot like a mitten. The split on the big toe is for wearing sandals or the wooden stilts for rainy days. Lots of the people use Japanese parasols.

In spite of the pouring rain last night two of Camilla's friends came to see me, Miss [Florence E.] Boynton from Frisco & Miss Baldwin from Connecticut. Miss Boynton has taken flower arrangements for 4 years & is now doing some extra fancy work in that, taking the Fuji course. She sent me a Fuji arrangement of a branch of a fir tree. It's shaped just like the mountain. Miss Flynn sent over some Japonicas & Miss Baldwin brought some candy. Miss Boynton is about 38 with beautiful grey eyes & slightly grey hair. She is full of energy mentally & physically. The English in the Japanese College here also gives lessons in Eng. Miss Baldwin is in her 40s & is a stenographer. Miss Flynn is a buyer of all kind of interesting things which her sister disposes of in the U.S.A. & is also a stenographer.

Camilla has all kind of things on hand for me in the shape of teas & fixing things for me to go to the cherry blossom tea which will be given if the Empress doesn't die. She is very ill. Miss Boynton is going to ask Miss Helen Hyde to meet me. She is an artist and an authority on this art. She lives here and has a wonderful house.*

---

* Helen Hyde (1868–1919) learned Japanese printing techniques and taught them to American printmakers, including Taylor and Alice R. H. Smith. Taylor drew a floor plan of the Sams house and a depiction of the socks the Japanese wore with their wooden sandals.

*Tokyo*
*April 13th [1914]*

To Nell

I thought one letter on real Japanese paper was enough so shall write on paper more conveniently shaped. Of course I am expecting you to keep up with all my letters because they are my diary so don't let any of the family have them.

The modern art was simply frightful!! The only things of interest were the lacquer which were wonderful & are considered by the Japanese themselves to be as fine as any ever made which proves that it is anything but a lost art. The present Emperor [Taisho] is not the son of the Dowager Empress [Shoken], who was 64 years old, but he is the son of her great friend & chief lady in waiting. When it was decided that the Empress could never have any children she persuaded the Emperor to take her lady in waiting [Yanigiwara Naruko] as his "mekake," which is the Japanese name for concubine. He had various other mekakes but this one was of the oldest family & of course, didn't lose caste, in fact the mekake was an established order of the old regime & is now commonly practiced but not when the man has another wife. A friend of Stanhope's had one & the Japanese vary about taking their wives to the house, the more modern will not & the others receive her as an equal. He says that all the foreigners out here have mekakes except the Americans & most of the Englishmen. The men pay the parents a certain amount every month.

The old emperor hated change of any kind in his personal life & they say the matting in his rooms was a sight & everything else shabby in proportion. The Dowager was devoted to him, in fact literally worshipped him, never approached him except on her knees. How would you like to flop on your knees whenever you were anywhere near George? Stanhope knew the doctor who was in charge of the Dowager Empress & says attending the royal family was no joke. When the old Emperor was ill they had to diagnose his case by means of his description of his symptoms, for no one was allowed to put their hands on his person. When you took their pulse you had to put a thin cloth on the wrist & feel them as well as you could. Picture Julius conducting a case of illness in the royal family! Of course everyone is disgusted that the poor old Empress died just at this time. They have only been out of mourning for the Emperor six months, & now they are in again for a whole year. All the members of the embassies have to dress in black all the time & every person in Japan wears either a black bow or a band on the arm. I was going to the cherry party but everything is off & the coronation can't take place until 1916. The reason that that is put off so long is that sacred rice is used in the ceremony & the seed can't be planted during a period of mourning. This means a tremendous loss of money to Japan because most of the tourists will go on to China.

Friday night we went to see the Empress [who died April 9, 1914] brought from the station to the palace, for she wasn't officially dead until yesterday. Mrs. Tigrin, a lady from Atlanta who had letters to Camilla, came here for tea & then about nine o'clock we started to Stanhope's office in Jinrikisha. It was so interesting, just swarms of people & all the Jinrikishas & policemen with the loveliest lanterns. Stanhope couldn't get off until eleven so we went on the Ginza & poked around the various booths which lined the street. We went

to the station to see if we could find a good place to stand but the crowd was too large. However we saw the carriage which was to carry the Empress, it being just a very fancy funeral carriage with a green silk cloth with a huge sun on it, thrown over it. The coffin must have been put across the seats for she is a Shinto, therefore would be lying out straight, for the Buddhists are buried in a sitting position. We went back for Stanhope & decided to go to the Tokyo Club & stand on the pavement & watch the procession from there. There really wasn't anything much to see. The green cloth had been taken off & the carriage had heavy red draperies attached to it. It was the same carriage which had been used for the Emperor.

We went to church at Trinity Cathedral which is a long way from here. I was much impressed with what an expensive church & houses they have. The missionaries certainly seem to have everything their own way. I can't see the necessity of such extremely hand-some buildings. I thought the congregation small but it seems it was quite large for that church. That part of Tokyo is low & near the sea, where all the foreigners used to be seg-regated but now most of them live where we are, on the hills. Consequently most of the Americans go to the English church which is quite near.

All the tea houses have the most fascinating bowls of various things to eat you ever saw. I was dying to taste some so we went into an attractive little place overlooking a lake. We took off our shoes & sat cross-legged. You know every house you enter or store even, you either take off your shoes as the Japs do or they put on slippers. Mr. Yabe ordered some of the things for me. I tasted everything but the raw fish & cuttlefish. The bowl had rice, pink seaweed, thin slices of the lotus root, raw fish, egg, cuttlefish, mushroom, dried shrimp, and ginger. Then there were little bundles of bean paste wrapped around with a thin dough of rice paste & a large leaf around that. That didn't taste so bad. You ought to have seen the little boy get to work on the raw fish!

*Nikko*
*May 2d [1914]*

To Nell

Camilla is spending more than she would otherwise by running around with me. I pay her $30 a month & my room is about $5.

Mrs. [John McD.] Gardiner was going up to Nikko to see to the fixing up of her place in Nikko so asked me if I would like to go, which I fairly jumped at because though I expect to go later, now is one of the most beautiful times. I managed to get off on the nine o'clock train & arrived at one o'clock. The country we passed through was not particularly inter-esting, mostly wet boggy fields in which the laborers sank to their knees in the black mud. They are preparing the lands & planting rice. The wheat is beginning to head. About 12 we began to see the mountains & soon the country began to be less thickly settled & more clumps of woods. All the ditches along the track were ablaze with the most beautiful aza-leas you ever saw, of every shade of red & pink. They were much more beautiful than those in Hybea Park because these just grew naturally & really looked as if they might have been planted. The flower is quite large. They grow all through the woods & the pierus japonica runs riot, perfect thickets of it & also growing low & covering the ground like a carpet.

Thirty miles before reaching Nikko, the marvelous Cryptomeria Avenue began & continued right up to the tomb of Iyeyasu, the 1st Shogun. The mountains are like those in Switzerland and not ours, are pointed & of marked volcanic origin. Some of them are partly wooded in conifers & some bare except for low shrubs. The very high ones still have snow on them in the valley & extreme tops.

In 1414 the son of the great Iyeyasu sent two retainers up to find a suitable resting place for his father's body & in a year the tomb was ready to receive the august remains, which ceremony took place under the superintendence of the great Lord Abbot Jigue Daishi, who is also buried here. In ten years the temples were completed & are the finest examples of their kind in the world. Some of the pillars have 100 coats of lacquer on them. Not much of the original work is left on them because no Japanese building is very enduring as they have to be constantly repaired. One of the most beautiful gates is being renovated so is covered with mats. The Japanese have always been very thorough so they started at these temples in their usual way, they first built good roads leading to the village!!! Then they quietly marked out a certain district surrounding Nikko & demanded that every man, woman & child should give their entire time to the building of the temples. All the able-bodied men had to work on the temple while the old people & women had to weave cloth for clothes, plant food for animals & men. You know the building of a house is a religious ceremony with these people so there were strict laws about purifications, particularly in the case of a death or birth. Everyone had to contribute either time or money so one Daimyo who was too poor to give money began raising cryptomeria, & planted this wonderful avenue. The Japanese proverb runs "Don't say 'Ikko' until you have seen Nikko." Ikko means beautiful. You first enter under the huge stone Torii which you have seen in cards I have sent, of course not this one. It is really something identified with Shintoism but the Japanese Buddhists adapted their religion to the requirements of the Japanese just as they are doing now in adapting certain Christian ritual & beliefs which is doing much to retard the advance of Christianity of today in this country. Just inside the court is the 5 storied Pagoda, built much later than the temples. It is built around poles being fitted into stone caps, to prevent destruction by earthquakes. Next is the Nio mon gate through which you enter the 1st court. There are several beautiful buildings, one containing the relics of Iyeyasu & another having the famous monkeys carved on them. "I hear no evil, I speak no evil, I see no evil." Another explanation is that they represent India, China, & Japan. The 1st, unable to hear good, or bad because illiterate; the 2d, Japan, taking everything in & keeping her own counsel; & the 3d willfully closing her eyes to wise reforms from without. All of the rich Buddhist ornaments have been removed since the establishment of Shintoism as the national religion, so there is only the large steel mirror & a bunch of white paper shavings, these papers are prayers. The river room is wonderfully decorated, but dimly lighted, so you can't see much. Every Japanese who presents the priest there with a coin is given a cup of sake. The priests' vestments are lovely, a white cassock & a green kimono, over it, then a black gauze cap.

The Mangwanji is the huge bell here & is rung by swinging a huge beam against it. The tone of it is wonderful. The famous red bridge is here. It has been washed away & replaced many times. It can only be crossed by the emperor.

Saturday afternoon we took tea at the Nikko Hotel with a Mrs. [Louise Norton] Brown*
Mrs. G. knew. She was very interesting. She had painted for years but had to give it up on
account of a nervous breakdown. She has been in Kyoto all winter & is making a study of
Japanese Art, prints particularly. She is to let me know when she returns to Tokyo & I do
hope she will.

Wednesday. My ride down was really an event for I never saw so many stunning effects
of masses of shadow & sunlight in my life. I felt as if there was nothing I wanted to do so
much as to have a huge canvass & a full brush & just splash in. I know I could have done
a masterpiece. When you looked back, you saw the snow-capped mountains through the
breaks in the trees. I rode to the next station & caught the train Mrs. Gardiner was on. On
my return I found that Miss Boynton was to have a charming luncheon Saturday & wanted
me to stay, also that Dr. Nitobe was to give the club another talk that afternoon so I decided
not to go to Kyoto until the next week.

Tuesday was a lovely day so Camilla & I started off with lunch in a box for Omura,
where the famous temple of Hommonji is. One of the Buddhist saints, Nichiren, died here
about 1282 & something like 20,000 pilgrims visit here during the festival every year. Only
a tooth & a few hairs are here. Do you remember St. Peter's lovely Jaw tooth in Vienna?
This temple is considered very fine & the trees beautiful, but unfortunately I had just come
from Nikko so it didn't impress me as it would have otherwise. We were taken all over the
Priests' apartments & saw some beautiful screens & the Ancestral Tablets of the royal fam-
ily & other illustrious families. The garden at the back was lovely. This shrine was the
favorite of the late Dowager Empress.

Yesterday we took a trip down to Tsukiji, where the E[piscopal] church & mission is. It
was the day at home of Mrs. Wallace, the rector's wife. She is very pleasant but bossy &
skins her hair back. He is the brother-in-law of the Bishop & never would have the place
otherwise, as he was played out before he ever came. Voila! We got rid of some other visits,
but at the rectory I met & had a long talk with Miss Scherewski, who is a charming Ameri-
can who was born in China & has lived here years. Her father, a missionary, made the first
translation of the bible into Chinese. She teaches here. She, very informally, invited me to
come that evening & have "guerabe" at her house, the Gardiner girl [Hasu no Hana Gar-
diner] & two men, so I accepted & went. We had all kind of real Japanese dishes & ate with
chopsticks. I was very expert so didn't use my fingers once & actually picked up the beans,
one by one! The things tasted awfully good. She lives alone like Miss Boynton. She is a per-
son with a very artistic temperament & I wish you could have heard her play. She has asked
me to take some trips with her. She is not a particular friend of Camilla's so I was invited
because she wanted me. By-the-way my being invited by Mrs. Gardiner to "visit" her was
rather unusual too.

---

* Louise Norton Brown was the author of *Block Printing & Book Illustration in Japan* (New York:
E. P. Dutton, 1924).

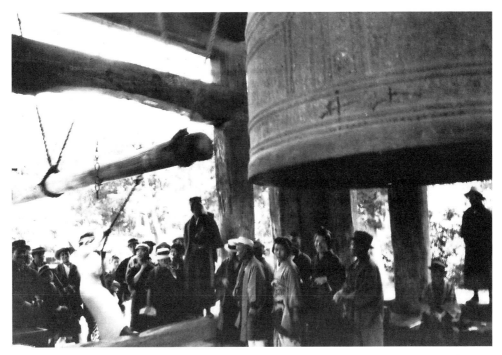

Anna Heyward Taylor in Japan ringing the Mangwanji temple bell. Courtesy of South Caroliniana Library, University of South Carolina, Columbia

*Kyoto*
*May 16th [1914]*

To Nell

After lunch the whole party went to a meeting of the Club which met at Mrs. Bliss' & was addressed again by Dr. Nitobe. He certainly is a man of unusual personality. This time he discussed Japan from the economic side, more its past than the present, emphasized the fact that it was communalistic in development while we Teutons are individualistic; that all people who are dependent on irrigation have always developed along these lines. One point he brought out was about the Ear monument of which I told you before. It is here in Kyoto. He said that it was not pure savagery which made Hydeyoshi cut off the ears of the 30,000 Korean dead but that their belief was that any person who died & had no burial rite said over him had no peace after death, but if only a small portion of the body was buried with the funeral rites, they would be saved, so these ears were brought here, given religious burial & the monument put over them.

Sunday morning the Yates, Amakers & another Japanese called, both families brought their babies & they were too cute for anything. In the afternoon the Bouls[?] were to come to tea, along with Cheves with whom he stays, also a woman doctor, Dr. Read, Miss Flynn, Dr. Wallace, the old preacher at St. Pauls & Mr. & Mrs. [Bernard Howell and E. Muriel] Leach, the last being the really interesting ones of all though Miss Neely, (with whom I am

staying now) says he is a fright. He is an artist & worked with Brangwyne [Frank William Brangwyn, 1867–1956] a while in etching, knows all those men in London whom I met. He came out here 5 years ago to make a study of Japanese pottery & art & was such an enthusiast that Camilla says she heard he didn't even have chairs in his house but lived absolutely Japanese fashion. He is going to take me to the pottery in Yokohama where he is now working & experimenting & is going to show me around.* He is also to show me his various interesting pieces he has picked up. The most interesting pottery I have seen are the ceremonial tea bowls which are usually black or red glaze, sometimes one dripped over the other, they all show the handwork very plainly. They came originally from Korea & the old pieces of Korean make in the Museums are beauties. Japan has been subject to wave after wave of Chinese influence, either from China direct or through Korea. About the only purely Japanese development, in which there seems to be absolutely no trace of alien influence, is the Shinto religion & the accompanying architecture. The green cups which I have at home are copies of the old Chinese "Celadon" & it never was made here, though this modern stuff is made here now for shipment mostly. Our Nathaniel Heyward china is Chinese, for I have seen nothing resembling it of Japanese make.

I arrived in Kyoto at night, & a rainy one too, so I saw it in its most charming aspect for in addition to lanterns everywhere everyone carried these lovely native umbrellas. Next day I took a rickshaw & did the sights. The temples are all pretty much the same but in some of them they had some very fine screens & kukimonos. I saw the two sparrows which were painted by one of the old great painters, which were so real that they flew off the screen & perched on a tree outside!! There isn't much left of the sparrows now, it looks as if the paint was worn off from being constantly touched.

One of the largest temples was built only about 40 years ago. It doesn't look as if Buddhism were dying out for it was built by public subscription in this section & people who were too poor to give money either gave their work or wood, etc. It replaced a very old one which was burnt.

---

   * Born in Hong Kong, Bernard Howell Leach (1887–1979) was an early British practitioner of Japanese pottery making. He studied at the London School of Art and then settled in Japan, where he learned traditional pottery techniques. Leach published an autobiography, *Beyond East and West* (London: Faber), in 1978. E. Muriel Leach was Bernard Leach's first wife.

*Tokyo*
*May 26th [1914]*

To Nell

I didn't tell you about our pest scare. It seems that there are about 3 pests in & around Tokyo & not long ago a case of the plague broke out in our ward. Well one morning Camilla saw a rat wandering on the kitchen shed so promptly called Elki & she & Elki tried to kill the rat with a feather duster!! He ran very slowly but they both claim he didn't look sick. He got into the box on the outside of the house where the wooden shutters are kept. So when Stanhope got up & had eaten breakfast the entire household was assembled including

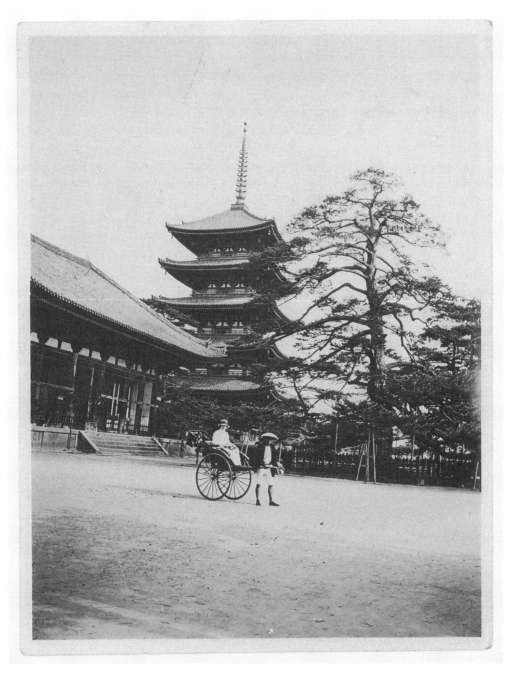

"Nara [Japan], May 18th 1914, Anna." Courtesy of South Caroliniana Library,
University of South Carolina, Columbia

Yamamoto, the cook's husband, everyone armed with broomsticks &, to my intense amusement, dusters. They poked in the walls & beat everywhere but no rat. It seems that the rat was to be sent to the police headquarters if found to see if it had the plague. That was over two weeks ago & every day Camilla smells a new dead rat & even I am finally getting to the point of smelling rat. I long to have Letty who you remember told Mother she could tell the difference between a dead rat & a dead mouse!

Now for the Empress' Funeral. The way had been covered with small stones & down the middle were piles of sand which were spread by numbers of men just about an hour before the procession began. You never saw greater precautions taken to prevent accidents of any kind & every few days since the Empress' death the Emperor has been urging through the papers, that the people must not take her death too much to heart, which usually means committing suicide as in the case of Count & Countess Nogi.*

Our dinner was really a beautiful affair & lasted until time to go out and see the procession, about 9:15. Early in the afternoon troops were stationed all along the way, two deep. First regiment after regiment of soldiers passed, with bands at certain intervals. I forgot to say that absolute silence reigned & continued until everything was over. After the soldiers came sailors & naval officers. I can't remember the order in which the various people came but you can see in the papers I am sending you. Some carried torches, some tall brocade banners of yellow & white, others drums & gongs, shields, cherts, etc. The funeral car was a huge affair of red & black lacquer with gold brocade hangings & drawn by 4 black oxen with white trappings. The wheels revolve on their axises [*sic*] in such a way that it makes 7 notes of the weirdest wailing sound you ever heard. Right behind the coffin came the chief mourner Prince Kan-in. The body was taken to the train where at some unearthly hour it left for Kyoto. The burial place is at Momoyama which is a short way out of Kyoto on the way to Nara. When I went to Nara I saw the preparations being made there.

Miss Boynton has proposed my name as a member of the Tokyo Club of "Curios" as her sister calls them & I am on the art section. We will meet twice a month & study porcelain & prints & its about the only way I will ever be able to really get hold of something.

It looks like Mr. Swensen [*sic*; K. P. Swenson][†] is going to make himself very agreeable & I must confess it is nice to have some man to take you around places, such as the tennis club, which places the Sams never go. He called while I was in Kyoto & again yesterday morning. I was calling at the Gardiners but he waited until I returned lunch time. He wanted to take me to call on Miss [Helen] Hyde & her sister. I had a meeting of our art committee at Miss Boynton's so we tried to work it in before I went there. He wants me to play tennis with him & I have told him I am a most mediocre player but I do hope he will put up with me for I don't begin to get the exercise I ought to. You see Camilla never can walk.

---

* Maresuke Kiten, Count Nogi (1849–1912), a hero of the Russo-Japanese War, and his wife committed seppuku during the funeral of Emperor Meiji. Their former home is a Shinto shrine.

† K. P. Swenson was a professor of metallurgy and mine engineering at the Imperial Polytechnic Institute, Nanking, China.

*Fuji Trip, Tokyo*
*June 14th [1914]*

To Nell

Camilla's friend Miss Baldwin came in one day & asked me if I would like to go on a walking trip around Fuji & you may believe that I fairly jumped at it. We started at 9 o'clock, Monday, June 8th and the weather was fine in spite of the fact that we are in the midst of the "Nyubai," the wet season in Japan. We took the train as far as Atsuki then got into the most absurd little train which held comfortably 8 people, but at times many more were squeezed in we found to our sorrow. However you don't find crowding as disagreeable here as you would at home in hot weather because there never seems to be any odor about them, only a smell of fish sometimes, which I would think would be more frequent considering the fact that they live on fish. We started from Atsuki about 1:30 and arrived at Yoshida at about 3:30. The whole trip is upgrade but not a hard pull as the roads are extremely well graded. We passed through a silk raising section of the country. Just now the worms are at every stage so you see the people cutting the branches of mulberries for feeding the worms & in the homes also huge piles of the cocoons ready to be unwound or whatever you call it. In many houses were hand looms with men & women working at them. The mulberries are not allowed to grow in the trees but are kept cut down to one stump about 2 ft. high & the long branches allowed to grow out from it, then all of these are cut off & they grow out again. We rested ourselves by walking whenever the train went slowly enough & the whole way we got lovely views of Fuji. The colors in it were wonderful, real red sapphire halfway down & then emerald green the rest of the way, melting into the bright green of the nearer hills. Of course some was on top & down the valleys. It was simply marvelous & just the color of some of the prints of Hiroshige & Hokusai. When we left the train at Yoshida we must have walked 1½ miles down the long village street to the Japanese hotel we expected to stay at.

Our luggage consisted of a brown bag such as the Japanese use which I had & two small bags which Miss Baldwin had. She has been camping a lot in the Sierras & is a member of the Sierra Club so had trips down to a fine point, consequently travels as Lee Haygood [*sic;* Hagood] does. One joy about native habits is that they immediately bring you a clean kimono, so I & all the guests are arranged alike for its quite [illegible] for you to walk around the village in them so you are with other guests in the same kind of kimonos all over the place. They are usually black & white—or blue & white plaids. As I told you before the Japanese fairly parboil themselves, have these huge ewers[?] with a charcoal stove in them which gets the water hotter & hotter. First you stand outside & soap & rinse off yourself in a basin then get in the tub & sit for ages. It seems that the whole hotel use the same tub & it's very bad for me to get into it without first thoroughly soaping!! Fortunately there were no other guests that we knew of at the hotel & the water looked so fresh that we decided to try it. We tried our best to get them to give us a cold bath but we couldn't get it into their heads what we wanted so resigned ourselves to a boil. I couldn't do more than step into the tub the water was so hot! Our rooms looked right out on Fuji so we ate dinner Japanese position & worshiped Fuji San. They always speak of it as Mr. or Miss Fuji,

"San" meaning [honorable?] in Japanese. We didn't have a real Japanese dinner but ordered rice, fried fish & potatoes which you can always get as they are commonly eaten by them. The worst part of the Japanese, or I might say the only disagreeable part, is that they are required by law to close the "arenadoe" which are the wooden outside screens. Of course that means not a crack for air, so we waited until things were quiet then after some time of searching found out how they were fastened, then as quietly as possible we slid one of them open. It wasn't a very restful night as the mosquitoes were bad & we stupidly had forgotten to ask for nets. The nets would be awful if it ever really got hot here. They are of green & much thicker than ours. It rained heavily during the night but was lovely & clear in the morning when we started at 7:30 across the fields for the Lake Kawagualu. The roads were very muddy, but who could think of mud & puddles except how beautiful the sky looked reflected in them! And such sweet odors, the roadsides masses of white roses & iris! If you look in the catalogues you will see these very roses advertised as Japanese roses. They are clusters of little white single roses & smell sweet enough for the Gods. Speaking of "Gods" reminds me that everywhere you go in Japan, as in Italy you see [illegible], but these are usually to the Lox god, who is supposed to possess someone if he hadn't a resting place. It's more of a superstition than a god of their religion. After 2 miles we came to a little village at the head of the lake, then we took a sampan & were rowed the length of the lake taking over an hour. The man stands up at the back of the boat & rows & steers with a huge oar. I got some snapshots—which will show you what it is like. We landed at another village the other end of the lake where we had to climb over a pass to Lake Nishinoumi. Going through some of the villages is a nerve-racking course for I got very nervous in the calves of my legs. They say these Japanese dogs are very uncertain creatures & all bite—so when they rush out barking it's all I can do to hold my ground & if a coolie is along I take good care to get behind him. The whole way we had glorious views of Fuji reflected in the lakes. It didn't take very long to climb across the pass, then we took another sampan & were an hour getting to the other end of this lake. We had such a nice coolie who was room boy at the Yoshida Hotel & of course he carried our bags. The six mile walk between Lake Nishinoumi & Lake Shoji was not only wonderfully beautiful but was so interesting from a geological standpoint. How I wished I had gotten my M.A. in it at College. It was rather sunny at first & we thought the lovely woods we had heard about was a delusion but finally we reached them & such lovely woods! You could people them with all kinds of beings. The valley along here must have been the course of the last eruption of Fuji, at least the direction in which the last lava & ashes fell for you see huge boulders of this porous stuff grey in color. Just imagine this covered with mosses of every kind & ferns, maiden hair in mosses, iris, azaleas, wygelia, deutzia & lots of other flowers I didn't know, & of course quantities of roses, the air was heavy with perfume at times. Just after we got in the woods we stopped & made coffee & had lunch. Every now & then we would come to open stretches of the grey sky with very lush vegetation on it. Finally we got to Lake Shoji which is the smallest of the three lakes. These are bellowed for the boat from the hotel to come across for its in the most delicious primitive fashion. We got there about 4 o'clock. The colors in the lake reminded me of the Mediterranean. Of course as soon as we arrived we pulled off our clothes & put on some big plaid black & white kimonos with red sashes. We made up our minds

to bathe in the lake, bathing suit or not—so we kept on our skirts & pantalets, put on kimonos & straw sandals & started for the boat landing. We were the only guests at the hotel & Japanese didn't embarrass us much as you will learn before the end of our trip. We hopped in the two garments & had a fine bath. Like the man in "King Foluacis Mines" [sic; H. Rider Haggard's *King Solomon's Mines* (1885)] I thought the natives would admire my "lovely white legs" but judging by the fact that we saw no one looking at us & the one man who passed us in a boat seemed to be more interested in his song than in how we were built, I don't see why we couldn't have gone in au natural. We roamed around the hotel in our "hikara" costume & looked at Fuji's changing color & its reflection in the lake. "Hikara" is the Japanese for high collar. It comes from the fact that when the Japanese first went to foreign countries they always returned with the highest collars they could find & the word is the nearest the Japanese could come to "high collar"—It's in common use all over Japan. We started for our long walk at about 7:50 & began climbing the pass at the head of the lake at once. If you could have heard me then, but I managed to make good time. It was too provoking to see skinny Miss Baldwin not turn a hair or draw one quick breath. At times I resembled "Woo" in more aspects than one for I really would have liked to have gone 3 legs after we began the descent. I gave my ankle two bad turns but I didn't feel them until later in the day. After we mounted this stiff pass we followed the ridge of mountains for miles, passing Lake Motosu, then descended into the valley & stopped for lunch at a great big farmhouse. Our lunch was beer, rice, & poached eggs. While lunch was being cooked we took to the stream & sat on rocks in the middle of it & let the cold water run on our feet & legs for about a half an hour, then greased our feet & put our shoes & stockings on very reluctantly. We wore straw sandals over our shoes & you have no idea how that saves you for most of our walking is over small stones. The rest of our walk was over another pass but not such a stiff climb. We got down to Tambara, the village on the Fujikueva River at about 4 o'clock. All this section seemed very prosperous & we passed through charming little villages every mile or so, of course curs always attacked us. Curs are very uncommon animals & always a sign of prosperity & we saw a good many along here. At Tambara we took a sampan & went down the rapids for an hour to Hakii. I tell you they were rapids & it was wonderful how the two men managed these big unusual boats. I tell you even Walter Bradley [son of Mrs. Leverett Bradley] couldn't have taken a canoe down this river even if he did go down the Broad [River in Columbia?] & not touch a stone. Further down the river another river flowed into the Lupkawas with such force that at some distance it looked like a series of fountains throwing water four feet in the air as the stream would strike the different rocks. When we landed we had to walk 2 miles to Minobu. I don't believe I told you it was 18 miles to Tambora. We had a most charming boy to carry our luggage who was a cousin of the hotel lady at Shoji. He did the honors for us at Minobu & actually got a cold bath, about which there is one good thing, no Japanese would bathe in it. Just as we arrived quite a typical scene greeted our eyes. Both of the bathrooms were right in front of the door & there were two men absolutely nude taking a bath. One was soaping & the other seated in the tub. We were given two nice big rooms & when our bath was ready I went down & took it. The whole room was surrounded by glass & each sash had a perfectly clear pane right in the middle, however that didn't faze me. After

we had bathed & were seated in our garment & our kimonos our valet came, looking too sweet & cool in the same kimono & nothing else, & had a long sociable talk with us. Swell a night as I spent! We had picked up hundreds of fleas in that farmhouse so just as soon as we got to bed they began. I shook my gown heaven knows how many times out the window & the whole time skinny Miss Baldwin never gave a wiggle. At last she suggested that we swap beds & fool the fleas. It helped some so I got a little sleep. The Japanese beds consist of 3 or 4 futons as mattresses & another to cover with. The futons are cotton or wool. We got up at 5 o'clock next morning & after a delicious breakfast on speckled trout we went and saw the temple on the top of a nearby hill. It contains the bones of a famous Buddhist priest. Our two & a half hour mile walk down the valley was lovely & we had time to spare before our boat left at 8:15. We took the mail boat as it was cheaper but we never did see the bags of mail. We had 30 miles of the most beautiful scenery I ever saw. I have never seen any river to equal it. The rapids appeared anything but safe. We got to Iwabuchi on Suruga Bay, at about 3 o'clock. The boat was full of people & we stopped at various villages on the way. We had three men managing the boat, one in front poling with bamboo poles which broke at the most critical moments, one at the big oar behind & the third at the back with poles. We got some lunch at Iwabuchi then took the train to Gotemba. We had lovely views of Fuji exactly from the opposite point from where we started. At Gotemba we had to bathe in a bathroom with almost nothing but clear glass & we didn't dare get in the big tub as we had just seen two men in it. Miss Baldwin went down at six in the morning in order to get an undisturbed bath. Just as she was standing up soaping in walked the hotel boy & with the most chivalrous bow he told her "good morning" & went about his business as if she were fully clothed in her kimono which at that moment lay on the other side of him!!! However we had been working up to this experience by degrees so she wasn't as overcome as she might have been. Thank heavens the fleas had somewhat abated so we got a good night's rest. Our horse train left at eight & we had a beautiful ride right around the foot of Fuji back to Yoshida from which place we started our trip. It started to rain about 11 in the morning & continued all day but not a heavy rain & the mountains looked lovely in it. We got to Tokyo Friday night at 9 o'clock.

*Tokyo*
*June 16th [1914]*

To Nell

Mr. Swensen took me over to the club several times to play tennis & also asked me to dinner the Sunday night before I went on the trip, but I couldn't accept as we had another engagement. He is seeing about getting me in as some kind of member & I hope he will manage it. The club has a long waiting list but I go in as a nonresident. He was over at Miss Boynton's this Sunday night when we were there & we had a nice long talk on China. He looked quite like a naval officer, wears the brass buttons in his white shirt, coat & vest. All the men in China wear that for evening dress in summer & it looks so cool. He is going to lend me some books on China to read when I go to Hilako[?] July 1st to be with the Gardiners 2 weeks. Miss Boynton thinks now that she will probably get off July 15th.

On Tuesday June 7th we three got tickets for the [sumo] Wrestling Matches at the Ryo-geku which is a huge circular building containing thousands of spectators. I have been try-ing to find something on the wrestlers but don't seem to be able to get much information. However these wrestling matches began hundreds of years ago & are quite as much a valu-able feature as Ju Jutsu. They are selected as young boys & regularly trained up to the pro-fession, & are quite in contrast to things Japanese by being perfectly huge men, such stomachs you have never seen yet they are as hard as iron. You can always tell them when you see them in the cars & on the streets for they wear the queue & wear black & white kimonos always. The remarkable part is they drink as much sake as they wish & eat any-thing yet seem to be in fine condition. They work up by degrees into the different classes, the 1st being the maku-shita—or "below the curtain" which comprises the most of the wrestlers privileged to appear in the arena. Those who have especially distinguished them-selves are selected & raised to the status[?] of maku-us-uci [sic; maku uchi], or "within the curtain"—The highest grade is the Yokozuna, the champion wrestlers, of whom there are only 3 in Japan. Yokozuna wears the rope at side and is equivalent to the laurel wreath—worshipped hundreds of years ago. However that one wrestler named Hajikawi proved him-self the superior of all & no one would accept the challenge, probably in a spirit of mirth—he went to the torii & took down the "shrine," which is a bundle of straw rope with pieces of paper, representing prayers, hanging to it. This he wound around his waist & said he would surrender to anyone who could touch the rope. No one dared do it so ever since the victor has been privileged to wear it as you will see in the folio I sent you. Hitachiyama [Taneimon, 1874–1922, the nineteenth yokozuna] is one now wrestling & Umegatani [Totaro I, 1845–1928] is passé.

The whole building was arranged for the spectators to sit Japanese fashion, only a very small section having chairs. There were about 20 foreigners along with us. Every man, woman & child had a fan & it looked as if the whole audience were in motion as they fanned continuously. I wish you could have seen the thousands rise in a body, wildly wav-ing fans—calling out when the great champion had a draw, the 1st in 7 years. The calling & enthusiasm kept up for over 30 minutes. Sometimes it takes them 4 hours to decide, which happened only two days before. In the center of the building a platform of dirt 3 feet high is raised & on this a kind of roof in 4 pillars is put. A ring is made of straw rope put in the ground. The men are practically nude, but after a victory when the whole side comes in to parade they wear richly embroidered aprons. The umpire is dressed in old feudal costume which varies according to the rank of the men in the ring. He carries a fan which shows the audience what his decision is. At the foot of each post the councilmen sit & such a time they have when something hard to decide turns up, such knocking of heads together.

I forgot to tell you that when the wrestlers come in the ring they always wash out their mouths with water & take a pinch of salt & throw it in the ring to purify it. Miss Flynn buys for her sister who has parlors in San Francisco & she tells me that the kimonos I sent you & Margaret would cost $5 in America. Don't you fondly fancy that you pick up any thing for .50 cent in Japan. They cost over $1.50 & the duty they charged was about right & I thought that you both, neither having a pretty wrapper, would be glad to get one for $1.05.

*Tokyo*
*June 28th [1914]*

To Nell

I received your letters of May 23d & 31st. I am distressed to hear of Ray's typhoid for she hasn't much constitution. I am not surprised because she hasn't looked well since that heavy cold she had last summer & we had such fits over her being taken to swim every day in that cold water. It just took all the vitality out the child & sometimes she looked so blue. I hope that both Walter & Eliza are well now. You seem to be in a state verging on the neurotic on the subject of the kimonos. I have a great mind to send you some more. When I go to China you ought to get some silk in pongee & [illegible] silk is very cheap & will be less after you pay duty than the sleazy stuff you get at home. Soon after I returned from my Shoji trip Camilla asked Miss Yonkers, Miss Tilton, Miss Clements & Miss Chapel in to tea. All of them except Miss Tilton will be in Karuizawa this summer & we hope to have some tennis together. Karuizawa is a mountain resort where lots of people go including many missionaries, some of them coming from China. Camilla is going there so when I come back from China I will go there & stay until Sept. 15. One afternoon I went over & played cards with Miss Tilton & her sister Mrs. [Isabelle Tilton] Brooke & some other girls. Capt. [George M.] Brooke is an attaché at the American Embassy here & I think was about in Johnson Hagood's class [at West Point]. His wife is quite handsome, from Portland, such nice well bred people. He is the Virginia Brooke & is from Lynchburg. Heard a most interesting talk on [the Indian author Rabindranath] Tagore the other night by a Hindoo who has been studying in England.

Miss Boynton & I went down to Yuesshima on Saturday. It's a lovely island just off the coast near Kamakura. We spent the night at a Japanese Inn right on the water. Miss B. tried to make the maid understand that we wanted the bathroom to ourselves for 10 minutes and she seemed to understand. Finally she came & said that the room was ready & picture our amazement when we entered the Inn to find a man in the tub!! The maid was most surprised we wouldn't go in, said "it's only <u>one</u> man." We told her it was one too many so went out to wait until he got out. In a little while she returned to say that it was ready now that only a little boy was in there now!! We finally got it to ourselves. A year or two ago the Japanese decided that they must consider western customs so required partitions between the men's & women's bath. There was an awful howl, the men said that it was so uninteresting they wouldn't stand it so they got around the law by pulling up one board!

Sunday, the next day, we went to Kamakura & saw the Daihiku [*sic*; Daibutsu, seated Buddha] which is considered one of the most wonderful Buddhist Art treasures in the world, & it certainly is a wonder. The story goes Youtomo saw the one in Kyoto & decided he must have one at Kamakura so this one was made. I am sure the Kyoto one of that date couldn't have looked like the present one. I sent you two letters & some cards on the last boat. I am also sending Ray a lovely kimono. I hope it will amuse her.

*From Dr. George Coffin Taylor*
*Tokyo [sic; Columbia]*
*July 12 [1914]*

It is a perfect shame that I have not written you before to tell you that Mariana Heyward Taylor was born on Wednesday, July 8. A finer fatter nice baby you never saw. She is very blonde and prettier than Eliza was at her age. Is one pound heavier than Eliza was. Nell is doing splendidly. She ate a perfectly splendid dinner today with a very keen appetite. She is very happy and jolly with the new baby and distributes her favours very justly between Eliza and Mariana. As for Eliza she is charmed with the infant. How many times a day she makes me or the nurse take her upstairs to see ("babee") I should hate to say. I certainly enjoyed your last letter immensely. I enjoy them all but this one about the wrestlers was fine. What a looking set they are. It makes one feel as if he were reading Plutarch again in his treatment of the Spartans to hear about such things in modern times. Bye and bye when the Japs gain some of the wisdom of civilization they will leave off these traditional sports and think themselves wiser than they were and are. To my mind it is just such customs as this as show the real wisdom of a people.

TAYLOR KEPT A DIARY of her trip to Korea and China. She then sent the "account" and accompanying photographs to Nell by registered mail. ∽

**Korea Diary**

July 15 [1914]. We left Tokyo last Wednesday & actually had a real "Baron" to see us off & a very handsome one. It took us all that night & the next day to get to Thiuneoseki, arriving at 8 P.M. All that day we skirted the Inland Sea & had most beautiful views. It really is a lovely part of Japan. Needless to say it was very hot so our night on the boat was very welcome. We managed to keep very cool for each of our staterooms had all electric fans & we had them going all night. It was really a beautiful steamer, every comfort possible but there were loads of croton bugs in the staterooms, & all night I fancied that they were cavorting over me. We got to Fusan at 9 A.M. & stood in the station until our train left at 10:30. Fusan is very uninteresting viewed from the station as most of the buildings in sight were hideous modern affairs. The foreigners' quarters were up on a bluff but I doubt if there were many, or at all interesting ones, as the place is quite small. It is beautifully situated, the mountains coming right down to the water & a fine big bay. The trains were fine as it's the through line to Siberia. It turned up roasting & reached 100° at midday but being a dry heat it wasn't so bad. The delivery car service is very good & you can get ice-cream almost any time. The country was beautiful, being very mountainous with lovely green valleys where rice was growing mostly. The country seemed well watered but not the abundance as the water power you find all over Japan. We were amazed to see numbers of cows & of very good herds, many showing a good deal of Jersey blood. You saw no evidences of Japan in the country but at every station you saw Japanese, all the officials & railroad employees being Japanese, & soldiers were always present. Some high official was on our train & at every station a squad of soldiers was drawn up & such bowing as went on by the officers!

The houses of the peasants were the most awful mud hovels with walls not over 5 feet high & straw roofs, not the beautiful Japanese thatch which is a work of art but something much more primitive. Not a trace of the beautiful until you saw a Japanese house or at the stations. There are always flowers, either in a little garden or in pots. The houses have only dirt floors, are joined together & often have a wall around them. The men wear absurd huge straw baskets on their heads as hats, but the better classes wear transparent black horsehair hats which look so funny for work. They wear the most wonderful colored suits, just the color of the wonderful sails in the Mediterranean! However that's the suit in Japan & they introduced it here when they took possession.

We arrived in Seoul Friday July 17th at 9:40 P.M. Our hotel enjoys the name of Soulag, is managed by a Frenchman, has Korean servants, & is furnished in a horrible mixture of Victorian & German taste. The only charming thing is the gardens with many flowers, however the bath is fine, but we can't begin to eat all they have. We decided to get an early start so were starting in our rickshaws at 8 o'clock next morning. We went on a most beautiful ride out in the country to see the White Buddha which is a most hideous inartistic affair, but the ride was wonderful. Seoul is surrounded by high mountains which have the most wonderful color in them. They are practically bare all over the country & show quite a great deal of erosion but since Japan has had the country they have started refurbiration [*sic*], of which you see on all lands but not to the wide extent you see in Japan. This ride took us through several of the little villages & through a pass which gave you a very extended view of the country. The lands look very miserable & anything but clean, but they did make most artistic groups & were charming with the few pines which seemed to be with every group. The pines seemed to instinctively take on artistic lives here as they do in Japan—All through the country you see little straw sheds built on 4 poles with a kind of upstairs & during the hot hours of the day there seemed to always be somebody taking a siesta.

Mr. Ainey [William D. B. Ainey, 1864–1932] is the representative from Congress sent to the International Parliamentary Congress in Stockholm via Japan. He has been very much entertained in Japan & we ran across him in the hotel in Seoul & he came up & introduced himself. After seeing all of this we went to hunt amber. Miss Boynton wanted to get some herself & also had several commissions. We got to a most fascinating little shop on a side street & such oriental bargaining went on, you never saw. By the time we bought Y50, Miss B. & the man were on a most intimate footing. We two & the man were all seated on the raised floor of the shop & were vigorously fanned behind by the old man & in front by a young one. The whole front of the shop was simply filled with Koreans & when they got too thick & the air inside too hot our young friend of the fans shoved theirs off which had effect for just about two minutes. It was really walls of fire. Different men in the neighborhood would bring pieces of amber to get the man to sell theirs to us. I wish you could have seen Will after he & Miss B. had gotten on this intimate footing of perfect understanding, repeat to one of the men who was asking a huge price for something, not only Miss B's words but her exact intonations & words "No! No! No! too much! too much!" The way the people out here trust you amazes me. He let us go off with that large amount without even our names, was to come to the hotel that night for the money. We had it but didn't want to go into our bags before the people.

We were charmed with the Koreans, they have such gentle faces & have so much dignity, that they really don't look as absurd as you would think in their black horsehair hats perched on the tip of their heads. The men & women dress in white, pale blue & tan grass cloth costumes. Both men & women wear very full trousers, the women wearing very full pleated skirts on top of little shobeaton jackets with the breasts exposed. The men wear long coats down to the ankles. They don't seem to wear any underclothes & the men wear very open work baskets of straw under their coats or shirts which keeps them from sticking to them in summer!

Miss Boynton & I are more impressed with the wonderful qualities of the Japanese since our visit to Korea than ever. It is almost unbelievable what they are doing for the country. From one end of Korea to the other they have built wonderful roads, so well built & engineered that at short notice railroads can be laid along there & operated. In every village of mud hut, you already see a fine new building which is the school. The railroads have fine roadbeds, really superior to the ones in South Carolina & the trains are equal to our best & are actually ordered from the States. The enormous engine, like those on the Saluda grade, was made in Richmond!! & the cars by the Pullman Co. They have introduced farmyard herds of cattle, pigs & horses & are trying to get the people to experiment in various ways.

## China Diary

*[At Mukden, Manchuria, late July 1914]*

Mr. Yokogawa sent a carriage for us at 10 & we went to the A[merican] Consulate to get passes for the palace. The consulate is in an old Chinese temple & is very charming. Mr. [Fred D.] Fisher, the consul, seemed a very nice man. Then we drove out to the Imperial Tombs which are about 3 miles from the city. The ancestors of the Manchurian Emperors of China are buried here. They used to make pilgrimages from Peking here to sacrifice to their ancestors. They were beautiful but very neglected. We drove across the plain which is very flat & very extensive, of course I mean we only drove the three miles. We had to ford a stream which came into the carriage, evidently quite a common thing for there were holes in the bottom to let the water out! While near the brink some of the fighting at the Battle of Mukden [in 1905] was done & the Russian soldiers hid in the Courts. We came back to meet Mr. Yokogawa at his offices at 12:30 to enjoy a Chinese lunch or Tiffui, as they call it in the East. I can't begin to describe all the courses we had & which I tasted, but you will be entertained to know that I ate bird nest soup & it wasn't at all bad, also sharks meat! We had some kind of pigeon eggs which didn't taste half as bad as they looked. Miss B. & I are sure they were buried for years!

After lunch we all went to see the palace & were showed around by a dignified Chinaman, the secretary for the Gov. General, Mr. Wong. He had charming manners & guided us with "I am pleased to meet you. So am I!" When we thanked him for his kindness he kept bowing & saying "Don't-mention-it!" all in one. Then we had a drive around the city & such streets & such smells! We wished that Japan could get in here, for the first thing she would do would be to have good streets & eliminate most of the smells, but it was delightfully oriental. The Chinese dress almost entirely in the loveliest hues, the women wearing some of the other colors as well. We saw them eating some fine looking watermelons

Anna Heyward Taylor in China. "How we had to land. Think of the cooley! June 11th." Courtesy of South Caroliniana Library, University of South Carolina, Columbia

so bought one! The Manchus are great big men, many of them over six feet. You can't help admiring the Japanese but it certainly is a fact the Koreans & Chinese are much more handsome. Mukden has 100,000 or more inhabitants. There are two walls, the Forbidden City—enclosing one mile square which was not entered until after the war. The outer mud wall encloses about 10 miles. There are about 6,000 Japanese & 150 foreigners. I certainly believe that it's only a question of time when Japan will have complete control of Manchuria. She now has a good many troops stationed in Manchuria & in another 10 years will have it as completely as Korea if Yuan shi Kai [1859–1916, the first president of the Republic of China] isn't equal to the occasion.

July 21st we left Mukden for Peking which took us from 10 A.M. on 21st to 9 A.M. 22d. We had a very comfortable trip down as it wasn't very hot & that night was the best I had spent on the train but even then I slept very little. I just can't sleep on the train. This train is considered one of the finest in the world but none have the toilets such as we have, they

just presume you don't want to do much bathing. The country was very uninteresting for sometime after leaving Mukden, just a flat country. Then we got into mountains & halfway down it got to be beautiful. At Chui-Wang-tao the old Wall goes right down to the sea but we couldn't see it from the train. It is quite a summer resort for foreigners, also Pei-tai-ho which is on the sea also, near there.

The two conductors from Mukden were such tall fine looking fellows & had charming manners. Later on another one got on & he & I became very chummy, of course it was to practice his English, however he was very useful to us when we arrived in Peking—July 29th. The crops in China seem to be some kind of pea & our corn, also some millet. We must have passed through thousands of acres of corn. You also see small patches of tobacco. The houses are made of mud, having mud roofs too. They sleep on brick beds on one side of the room & under it runs a flue from the fireplace which warms it in winter. The whole house-hold piles on this bed & of course never think of changing clothes or bathing. The colder it gets the more padded garments are put on. They have 3 months of solid ice for skating every winter & this extreme heat during the summer. The men are superb looking, finely built & most of them 6 ft. How they develop in the dirt, poverty & masses of human beings, I don't understand. Their powers of resistance to disease must be stupendous. They are mostly clothed in rags & their smell is something awful!! In the first few days I would have awful spells of gagging every time I got in a rickshaw & then I have my handkerchief soaked in cologne & don't budge without it up to my nose.

You see quantities of bound feet & they are too pathetic. The foot is shaped so the big toe coming down in a point & the other toes twisted under the foot. The bones in the arch are broken & the [illegible] bent under something like this.* The legs are spindly & unde-veloped & frequently the feet are gangrenous & frequently drop off. The upper classes are ceasing to do it but the lower classes keep it up. These people have so much dignity. The queue adding so much to their looks. We took the 11 o'clock train for Peking, arriving at 1:30 P.M., I going to the swell hotel & Miss B. to her boarding house.

Next day, July 25th, we started out in the rain to see the Temple of Heaven. Five altars have been built within a huge enclosure & of course it began to pour when we started across the park. The walls were shoulder high & the paths were rivers so in a short time we were dripping. The buildings have the most beautiful roof of lapis blue tile you ever saw & the balls on top are gold. One of the buildings was restored a few years ago & that is where the parliament sat. The platforms & steps are of white marble & beautifully carved.

It is very difficult to get in the Forbidden City, in fact only 5 parties have ever been taken in. Inevitably he wrote to the legation some weeks ago that he was coming so they tried to get admission & succeeded, although both the English & Germans have been refused lately. Mr. Ainey very kindly invited us to go & also got permits for us to see the Winter Palace & Lakes. Several American men who were at the hotel went along too. The Forbidden City is beautiful & I got some very good snapshots. It is pathetic, though, to see how neglected everything is & how poor the government is. We saw numbers of priceless rugs rolled up in covers covered with dirt. A Curio dealer was along & he said he could get $1000s for each of the rugs. The roofs were beautiful melon yellow, some being green. When you see one

temple or building you see all, except some have more beautiful tiling than others. We saw the Obintes Palace, then the two men with us bribed a boat to take us across to the temples on the other side that you aren't supposed to see, so we crossed a lake full of lilies blooming in a real Chinese boat, like the one on the china, & landed in early boathouses. We went over the buildings which were more dilapidated than any we had yet seen but we saw some marvelous tiling.

When we got back to the hotel Mr. Anderson took the two men & me for a ride in the Chinese city & we went through some of the busiest and smelliest streets in the world, however it was wildly interesting. I haven't told you about Mr. & Mrs. Guyuere.

We took tea with the Guyueres & they have asked us to dinner Saturday. Mr. Guyuere is going to give us a detailed account of Siege of Peking. They took us to a mission compound & it was such a charming place. The whole place was torn down & even the foundation dug up the Boxers. Miss Muior [*sic; Muir?*] was in the Eng. Legation during the trouble.

*Peking, August 2 [1914]*

Such excitement as there is everywhere over the war. For two days at the pension Herr Bach fairly lived at the phone & got all the telegrams. One of the men left for Torrington where the German troops are all mobilizing. All the French, German & Russian troops have left Peking so only the American & Japanese are in full force for some of the British have left. The people are rather nervous for the Chinese Army is an uncertain quality. Yuan's [Yuan Shi Kai's] Army is paid by foreign loans. He can't get money, and the only thing which keeps a Chinese soldier in bounds is his pay. This war seems too dreadful as we are anxiously awaiting news when we land at Moji which is in a short while now. Everything is thoroughly demobilized in a business way. Whole groups have been ordered home and German and French Banks refuse payment. In fact the Japanese & ourselves are the only ones not feeling the war scare. If England gets drawn in, it means I will have to give up my trip & come home in the winter.

Aug 7th. On board ship going to Kobe. We went to the Fair I said we were going to & it was so oriental, you were absolutely in the heart of the East. The open space was simply jammed with little booths selling all kinds of things, curios, stoves, clothes, & even an auction going. There were 3 men running the affair & as each man would stop his sing song auctioning of some garment one of the others would take it up, each having his own musical variation. We stood some time listening and watching the crowd. Of course there were masses of lovely colored fruit. Peking is just the place to come to see the real East unless you go into the interior. Nearly all the men wear queues which they don't do in the South. These Chinese houses lend themselves to the most artistic arrangement. Miss B. & I are dying to get our hands on one. I could make a stunning place out of it. The natives use a coarse mat on the floor which when put on the wall have a most charming quality of color & texture. We had our mouths sweetened for a cup of tea & do you know they never gave us a drop, the most unusual thing I ever had to happen. Out here tea is poked at you any time of day or night. We finally got strength enough to leave when we realized that no tea

was forthcoming, & took ourselves down to the Lunch Bakery & stuffed on teas, cakes & ice cream.

There is such a huge difference between the Chinese & Japanese. To begin with there is a common look about even the well-bred Japanese, excepting Count Meekin & Dr. Intole, which you don't see among the Chinese. One is like a racehorse & the other a marsh tacky. Also with the Japanese there is no such thing as conversing, you simply spend your time asking questions & getting answers, but the Chinese converse charmingly, certainly this has been our experience with the two men we have met & Mr. Guyuere says it's the case with all. But it is explained by the fact that the Japs are silent people as a nation, you never hear street rows & continual talking in the cars, though you do come across it sometimes, but the Chinese are a mouthy crowd, remind me of the Negroes very often. With the coolies you just have to tell them to shut their mouths.

Aug 8th. We spent from 11 in the morning yesterday to 3 A.M. in Moji harbor. The two men went on shore to get the news & we were all distressed to hear that England had been drawn in. It seems too dreadful. News is very uncertain out here & reports are always being contradicted so I have no idea what is the real news. Mr. Rosier went on a French boat which had been stopped there by the French Government & told to send all passengers to Yokohama & fill up with coal & await orders. A German vessel was there doing the same thing. The French returned out to the harbor, but hearing that there was German war vessels being near she returned, so the two vessels are sitting there watching each other with steam up. Everyone is expecting the English & French to bombard the Germans at Taingtao. We get to Kobe early in the morning & I hope to catch the express to Tokyo.

&ast; Taylor inserted depictions of Chinese foot binding.

*From Kate Crawford*
*Columbia, S.C.*
*5th August 1914*

The War—the Crime of the Age—is a fearful thing to think about and it fills my heart and mind to the exclusion of all else. How can such a terrible affliction come to the world (for it really will affect the whole world) in this presumed enlightened age! Even Japan may have to appear in the picture—as an ally of England. The two Emperors of Germany and Austria are entirely to blame and poor little Servia—insignificant as she is—began the fray. I fear your plans may be upset and that you will return without accomplishing all you desire.

So many Columbia people are in Europe and there seems much consternation as to their arrangements to return home. S. A. Smythe was at Oban in Scotland when I heard from her and expected to sail 20th Aug. Hunter Gibbes with his sister Mrs. Montgomery sailed only last Thursday for a six weeks trip. They may be turned back.

*Tokyo*
*Aug. 12th [1914]*

To Nell

I sent by registered mail my account of my trip & some photos. I hope they will arrive all right even if the "Siberia" may be taken by German vessels. If she is, I shall never cease to regret that I wasn't aboard. When war broke out & I was in China, Camilla immediately said that she knew I would be enchanted if our vessel were taken by German battleships. Ours was the last vessel which left Tienken before the harbor was mined & a pilot necessary. Such a prey to different feelings & decisions as I have been prey to. At first I didn't think of anything but that I ought to go, so flew down to Yokohama & got passage on the "Siberia" sailing 3 days later, Wednesday. In an hour's time I returned to Cooks & changed to the "Chiyo Maru" sailing Saturday. First of all I went right to the Consul to ask his advice & see if he thought I would have much trouble later about passage & money. Hazel Dick was away & the Consul out for something, so I wish you could have seen the pompous creature who replied when I told what I wanted to see the Consul about, that he would do as well as the Consul & that is give no advice at all, that the Consul had made a point of giving no advice. I asked if other Americans hadn't been coming in with the same questions as myself. "Oh yes, but we have been giving them no advice." I was furious but there was nothing to do but walk out & go to Cooks. I don't know if I will do any good but I let off steam. The more I thought the more I decided I didn't want to leave now. I am ill of traveling in hot weather after my dose in China & leaving now would mean a hot trip, though I could break it by going through Yellowstone Park. That would put me on the East Coast about Sept. 15th & what was I to do with myself? Then things may calm down enough by November for me to go to Shanghai, Hong Kong, Java & Manila & then home.

I arrived last night finding a lot of letters with the delightful news of Mariana's arrival & also the cable which we read at once with my book. I felt as if I really ought to go, though going hadn't entered my head, everything is so peaceful & I was in hopes that by November I could see my way more clearly about traveling. However, I went to Yokohama early this morning, with every intention of going & engage a berth on the "Chiyo Maru," it being one of the last, however there are many on the "Liberia" sailing Wednesday but arriving about the same time, my boat leaving Saturday. I went to the Consul to ask his advice but could get nothing out the job clerk or Junior Consul. Tonight I am making plans on going. I shall arrive at such an awful time, no place to go except the St. Louis[?]. No plans for the winter, in fact I shall go to the Embassy & ask there & probably cancel my passage & cable you I shall stay on. I flew around Yokohama & bought some things I wanted & needed & shall get some other things so I can go on short notice. Everyone is excited over the news but otherwise things are quiet. I cashed $100.00 today & for several days money has been much looser. Don't christen Mariana until I come for I want to be her godmother too. I am sleeping at Miss Boynton's & staying the rest of the time at the Louis. Stanhope had an abscess which had been opened before I left, but since being away it has been opened again & he is just recovering, however he goes to work tomorrow. Being here in the heat doesn't seem to have pulled Camilla down. They are crazy to get home & hope can manage it this Fall.

Everyone is dumbfounded over Germany's behavior & over her losses too. Who would have thought that Belgium could have defeated her with the immense difference in loss of men.

My trip to China was very expensive, costing about $180 & I didn't buy anything. I am so glad to book it when I did. I shall now remain quietly in Japan, if I don't go home, & recuperate my finances.

*Tokyo*
*Oct. 2d [1914]*

Today is a glorious Fall day & I am thankful to say I feel like myself again & things I eat have some taste now. We have had 3 days of a steady downpour & there was an awful storm & tidal wave down at Kamakura, when something like 100 fishermen were lost & a big launch turned completely over. They say the wave was not the result of an earthquake but the storm.

It cleared yesterday afternoon, so I started out for a walk & got lost in the midst of a cemetery & would have been frightened to death if I had been home for it got dark & I seemed to see no end to the place so decided to jump the fence & walk along the car track just outside. In the process I slid down an embankment & sat in a muddy ditch, & incidentally walked about half a mile along the car track through an uninhabited track, however the barracks were on the hill, but if anyone had attacked me not a person could have heard me. I was thankful to have a walking stick which I shall always carry when alone. I finally reached a station & got on. I was just about where I thought I was. It was the wildest & most thinly settled part of Tokyo. I wouldn't have been safe in any other country in the world. You never hear of Japanese assaulting women. Another thing happened the other day which makes this country unique. A German boy rode down one of the principal streets the other day flying a German flag. Do you think that could have happened in England, France or Russia & he not been mobbed? When I got home I found Mr. Pendleton & Miss Boynton. I was a sight with muddy hands & the back of my dress full of mud. Mr. Pendleton reminds me of Lee [Hagood], he would enjoy talking just as much to Camilla as me, or rather I might say more Walker! He gave us the most absurd account of how he passed three months up in the interior of the country in Philippines. He knew he wouldn't get any mail the whole time, so just to have something to think about he sat down & proposed to a girl in the States he was sure wouldn't have him, then took to the jungles & began to wonder what he would do if she really took him. He says the 3 months flew by & to his intense relief he found a letter kicking him as high as the sky.

In case you don't get my other letters, I will repeat myself. I sail Oct. 24th on the Pacific Mail "Siberia" getting to Honolulu about Nov. 2d & to San Francisco about Nov. 9th. Send mail to the St. Francis Hotel. I will go right to New York & stay at the Woodward. I hope Frances will join me. I thought I might stay some weeks there, but the war has made such a difference in the opera & theatre that I will not be there more than two weeks probably. Then I am getting homesick now that my head is turned that way. I wrote Sue asking if I might stay with her, so if she doesn't get the letter do ask her for me. I will get home about Dec. 1st. I will telegraph from "Frisco."

*From H. Middleton*
*24 Great Western Road, Shanghai*
*14th August [19]14*

I found your letter of the 2nd inst. awaiting me on my arrival here on the 7th inst. It was nice of you to write so promptly. I enclose a memo giving you some idea of what you could do in a limited time in India. I don't think your round the world ticket will cover the steamer trip from Singapore to Calcutta, as it is off the regular run of the P[eninsular] & O[riental Steam Navigation Company], N[ord]D[eutscher] L[loyd steamship company] & M[essageries] M[aritimes] steamers, from Hong Kong to Suez. You get a local line for that little bit. From Bombay there are weekly sailings of the P. & O. boats. Tho[ma]s Cook will no doubt tell you exactly what your ticket covers.

Did you bring off your visit to the Summer Palace & what do you think of it? The place impressed me a great deal. I've got to be in Peking early in October for a week, & will try & visit it again. Isn't this war in Europe a terrible affair? One can only hope it won't last long.

[Enclosed memorandum for an itinerary]

Make the following allowances for time to be spent on your proposed India tour—

1 day travelling from Calcutta to Darjeeling

2 [days] at D[arjeeling]. If weather is fine start out very early & get to the top of Tiger Hill on Senshal. The top of Mt. Everest can be seen from there. Better ride, as it is a stiff walk there & back in a day.

1 [day] Darjeeling to Calcutta.

2 [days] in Calcutta. See the zoo at Alpur & the botanical gardens at Sibpur, across the river. The latter is a whole day's trip.

1 [day] Calcutta to Benares. Travel by night & spend the day in visiting the temples. Leave at night for Agra.

1 [day] Benares to Agra. This will probably allow for a spare day if you can do your travelling at night.

2 [days] at Agra. One for the Fort & Taj [Mahal] & one for Fatchpur Likri. If you have a spare day as above, do the fort & palace on one day, the Taj the next & Fatchpur Likri the next.

3 [days] at Delhi. The journey from Agra takes a few hours only. Visit the Pearl Mosque, the palace, Kutb Minar & a number of very interesting old tombs in the neighbourhood. Many of these are built largely of white marble & are beautiful specimens of architecture. Also the new Govt. of India buildings. It might be practicable to run up to Simla for a day.

C.f. 13 days.

2 days Delhi to Bombay. The actual time by train is only a little more than 24 hours.

1 [day] Bombay. See the caves on Elphanta Island.

16 days in all.

If you can give 3 Weeks to the trip give:

1 day to Lucknor which is between Benares & Agra. The ruins of the Residency are interesting.

1 [day] to Jeypore, the capital of a very progressive native state in Rajputana. You could take it en route from Delhi to Bombay. It is well laid out & there is some fine inlaid work on brass there.

1 [day] extra to Bombay is worth it. A steamer trip across the harbor to the mainland is interesting.

1 [day] in Poona or Mahableshmar on the way from Jeypore to Bombay.

Total 20 days.

TAYLOR'S LAST ASIAN NOTE was dated October 24, 1914, and stated that she was sailing for San Francisco: "Now that I am turning homeward I get awful spells of homesickness and certainly would love to kiss Eliza and Mariana. I dreamed about Mariana last night." ∽

# 6

*With William Beebe in British Guiana, 1916*

After her hasty return from Japan in the fall of 1914, Taylor spent nearly two years in South Carolina and the Northeast. She combined her work with teaching and study to improve her skills, but her taste for adventure was undiminished. She embraced an opportunity to visit South America on a different kind of enterprise. She joined a scientific team headed for British Guiana to work as a scientific illustrator.

The naturalist William Beebe was an explorer, an ecologist, and a writer. Former president Theodore Roosevelt was Beebe's mentor. Beebe worked for the New York Zoological Society and was the expedition leader. When the team returned, he published *Tropical Wild Life in British Guiana: Zoological Contributions from the Tropical Research Station of the New York Zoological Society, by William Beebe . . . G. Inness Hartley . . . and Paul G. Howes . . . with an Introduction by Colonel Theodore Roosevelt* (1917) as a scientific report. He also wrote *Jungle Peace* (1918), a popular account of the expedition that mentioned Taylor's work.

Rachel V. Hartley (1884–1955) was one of Taylor's artist friends in Provincetown. She and her brother George Inness Hartley (b. 1887) knew Roosevelt and Beebe. Rachel and Inness were the grandchildren of the American painter George Inness and children of the sculptor Jonathan Scott Hartley. As early as 1906 and until at least 1940 Rachel Hartley visited Charleston—and presumably Taylor—and painted street and rural landscapes. Her brother accompanied Beebe on expeditions and coauthored the British Guiana report. On his own he published *The Importance of Bird Life* (1922) and *The Last Parrakeet* (1924).

Taylor drew and painted specimens for the scientists. She also painted for herself. Traveling there and back, she visited Caribbean islands, sketching and painting as she went. A decade later she spent several months in the U.S. Virgin Islands, where she painted to her heart's content. ∽

*101 Pinckney St. [Boston, Mass.]*
*Dec. 5th [1914]*

To Sue [Ames Taylor]

On Thursday I moved into the rooms I will keep, one small bed room & a sitting room. The fare is so good here & some possible people. I was talking to a very nice girl who is studying music & also met a man who looks quite possible who is an interior decorator & had his arms full of prints, Japanese, so I asked him to come over to my rooms when I get settled as he said he would like to show them to me.

*From E. Muriel Leach*
*6 Fukuyoshi Cho, Arasaka [Tokyo]*
*Jan. 31st 1915*

You will be interested & not surprised to hear that my husband [Bernard Howell Leach] is in Peking, for the second time! He went in November & was away six weeks, then he stayed only three weeks at home & was off again a fortnight ago. He was hugely interested both by the place & the life of which he seemed to see a good deal. He must write you about it sometime. He would love to I know but sometimes he is ages doing even things he likes so I will send you a few lines to go on with! Did you hear of Dr. [Alfred] Westharp? It is he with whom my husband is staying in Peking, a Chinese house rather a long way out I think, somewhere to the S.W. of the Legation Quarter. He lives the whole time on Chinese food too & enjoyed it & said the smells were not nearly so bad as he had expected. Perhaps they don't rampage so in the winter! But these are details. It is with Dr. Westharp's ideas that my husband is chiefly concerned at present, so much so that he has given up pottery & etching for a time & decided, instead of taking a whole heap of pots back to England, to sell most of them here—much to my relief.

He may possibly stay in Peking till April & then come home to wind things up after which we may all go over together & stay there until it is time to go home. If on the other hand the work he thinks of doing with Dr. Westharp doesn't progress he may come back sooner. It is strange without him but I am delighted for him to be there, I know it is doing him all the good in the world—mentally & morally which as you know is all he cares about. [What] Dr. Westharp is after (& my husband through him) is nearer understanding of the east & a discrimination as to what it should & should not take over from the west. Its all very interesting but quite too big a subject to write fully about just now—anyhow I don't think I am capable.

*From Katherine [Bayard Heyward]*
*1 Gibbes Court, Columbia*
*June 8, 1915*

I have been wanting to write to you for the last week or more but with all the commencement doings, and straightening up things in the studio afterward and all the thousand and one things that had to be done I haven't had a minute. I'm very much interested in your plan of our opening up a studio and I don't see why it should not succeed but ever since

we've known the college [Presbyterian College for Women] would not continue I've been laying my plans to go to New York next winter and study. It means borrowing some money, of course, but I think I can manage that part of it all right and it seems to me that if I'm ever to have a winter there now is the time to make all effort and do it. I want to study designing and if possible get in to some work along that line instead of teaching always, for it seems to me there ought to be more in it financially and every other way. That part of it remains to be seen but, anyway, it seems to me that now is the time to go and study some more, never mind what I do after that. I would be in a better position then to decide. But I do like your scheme awfully well and possibly we might be able to work it out some other time.

Chicora [College for Women] has practically decided to come here and they are going to start off with a great flourish, but a great many predict that it won't last long under Dr. Byrd's management and it may be that a little later on would be just as good, if not a better time, for us to open up. Miss McClintock was so busy that I didn't have an opportunity to talk it over with her, as you suggested, but everything is still in such an uncertain state no one knows what any one is going to do. Would you think of opening up a studio next winter by yourself?*

* Both Taylor and Katherine Heyward had taught at the Presbyterian College for Women, which from 1890 to 1915 was located at the Hampton-Preston House in Columbia. In 1915 Chicora College for Women took over the facilities and remained there until 1930.

*From Helen Hyde*
*Lake Beulah, Wisconsin*
*September 22, 1915*

Your letter fell [illegible] into what I had been thinking about, that it is funny—Did I <u>say</u> I wanted to come South. Well I do & was just thinking the last four days that if I am debarred from Europe for some years perhaps I <u>might</u> do something with little nigs [Negroes]. I don't know that I <u>can</u> but at any rate I have been wanting the worst way to come South.

I am to work up to New Years on some etchings but after New Years we might make more plans.

Charleston sounds <u>very</u> good to me for March any way & perhaps part of April. Like a looney I tied up my Spring in the middle like an hour-glass by promising to be the leading attraction ahem! At the "Woman's Club's" biggest day of the year its Spring Meeting—Japan its theme. I am scared to death but if I am to live in Chicago I want to be thoroughly known in the city & this was an opportunity as a professional woman ought to be known by every body—& I am just getting on to that fact—so—When the day comes I don't know, but I would have to tear myself away from the pretties & come back for that. The later in April they have it the better for me so I say.

Also I like the sound of that summer class. I must do <u>some</u> thing to get some body to help me get out of this rut. I am doing the most awful amateurish work, no one would ever know I have ever thought of arriving. So, I'll write again after I have seen Mrs. K[ennedy] or heard from her.

*From "Fland" [Florence E. Boynton]*
*[Azabu, Tokyo*
*ca. October 1, 1915]*

Your letter is going on to China to the Leachs just as soon as they are located. Mr. L[each] regretted very much that you had given up your painting. He will be overjoyed.

A very interesting new arrival from New Orleans has appeared on my horizon. She is a Miss [Anne Heard] Dyer who was secretary to Fenolossa [*sic*; Ernest Fenollosa] for years. You would enjoy her. She lives for the joy she gets out of life and in consequence has a very rich one.*

I saw Miss H[elen Hyde] in S.F. She is yet content with America but finds herself longing for Japanese things and each letter brings its commissions. I told friends on the steamer how we had a snap[shot] of Y[u]an Shi Kai's son and they said he would be most flattered with a picture. Now is your chance to "hob nob" with the throne.

Mrs. L[each] is expecting a little Muriel this October—next month. I got to know her quite well after you left. She is very dear and just as clever. Mr. L[each] is quite taken with Dr. [Alfred] Westharp, a German Jew, brilliant but as far as I can make out very eccentric. He collaborated with Dr. [Maria] Montessori on one of her publications which came out I believe in German. Mr. L. believes that he [is] far ahead of Dr. Montessori and that together he and Dr. W. they will be able to establish some Chinese schools on her method with individual handling to suit the needs of the Oriental.

   * Anne Heard Dyer lived in Japan prior to 1900. She translated English-language works into Japanese and published an English-language edition of Woldemar Von Seidlitz's *History of Japanese Colour-Prints* (Philadelphia: J. B. Lippincott, 1910). Published in German in 1897, it was a seminal Western study of Japanese printmaking. This letter was written on Japanese illustrated stationery.

*Port of Spain, Trinidad*
*Sunday, Jan. 23d [1916]*

To Nell

From day to day we have been waiting to sail, in fact all the excitement has departed. In true South American style the boat has not sailed on the stated date. We hope to get off at 9 A.M. tomorrow. Inness [Hartley] tells me that the staterooms are very small & there is no promenade deck, I suppose more like the Clyde Line than an ocean liner. We are two weeks on the trip, stopping five days in Trinidad to get cargo. We will probably have a charming time there & be entertained by the orchid collector Mr. Eugene Andre.*

Agusto Campbell had Rachel [Hartley] & me to dinner Thursday & then took me to a dance at the Netherlands. One of the men was Dr. Fielding Taylor, whom I was glad to meet at last for many people ask me if I'm related to him. He's from Norfolk. Mr. Campbell certainly is a handsome attractive fellow. He gave us each a bunch of orchids. Mrs. Roosevelt sent us home in her car which I thought as thoughtful & quite unlike New York. Mrs. R. was thinking of going to Japan & China in February so I gave her some letters, but since then she has put off the trip because of the unsettled condition of China.

Our party seems to be very well-known & causing much interest. Accounts of it are in all the papers & scientific magazines. Rachel & I are offended because we don't seem to be mentioned. The idea is to establish a laboratory there for intensive study. I am getting quite keen about getting a collection for the S.C. University which Inness [Hartley] says is perfectly possible. I will learn how to skin & prepare the specimens & then the Alumni Association can mount them & get the cases for them at the University. Of course I can't paint all the time as my eyes will not stand too continuous close work & this will be a fine occupation in between.

I will keep a diary & mail it as the boat sails. Please <u>keep up with my letters for they are my diary of this trip.</u>

  \* Eugene André (1850–1922) was an early naturalist-explorer in South America. He wrote *The Caura* (Port of Spain, Trinidad: Mirror Office, 1902) and *A Naturalist in the Guianas* (London: Smith, Elder, 1904).

*Lying outside St. George, Grenada*
*Monday—Jan. 31st [1916]*

To Nell

This is the most perfect tropical evening you could imagine. The sky is simply ablaze with stars but the Southern Cross isn't visible yet, not rising until after 12 o'clock. The island is an uneven dark mass on the right with the lights of the city along the shore & up the side of the mountain. All evening we have been having sudden little showers as they do here in the tropics & the funny part is that most of the time you can't see a sign of a cloud. We cast anchor at 7 o'clock & soon after the harbormaster & two other boats came out. The Negroes talk almost exactly like the Charleston Negroes, the same intonation & rising inflexion at the end of sentences.

We had the most absurd getaway from the Hartleys. Of course Rachel at the last minute couldn't find her important address book, her gold watch, & something else. Everyone was searching wildly & finally gave up in despair. We finally started, Inness, & six women streaming before & after the lone male. In the subway of course no one could make up their minds as to what train to take so 2 expresses & a local flew by, the last carrying Rachel by herself, she getting on thinking the party was following. If you could have seen Inness!! He really behaved with the most wonderful self-control, only due I am sure to his having experienced the same thing many times.

Our party consists of we two girls, a Mrs. [Gertrude Singleton] Mathews, Donald Carter, the keeper & catcher of snakes & animals, Mr. Beebe, Inness, & Paul Howes. Mrs. Mathews is a friend of Mr. B's who is going to Dutch Guiana to study some situation there. She is an extremely clever woman of about 34 with enough self-reliance & assurance to take her to the North Pole & back. She's not to the manner born, but quite pleasant. She may stop a little while with us in Georgetown.\*

Donald Carter is a nice young keeper at the Bronx Zoo. Paul [Griswold] Howes is to take all the photos & study bugs. He is about 23 & awfully nice fellow to have on the party. He takes wonderful photos.

Mr. Beebe is quite a study! He was married at dawn in an apple orchard! No wonder he is now divorced! They say his wife was always in search of sensations; so long as he was exploring, it was a happy match. Inness told Rachel that he didn't believe that Mr. B. had ever known women like us before, his wife & the ones he knew were just a little free, not fast but rather bohemian. He doesn't know it but he is rather <u>free</u> sometimes, doesn't mean a thing. He is very clever & companionable, & a delightful person to travel with for he enters into every thing with his heart & soul, deck sports, a joke, or science. He's a man with lots of imagination which accounts for his writing as he does.

There is a very attractive man on board which I at once placed as being a gentleman, so he turns out to be. He is Lloyd [T.] Emery from eastern shore Maryland. He is a mining engineer & seems to have been everywhere. He talks delightfully about a trip he took to Asia Minor with the party under [Howard Crosby] Butler who were excavating Sardis, the old Greek city there. He is a man about my age not at all good looking with very good manners. He seems to have attached himself to us just now. He is going to Georgetown & then on to Dutch Guiana. He lives in Phila. & knows the Sinklers & all of the rest of the people I know so we often discuss them.

* Gertrude Singleton Mathews (1881–1936) was a journalist and the author of books on natural history and travel. A member of the Society of Women Geographers, she accompanied Beebe on several of his Guianese expeditions. Her novel *Treasure* (New York: Henry Holt, 1917) was based on her visits to the gold-mining region of Dutch Guiana, or Suriname. She later wed Dr. Edmund P. Shelby. Mathews spent time in coastal South Carolina studying Gullah culture and collaborated with Samuel Gaillard Stoney on his books *Black Genesis* (New York: Macmillan, 1930) and *Po' Buckra* (New York: Macmillan, 1930).

*Port of Spain, Trinidad*
*Feb. 3d [1916]*

To Nell

Yesterday we spent in Granada. We arrived the evening before & had the excitement of hanging up on the mud bank, having to start up the engine & back off. Anything does for excitement on ship board! The nights are so glorious that I hate to have to go down in the stuffy stateroom. We anchored outside & went into the bay at daylight. St. George is the most charming little red-roofed town just at the foot of the high hills. There is a beautiful old fort on one side of the entrance. We got just wild to paint for there were tidbits on all sides just waiting for the brush. Rachel & Paul Howes tried sketching but got the usual rotten sketch when the light changes every few minutes. There is a tunnel taking you under the hill from one side of the town to the other. We took a most beautiful walk encircling the town, & the men of our party spent their time looking at all the birds through spy glasses, turning stones over to find hippo bugs & other kinds. They found an exquisite little hummingbird nest with two eggs in it.

When we got back to the boat Mr. Howes lost the bottom out the box containing the scorpion & bugs & most of them escaped. The scorpion was found that night in one of their beds but the bugs haven't been heard of since. After lunch on board we got in a boat

& were rowed 3 miles to a delightful bathing beach. Our party was the usual one of ourselves, Mr. Emery, & the Captain, who is a nice jolly old fellow. In addition was a Mr. McGregor, an islander half French & Scotch. Rachel wore a bathing suit which the captain happened to have on board belonging to his wife, but none could be found large enough for me so I had to sit on the beach & look on.

The approach to all the islands is beautiful, the jagged horizon lines are so beautiful. The town is very foreign & picturesque. The bougainvillea vine is in bloom on every side, glorious hibiscus, & wonderful palms, the royal being particularly beautiful.

*In the Port of Spain, Trinidad*
*Thursday—Feb. 4th. [1916]*

To Nell

This morning Rachel & I strolled around town & each made a small sketch, which were more interesting in the doing than the result. The houses remind me of the old places in Charleston which were evidently modeled after these West Indian houses. It is weird the similarity between the speech of the Charleston Negroes & whites & these. The other members of the party find it very hard to understand the Negroes, whereas I understand them without the slightest difficulty. There is only 1% of whites on the island & you can easily believe it for a white person seems to be rare. Among the Hindoos only 30% are women, which is the cause of frightful murders at times. Generally is a young girl married to or living with a rich old man. She gets tired of the old man & has a younger man on the side. When the old man finds it out he proceeds not to cut up the man, but literally to chop up his wife. Several men have been hung for it. Very few of the women are married to the men they live with because there is something in their religion which prevents their marrying outside India or of murdering the man in the triangle I just mentioned.

This afternoon two friends of Mr. Beebe's, Mr. Eurick (a Creole) & Mr. Rozar [Robert Crozier?] (whose mother wrote the cookbook) took us out for a trip to the jungle. We saw the parasol ant. The path they make is about ½ foot wide & leads for long distances from the nest, which is a series of hills in an area about the size of a small room. They are called "parasol" because they carry small leaves or sections of leaves many times larger than themselves. These leaves they chew up & make into small balls which they plant as fertilizer in the ground. They then take small sections of a certain fungus & plant them regular distances apart. In 24 hours they have a fine crop which they feed to their young. One curious thing is that you frequently see small red ants riding on the pieces of leaves. It has never been exactly explained why they do it, however Mr. Eurick has found that they are nurses for the young. The working ant is a little larger than our big red ant. It has powerful jaws which draw blood when they bite. In S.A. the Indians used them to hold the lips of wounds together, cutting off the body when the ant got a good hold. Of course the men had various curious bugs & a snake. Mr. Eurick is a mulatto but I never would guess it in the world, & of course goes everywhere here & plants well. He's the ecologist here. He has charming manners & is very handsome, having a profile exactly like my Dante.

*Saturday, Feb. 5th [1916]*

To Nell

Yesterday morning we spent doing some more shopping, which we both detested. However it wasn't so bad when we had Mr. [Lloyd T.] Emery [a mining engineer] tagging on carrying umbrellas, cameras & bundles. Then we went over to the Victoria Museum, the smallness of which collection amazed me considering the marvelous wealth of the fauna & flora down here. Of course it had a frightful picture of a hideous English Royalty in a conspicuous place. Inness & Paul Howes met us at the hotel for lunch, & after writing a lot of cards we started for the Experimental Station.

Mr. Rozar & Mr. Eurick are the two men in charge, the former being the entomologist & the latter the ecologist. They had some wonderful glass frames in which they had colonies of the parasol ant. We had long squints at them through the microscope. It was most amusing seeing them lick the larvae & feed them with the fungus. Of course we saw cases & cases of all the various insects & very often the whole life history.

After there we went to have tea with Mrs. Rozar who has a house on a hill overlooking the whole city & bay. The tea house was a little banana leaf roofed shack & most delightfully cool. Her house, like most of the houses here, has huge verandas with shutters, stationary shutters & the whole held out with a stick. The houses reminded me of those in Mt. Pleasant & Sullivans Island. She is not at all good looking but very pleasant & a Washington girl. She had three of the most beautiful macaws I ever saw. They are the usual South American parrot & very varied in color. She also had two little pet marmosets, which are little monkeys which seem to be squirrels with monkey faces. Of course a dog & pet goat circulated around. We did enjoy the sandwiches & cake & milk as we were quite tired of ship & hotel food.

We arrived at San Ferdinando at about 5:30 A.M. & had breakfast at 6 so we could go ashore. This is almost on the huge estate in which Mr. Stewart is interested. He had two machines there to meet us & we motored thro' the village & five miles out to the St. Madeleine estate. They plant 10,000 acres in cane, but have 17,000 acres altogether. His company took it over, or rather bought it for 50,000£, not in cash but in shares. The place was in the courts bankrupt, & the courts refused the offer but the people of the island brought pressure to bear & made the courts consent to it. Last year the profits were £5 on every ten, whereas before the old company had lost $5,000,000 in 40 years, in fact had never paid. If the courts had not consented to the sale it meant thousands of people out of work for they employ 8000 hands, indentured, & several thousands more who do not live on the lands. While we were at breakfast he received a letter from the government offering them $1,500,000 for the entire crop, which he said was not enough but that he would accept it because freight was so high now & then the government could command 60% of the crop anyhow.

The plantation houses are large airy places & Mr. & Mrs. Todd most charming hospitable people. As soon as we said how-do-you-do we all left to go over to the sugar mill. I will not attempt to describe it for I remember very little except that the huge pile of brown dirt I saw being shoveled proved to be sugar! Of course there were the crushers, vats

for boiling, etc. The chemist is an American who gets a huge salary for being down here five months.

Mrs. Todd has lived for years on St. Kitts & says that there there is no mixing, the white having their own clubs & the colored never invited around socially, but that here it is quite different & quite a shock at first. One of the women at lunch was a mulatto, but very light. I got a nice sunny little sketch in Port of Spain [Trinidad]. Feb. 9th. Landed on the 7th, haven't time to write more.

*"Demerara" or Georgetown*
*Feb. 9th [1916]*
To Nell
It is quite the order of the day for us to get up at dawn, so Monday we were dressed hours before landing. Mr. Beebe's friends, the Hayes, with their two children, came down to meet us. Mrs. Hayes is a very charming little woman with soft brown eyes & grey hair. He is very gentile [genteel] looking, is a large rubber planter, having several very large estates making about 80,000 trees in all. They took some breakfast with us then piled some of us in the machine & took us to their house.

Georgetown is a lovely tropical city, of course swarms of Negroes, mulattoes & Hindoos, as well as Indians, but there seems to be a larger percent of white people than in Trinidad. Some years ago when Mr. Beebe was here, most of the streets had canals down the middle & the canals were filled with Victoria Regina lilies. Most of them have been filled in as it was decided that they were too unhealthy. The few streets which still have them are charming & I hope to get some sketches. The royal palms which you see on all sides are the most wonderfully beautiful trees I have ever seen. There is an avenue in the Botanical Gardens & in the park by the Sea Wall which are the most decorative avenues I ever saw. Tea at 4 o'clock when all the stores & places of business close, then all the world goes to the tennis, golf, or cricket club, or out driving by the Sea Wall or in the Gardens. The walk by the wall is beautiful but you mustn't fancy that the ocean is like that at Granada & Trinidad for it is not that wonderful color, but muddy, owing to the Orinoco River, Demerara River & others. No one goes in bathing here on that account, but it wouldn't faze me for I remember slipping around in the old tin bath tub on an inch of yellow Congaree mud!

I never met 4 men more considerate & polite than Inness, Mr. B[eebe], Paul Howes, & Mr. Emery. We miss Mr. E. dreadfully for he was always lending us something such as suitcases, raincoat, or was himself loaded down with our trunk. He expects to be in Surinam about six weeks & then come back here, being away from U.S. until July. Mr. Beebe is kind of offhand compared with the men I usually know, but it's only surface. Rachel [Hartley] & I both feel as if we know him better now & understand how to take him. I think that he considered us quite standoffish. However it probably did him good as he is used to having women make a dead set for him. Mrs. Mathews improves on acquaintance but has a tendency to take too much on herself when it comes to affairs in connection with the party.

Fortunately Rachel is the most even-tempered person I ever saw. As for me, I try to keep in the background as much as possible & refrain from making any decisions. All is new to

me so I don't care what they do. Rachel says that she doesn't recognize me! I have no idea if Inness & Mr. Beebe think that I take too much on myself. I am to help Inness primarily, & then Paul who is working on wasps & some other insects. Inness is working on the embryo of birds, making comparative studies of the growth of the bones in the legs & wings, an entirely new field of work. He will also study the development of the beak. This will require pen & ink outline drawings & some little color work, but not the finished kind Rachel will do. Inness expects to complete his study on this line while down here & publish the book.

Mr. Beebe seems to be a singularly unselfish fellow & so interested in pushing & helping young fellows instead of holding them back as most men do on these kind of trips. If a fellow strikes something new, the usual type quietly takes up the line himself & pursues it, getting all the glory & the real discoverer none. All he is asking of these fellows is not to use material in magazine & newspaper articles because that is the only way in which he can get the money back which he has put in the expedition. He has put every cent he owns into it.

Rachel has this class which she teaches for six weeks every Fall & spring at Charlotte Nolan's school in Va. This necessitates her returning in April, unfortunately just when she will be getting her hand in. Mrs. Beebe wants me to remain, as she doesn't want to be down here by herself & then I can carry on my part of the work.

I am the housekeeper, at least I have charge of the cook & the ordering of things. It certainly carries me back to the hours mother used to spend in the storeroom giving out things, for you have to keep things under lock & key.

We went to the Botanical Gardens Monday afternoon. They are next to the finest in the world Mr. Beebe thinks, says those in Java are the finest. At sunset the air becomes alive with birds & insects. As for the frogs they almost drown everything else. There is a little frog the size of a man's thumbnail which gives the most tremendous whistle for its size that you ever heard. There were loads of white & grey cranes going to roost & thousand of other birds. You heard kiskadee calling on all sides. They are called [that] from the call they give. Friday. Feb. 11th—Yesterday afternoon we had such a delightful time. Mrs. [Henri] Seedorf [wife of the German consul] & her daughters came for Rachel Hartley & me in their machine & took us to the Cricket Club. It was as English looking as anything could be, the beautiful grass with various tennis courts laid out & all filled with people playing. On the opposite side from the pavilion they were playing cricket.

At six o'clock we went to Bertha Hayes, where she was having a "swizzle party" for us. Swizzle is an awful bitter kind of cocktail they have down here & these parties are quite the thing here.

Demerara Swizzle:

  1 Swizzle glass Gin—
  1 teaspoon Angostura Bitters
  1 pinch sugar
  ½ swizzle glass water
  with plenty of crushed ice.

Swizzle all together in glass jug and strain through the fine strainer. Sufficient for 3 glasses.

She had all the elite to meet us & most of them were very attractive. I spoke of Sir Charles Major being on our boat when we came from Trinidad. Both he & Lady Major were there. She is quite a distinguished looking woman with the most charming cordial manner. Just as soon as these people hear I am from the South they seem interested at once. So few foreigners heretofore have ever known there was a difference. They are all keen to hear how I get on with the darkies & were quite amazed that my cook actually told me yesterday that I was being charged too much for chickens. Bertha tells me that Lady Major was very much attracted by Rachel & myself & is going to give us a bridge party. Sir Charles is Lord Chief Justice Kt. I shall present my card & self on Lady Cox in a few days. She's Miss Cushman's friend. There was a Col. & Mrs. May who were awfully nice. The men were quite taken with him.

Sunday, Feb. 13—Friday evening Paul & I took a walk in the moonlight. It was a glorious tropical night, deliciously cool & the stars much more brilliant than the stars at home. We haven't seen the Southern Cross yet because it's so low on the horizon early in the night. You couldn't imagine anything more beautiful than the dark silhouettes of the houses & royal palms against the deep blue sky with big masses of filmy clouds. Then all of this probably reflected in a canal. How I wish I could paint from memory. We heard some most absurd band music, in which the base drum must have mistaken his identity & thought he was carrying the tune. We followed it up & found that it was a dance some Negroes were having. They fairly shone with the perspiration & I am sure the odors must have surpassed China!

We were to have tea with Bertha so Mrs. Seedorf sent us there in her machine. After tea we went to the Sea Wall to hear the band concert & see the world. Then we took a beautiful drive outside the city where they have a bazaar every Saturday. It was a wonderful picture, the Hindoos in their wonderful colors & the Negroes, squatting in front of their wares or wandering in crowds up & down the road which was bordered with superb royal palms.

The two boys, Inness & Paul, were a scream. At best Inness isn't a shining light at functions, for he shuts up like a clam; the only thing which saves the day is that he is a handsome tall fellow. He was absurd trying to balance his tea cup on his 6 ft. of legs & being forced to drink the poison in the cup because Mrs. Hayes was right next to him. Paul had the daughter & said that he spent some awful moments trying to think up something to say but no inspiration, finally it came in the shape of a woolly dog which strolled into the room, & then he got launched & didn't know to stop & ended by giving the life history of nine dogs! About that time it was proposed that we walk around the garden & then go into the Park where the band was playing. We saw some wonderful orchids, & among them the very rare "Holy Ghost" was in bloom. There is the most perfect little white dove facing you that you could imagine. The flowers were wonderful. Mr. Hayes showed us all his laboratories & thermometers, etc. Such a time as we had roaring over the tea. Rachel distinguished herself by becoming effusive everytime she saw a woolly dog. We finally managed to wake from a lethargy & tore ourselves away.

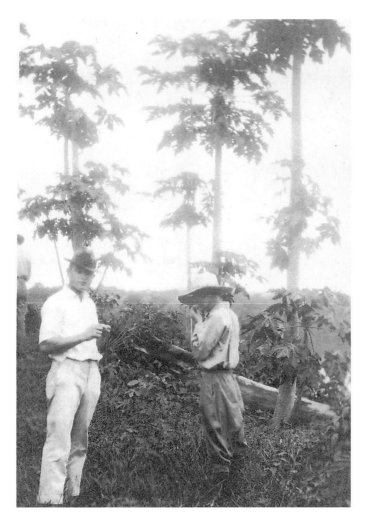

In British Guiana.
Courtesy of South Caro-
liniana Library, Univer-
sity of South Carolina,
Columbia

*"Kalakun [sic]," Mazaruni River, Essequebo, B. Guiana*
*March 1 [1916]*

To Nell

My idea of the tropics & jungle is absolutely different from my preconceived notion of it.
For instance there isn't a single mosquito on this hill & I have only felt 2 since being up here
& that was the other night in the valley when walking over to the Withers. We use nets to
keep off vampires. We have had such an absurd time trying to kill one, at least the men
have. They don't use nets in sleeping over in the sitting room but burn a lamp which keeps
the bats off. They decided that Inness' big toe was to be used as bait for he slept so soundly,
then the other two were to keep awake & kill the bat as he sucked or get a flashlight. Need-
less to say all three went to sleep. The next night Paul had the gun & the others woke when
the bat began to fly low. Paul was so sound asleep that they never did succeed in waking
him. In the evenings before going to bed Inness gets in my Berbice chair, which is half re-
clining, crosses his legs way above his head, arms himself with a flashlight & rifle, & never

kills a thing. The only one killed was one that fell in a corner & he killed it with the butt of his gun! It was not a vampire, however he skinned it. They haven't brought in any birds for me to skin yet but they left for the jungle at 5:30 A.M. today & he promised to bring me something to skin & to eat also. He really is an extremely good shot.

Inness & I worked on his heron series yesterday. I am surprised at the ease with which I do close drawing. It is very interesting work. I am afraid that we can't finish this series up here because there don't seem to be any blue heron, but lots of Ani.

Yesterday everyone elsewhere said it was very hot, but I got so cool when sitting down reading just after breakfast that I put on one of my new smocks. It gets warm after lunch & is quite close in our bedroom but I lie on a cot in the hall, where we have three. Paul got a very good picture of our lunch party for the Roosevelts & the room shows up splendidly. I will send mine on to you. Sam, the boy, had never waited on table before & he did amazingly well.

The Roosevelts left early this morning, Mr. Beebe going with them, hoping to return tomorrow.

Mar. 4th. Night before last when I was about to get in bed I heard the most extraordinary noises way off in the distance towards the jungle. I hung out the window & called Rachel. They were the howling baboons & it must have been 1½ miles away. When they are in a tree just over your head Will says it's the most terrifying noise in the world.

The most exquisite iridescent greenish-blue bee flew in today so I made a study of it, which was quite successful. I got quite the quality of color. It's about 1¼ in. long. Have also made some studies of flowers & succeeded in identifying them in the antiquated books on the flowers of French Guiana. It is so old that all the Ss are long & written in French. I shall have a time making any headway in Botany & it will probably end in my sending the specimen for the men in Georgetown to identify. Unfortunately I seem to be taking hold of the work better than Rachel, which is very discouraging for her. Of course my direct painting & drawing in the laboratory at college is a help.

Will Beebe came up yesterday & has been settling himself today. I have never seen a more energetic man or a more restless one. Inness & Paul left at 5:30 A.M. for the jungle & didn't return until 5 P.M. Paul declares he saw the Cock of the Rock which is a very rare bird & one which has never been seen down here.

Mar. 7th. Will Beebe was out in the bush today & came back with a male monkey (Capuchin). He was watching the troop for some time, there being about 5 females with young ones & several males. He saw something which he had never seen before. The mothers would go out on a limb until it began to droop then send a young monkey as far as his tail would allow, then would pick fruit & stuff his cheeks full then with a yank the mother would pull him back, he screaming & struggling with all his might. Then she would put her hand in his mouth & extract all the fruit, with the accompaniment of squeals & struggles of the youngster. She would eat the fruit & then send him out on another branch. His struggles would sometimes be punctuated with a sound box from the old lady.

Monkey is awfully good eating so Will suggested that we have him for dinner. After he was skinned I took him in the kitchen to see Anne about cooking him. She almost expired at the idea of cooking & eating monkey, never having cooked one in her life before.

Fortunately Sam came in just then & said he knew all about it that he would show her & eat all we didn't. Well this was just the occasion to get something up on Rachel, for Inness had eaten them in Brazil. We just had soup so we could have a good dinner first, then a warmed over roast came with the covered dish of stew into which Sam had slipped the uncooked hand. Will helped the dishes, so he helped Rachel to a little which she exclaimed over "It smelt so good." We all fairly held our breath. Will helped Inness next, pulling the black hand under some pieces of meat. What must Rachel do but spy this dark thing. "Oh, that's a gizzard, isn't it? Do let me have it" & make a dive for it with her fork. She picked it up & put it on her plate & then—if you could have seen her face!! "Heavens, what is this!" She fairly shouted. Needless to say we drowned her squeals! It really was awfully good & tender but I couldn't do more than taste this time for I had seen the skinned skull with the eyes still in.

We were to go on an all day exploring trip in one of the Prison Settlement launches with Mr. Fiere [sic; Harold Frére, prison superintendent]. However it's put off until Thursday. Saturday afternoon, Will, Inness, Rachel & I accepted Mr. Fiere's invitation to take a walk in the bush & have tea with him. The men took some guns & came back with some beautiful birds. I saw toucans for the first time. There is nothing known about their nesting so that is new ground. There is a lot of study to do on the macaws also. Mr. Fiere gave me a skin of a macaw & Rachel one of a toucan. We had tea at his house when we returned & such a spread of cakes & sandwiches you never saw. He certainly is a nice man & has a fine strong head. He is in charge of all the Penal Settlements in the Colony & is kind of a government inspector & controller.

Mr. Beebe is quite enthusiastic about my work. I shall do the flowers with the insects on them which light on them. We found a beautiful lily this afternoon with a beetle inside. We caught the beetle & will get the lily tomorrow to do. I am getting so interested in the botany. No one is much help, for Will is the only one who knows anything about it & that's not much when it comes to identifying.

*"Kalakun," Mazaruni River, Essequebo, Georgetown, British Guiana*
*March 3 [1916]*

To E. M. Robertson

We got to Georgetown three weeks ago this past Monday. It is a lovely city and was most unique a few years ago when most of the streets had canals down them in which Victoria Regina lilies grew, but the fool town council of Negroes decided to close them up so very few canals are left and none have lilies on them, however there are beautiful ones up in the Botanical Gardens. The place anyhow is very picturesque and paintable, but we didn't get a chance to make any sketches between fear of sunstroke and social engagements. I had a little spell of the heat so have been careful ever since.

I am housekeeper because Rachel has never had any experience nor has she had any dealings with Negroes. My cook is a nice old Negro mamma and a little black kinky-head girl waits on her and on us too. I detest having to lock up.

The most charming people whom we have met are Sir Charles and Lady Major, who gave us a card party, and Mr. and Mrs. Weiting. There are several "Sirs" and "Ladies" so I

am quite at home with them now, particularly as one of the Ladies has a touch of the tan. Of course Negroes go almost everywhere and you fairly step on them at Government House, but there is a circle in Georgetown which will not admit them. We are far from social life, now being 60 miles up the Essequebo River just where the Mazaruni, Cuyuny and Essequebo join.

"Kalakun" belongs to Mr. George [B.] Withers. Just the type of an aristocratic English-man, very handsome too, and of course has lived in the East and Africa. His wife is a delight-ful little woman and the daughter of 8 years, Grace, most gifted musically.

The only people near us for many miles are the 4 white people living at the Penal Settle-ment just across the river. Mr. Withers has lent the plantation to us, it being about 20 min-utes walk from his place, "The Hills," which is plainly seen on the top of a hill. We are on a high hill looking straight down the rivers and have a wonderful view. When you look up you see the beautiful blue hills in the distance.

They have been kindness itself in lending us their coolies and everything else so we are settled already since arriving last Thursday and actually gave a swell lunch on Monday. What do you think of me entertaining [former president Theodore] Roosevelt and his wife [Edith Carow Roosevelt] in the jungle? Roosevelt is a great friend of Mr. Beebe's and really came this far down because of our party being here. Of course Mr. Beebe had known the Withers when he was here before so that accounts for their being so generous. They at once offered to invite the Roosevelts up as we really had no room for them to stay at "Kalakun." They arrived in Georgetown Saturday and left on a special Government boat early Sunday morn-ing with Mr. Beebe and Mr. Norman [*sic*; Sir Walter Egerton], the Governor General of the Colony.

We just about fainted when Will came over Sunday afternoon and broke the news that they would all be over to lunch Monday. We all walked over after dinner Sunday evening and met them. "Teddy" at once claimed relationship with me through the Barnwells and Elliots, and Mrs. Roosevelt and I talked about Cousin Sally Coles and various other kin of mine in Virginia. I think that he is physically one of the ugliest and most unattractive look-ing men I ever saw, but very virile and forceful. I never saw anyone so well adapted for cari-cature. She is very attractive.

Our dining table for our lunch for 12 people was made of three rough boards nailed to-gether and put on horses. Some of the party sat on boxes as there weren't enough chairs to go around. Our doilies were pieces of white cloth I had bought in case of emergency for we couldn't find our paper ones anywhere. Our center piece was a lovely Hindoo square which toned in beautifully with the red of the bare boards and the pink wild flowers were in a dark pottery Indian bowl Rachel had picked up. The color scheme was charming. Of course Roosevelt was on Rachel's right and I sat next to him. They were all amazed at the lunch Rachel and I managed to get up. We had veal, rice, butter beans, pumpkin, asparagus and mayonnaise, rice pudding and canned pears. You see everything has to be ordered from Georgetown and fortunately I had not touched the leg of veal and had plenty of canned things. I have never seen people easier to entertain and they "spent the day" in true old time fashion? Roosevelt not leaving until dark, but Mr. Withers took the ladies and us for an auto ride. He has fine roads all over his rubber plantation and to Bartica, the nearest village.

Mr. Withers has something like 17,000 acres in his estate and hopes to put a good deal of it into rubber. Some of his trees have just begun to be tapped so the other day he took me around. When five years old they begin tapping them and the flow increases each year. The bark is removed from a groove about an inch wide and a metal trough put in the angle to catch the liquid which flows into the cup. Every morning they use a small grooved instrument to remove the hardened liquid collected on the bark and to expose a fresh surface. The liquid is collected and put in pans of water, where it hardens into round curd like biscuits. Then it is rolled through rollers and then dried. By that time it is ready to ship to the factories.

Our place is most ideally situated for scientific work. We are within a mile of the jungle and between it and us is a stretch of undergrowth of two years standing. All these islands in the rivers and the jungle are practically unexplored, only the river's edge being known. Already our party has discovered birds and insects which have never been studied. Absolutely nothing has been published on the flora so I am pretty much at sea trying to do something with it. Mr. Beebe wants me to identify the various trees and plants with which they may find connection with the animals and insects.

In the evenings Inness gets in a reclining Berbice chair, crosses his legs about over his head, arms himself with a lantern and gun and lies in wait to kill a vampire. He hasn't succeeded yet but we get showered with shot. The house is a large place all open together at the top and lots of birds fly around all the time. It's delightfully cool with a glorious breeze all the time. Of course it's hot in the sun. Not a single mosquito! Nets only to keep off vampires. Do write and tell me everything.

*"Kalacoon"*
*March 31 [1916]*

To Nell

Both your letters arrived March 15th & Mar. 8th, & were much enjoyed. Also received a letter from Miss [Helen] Hyde & she's at Mrs. [Elizabeth Allston] Pringle's [plantation Chicora Wood] near Georgetown & likes it so much. She had a delightful week end at Emily's & Julius seems to have made a hit in spite of his inquiries about her bath!

Paul found a Toucan nest & they have succeeded in falling the tree & getting the eggs intact. This time it was a green tree so it didn't break all to pieces. The birds had built in a hollow & the two eggs are white with brown spots. It's the first time in history that a nest has been found & described. They have cut the tree in sections & are going to ship it to the N.Y. Museum where they will reconstruct it. Needless to say they are much elated. The birds are not the species Inness found but have green beaks.

Rachel & I always enjoy our days at the Withers for it is good to be civilized & have things dainty & clean. We have decided that we are ready for formal life again.

Thursday—Monday evening Sir Walter & Lady Eggerton [*sic*; Egerton, governor general of British Guiana] came over to inspect the laboratory & seemed tremendously interested. She is a most intelligent woman but is the haggard dried-up type of English woman. They knew William Copeland Crawford in Africa. She told me of the more horrible way of killing people which the Negroes have out there. They take the victim, tie him down in the

path of the ants, put sugar in his mouth & leave a trail to the nest & leave him. In 24 hours he is completely skeletonized! It gives me the all overs even now to think of it. Mr. [Harold] Fiere says that in Borneo he has come across some of creatures half-eaten. These scientists put out birds & animals to be skeletonized & it's amazing the rapidity with which they do it.

Will says that it is very necessary to have someone to do the painting as this is the beginning of the most important season—that we are not in the way, besides he prefers some woman because otherwise the other men will get entirely too lax. It's very interesting painting here & the scientific work is also interesting. When the men go off on trips of several days I will stay with the Withers.

Georgetown. April 8th—It was a beautiful day Friday when we came down the river. We started at seven & didn't get in until 5:30.

This morning he [George B. Withers] came in his machine for Rachel & me at 7 o'clock & motored 12 miles out along the [word missing] to one of the five sugar plantations. He phoned the evening before to the Manager, a friend of his, & asked him if he could bring us up to paint, also asked that he have some of the Cooley [Chinese coolie] women dress up in their holiday raiment. It is a fine old big house with a lovely garden, where Mr. Brassington lives. He is a tall fine looking lordly Irishman, seemingly gentile [genteel] people. We met his father, sister & brother & they were cordiality itself. Mr. B. amazed me by knowing all about South Carolina & Wade Hampton. He took us out to the Indian village where we got two good sketches, at least beginnings.

I need more paints. Do look in the closet next to the piazza, on left hand side of door, lowest shelf, you will find some small paste board boxes in which are tubes of paint from Fredericks, N.Y. Please have them packed in a small wood box, securely & send to me at once. I would order direct from N.Y. but they were entirely out of French paints so you know they have none now. Do this at once. Send all you find.

*Kalacoon*
*April 26th [1916]*

To Nell

If you could have seen me on my way to Kalakun! I had to take the ferry across the river before I took the train, then finally changed to the steamer. I had my black suitcase, brown cloth-bag, two umbrellas, hat in paper bag, fan, sketch box, wet sketches, tin box & purse.

How Eliza, in fact all the children would thrill over the zoo! We have a huge bushmaster, 8 ft. 6 in. It is the most poisonous snake in the forest. Will, Donald [Carter] & the Indian caught it the other day. We also have a sloth which crawls & climbs all over creation. Its fur looks like a very coarse grey & white fur, in fact it's as soft as can be. I am surprised that its fur hasn't been used for something. The deer is too darling. It runs all around now but still feeds on a bottle. We have an anteater & lots of birds. Also a laba which is a kind of rodent. We don't get much meat but the Indian brings it in. This week we have had a deer & birds. We frequently have agouti, which is a rodent & tastes like rabbit. Sometimes by this plan we have nothing at all in the shape of meat so have to use canned things of which I keep a good supply. Inness & Paul have gone over to Agolaste with the Withers

to fish. It seems that when they dump the refuse from the Linch factory in the river that a lot of big fish come to the surface so they hope to catch some & I hope they will. Will & Gertrude have gone out along the path the convicts have been cutting. Mr. Fiere suggested that Will apply to the Government to get a squad of convicts to cut a path through to the forest. He consented, so for two days 20 convicts came over & cut with remarkable rapidity. Our men became quite attached to some of the convicts. In fact Will enthused so over one "trusty" named "Hope" that he declares he is going to employ him when he gets out in a month's time. He & his beloved "Hope" were walking down to the stream & this Negro slipped over a bushmaster knocking a leaf up on his nose. The snake was so exactly like his surroundings that the Negro didn't see him but Will did, coming along just behind. "Look Hope at what you almost stepped on!" The Negro got perfectly limp with fright, fell against a tree & turned white. We can get to the forest in 20 minutes now & have a shady path. The forest trees are beginning to bloom now & Will wants me to do some of them. I wish you could see the hairy caterpillars about these days. I have done some of them. We are getting some of the insect's life history fairly complete. For instance, caterpillars, plant it feeds on, pupa & final butterfly or moth.

I had a horrid attack of malaria but am feeling fine & looking well. I seemed to have recovered in a week. I had fever for about a week & had two big dosings of quinine. The second time Will took me in hand & gave me some of the most extraordinary homemade pills you ever saw. I've had lots of fun saying his medicine didn't cure me, that it was the result of mine, & he gets so absurdly put out & of course we all howl.

Paul & Will were in the forests not long ago & were charged by a jaguar, which they have the nerve to announce, took him for "deer." Needless to say the rest just about expire now when the incident is mentioned. And "dear" & "deer" are touchy words now.

My fever made me miss the mangos in new leaf which I was anxious to paint.

I came down with Mrs. Mathews & Will because I couldn't be up there alone. I also wanted to paint some trees. I shall be down until Mrs. Ewers goes back with me. Mrs. Mathews sails next week. The trees are beautiful now, but I like an ass forgot my sketch box which contained all my paints & brushes, but remembered what I was afraid I would forget, my easel, panels & rags! However I telegraphed the boys to be sure to get it on the Wednesday steamer.

Mrs. Mathews gives a most interesting account of her trip in Suriname. She took trips all around up in the gold country & came in close contact with the bush negros there. These Negroes were slaves about a 100 years ago. It seems that French gun boats keep coming down & levying taxes on the sugar planters there. They had to pay in proportion to the number of slaves they had. So to avoid this, the planters would turn loose their slaves in the bush & let them shift for themselves until the boat left. The result was that the Negroes found they could get along on their own resources, so many of them never returned & very soon reverted to the savage state. She says their villages are very interesting & they practice all kinds of weird charms & superstitions. Of course they go practically nude. They became so savage & made so many raids on the plantations that the Government confined them to a certain section & had a line of patrols entirely across the colony to keep them back.

I wish that you could hear her describe the various costumes the different peoples wear. There are Hindoos, Chinese, Negroes, Indians, & Lovanders, which are Negro & Indian. She says the women wear the most wonderful head handkerchiefs you ever saw & each design has a history. Very often it commemorates some scandal in the colony! Frequently some superstition, or named after some person. Each woman has hundreds of them.

I have decided to sail on the "Guiana" which leaves here about 18th May, but you can't count on these boats sailing or being sure of getting a seat. I decided I didn't care to risk having fever again, though I feel fine & look well now. Dr. Roland says he doubts if I had another, but I'm ready to go home. The chaperone question is difficult, however Mrs. Beebe would solve that when she comes the 1st of June, but I don't believe I will hit it off with the old lady. She's a real N.E. Yankee. The men hate to have me go as my work is very much needed but I'd rather leave when they regret it than leave when they are inclined to have me go.

I received Margaret's [Margaret Law's letter], a week later George's & now yours, May 2nd. I am delighted to hear how well you & Edmund are doing. For heaven sakes go to bottles the minute your milk begins to fail you.

*From Helen Hyde*
*1138 N. Dearborn St., Chicago*
*April 28 [1916]*

Your letter came finding me very homesick for your beautiful South but doubtless I shall readjust myself! I came up from the South with as much money as I took down!!! Never was more surprised in my life & people were all <u>so</u> good to me & I did enjoy it, so its me for the same land next spring—that is if the Southern work has any success at all here, but it will take me so long to make the prints I may not know for some time.

You <u>ought</u> to see Alice Smith's 1st block print & Sabina Wells.' I was as proud as punch of my pupils.*

And now to your picture I would be delighted but Miss [Frances] Dill gave Miss [Caroline] Sinkler that very identical print! I am so sorry[;] is there any other you think of? <u>I</u> gave her my "Mexican Coquette." Yes both plantations were lovely & I hope to go back to both next year. Mrs. [Anne Wickham Porcher] Sinkler's [Belvedere] and Mrs. [Elizabeth W. Allston] Pringle's [Chicora Wood].

Mrs. Sinkler just hated to have Emily [Wharton Sinkler] marry but she wrote she was such a happy joyous bride it made it less sad for her—as for Chicora Wood! I was there a month.†

You must be having a wonderfully interesting time. I <u>had</u> decided on Provincetown but later developments lead me to suppose I should be here in Chicago until the end of July & then to Colorado. I think I need those mountains more than the sea though I did expect to go.

---

* Alice Ravenel Huger Smith (1876–1958) became a distinguished artist, and Sabina Elliott Wells (1876–1943) was a founder of the Newcomb College Art Pottery.

† Emily Wharton Sinkler wed Nicholas G. Roosevelt (1883–1965) in early 1916.

*Kalacoon*
*May 14 [1916]*

To Nell

Gertrude Mathews got off last Tuesday accompanied by an electric eel 5 ft. long, & a bush-master 8 ft. 6 in. I am sure that she will have a most entertaining trip up as Mr. Davidson was going too. We caught the Government steamers at 10:30 the same day & came on up here. The Ewers [family] came along to Mr. Nickles [*sic;* Nicholls]. He is the young fellow who turned up for Sunday tea. He is a nice chap of about 24 & a son of the painter Rhoda Holmes Nickles [*sic;* Nicholls, 1854–1930]. I met her once at Cecilia Beaux' [1855–1942]—she does watercolors.

The rainy season has started so it rains a part of every day, but the nights are beautiful. The flowers are beginning to come out a lot & Paul is beginning to smile because all kind of bugs are beginning to come out.

*Barbados*
*May 24th [1916]*

To Nell

We finally left Demerara Monday at 6 o'clock and of course didn't know until the boat got in whether we had passage or not. Will, Nick and I came down on Friday and had a fine trip down. Our last ten days at Kalacoon were delightful, so jolly and almost cold. When sitting out in the evening, one sweater was hardly enough and a blanket a bit too light at night. One day Mrs. Ewers, Mr. E. and I took a walk along the back trail which the convicts cut into the forest trail, which in turn went into the Colouri trail, then the Agabost road, finally across the Withers plantation. We were armed with a butterfly net and the bottle to kill them. All through the forest the most beautiful blue butterflies fluttering everywhere. First Mr. Ewers took the net and enjoyed making a spectacle of himself and needless to say, not coming within an inch of one. Then I, clothed in my pants and smock, leapt around like a fawn. Can you picture me catching butterflies on a light fantastic toe! But such a heavenly walk.

I really hated to leave Kalacoon. Inness amazed me by giving me his finest and biggest howling baboon skin! I shall have it tanned in New York. I also have the boney box in the throat with which they make that awful noise. Paul gave me some prints of his photos, but I can get prints of any I want when they return to New York in the fall. I have gotten to know Will a great deal better lately and he has given me some of his articles in the rough to read and been discussing his book, which of course makes my interest in this expedition much greater. He has gotten very much interested in the botany and likes my plates hugely, in fact so much that he is thinking of not putting these 30 plates of mine in his present book but to get me to come down next year and go more fully into it as I could be better equipped from the botanical standpoint and publish a bigger thing. Many of the plants and trees are unclassified and few plates made of any, in fact it's an absolutely new field when it comes to publication.

Nick is making such a nice traveling companion, sighs with relief that he is with a woman [to] whom you don't have to make love all the time! I am afraid that he will not be

able to restrain himself much longer if we continue on our lovely rides and evenings by the breakers. He will have to make love to me! He is really too absurd about women. I was amazed and he insulted when I found out he is 27 and not 23, as I thought. The "Guiana" got to the Barbados only this morning and will leave tomorrow at 11 o'clock so we are here for the night. Fortunately we engaged a car as soon as we landed, which proved to be about the last in town for today is one of the awful bank holidays. You remember them in England? Two other Americans wanted to go but couldn't get a car so asked if they could come with us, so they shared expenses. We motored to a high cliff overlooking the shore and another part of the island about 12 miles off. It was a beautiful view and reminded me of Polée in Honolulu.

I am taking up a lot of animals, among them the Cock of the Rock, "worth $450 in N.Y. alive!" I hope to heavens that nothing happens to it. Of course one of the stewards has charge to oversee him.

*On board S.S. Guiana*
*May 30th [1916]*

To Nell

Nick & I had a neck breaking time catching the steamer in Barbados. The boat doesn't dock at any of the islands, but you go ashore in row boats which fairly swarm around the vessel as soon as she anchors. The reason for that is because of the hurricane certain parts of the year. Just as soon as one is seen coming, the vessels steam out to sea until it is calm again. Speaking of that, this boat was in port on the other side of Martinique when Pelee erupted some years ago. But another of this line was in harbor at St. Pierre & in five minutes the boat went down, only one man escaping. The town was completely destroyed, only one man left alive & he a prisoner in an underground cell! We passed St. Lucia in the night & Martinique early in the morning.

Pelee looked beautiful with the clouds waving over the top. These French islands are really more interesting than the English because the buildings & costumes are more foreign.

Our next stop was at Dominica. We found out that we could get horses & take a lovely trip up in the mountains to a lake, so I dug out my riding skirt & Nick, Mr. Greenwood & I went ashore dressed for riding. It was a beautiful trip & particularly interesting by the fact that this virgin forest was so different from that around Kalacoon. On all hands you saw masses of pink & white begonias like those Mrs. Eison sells Xmas! There were a lot of other wildflowers. It was a steady climb most of the way & very rough, however our ponies were very surefooted. Nick changed into his bathing suit & had a swim & then joined Mr. G.'s & my boat party on the lake in a most unsteady dugout. We climbed up to a point called Roselin View where we got a most wonderful view from the divide. We got aboard just in time for dinner, but we didn't leave until about three o'clock. We passed Guadeloupe in the night.

The next stop was St. Kitts, which is a beautiful island & where we had a delightful trip. We landed about 9:30 & hired a machine & motored twelve miles to an estate owned by a Mr. Davis. There we expected to get information about climbing Mt. Misery, the extinct volcano. We found that that would be impracticable but we could climb to the crater & see

the lake. It wasn't a very long climb but a very steep & difficult one. It was the only point which was at all like my preconceived idea of a tropical forest. It was mostly the most beautiful tree ferns & cabbage palms with a few huge trees. We had to scramble over huge lava boulders covered with green moss. The lava fields are so different from those around Fuji. In Japan they seem so recent. The men went ahead, but I kept one of the Negroes & took my time; consequently, I wasn't the least bit knocked up. In fact the 20 miles ride at Dominica never knocked me up a bit, not even a little stiff. I'm surprised because I haven't had any exercise in months. The water all through these islands is wonderful in color & Nick goes in every time he has a chance regardless of the shark myth. In every harbor he goes in about twice. So as I was behind them, they made use of the extra time by a dip in the sea. The motor ride back along the coast late in the evening was beautiful. We were too late for dinner on board so got a make-believe supper at the hotel.

We left about nine o'clock. Early in the morning we passed Santa Cruz & got to St. Thomas at about 2:30. We had two hours ashore. It is a lovely little island with low mountains & the charming little town climbing up the sides. It is a Danish possession & the U.S. & Denmark are having a discussion now about our buying it.* We saw several swell officers. This is where you get fine Panama hats & I invested in one. I would have gotten you one if I had been sure you wanted it. You get them for ever so much less than at home. That was our last island, our next stop being New York.

It's been a joy having Nick along, in fact he has made the trip for me. He's been fairly eaten up with curiosity to find out my age & didn't until today when the purser very tactlessly asked me to fill out some papers before him! I hope the shock hasn't been too great for him.

June 4th. Arrived this morning. Will leave for home either Tuesday or Wednesday. Will telegraph.

* The United States purchased Saint Thomas, Saint John, and Saint Croix from Denmark in 1917 for twenty-five million dollars as part of a Caribbean military defense plan.

*From Bertha Hayes*
*5 Main Street, Georgetown, British Guiana*
*July 18 [1916]*

I would have given an old pair of shoes to have seen you and Nick and Mr. Greenwood sailing up 5th Ave. with all your traps loaded on the old four wheeler, and the Berbice chair crowning the top! It certainly must have looked English! I'm glad you reached home without anything happening to the "Cock of the Rock," for you must have felt as if you had a great responsibility. You spoke about Mr. Greenwood eventually thawing out—but I'm sure you could make him, if anyone could. He has a perfectly dear wife in London and when she visited here two years ago we all fell in love with her. Nick evidently didn't present you with the small diamond before reaching N.Y. did he?*

* This letter was forwarded from Columbia, South Carolina, to Provincetown, Massachusetts.

# 7

*Provincetown's Art Colony in 1916*

AFTER HER BRITISH GUIANA EXPEDITION, Taylor returned to Provincetown. There she studied painting and printmaking techniques under the Swedish artist Bror J. O. Nordfeldt and enjoyed the companionship of a variety of artists. The summer of 1916 in Provincetown was likely the second great leap in her artist's training. A year earlier Nordfeldt and others had experimented with a new form of woodblock printing, white-line block carving. Also called "Provincetown printmaking," this new method radically changed the character of woodblock printing.

Taylor also may have profited from her exposure to the landscape painting styles of Nordfeldt and Charles Webster Hawthorne. Her sinuous, highly colored watercolors demonstrated a style and choice of subjects similar to the works of these men. Finally she met William and Marguerite Thompson Zorach. This husband-and-wife team of artists was trained in Paris in the latest trends in modern art and keenly interested in textile arts. Marguerite Zorach, in particular, created a variety of fiber art works, including batiks. They may have introduced Taylor to batik making as a modern art form.

In spring 1917 Taylor was planning to accompany Beebe on a second expedition to British Guiana. However, her plans changed radically by the end of the summer. The United States joined the Allied forces on April 6, 1917, when it declared war on the Central Powers. By the end of the year, Taylor embarked on another great adventure, service to her nation in the Great War. ∽

*From Florence E. Boynton*
*[Azabu, Tokyo]*
*July 7th [1916]*

Picture me in sack cloth and ashes. Of course you can storm away but what's the use. Please "mum" just so knows we's all human. I did thank you a thousand times mentally for that very attractive leather case you sent by Mr. Swenson. Now please forget all my shortcomings and love me again. And don't tell Miss Hyde. I shall be a worm by the time her letter is finished.

Now that you have promised to love me as much as ever I can babble away.

Tokyo News In Brief

Camilla and Stanhope have just completed the Orient tour and aren't they headed again for it from Kobe. Camilla says that Washington was much pleased with his first report. Isn't she in her element flitting from place to place? She sent from Soeul [sic] a wedding gift for Hasu [Hasu no Hana] Gardiner who was married [to Shirley Hall Nichols] June 20th.

The wedding was like the usual Tokyo one—about three hundred guests. An awning over the garden enlarged the accommodation considerably. Miss Myers who was one of the four bridesmaids announced her engagement to Mr. Lloyd during the course of the afternoon. They will be married in September and live in Kyoto.

Every one is running off to the hills. Karuizawa is as popular as ever. I spend the week ends there till school closes July 13th. The Hokkaido is to be my destination when I set out on the 15th. From all I hear two weeks will suffice and then off to Karuizawa, Nikko and Ikao.

There is an entirely new set here. It centers around our new naval attache's [Frederick Joseph Horne] wife Mrs. [Alma Cole McClung] Horne. She is very gay and entertains extensively. You should be here for her jolly functions. They have a large house near Igura Katamachi. Mr. Swenson is a great friend of theirs.

Miss Flynn is just the same. This year I have had a Miss [Gertrude] Emerson and a Miss [Elsie F.] Weil with me.* We have the little house by the side of mine as the No. 25 extension or I had better say annex. The girls are Chicago Varsity graduates doing journalistic work out here. China received them royally. Even Yuan [Yuan Shi Kai] shook hands with them and a further invitation was extended to them to dine with his fourteen sons—he has twenty-eight children. Three of their big articles have already appeared in the N.Y. Times. This winter has been a very interesting one for me at No. 25. Miss Emerson was here before for a year with me in 1913. Perhaps you saw their coronation articles—Travel and ——? Now they are getting material for Jap[anese] articles. Don't tell me you wouldn't have given your eyes to have been present at a luncheon here yesterday—three charming geisha our guests. An article on the geisha is soon to appear from their pen. Ma! Wouldn't Tokyo be shocked at the thought!

Am I down to your commission? I suppose so. Don't you think for one moment I haven't been on the hunt ever since your letter arrived. The war has sent every thing sky high and some how it is very difficult to find beautiful patterns these days but I trust the ladies will like what I am sending. Rachel Hartley's N.Y. address has never come. I am sending hers Main P.O. N.Y. so please notify her.

The account goes on separate sheet. Do give my love to Alwehav [Keziah Hopkins Brevard's antebellum home in Richland County, S.C.] and keep a goodly share for yourself.

| Miss Hartley | | Mrs. Robertson | 12.50 | Mrs. Taylor | |
|---|---|---|---|---|---|
| 1 Kimono | 9.00 | 1 Yellow and blue | 10.00 | 1 Winter | 9.00 |
| Com. 20% | 1.80 | Com. | 4.50 | Com. | 1.80 |
| Postage | .48 | Post. | .72 | Post. | .48 |
| [Totals] | ¥ 11.28 | | 27.22 | | 11.28 |

I have a stunning light one for Mrs. Taylor but the lining is being dyed to order. The Lantern fillers will be in that pkg.

* Gertrude Emerson Sen (1893–1982) was a pioneer journalist in Japan and India. She and fellow journalist Elsie F. Weil founded *Asia: The American Magazine on the Orient* at the start of the twentieth century. Emerson moved to India in the 1920s and wed Dr. Bashishwar Sen. She then wrote books on India. She was the sister of Alfred Edwards Emerson.

*Provincetown*
*July 25th [1916]*

To Nell

What an awful experience you must have had. I, too, am thankful that nothing happened to George and that William [Cain] was saved [by George Taylor from drowning in Dent's Pond]. The picture of the children is too cute for words and splendid of each. Mariana is most certainly having her picture taken! As for sugar lump Edmund, I should love to have him to hold but Lily [the nurse] quite near to take him when he begins to spit.

I had to fly around this past week and get my frames for my pictures of Guiana which I sent to the exhibition. They really looked fine when they got in the frames, now I am waiting to see how they look among the others. I took them to [Bror J. O.] Nordfeldt's studio for him to get some idea of my work before I began with him and I was amazed at his perfectly sane criticisms, just about what Chase would have talked about. I am launched in the new method and find it quite thrilling. I first draw the picture in carefully, making a careful study of the subject from the standpoint of line and space composition; then I put in color in more or less flat tones. I really feel that I will get a lot more out of it, certainly in the matter of composing pictures. I can hardly wait for his criticism to see what he says about the ones I have done. I was quite thrilled over a still life I did today. Rachel [Hartley] is pulling up tremendously in her work so she has decided to stay until Aug. 15th. Sarah Cowan* can't come until the end of August and I haven't heard from Katherine Woodrow yet.

I wish that you could see Zorack [*sic*] and his wife [William Zorach, 1887–1966, and Marguerite Thompson Zorach, 1887–1968].† They both not only paint like the primitives, but actually succeed in looking like them. He has long frizzy hair and wears no socks! She has short greasy black hair. The baby is a healthy little brown savage.

* Sarah Eakin Cowan (1875–1958), a native of Hendersonville, North Carolina, was a miniature painter. Some of her silhouettes or black profile paintings were exhibited with the New York Society of Independents in 1917.

† A Californian, Marguerite Thompson Zorach studied art in Paris and became involved with the fauve movement, which included Henri Matisse and Georges Rouault. The fauves, or "wild beasts," used bold, incongruous colors to emphasize their rejection of traditional representational painting. She wed the painter and sculptor William Zorach in 1912 and became a textile artist. She was making embroidered tapestries and batiks in New York City and Provincetown as early as 1916. While in Europe, Zorach wrote travel dispatches to her hometown newspaper, the *Fresno Morning Republican*. Her columns were collected and published as *Clever Fresno Girl: The Travel Writings of Marguerite Thompson Zorach (1908–1915)*. Zorach may have been an early influence on Taylor to take up batik making.

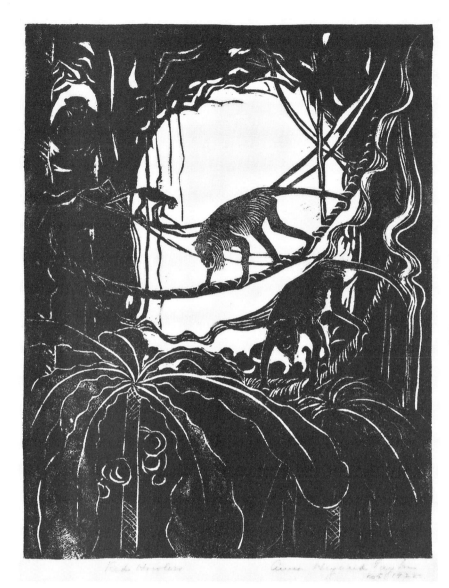

1. *Red Howlers*, No. 5,
1928. Courtesy of
Edmund R. Taylor

2. (*below*) Cut stem
and batik. Courtesy
of Edmund R. Taylor

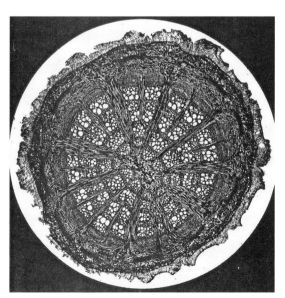

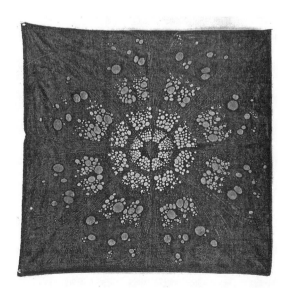

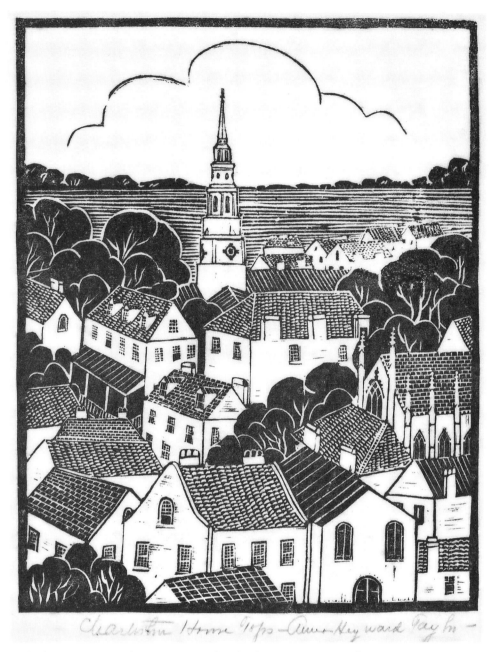

3. *Charleston House Tops,* by Anna Heyward Taylor (American 1879–1956).
Work on paper. © Image Gibbes Museum of Art / Carolina Art Association

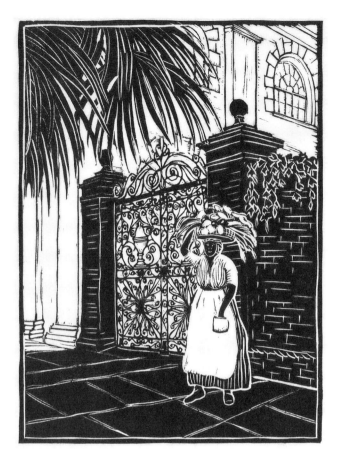

4. [Woman with a Basket on Head], by Anna Heyward Taylor (American 1879–1956). Work on paper. © Image Gibbes Museum of Art / Carolina Art Association

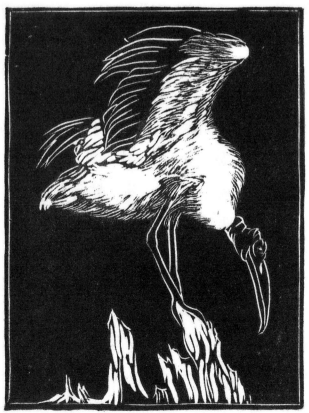

5. [Wood Stork (Ibis)], by Anna Heyward Taylor (American 1879–1956). Work on paper. © Image Gibbes Museum of Art / Carolina Art Association

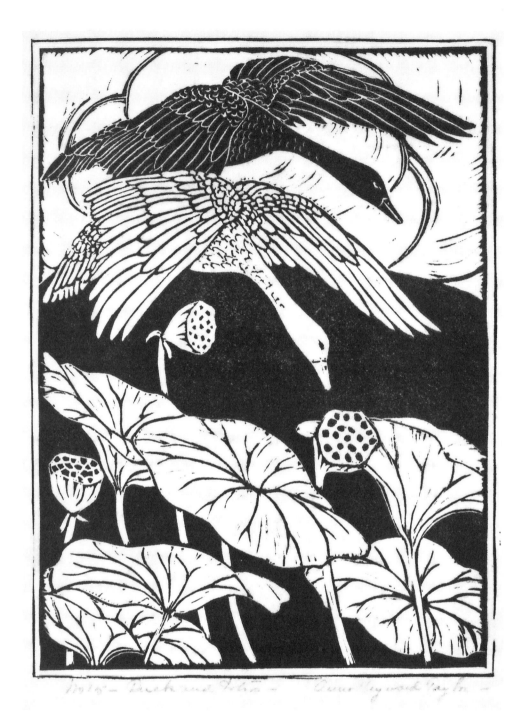

6. *Duck and Lotus,* No. 15, by Anna Heyward Taylor (American 1879–1956).
Work on paper. © Image Gibbes Museum of Art / Carolina Art Association

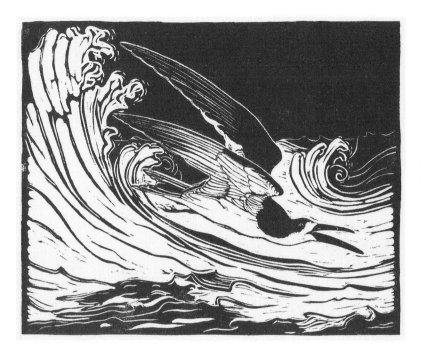

7. *The Skimmer.*
Courtesy of Edmund R.
Taylor

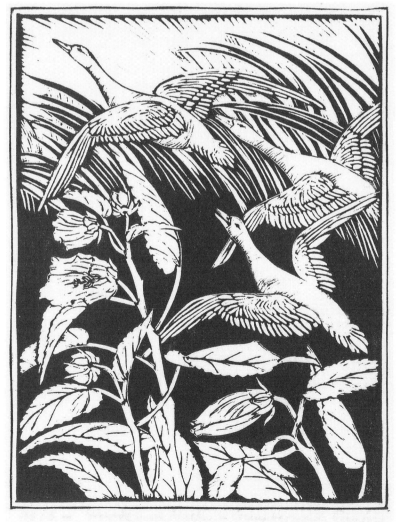

8. *Duck and Mallow,
No. 13.* Courtesy of
Edmund R. Taylor

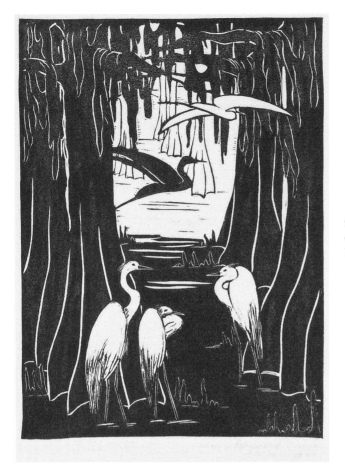

9. *Herons in Swamp.* Courtesy of South Caroliniana Library, University of South Carolina

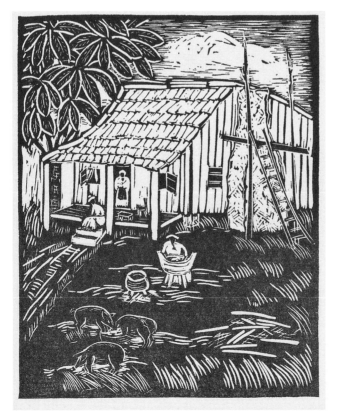

10. *Cabin Scene.* Courtesy of Edmund R. Taylor

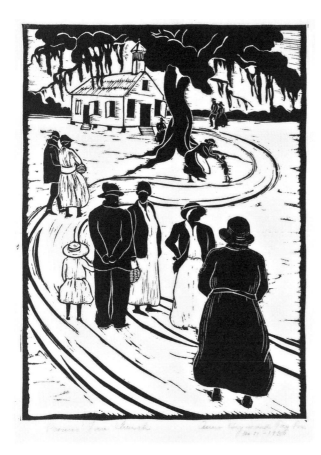

11. *Promis' Lan' Church,*
No. 11, 1930. Courtesy of
Edmund R. Taylor

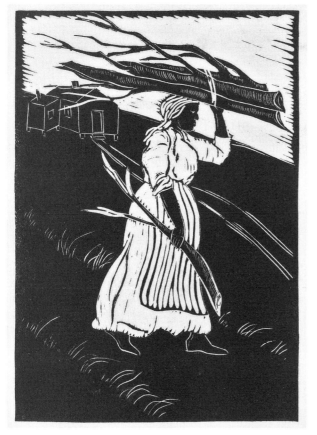

12. *Lightwood.* Courtesy
of Edmund R. Taylor

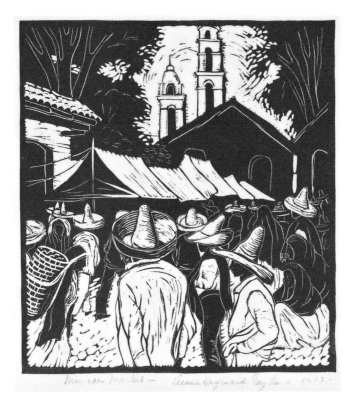

13. *Mexican Market,* No. 13. Courtesy of Edmund R. Taylor

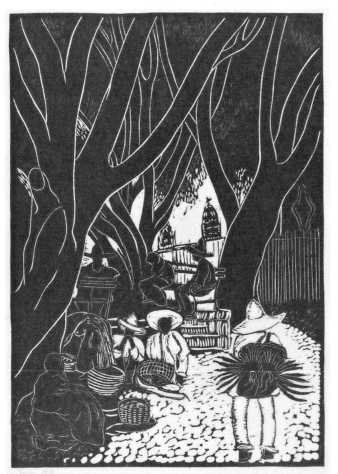

14. *Taxco Market,* No. 3. Courtesy of Edmund R. Taylor

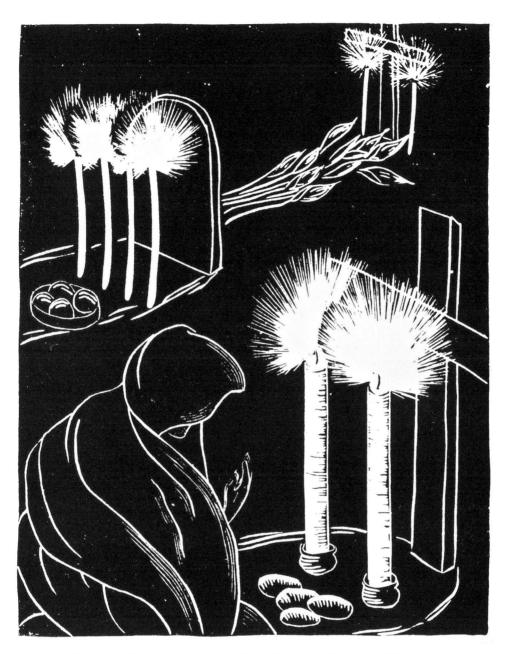

15. *Mexican Graves.* Another state is *Day of the Dead,* No. 4, 1937. Courtesy of Edmund R. Taylor.

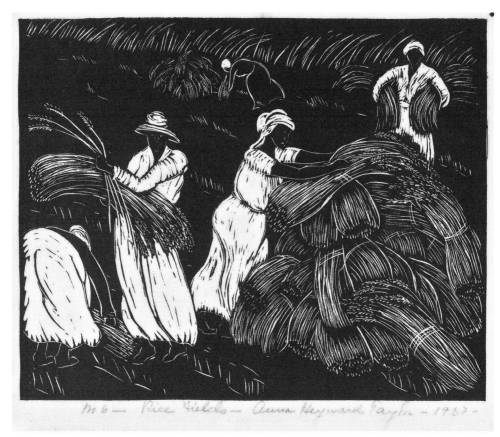

16. *Rice Fields,* No. 6, 1937. Courtesy of Edmund R. Taylor

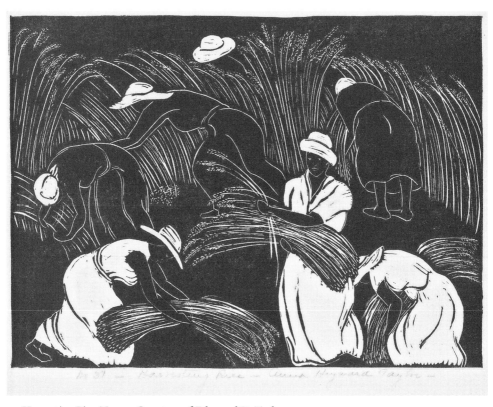

17. *Harvesting Rice,* No. 37. Courtesy of Edmund R. Taylor

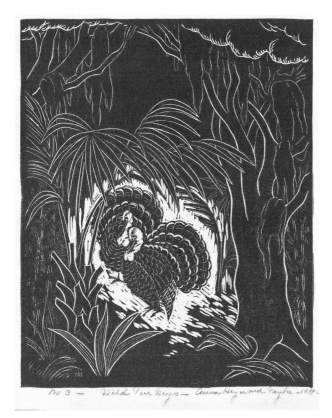

18. *Wild Turkeys,* No. 13, 1939.
Courtesy of Edmund R. Taylor

19. (*below*) *The City,* No. 1, 1939,
"For Helen Semple," a view of
Charleston, by Anna Heyward
Taylor (American 1879–1956).
Work on paper. © Image Gibbes
Museum of Art / Carolina Art
Association

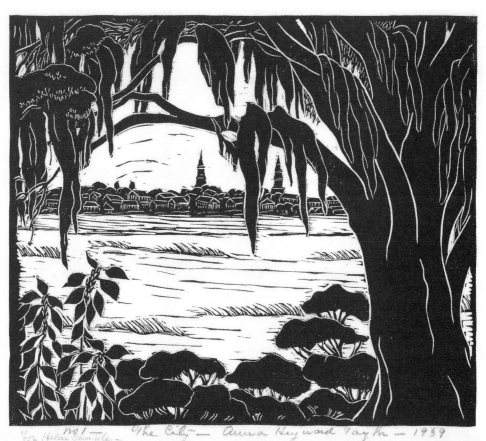

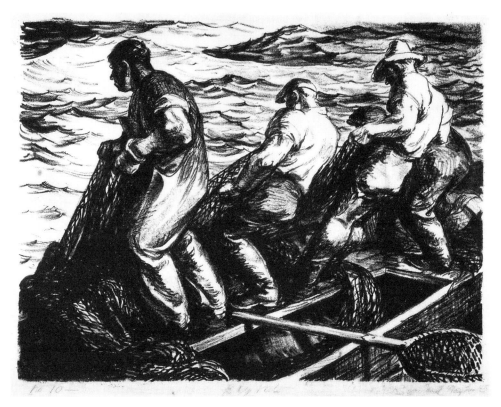

20. *Big Nets,* No. 10, [19]45. Anna Heyward Taylor, American 1879–1956, *Big Nets,* 1945, lithograph. Collection of the Columbia Museum of Art, 1984.30

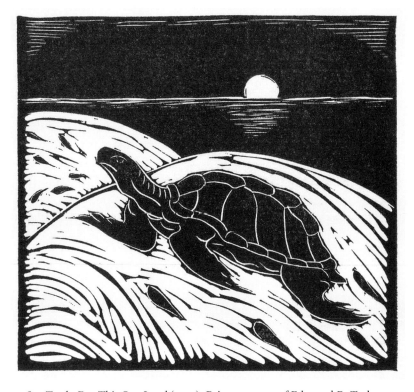

21. *Sea Turtle.* For *This Our Land* (1949). Print courtesy of Edmund R. Taylor

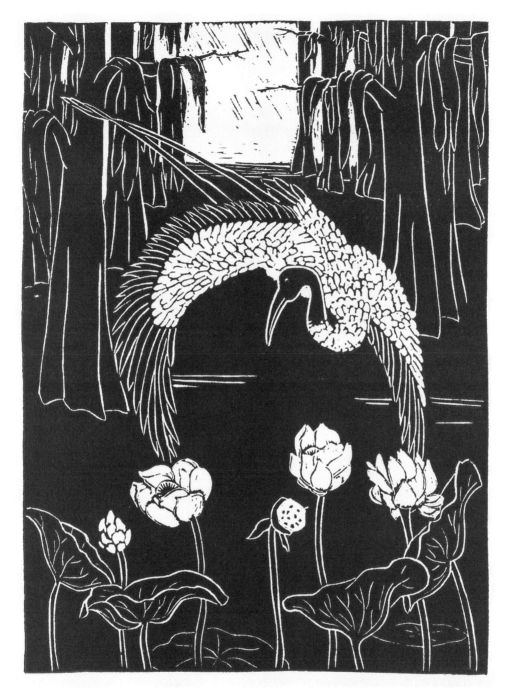

22. *Wood Ibis.* For *This Our Land* (1949). Print courtesy of Edmund R. Taylor

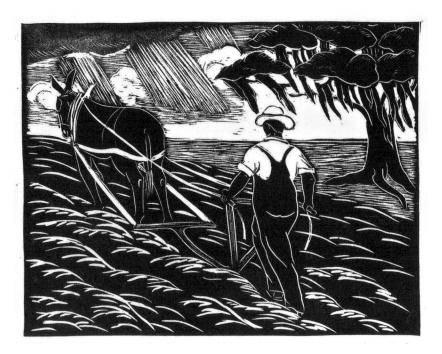

23. *The Coming Storm.* For *This Our Land* (1949). Print courtesy of Edmund R. Taylor

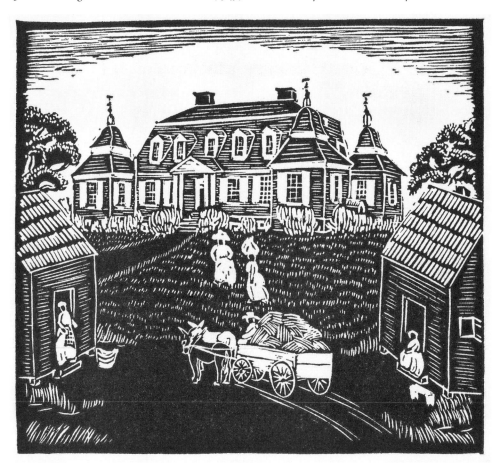

24. *Mulberry Castle.* For *This Our Land* (1949). Print courtesy of Edmund R. Taylor

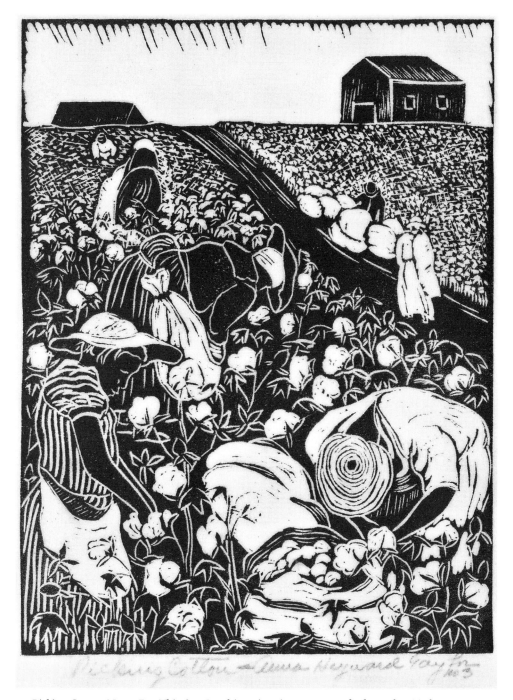

25. *Picking Cotton*, No. 3. For *This Our Land* (1949). Print courtesy of Edmund R. Taylor

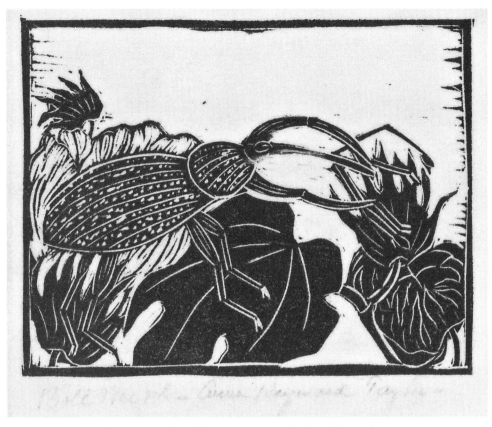

26. *Boll Weevil.* For *This Our Land* (1949). Print courtesy of Edmund R. Taylor

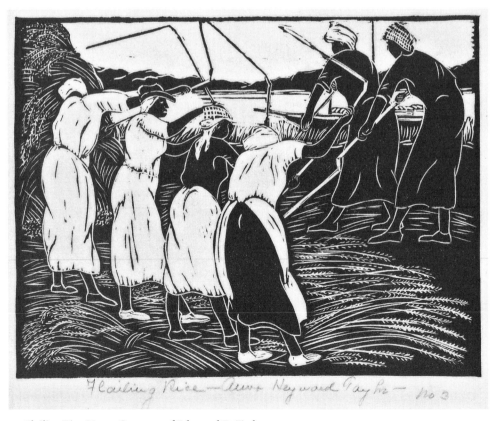

27. *Flailing Rice,* No. 3. Courtesy of Edmund R. Taylor

Highland Light, Cape Cod. "Highland Light, Mrs. Chisholm, Mrs. Fox, Mr. Ketcham, Jack Fox, Margaret Law, Mr. Fox." Courtesy of South Caroliniana Library, University of South Carolina, Columbia

*Provincetown, Mass.*
*Aug. 1st [1916]*

To Nell

I am having the most thrilling time working with Mr. Nordfeldt and he seems to think that I am getting hold of things right along, and I certainly feel that he is helping me. I am now trying to compose pictures intelligently, and trying for solidity and rhythm of line. I also paint in a lower key so I can get much greater richness of color. He, of course, knows about the scientific relations of colors, about which I know nothing. All my friends are quite thrilled over my studies, come to view them and are always keen to know what Mr. Nordfeldt has said. I know that you will faint when you see them.

Frances Ward finally sent me my lovely yellow sweater. Rachel had such a curious experience, a propos of the sweater. She was on the train going down to Southampton, after seeing me in N.Y. after I landed; she was taking a little monkey with her. Of course he was chattering as she fed him with a banana which caused a lady to become interested and speak to her. Rachel explained that it had just been brought up by a friend in South America and also mentioned that she had been there this winter. The lady remarked that a great friend of hers was making a yellow sweater for a girl who had been in South America this winter, a Miss Anna Taylor! Of course the two bubbled over that. Frances was to have come down

this weekend but has put it off to my disgust because I wanted Rachel to meet her. Then I know we can't have as much fun or be so congenial a crowd when Sarah Cowan and Eliza Rhett are here. I wanted her to meet the Nordfeldts and Websters [Edwin Ambrose Webster, 1871–1978] whom I am to have in for tea Friday.

We had tea Sunday afternoon which was a huge success. There were too many people for chairs and cups so they sat on the ladder, camp stools, steps and waited turns for cups. We had George Elmer Brown[e, 1871–1946] and his wife, Mr. and Mrs. Giberech [Oscar Giebrich?], the three Sands, Miss Thomas, Miss Dodd, Miss Ryerson [Margery Austen Ryerson, 1886–1989] and an awful possum friend who looked at the ceiling and talked like [Charles Augustus] Stoddard on Russia! Also Suzanne and Janet, then May Marshall [May Chiswell Marshall, 1874–1959] and her friend came in to call, also Miss Simpson. Of course they all insisted on viewing my new Art sheets. Eliza writes that she wants to come the 15th so I wrote to her to come & if it is too close quarters here that she can board somewhere. She may be able to go in with May Marshall who has a house this year. Sarah C. comes at the end of Aug. but I haven't heard from Katharine Woodrow yet.

Rachel says to tell you that she regrets so not coming to Columbia this winter so she can meet you and Eliza. She will be at Fox Croft in charge of the Alumni House.

I heard from Will Beebe today. They sail Aug. 15th, getting to N.Y. Sept. 1st. He wants to have a reunion about Sept. 10th. I don't see how I can stand the expense of a run down, yet I hate to miss it. [George B.] Withers has offered him [Hills Rubber Estate at] Kalacoon again and he evidently expects to accept.

*From Will Beebe*
*[August 1916]*

I am glad Greenwood turned out all right. [George] Withers has blamed us all, but he repeats on everyone he mentions, and everyone laughs at his gossip. He has been very nice to our face, & promises the house for January if we wish it, and will let my fixing it—paint, a water pump, new stairs, etc.—go as rent. So it looks as if we could afford the launch. He is to let us put our stuff in one of the rooms & lock it up.

Don't forget our reunion in early September, say about the 10th if everyone can be there. We will have a good crowd, and if we give one of our recently inaugurated comb concerts we shall probably be arrested!

*Provincetown*
*August 9th [1916]*

To Nell

Mr. Nordfeldt likes my things, thinks that "I take hold of things very intelligently." I feel that he is helping me a lot. Rachel is crazy to take from him but has to leave next Monday, but is going to take one of my studies with her to Virginia next winter & will try to work along the same plan. She needs it badly.

I expected Frances Ward here last weekend but she couldn't come for some reason. I had her tea anyhow because they were all people I wished to ask. We had Mr. and Mrs.

[Margaret Doolittle] Nordfeldt, Mr. & Mrs. [E. Ambrose] Webster, Miss Thomas, Miss Dodd, Suzanne, Janet, Miss Roosevelt, Miss Kissel, Elizabeth Howland, Katherine Crither [*sic;* Catherine Critcher, 1868–1964], Miss Kerr [*sic;* Myra Musselman-Carr, b. 1871] & her mother [Penelope Burgess Musselman]. Miss Kerr has her Modern Art School [of New York] & is a very attractive unusual looking woman.* Of course she dresses in a curious becoming way. She is from Lexington, Kentucky. Rachel wanted to ask Mrs. Robinson & her queer daughter but I told her not to ask her this time but another because they simply wouldn't fit at all. Mrs. R[obinson] was a Biddle from Philadelphia; is considered a freak by her family. She is quite pleasant but this type of society woman who takes up "Art" & proceeds, by design, to be nice to the poor "art student," some of whom own autos as well as herself. You can picture how she fitted in with these people who were all working seriously. Picture my amazement when up walked Mrs. R[obinson] and Miss R[obinson], most obviously having been invited. Rachel had quietly gone ahead & asked them & not told me because I hadn't wanted it. Of course she sat right in the middle of the "Moderns" & bored them to extinction. I was so provoked with Rachel.

The piazza looked lovely. We had the hanging straw ferns (like those I got last year) hanging with a green bowl with Nasturtiums in one, & a dark blue rose with marigolds in the other. The calendulas in the boxes looked lovely. On the table we had a little bowl with wrinkle flowers. Mr. Nordfeldt was so enchanted with it that he is doing a picture of it.

 * Myra Musselman-Carr, Bror Nordfeldt, William and Marguerite Zorach, and Edna Boies Hopkins taught in the Modern Art School, which held classes in New York City and Provincetown.

*Provincetown*
*August 15th [1916]*
To Nell
Rachel left on Monday & I will miss her awfully as I am alone. Gertrude Mathews wrote that she was coming on Saturday but hadn't turned up yet. I expect Eliza [Rhett] almost anytime & Sarah Cowan the end of this month. I have had poor luck with my guests. First Ray [Taylor] couldn't come. Then Frances Ward failed me but wants to come later. Now Helen [Hyde] & Mrs. Robinson were to come down later on their own hook.

I enclose a letter I received from Will. I also have a long one from Bertha [Hayes] but will wait until Gertrude [Mathews] sees it before sending. Inness [Hartley] writes that Mrs. Dale says the wrong thing to everybody if possible & that her old maid friend was not built for bush life. Her stunt seemed to her to get lost in the jungle. One day the boys let her stay out in an awful tropical rain before going out to hunt her. Withers talked horribly about Will & everyone at Kalacoon, yet has offered the place again! But more remarkable still Will has accepted it! He will paint it, put in staircase & for rent.

Katherine C[ritcher], Elizabeth H[owland], Rachel, & I took supper Sunday with Miss Thomas and Miss Dodd. We almost ate ourselves to death. Miss Boynton finally wrote & has mailed some of the kimonos.

*From Florence E. Boynton*
*Nitta Yama [Tokyo]*
*Sept. 17, 1916*

I have just learned what my cliff was called in the days when Hikawa shrine occupied it. Nitta is from Nitta Yoshi Sada, the Moses of Japan who planted that huge fir tree in my miniature garden. Do you recall the stone tablet by the old stump. It has an inscription by Nitta on it. Yama of course is mountain. But Crow's Nest, though a bit modern seems more suitable. It applies to the human as well as to the bird.

We were at lunch table when KiKuKisan passed over the budget of home mail to me. I had not read but a few lines when I said to Gertrude [Emerson], You must meet Miss Taylor. Isn't she fine to receive me with open arms despite all my faults. And let me say Anna that you must meet her father Dr. [Edwin] Emerson, for years connected with the Art Institute at Chicago. He is [a] man of about 55 and has the spirit of one of 25. Private theatricals calling for ancient stage settings are his joy and he never fails to take a role. [Gertrude's sister] Edith Emerson has carried off several of the prizes offered at the Art school at Phila[delphia]. She is now at work on the mural decorations of the little theatre there. Gertrude sails from here Sept. 30 so you will see her in N.Y. if you are there this winter. Address to Miss Margaret Emerson, 955 Madison Ave. She knows all about you and wishes to know you.

I am quite excited over the idea of having your friends for my neighbors. Just say the word and Miwa-san will have the house, servants and all ready at any time. Miss Hammond cellist and Mrs [Eunice] Tietjens poet had a fine little house for a month with Ueno and Yone san as servants.* But let me warn people that they cannot live on the budget published in the Japan Supplement of the London Times cutting out the ineradicable squeeze it could not be done on their figures. Imag[in]e three people living a week on meat 70¢, fish 65¢, vegetables 65¢ and I must not fail to mention that they were always prepared for a guest. I add that I am thankful I was not the guest. Living here is the same as at home but more expensive than in the South I have been told. But you know all this from your own experience. Just let me hear soon that you and your friends are on their way.

I cannot tell you how I swelled toad like when your warning came to me through Mr. Swensen. I always answer my correspondence and comply with my friends' requests. The Kimono are on route. Just now I got out the letter and fished for the order for the third Robertson kimono. You are right—it was there under a second (b) but Anna dear, own up—Don't you agree with me that a little Crown Bossy as the girls call theirs because [James] Boswell took down [Samuel] Johnson's great thoughts would bring joy to friends hearts when they received your delightfully refreshing missives. Miss [Elsie F.] Weil who collaborates with Gertrude will no doubt be in N.Y. later in the winter. She is a stunning type for a portrait. Fair with jet black hair and very rich coloring. Did I tell you that the girls hobnobbed with all the people of China. They will tell you about it.

You must come back to do Taiwan with me. For the love of us'ens three don't tell Miss Hyde we dined geishas chez nous. Her sense of propriety would be shocked beyond all repair.

Anna, you did write me a most interesting letter about the scientific expedition and if I did not mention it forgive me. But don't go again; instead come here.

Camilla [Sams] is at Manila but will soon be back so I shall hold the letter. Tokyoites are as you left them. Oh but Miss Myer is engaged to Mr. Lloyd missionary of Am. Episc[opal] church. They were to be married this month but he had a stroke and was confined to his room all August. The doctor advises postponement. It seems he is not strong and has had one severe shock after another. She was with him and his mother at K[yoto]. I saw Hokkaido for the first time this summer. It is very uninteresting. The month of August I spent at K[yoto].

Miss Flynn is just the same. Her China trip was such a financial success last year that she is going again. Mr. and Mrs. Kennedy are going so it leaves a way open to her to take the two months off.

The last page to business. I understand Mrs. [Helen?] Robertson wanted something very nice by sending $15 for I thought 2 kimono. But, anyway, Anna, tochirinien has so mounted in price that I think raw silk is better for the price.

Miss? Morse wrote me for samples and as you recommended to her I felt like making my custom of buying only [on] receipt of money but then on second thought I was sure you would not like it. The fact is I have been obliged to make the rule for self protection. Do tell Miss Mrs. or Mr. Morse how sorry I am.

| Two kimono are off. | Cost $12.00 each | |
|---|---|---|
| | 2.40 com[mission] | |
| | .36 Post[age] | |
| | 14.76 | |
| | 14.76 | |
| | 29.52 | |
| | $14.76 | |
| Received | Dispersed | |
| $5 | Hunt | 5.64 |
| 15 | Rob[ertson] | 13.86 |
| 10 | T. | 5.64 |
| 10 | | 14.76 two just sent |
| $40.00 | | $39.90 |

The colors this season are very vivid. Tochirinien is so high that I thought it better to get silk for the little differences. Habutai silk is in such demand in America that the dealers are short. Miss Flynn is buying in Pekin. Mrs. [Bernard] Leach lost her mother. She is going back to England with the three children to be with her father a while. Mr. L[each] is coming here to do some translating with an artist Mr. Yanagi.[†]

* Eunice Tietjens Head (1884–1944) was a poet, journalist, and novelist. She was a World War I correspondent in France for the *Chicago Daily News* and associate editor of fellow Chicagoan Harriet Monroe's *Poetry* magazine for twenty-five years.

† Yanagi Soetsu (1889–1961) was a Japanese cultural philosopher and founder of the Mingei Movement, a folk arts and crafts movement similar to those under way in Europe, Great Britain, and the United States in the early twentieth century.

*From Bertha [H. Hayes]*
*45 Main Street [Georgetown, British Guiana*
*ca. October 2, 1916]*

You & Rachel certainly did give us a shock when you sent us the lovely luncheon kit for our motor car. I wrote to Rachel right away, but not knowing your address—that is—whether you were in Provincetown or the South, I thought I would wait & perhaps receive a card from you. You girls certainly outdid yourselves to go and select such a charming gift for us. I really was dumbfounded! It is so complete, & as I wrote to Rachel, we shall feel that our lunches must be pretty fine to be worthy of the case we carry them in. Now you must come back to Georgetown & help us use it. It surely was very good of you to send us this complete & lovely case. I really cannot thank you enough. Your letter made me realize you must have been having a very jolly good time at Provincetown and how fine to have had Rachel & Mrs. Mathews [Gertrude Mathews] for visits. I'm glad for Mrs. Mathews' sake that her husband died as he must have been a constant source of sadness & anxiety in her life. I do hope such good things for her book. The title sounds mysterious. "Treasures" might mean so many things, and that in itself ought to help sell the book. You may have seen Paul or Inness or Will Beebe by this time, and they might have told you all about the Ark for next year. It was most amusing to hear them talk of all the plans for housing their guests & receiving people from shore and the proper costuming of the inhabitants on board. The Admiral's hat, and the Middy blouses & sailor caps for the boys—all this and more. Sam and the others to be rigged out in true Arkish toggery—Shem, Ham & Japheth as the owners. I believe there will really be some excitement in the neighborhood of the "Splash." They sent us such a beautiful invitation in the name of Messrs. Shem, Ham & Japheth for a visit to the more or less good ship "Ark Eopteryx" for the period of next year's flood (tide), and addressed it to Chief Stewardess B. H. Hayes. Well, I wanted to hear more about some young man who figured conspicuously in a view of the new art exhibition and by the shock he got when Rachel took him to see a late version of an Adam & Eve picture. Think of a modern young man being shocked at such a picture. It must have been very funny. Do you think Rachel is having an affair on? She is killing t'aint she.

My butler, Jane, has just gone on a holiday, by request, and I have my other fine old butler back again. She was with me for a long time when I first came to the colony and is splendid I think. She always had the delightfully artistic sense of arranging flowers properly. I could forgive many things for a virtue of this kind. I told her this morning that I hadn't a flower hardly in [my] garden, but I felt sure she would bring in the two or three there & make a pretty table decoration. Mrs. Weiting has been at home for the past three weeks, not very well. She had a slight operation and while at first she got on splendidly the wound had to be opened again & later on the second time. She is about again, but does not look very well. Mr. Weiting, too, has had a bad cold & influenza. Do you remember the swizzle party & dance I took you to at the Murray's one evening? Well that was the announcement party for the young lady's (Dorothy's) engagement. She was married yesterday—a very large wedding! Ruth Laing is to be married next Monday at St. George's Cathedral.

*From Bror J. O. Nordfeldt*
*135 MacDougall St. New York City*
*[ca. November 20, 1916]*

My dear Miss Taylor, Your letter which came several days ago has been layin[g] unanswered so long because I have been so infernally busy with the Theater. I have been making all the sets and I am also playing in one of the plays. Just as your letter came one of the plays we were to produce was hastily taken off and another substituted—giving me two days to make an entirely new set. It was awful.

I'll not be able to send as many as one hundred prints to you but I will send about fifty— matted of course—not framed. And they will be on hand on the fourth.

Your commission is allright of course. I usually pay more and if sales come so much the better, if not well we might have to take it with a bit of philosophy. I judge that you were right busy yourself putting things over. I hope however that you'll have better luck than I have about having time to paint. Since I came to town I have not painted at all. I have been everything but an artist.

Provincetown Players were a huge success. We have about 900 associate members, which pays us right up to the end of the season and all of us were pleased of course but also desperately busy. Mrs. Nordfeldt is the Secretary and there is a steady stream in and out of our rooms, all day long. I wish that you might have a chance to see it for yourself.

The prints will leave here early next week and I hope that they will get to you without trouble.

*From Helen H[yde]*
*53 West North Ave. [Chicago]*
*November 29, 1916*

Yes I am alive & I am going to prove before the New Year that I am to all my friends. Even my family have gone without news.

Don't know why, but just snowed under that is all! & yet I go from morning until night.

I think just as I begin to enjoy life here I shall be trooping off South again for I hope to start south early in March. It seems silly just as I am settled but I do want to get a lot more southern material as I didn't get enough to make a really sunburnt[?]! & don't look at me reproachfully but none of the things I did bring are yet on copper & wood. Next year 1918 I shall stay at home but this year 1917 I wish to come south so there!!!

I'd love to peek at you & the Sinklers [of Belvedere Plantation] have very kindly asked me there. I do want to get a whack at that wonderful [illegible word]. I wish we should be there together. But mostly I am coming for as long as possible with Mrs. [Elizabeth Allston] Pringle on her [Chicora Wood] plantation. I do hope nothing will turn up to prevent.

Some of my prints owing to scarcity have gone up with the price of eggs. Among them this one I am sending but as you asked about it before I [illegible word] you shall have it at its then price [$]7.50. I only mention it in case any one should see it in your possession & ask the price. It is now $10——& may go higher but I think not for a while as I found an unexpected small lot of them in the bank! the other day.

I'll tell Miss [Bertha E.] Jaques. I shall see her tonight. There is some prospect of her coming down with me in March to give a talk on etching at Charleston & it may be she thought she might do the same in Columbia.

If you haven't said anything of the sort & she does come seems to me it would be well

If [illegible word] at her but I don't know. You see she only mentioned Charleston to me.

What a wonderful experience you did have in S[outh] A[merica]. I have fully forgiven your absconding for I had a perfectly beautiful time without you—so there!!

I [illegible word] those children are lovely. Your sister in law sent me the sweetest picture of herself with her chicks & I have no doubt your sister Nell is a duck too. Your people were all so lovely to me & you can't imagine how I enjoyed it all. I think it is that of course [that] lures me from all that ought to hold me here but then all my family want me to go so it is all right. I am going to spend Thanksgiving & Christmas vacations with my sister in the country & must go out this minute for stuff to paint my radiators. You know my sister Mrs. [Mabel Hyde] Gillette on whose account I came up to Chicago & lives this winter in the country. Just as I go to housekeeping we all think it a most original plan. But—you see it gives me a place to stop in the city.

*From Inness Hartley*
*344 W. 87th St., N.Y.C.*
*Dec. 7, 1916*

Your note came this morning. When Will told me the other day about asking you to go down with Miss [Persis] Kirmse I asked him about a chaperone. He was positive that it would be alright as long as there are two of you and I think so too. He said he would write to Lady Egerton to get her sanction believing that to be the best way to cut the ground from Whethers [*sic*; George B. Withers] for he would be the only one who would think it amiss. If you think it best to write to her you had better ask Will to do so at once as if the idea came from you. As for an actual chaperone I shouldn't think it any more necessary this year than last for everyone there knows the conditions. There will be other people with us, besides, for a good part of the time. Proff. Osborne and Miss Osborne will spend quite a visit with us beside other members of the Zool[ogical] Soc[iety] with their wives. At least that is the plan at present, though where we will put them is a question. Probably it will mean that all the men of the party will sleep in the lee scuppers, whatever they are, or down in the hold, soothed to sleep by the gurgle of the bilge water, as the good ship strains at her cables.

Persis Kirmse is a big husky English girl with a hand like a foot.* Have only seen her once or twice so don't know her well at all. She talks about one word a minute—twice as slow as I do—but seems to be a decent sort of girl without much pep. Judging from what I have seen of her would say that she is not particularly romantic by nature—but you never can tell. At any rate she seems to be 100% better than Miss Parke though I doubt if she will be much run after by the men of Demerara.

As an animal artist I think she is very good and as seen from a book of clippings appears to have quite a reputation abroad. Can tell you nothing more about her. If you should happen to be in N.Y. this winter perhaps it would be a good idea to look her up.

For the past month I have been at the Park every day but have seen little of Will. He seems to have graduated from there and is making a close study of the life in Bohemia—Wash[ington] Square—and other places, propounding many theories to the world in general. I wish he would get busy and not blaim [*sic*] our late start in March on his old Pheasant Monograph.†

* Persis Kirmse (1884–1955) was a British painter and etcher known for her depictions of pet animals. In the 1930s she published illustrated books on animals depicted in the works of William Shakespeare. This letter was addressed to Taylor at 1019 Gregg St., Columbia, South Carolina.

† Beebe published volume one of *The Monograph of the Pheasant* in 1918. Three more volumes appeared in the 1920s.

*From W[illia]m Zorach*
*123 W. 10th St. [New York*
*ca. November 29, 1916]*

I received your letter & was very glad to get it as I had lost your address. Also I am awful[l]y glad you can wait until January for the embroideries. I was afraid that I had told you I would let you have them in December. The Crafts exhibition here closes January 1st and I can let you have the things by the 5th or so. I will drop you a postal or let's say that I'll send the things from here the 6th of January. We have been awful[l]y busy lately. I hope you like it at home & Mrs. [Marguerite Thompson] Zorach joins me in wishing you very joyous & fruitful winter. P.S. [Our son] Tessim sends his love, he's growing wonderfully.

*From Helen Hyde*
*53 West North Circ[le, Chicago]*
*December 15 [1916]*

My dear Miss Taylor, Your note just arrived minus the check. The envelope was so tightly sealed & bears no mark of having been unsealed that I think perhaps it was mailed by mistake before the check got in. I send this off in a hurry as you can stop payment of the other check in case it was in.

That is nice to hear about the Sinklers. Yes, I do want to go there very much. It was a most delightful experience—Thanks to you.

Last year every one said I was much too early coming South so this year I am putting it off until March. It will be hard getting away then as my house will be barely finished. So many details & work always interrupting. I shall be disappointed if I don't see you this time either. Miss [Bertha Evelyn] Jaques tells me if she goes it will be in January because she will have to combine Savannah & Charleston.* It would be well if she could come to Columbia too & it might be easier all around if she could. I don't know her business arrangements. She said Savannah was willing to bear half the expense but not all. Charleston wanted her but didn't think they could spend any thing. Miss Anne Sloan was writing to her. You might write to Miss Sloan. Just went to telephone Miss J[aques]. She is writing to Mr. Miller of Charleston who is [illegible word]. Terms $25 for talk & Ex[hibition] & expenses but all four places could divide on share[?].

She is surely going to Atlanta in Feb. If you are interested write directly to her. I think you would be pleased as she is a very clear speaker & goes all over the country doing this. I suppose her Ex[hibition] couldn't stop but will only be [there] for the time she was there very short. Her address: Miss B. E. Jaques, 4316 Greenwood Ave., Chicago, I[llinois].

\* Jaques corresponded with Alice R. H. Smith regarding woodblock printing and with Motte Alston Read (1872–1920) of Charleston about collecting Japanese prints.

*From Bror J. O. Nordfeldt*
*135 Macdougal St., N.Y.C.*
*Dec. 17, 1916*

The package of etchings arrived safely—also the letter with the cheque. Many thanks for your interest and kindness.

I am awfully sorry that Kahlo behaves so like a Jew (he is a Jew). I have never known him to be as rude as that. When I see him I'll rub it in—and I am glad to know about this. Of course it does not hurt me financially at all. The Kahlo people own all the copies of the New York series. Still it would have been only decent to send them—would it not?

I can just see you stirring up your town. Mrs. [Gertrude] Mathews and I were talking about it the other day—dragging the poor unwilling public into art, when all it wants is to be left alone wallowing in its tea and muffins.

*From K. P. Swenson*
*Tokyo*
*Jan. 13, 1917*

I find as I look at my stack of unanswered [letters], the way to stop writing letters entirely is to wait for time to reply. Your first I remember was put off because you asked a quick question, demanding prompt action. But I find that your answer was taken care of by another party—Miss Boynton—and she did gloat over it.

And now I might be tempted to wait some more or until the arrival our unique Jack Reed and perhaps [his wife] the no less renowned Miss [Louise] Bryant so that I could tell you about them and what I could do for them.\*

I have sent your South America pictures before me—a very interesting looking lot of people you were with.

\* John Reed (1887–1920) and Louise Bryant (1886–1936) were journalists and supporters of the 1917 Russian Revolution. Among other books, Reed wrote *Ten Days That Shook the World* (1918), and Bryant was the author of *Six Months in Russia* (1918).

*From Will [Beebe]*
*92 Fifth Avenue [New York City]*
*March 10, 1917*

The trip is off. There is no certainty of the steamer sailings & Inness & I are both going in for aviation as there seems no doubt of war. I am bitterly disappointed. We shall probably

take two short trips to Florida & Labrador if we elect to go to France. Be sure to let me know when you come to N.Y. & don't give up hope for another year.

*From Helen Hyde*
*Chicora Wood, Georgetown P.O.*
*March 20, 1917*

I arrived here yesterday & it is lovely. Peach trees alack somewhat passé but everything else lovely.

You would better make up your mind when you are coming as Mrs. [Elizabeth Allston] P[ringle] can only take four at most. If you came about April seventh you & Miss Dill would have that big front room with a divided[?] room opening out—two beds & suppose Miss Watson will be in the room opposite mine.

*From Gertrude S. Mathews*
*119 Washington Place, New York*
*March twenty second [1917]*

If I had written you as many times as I have thought of you you would be swamped with work [to reply]. But I have been swamped myself, working over time here and having far the busiest and pleasantest winter socially that I have ever had. But I want to tell you about Miss Kirmse and Mrs. Watson.

Will called up and asked me to receive Miss Kirmse—oh way back in December or January, I think. For your sake I did, and out of a reasonable curiosity. Had her to tea, but she must have fortified herself before she came, for she wouldn't drink—an Englishwoman! Anyhow I am going to be quite frank about her. She struck me as being uncouth. Not horrid. Just heavy and queer. Will called her "wild." That side I didn't see. I do not think he meant what one does when he calls a man wild—just crazy.

When do you think you may go [to British Guiana]? And if the thing is off will you come north very soon? I don't think there is any doubt that we will have war, and while the ships on that run [to South America] have so far escaped I think it quite likely that some of them will go to the bottom any time and I hate to think of the dangers.

So much for all that. Treasure is out, and the biography will be issued the 31st of March. So I am two times an author this month.*

The Pen & Brush has been going fine. An awful lot of work in it, but we have a stunning program for the next two months, if I do say so. Ellis Parker Butler, Joseph McCabe (who wrote The Tyranny of Shams); Miss Elliott, F.R.G.S. author and editor of the Pan American Magazine; Frederick A. Stokes, the publisher, Honoré Willsie, Kate Jordan, and Irvin Cobb.

---

* Gertrude Singleton Mathews Shelby published *Treasure* (New York: Henry Holt, 1917), about her expeditions among the gold miners of British and Dutch Guiana. The biography she mentioned was *Galusha A. Grow: Father of the Homestead Law* (Boston: Houghton Mifflin, 1917).

*From Will [Beebe]*
*New York [City]*
*Apr. 24, 1917*

I have had the [Berbice] chair crated and it goes by express to-day collect. I had the crating done for me by the Park people. In a few days I will have finished the flower plates & will send them on.

# 8

## With the American Red Cross in the Great War, 1917–1919

HONORING HER FAMILY'S TRADITION OF SERVICE TO THE NATION, Taylor signed up for duty with the American Red Cross in France. She did no painting in France, rarely mentioned art, and once went to the Louvre but recorded no impressions of her visit. She was completely involved in the war effort but sent home copious descriptions of her jobs, coworkers, and visitors to her Red Cross canteens and of life in a nation devastated by war. Taylor began numbering her letters with Roman numerals so that she and Nell could keep track of the amount and sequence of their correspondence. ↝

*From Helen Hyde*
*Charleston, S.C.*
*May 16, 1917*

Dear Miss Taylor, I think you are wonderful with all your war doings. I expect to do something when I return to Chicago. They write they expect me but this summer I am going on with my own work to get my crop out of the way so I can help at home in the Fall & Winter.

I have at last heard definitely from Mr. Taussnig [possibly Charles William Taussig] that he is to be in Provincetown. I want to "pick his brains" for etching etc. tricks. I am having so much trouble with the mechanics of it. I have written just now to Miss Bloomfield to see if she has any room. I heard her house was so very nice but as I didn't know until yesterday perhaps she is all full up. I see by the vacation Bureau booklet there are a number of names so I am taking the liberty of writing & asking you which would be the best if I couldn't get in Miss B[loomfield]'s house.

Going for work I would like a place where I could be sort of independent & not be expected to be [part of] "family life." So be a dear & tell me which of these to write to. I don't want to pay more than 15 [dollars] a week. I prefer the 12 as I pay house rent in Chicago all this time. Love to you. Write me a word to 7923 Lincoln Drive, St. Martin's, Philadelphia, Pa.

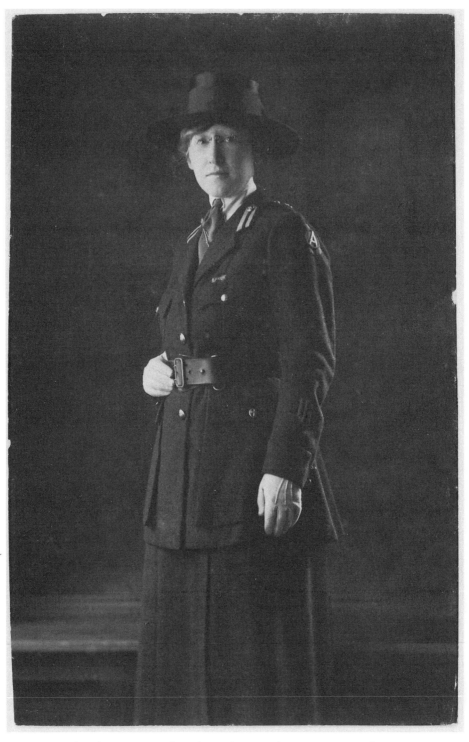

Anna Heyward Taylor. Courtesy of South Caroliniana Library, University of South Carolina, Columbia

*From Will [Beebe]*
*New York [City]*
*June 9, 1917*

I did not mean that I reproduced your flowers but that I had used them in identification constantly, in connection with the vols. This is going to be over 550 pages & I am struggling with the proofs alone in absence of the boys.*

* Beebe intended to publish several volumes containing scientific information from the 1916 expedition but was only able to publish one, *Tropical Wild Life in British Guiana: Zoological Contributions from the Tropical Research Station of the New York Zoological Society, with an Introduction by Colonel Theodore Roosevelt* (New York: New York Zoological Society, 1917).

*From Will Beebe*
*New York Zoological Park Guadeloupe [West Indies]*
*August 28th [1917]*

I have a minute before the boat starts to write this. We are a party of ten just going down for a few weeks, I to salvage the Kalacoon stuff and see that it is put in the care of the government and to give my broken wrist a better chance to mend so I can be off to France in the autumn. Yesterday we swam at that wonderful beach at Antigua, and Miss [Isabel] Cooper, one of the party, stepped on a purple-spined urchin and filled her foot full of the spines, so we have two invalids now. We must surely go down again another year all prepared to do some great work. Inness looks fine in his lieutenant's uniform. I hope we shall both get through without killing, and go back safely to bugs and more interesting things than war.

*On board the S.S. Rhochambeau [sic]*
*Nov. 5 [1917]*

To Nell

The boat is the usual large liner, but of course much of the lower deck space & the entire upper deck is taken up with lifeboats. Guns are mounted both fore & aft and now, the last days, a gun crew is on duty all the time. Some of the sailors are exactly the malot described by Pierre Loti. Of course the gun crews are naval men & our captain is a naval officer, an exact reproduction of Cyrano de Bergerac. He was much opposed to women helping in any capacity, except in hospitals. Since being over there he has changed his attitude & these women are going by his special request & others will follow.

I can't decide whether I am utterly lacking in imagination or whether I am brave. I don't believe that I don't realize our danger for I do, but I seem to have absolutely no fear & look forward to a possible accident as a danger I shall pass through & can't imagine myself drowned. There is some question of our being allowed to wear our suits if the boats are crowded. Lots of people have been going around armed with life preservers, but I keep my two on my steamer chair which is directly in front of our boat. The boats are said to hold 53, but how they get in I don't see. You really aren't conscious of the strain people were under while in the danger zone, which we passed at 8 o'clock this morning, but the rise of spirits

was very obvious at breakfast. We passed some patrol boats this morning at 7 o'clock & are being convoyed by two destroyers. We should sight land before long & will have to spend the night on board as we get in too late to be taken up the river by tenders. It's a 4 hour trip up the river to Bordeaux. I thought it was on the Channel!! I wish you would get Mr. Gittman to order me a copy of [Joel Chandler Harris's] "Uncle Remus" like the one you have.*

* James Thornton Gittman (1872–1951) operated Gittman's Bookshop in Columbia during the early twentieth century. His bookstore was a center of Columbia's intellectual life for many years.

*Hotel de Balzac, Rue de Balzac [Paris]*
*Nov. 10th [1917]*                                                           *II*

To Nell

I shall number each one of my letters so if one is lost you can let me know. Be sure to do the same to yours. Now for the real exciting news. I wrote you that I really couldn't understand myself, that either I had no imagination or was wonderfully brave. I have come to the conclusion that it's lack of imagination because I never pictured the pandemonium which would reign on a boat which had been torpedoed. I concluded that order would be the natural thing. Bishop McCormick told Virginia that the captain said that he had never had such an anxious voyage before, because of the large number of women on board & the 300 Armenians below. If anything had happened & if the vigilance committee had not been able to hold the Armenians back no one would have been saved. They all went around armed, which I hear the Captain didn't like. There were six spies on board, I hear, & we also heard that one was tried immediately & shot next day. The captain never left the bridge once. Tuesday night we were chased by a U-boat & lots of people, not me for I was sleeping the sleep of the brave on deck, felt the boat speed up tremendously & continue going fast for some time. That was the critical moment. The boat sent out an S.O.S. call which explains the destroyers meeting us so far out, out of sight of land & the whole way in two were crossing & recrossing in our wake until we got into the river. We went some distance up & anchored for the night, the tenders coming early next morning. We were all piled on the tenders along with our luggage & were in even more danger than from the submarines. There weren't seats for a third so most of us sat on suitcases & almost froze to death. It was cold & misting just like the day Julius & I went up the [Columbia] Canal. I was chilled to the marrow. We were on the boat from 1:30 to 9 o'clock. I realized that what would have happened if the steamer had been struck, for when we started to get off up the narrow gangway, I have never seen such pushing & brutal behavior in my life on the part of some Cubans, Frenchmen & Americans. The Armenians had been sent up earlier on the other boat.

I toured the town (Bordeaux) & ended at a pension with the old familiar smells. That was about 11:30 P.M. & nothing daunted Miss P., Miss A. & I started out to find some dinner. We flew to the place where we had seen an hour ago some of the party hurrying to a café. We got there but they were closed & refused to sell us a thing. So off we started again & learned from a cab man that we could get something at the Bristol Continental. We landed at the latter at about 12 o'clock and had a delicious hot dinner! We had nothing

since breakfast, & that a European one. We had a "vin chaud" which certainly went to the right spot. Our pension was down a little dark spooky street but we found it. While on top of the bus hunting for a lodging two soldiers stopped near us & I couldn't keep from hailing them. They were enchanted to see us. They are in a camp near there & were engineers. They told us that about 200,000 soldiers were over & that 80,000 more were in the trenches. They had been attacked by the Germans & 3 killed, several wounded, & 12 taken prisoners.

I must tell you the real thriller of my letter. It seems that the men were introduced to Mrs. Schelling & one remembered that he was so thankful that the Rhochambeau had come through safely, that he had just been on a ship which had been torpedoed. He proved to be the captain of the "Antilles." He said that they were about 250 miles from land & being convoyed by [John Pierpont] Morgan's yacht the "Corsair" & the [George] Drexel yacht [Alcedo]. He was in the bath when attacked but managed to get on a shirt, shoes & at last, trousers. She sank in exactly 4 minutes, that he swam off from his deck! He went down & came up under an overturned life boat which he managed to climb on. They were picked up at once & taken back to port. Then he started back on the "Finland" which had come over with the Antilles with a convoy. They were in almost exactly the same place when they were attacked. He & his mate ran to the bow & decided that she wouldn't sink & told the captain so. As it happened she didn't & made port under her own steam. But he said that he had never conceived such a frightful scene as reigned on that boat after she was struck. The crowd below surged up & cut the ropes of the boats filled with people & they fell to the water & turned over. I am convinced that none of us would have escaped if we had been struck. When I come home it's by the North Pole or on any army transport where there will be discipline.

We left Bordeaux at eleven on Friday & had a most beautiful ride up to Paris, getting here about 8 o'clock. The country is wonderfully beautiful with marvelous old chateaux on hills with the villages climbing up the sides. Such marvelous color in the tiles & walls. If you could only have seen the wonderful approach to Angouléme! We passed through Poitiers, Tours, in fact came up the length of the chateaux region. The foliage was superb & I was mad to paint. Nothing could have been further from my mind than surgical dressings.

At 10 o'clock this morning we went to the Red Cross Headquarters & I wish you could have heard the little talk Major Murphy's Assistant gave us. He said that they were never so thankful to see a crowd of workers as they were to see us. They said that the supplies for our men depended on us. It seems that there has been some hitch & delay in America in the making of "Front Packages" & we are to fill them. The saving of many lives depends on these packages & the people at home haven't grasped it yet.

The Captain of the Antilles says that the reason the Rhochambeau hasn't been sunk is just that the Germans don't want to sink it. She carries the German mail.

The walk down the Champs Elysees was beautiful. It was jam-full of people, loads of officers in every kind of uniform, some without arms & some without a leg. I saw some Japanese privates & can't understand their being here unless there are Japanese troops in the trenches.

*Hotel de Balzac, Rue de Balzac, Paris*
*[November 10, 1917]*

To Nell

There were six spies on board, I hear, and we also heard that one was tried immediately and shot next day. One woman, whom I remember very distinctly, had her hair taken down, her clothes removed and acid applied to see if anything were written on her skin. A Miss Tasseman, who was suspect and I just missed getting to the window in time to see her being questioned by the officers.

*Hotel de Balzac, Paris, France*
*Nov. 17th [1917]*                                                                                            *III*

To Nell

It's the same old story of a thing becoming a fad & women of social prominence filling executive positions they are wholly unfit to fill. The Red Cross is anything but well organized yet. In fact we hear on all sides that the only well organized organization is the Y.M.C.A.

Everyone says that the moral conditions here in Paris are awful. [General John J.] Pershing says that he doesn't wish an American woman in France not in uniform & wishes no provision be made for the men spending their leave here. He prefers their going to Southern France. One of the men told a woman I know that it's the usual thing to be stopped eight times in two blocks by women at night. Everything closes except theater & movies by 9:30 P.M.

She (Dr. [Blanche Wilder] Bellamy) said that she was serving tea & one sailor came up to her & kept on looking at her in the most intense way & answered in such an absent-minded way about the tea that finally she asked him if he wanted anything. The fellow kind of pulled himself together & said "I just wanted to look at you. Do you know that you are the only decent woman I have spoken to or who has spoken to me in 7 months." He has been on one of the destroyers. She said that the fellow just seemed to overflow, & seemed so sick & disgusted over the conditions over here that he fairly ached to talk to & be with some clean American women.

Please get several pounds of Washington coffee & send it over at once. Also send some sugar but not in the coffee bundles. You will have to smuggle the sugar in, for if you mark it, it will be stolen. Hollow out a book and fill it with lump sugar, that's one way a girl got some. Several packages were stolen before her mother thought of that. Send me a picture of yourself.

*Hotel Balzac, Paris, France*
*Nov. 22d [1917]*                                                                                            *IV*

To Nell

We are hard at work down at the Faisonderie rooms. I am changing my work each day so as to learn how to make all the things going in the package & how to wrap it up. They are in three sizes to suit the various size wounds. In a muslin bag are put for [size] No. 1 a pad or "peusement," bandage tacked on to the pad, 4 cotton wipes, 4 gauze sponges, & 1 gauze

drain. This is wrapped in waterproof paper very compactly & slipped in the bag. These are sent down & sterilized.

I hear that the American dead were pretty badly treated by the Germans, throats cut, etc. Of course, it's hearsay, but it sounds like the truth. There is the greatest excitement over the formation of the new Cabinet. [Georges] Clemanceau [*sic*] seems to be considered the only strong man of the moment. We have been very curious to find out what the scandals are, referred to all the time in the papers so last night I asked some American about it. It seems that there is a Bobbo Pasha, who was given his title by the K[h]edive, who is a deputy & a man of great wealth. He has been accused & it proved that he was in the employ of Germany. He tried to buy the paper "Le Temps" & the owners were advised to sell to him by the Lord Chief Justice of France!! There certainly is treason in high places. There have also been scandals in the purchase of government supplies etc.

We heard that a woman spy was executed at Versailles the other day. She was a German actress who had been living here for some years. She had been to the front several times in spite of being under suspicion. Finally she was caught & executed in spite of the fact that France said she would never execute a woman. She showed the most extraordinary amount of bravado, tripping down between the line of sixty men, chucking one fellow under the chin, saying that she hated to leave such a handsome fellow, & making remarks to various others. It seems that a spy has to walk down between a line of sixty men, each stating that he recognizes the person.

Sunday Miss Pryor, Miss Peak & I got an early start & went over to Notre Dame. It is perfectly beautiful in the "Cité," the church being so wonderfully located. We stayed through one Mass then wandered around the Church. The windows are marvelous. I also saw Sainte Chapele for the first time. It is like a wonderful piece of jewelry set with marvelous stones. I never saw it before. The walls are just a series of stain-glass windows reaching to the ceiling.

*Paris*
*Nov. 29th Thanksgiving [1917]*                                                              *V*

To Nell

Well it looks as if we are going to be regular factory hands. I can stand it but I don't believe all the women are going to be able to stand it. We practically have a ten hour day for we leave at 8:30, & though we have two hours for lunch it takes all that time to walk home & eat, fool around for a few minutes & get back. Mrs. Austin had a séance with us the other day & practically put her foot down on our having an afternoon off each week. Personally I believe it will make for efficiency giving us that relaxation in addition to Sunday. Not one of us have been accustomed to a life like this & you can't take a racehorse & make a draft horse of him, he'll pull himself to death. Everyone says that she is almost a slave driver, never conserves the strength of herself or help. Just now its moonlight, though we never see it, & the time for raids. We hear airships every now & then night & day & some have been lucky enough to see some. Almost any time there is an attacked [*sic*] observation balloon visible. All the streetlights have little roofs to throw the light down & no cars have

lights except candles in the lanterns. From the stories I have heard from some of the nurses who have been at the front, I feel that it's about time for us to stop giving all our money & energies to the French. I am thankful that I am working on supplies for our men. The account of the waste in the French hospital of surgical supplies makes you sick & here our dandy crowd of fellows are going into the trenches without enough warm things & not enough surgical supplies. At the British & American Hospitals not a piece of anything is lost or wasted. However, I do believe that the French are pretty near the end of their rope & it remains for the British & Americans to win the war. One hears that the British & our troops don't hit it off at all except the Anzacs, & in that case they are bedfellows. The Anzacs don't get on with the rest of the British either.

You know it's against the law to offer an American man in uniform anything to drink. Speaking of that, the men said that it was appalling the number of men who had gone to the bad since our men came over. The open bars & women have finished them, & lots of them, this officer thought would never pull up. Conversations certainly go back to elementals these days. All the armies are permeated with spies.

*Paris*
*Dec. 8 [1917]*                                                *VI*
To Nell

A party of us from the house went to hear [Jules Massenet's opera] Thäis, which was exquisite. I didn't remember before that the plot was taken from something of Anatole France. The music is exquisite. The Meditation is an orchestral part & comes between the 2d & 3d acts. The audience was most enthusiastic all through particularly then. The orchestra played it twice. In the last act it is continually appearing & sometimes the voices carrying the melody & then the orchestra. The leading woman was an English woman, who had a beautiful voice & figure but wasn't particularly graceful. Her costumes were lovely. The other voices were fine & the ballet was beautiful. The house was full & most of them men, quite a sprinkling of Americans.

*Paris*
*Dec. 23d [1917]*                                                *VII*
To Nell

I hear that the only people the Germans are really afraid of are the Negro French Troops from Africa. They never use any weapon but huge Bowie knives, & if possible simply cut the Germans' heads off. The prize they always aim for is a Col's head. The other day in a drive they had orders to take a certain section which the regiment proceeded to do & got there ½ hour before the other troops took & held it with the loss of only 3 men. They never take a prisoner & the Germans make for home when their black faces loom up. In one of the first aid huts they had a lot of wounded of both armies waiting to be dressed. A huge Negro was lying unconscious with just the stub of an arm left. He came too & realizing that a wounded German boy [was] next to him, he found his knife, bent over on his stub & hacked off the head of the German prisoner.

I heard of an older, German officer who was taken prisoner to his disgust. In a furious rage he said that he knew his son was killing 20 "English pigs" a day even if he couldn't. As he was landing in England he heard a cheerful voice hail him, "Why, is that you, Pop?"

*Paris*
*Dec. 26th [1917]*                                                                                        *[VIII]*

To Nell

I have never told you about the people in the house except for Mrs. Bellamy & the Mowry's. There is an awfully nice little red-haired woman from Syracuse who is a doctor & has just completed a course with Mme. [Marie] Curie on X Ray. She says that Mme & Mlle are the most extraordinary pair you ever saw. Such clothes you never dreamed of, long skirts fearful things. Mlle is only 19 & is now working on her Ph.D. She wouldn't be so bad looking if she were properly dressed. Both women think in chemistry & physics.

Saturday night I went to the Comedie Francaise & saw "l'Abbe Constantine" with [Captain Hall]. I was afraid he was awfully bored but was relieved to find that he had been there several times before. During the performance we had an air raid scare which of course we never heard at all.

Sunday night (Xmas Eve) we went down to the Gare du Nord to sing Christmas carols to 300 French soldiers just going out to the trenches last night. The French R.C. has a beautiful pavilion down there. I didn't believe such a barn could look so home-like & attractive.

*From Marié Margueríte Fréchette*
*Pension Anglaise*
*Dec. 27th 1917*

I have been doing a good deal of painting this autumn, mostly miniatures, of which I am getting together enough to exhibit—rather a difficult thing, for the portraits I have done are in the possession of their owners, & scattered over the globe in consequence.

I am most eager to see your studies of those wonderful tropical flowers. They must have great charm & beauty. Usually I think botanical plates the greatest possible bore, but with your sense of arrangement I am sure yours are different.

*Hotel Balzac*
*Jan 3rd [1918]*                                                                                        *IX*

To Nell

I forgot to number my last letter which was VIII. Sunday afternoon a party of us met to hear [Edouard Lalo's 1888 opera] "Le Roy d'Ys" which was really beautiful. The scene is laid in the time of Edward I in Brittany. They also gave [Pietro Mascagni's 1890 opera] Caval[l]eria Rusticana.

New Year's Eve I went to the Canadian Canteen & about 200 men came in so we were moving around lively. You would be surprised to find how often the men say they get tired of Paris in a few days and want to get back to the front. One man said that out there they knew each other but just as soon as they come to town they become strangers to each other.

He says that it's the ordinary thing to see a man take his last piece of bread & give it to some wounded man, that the men never seem to think of themselves.

One really funny fellow was Sgt. of a stretcher bearer's squad. He was one of Dr. [Thomas John] Bernardo's "boys" as he called himself. I had heard of the doctor & his wonderful work sometime ago. He would take all the foundlings & orphans around London, send them to school & when they became of age would place them out in the colonies. This man, Hubbert, was taken when only 2 months old, his parents having died, & was educated & then sent off to Australia. In time he received 1600£ from the Bernardo Fund [of London], which together with his savings enabled him to buy a dairy farm & he now has 100 cows. He has been over two years in the war as stretcher bearer, & he has a man running his farm. He told me with pride that he didn't have a tooth out when he volunteered and had never been hit. They all tell him that he has a charmed life. He goes right out into No Man's Land. I am surprised to find that they don't seem to feel any intense personal animosity towards the Germans, but it's a fact that some Canadian & Anzacs never take a prisoner if they can help it. He told me that he had seen such awful things that he would never be able to talk about them & that he longed to get away & try to forget them. He was to leave for the front next morning. He was most amusing about Paris. I asked him how he liked it & he said he was afraid of it & said "You notice I stay around here pretty close. I am a great believer in the Y.M.C.A. and I'm a Salvation Army man, too."

The novelty of things is wearing off & I begin to regret the delightful winter I left behind, but I am doing my bit by doing the most uninteresting work in France.

*Hotel Balzac, Paris*
*Jan. 12th [1918]*                                                                                          *X*

To Nell
<u>Not to be read at a supper party a la Julius!!</u>
Several times I've heard a story of German crime which seems possible & formerly perfectly incredible. It is that in Paris & London there are immoral women thoroughly diseased who are in the pay of Germany & kept in these places to ruin physically as many soldiers as possible. Well I heard of an instance the other day which looks as if it tallied with the story. Virginia met an engineer the other night & as very often happens the conversation turned on the moral condition of Paris. He said that he was thankful that the American soldiers would shortly leave the city & have no leave granted here. He went on to say that two fine young fellows whom he knew had in the last few days been sent to the hospital with bad infections & he went at once to see them. He had given the boys talks on occasions so asked at once how they managed to get themselves in this awful plight. The men replied that they were about as much surprised as he was and that they had met these two well dressed, well mannered "ladies" as they thought had taken them out & one thing led to another and when they came to they were done for. Both women were evidently in bad condition. Not a dollar passed between the men and the women! It certainly looks like the hand of Germany. I read the other day that when war broke out, Germany had every prostitute examined & any diseased woman was put in munition factories & kept there under military rule.

This afternoon I went for a walk down the Champs Elysee & saw a real Cossack, I am sure. He had the small, round hat with astrikon [*sic*] fur around it, the long linen colored coat or blouse belted in at the waist with narrow leather belt, a handsome dagger stuck in his belt, belt of cartridges across his breast, beautiful decoration pinned at his throat & several others on his chest, in fact he certainly was the observed of all. His face was distinctly tartar in type & quite young.

*From Nell*
*Columbia, S.C.*
*Jan. 13 [1918]*

For God sake write some letters giving some hopes for the ultimate victory of the allies, or you will have a lot of old men hauling their worthless old carcasses over to France, which the Gov. say they don't want at present.

*From Camilla Sams*
*Columbia, S.C.*
*Jan. 15 [1918]*

I certainly wish I had known that we could have seen you, for there is nothing we would have enjoyed more than seeing you again and having a long talk together, Stanhope, you and I, as we used to do in Tokyo! I envy your having the opportunity to go to help France and our own country in this awful war and I only wish I could do the same thing. I am at least trying to learn how to make surgical dressings in the morning class taught by Miss Watt in the rooms at Harper College on the [University of South Carolina] Campus, and also I have tried here, and everywhere we have been, to do some Red Cross work. Innumerable Tag Days, Soldiers or Sailors Days, etc., are the best money-making methods among the British Colonies in the Far East, and Australia and New Zealand. They could teach us much in the way they support and manage their Rest Homes and Convalescent Homes and Repatriation schemes. At first, when we came back it seemed as if America would never realize what the War really meant to us as well as Europe, but there is a steadily growing realization of it even down here, and the shoe is beginning to pinch when the people suffer for lack of coal and other necessaries as they have had to do this winter even here. But I want to get out and preach it at every corner, as the Australian women do in the Sydney "G.P.O." Place, that we in the South, <u>every</u> man and woman, must help to win this war more than any of the Southerners even in the Civil War, that our own lives and homes and freedom are more endangered than then. I hate this provincialism, but that local application is all that will make us realize it until our own boys are killed at the front. But what is the use of saying this to you—the one that has realized it more than any other Columbia woman— or man either, so far!

*Hotel Balzac*
*Jan. 17th [1918]*

To Nell

Some Canadians at the canteen were telling Mrs. Bellamy the other night how they frater-nalized with "Fritz" last winter. It was when there was such an awful tension on the front & diplomatically too. The trenches were within a few yards of each other so the men would stand up at times on the edges & snowball each other as hard as they could & not a shot fired. Each side would keep watch & the minute an officer was seen they would yell, "Here comes an officer!" and everything would duck into the trenches. Doesn't that seem incredible?

Will Beebe is over here, came a few days ago. He rang me up & said he was coming around yesterday but never turned up. He is so erratic anyhow, & being in France I am sure has completely demented him for the time being. In New York he was wearing all kinds of unknown letters & insignias on his arm so there is no telling what he carries now, perhaps wings on his ankles!

Jan 21st. Well, Will Beebe has finally turned up. He didn't come the day I was expect-ing him because it was a fine day for flying so he went on a jaunt to the front lines. He has been out there 4 times already, it only taking an hour, but they are not allowed to land so he has his eyes popping as observer because he can't go as pilot. Even if he is as fine a flyer as he thinks he is he can't, on account of his wrist which he broke last August. His get-up is most remarkable, the most conspicuous article being his leather aviator's coat, but he is minus the various letters & insignias he sported in New York. He is a most amusing, non-descript & adds a romantic touch by carrying his right arm in a grey silk sling & always shaking hands with his left hand. To cap the climax he wears a gauze bandage around his injured wrist, why the Lord only knows! He is here partly for the Government in a very in-teresting capacity according to him, then he is observing on his own part & expects to write various articles for the Atlantic who will take all he writes. If he can't do any flying by next summer he is thinking of going on down to Guiana and go on into his scientific work. Will also had a pow-wow with Capt. Campbell who is the head of all the Canteen work in France. About 160 men came, first Canadians & then Anzacs. He was tremendously impressed as I was with the type of the men & we did have some dandy looking fellows. He & I got to talk-ing to a group & the Sergeant had a time getting them to leave as they keep saying that they would get a taxi & he kept saying but "you can't this time of nights." The ones I was talk-ing to were telling me about how they lost their guns in the Cambrai fight but they fixed them good before Fritz got them & then they had the luck of getting them back. "Fritz got us our leave!" It was because the guns were being fixed up so they were having a few days leave. Some hadn't had leave in 14 months.

As I wrote you before, this canteen is really to help the fellows get hold of themselves & [become] adjusted before being turned loose on the town. Before coming down for their supper they are given a 15 minute talk on the moral conditions here & a few plain truths told them. Every man has to report just as they do in U.S. Army & have an inspection. But they are not required to give their name as such, but if he becomes infected his people are notified & his wife's pension stops. They say that this method has produced better results than any other.

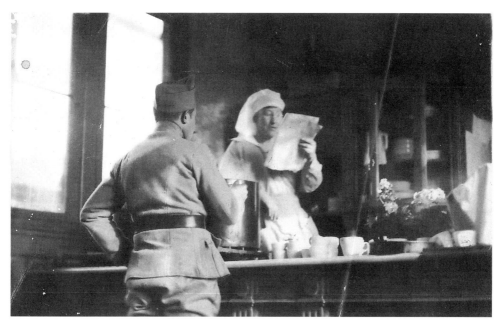

Canteen duty, 1917. Courtesy of South Caroliniana Library, University of South Carolina, Columbia

It certainly was a pleasure to see Will Beebe, & talk & discuss things with an intelligent man. The men in this house are perfectly impossible.

*From Margaret Babcock*
*Columbia, S.C.*
*January 21 [1918]*

The Service League is coming around now. Nearly all the clubs this year are giving their time to working on surgical dressings instead of to regular meetings, and Mrs. Manning called a meeting of all the commandants last week and asked all the detachments to give a regular time for work at the Red Cross and they are doing it. In fact I have been there many a time when there was not room for all the workers and some have gone home, which was too bad.

Everyone is busily knitting these days and we have knitting parties instead of bridge. Have had two lately myself. I am trying so hard to keep up my end and do my share for the army people but somehow seem to be always behind—like the old cow's tail. Saturday night we had the Chaffees and two of the French officers in for supper.

*Hotel Balzac, Paris*
*Jan 27th [1918]*                                                                                    *XI*

To Nell

The English woman here, Mrs. Cox, has gone to the front. I wish that you could see some of the women in that group. They have their hair cut like men & are sights to behold. They are motor drivers & go up so close to the lines that they have to carry steel helmets, their own beds & tin basins. Most of the time they sleep in a curtained off corner of the building

where the men are quartered & their billet arrangements are primitive to the last degree, simply a trench! They never see hot water & for an all over bath use powdered sulphur, which smells much more like something to kill cooties than a bath. Of course we will never live under such conditions such as that because the canteens are much further away.

*Hotel Balzac, Paris*
*Feb. 2d [1918]*                                                                                    *[XII]*

To Nell

My experiences are beginning! We had an air raid about which you have already read all the details in the paper. It occurred Wednesday night. I spent the evening writing to Frances, then undressed & went to bed. I was just dozing when I heard a prolonged whistle off in the distance & in a few minutes the sirens began up & down the streets of Paris. I hopped out of bed & ran out in the hall in my pajamas only to gaze on all the other women in their pajamas doing just as I did. Fortunately the only two men up here remained in their own rooms. Just as quickly we all scuttled back to our rooms & began to put on some clothes & as it turns out they all did as I did, just dressed on top of the pajamas. I stopped by Virginia's & Helen's room & found them clad in pajamas with their money bags around their waists, why they hadn't gotten more on I don't know. Helen's eyes nearly popped out & she protested when I said that I was going to view the raid & that I thought the best place was out my window, on the top floor. On going downstairs I met the entire hotel in various degrees of being dressed, either on the stairs in groups or in doors all talking excitedly. Capt. & Mrs. Mowry, Dr. Blair, Mrs. Bellamy & I at once went into the street. We had really a very good view of the heavens as we are on a corner. We could see the bursting shells of the barrage down the end of the street & from time to time airplanes flying around in the sky, once so low that we could see the end lights. They would signal by lights & sometimes they would burn a long time & looked like large stars in the heavens. It was a clear brilliant night & you couldn't tell the planes from the stars to save your life, except by watching to see if they moved. One machine flew awfully low with a huge searchlight in front & red & green lights on the wings. It flew right over us, & as it turns out now might have dropped on us for they were having engine trouble & they were seeking a landing & eventually landed in a smash up on the Place de la Concorde. One of the wings struck a column & broke off which capsized the machine & injured both men, one more or less badly. A girl, a friend of mine knows, had been out to dinner with two men & was crossing the Place just then. They were almost crushed by the machine. She rushed up to the injured fellow & felt his pulse, just before he lost consciousness he remarked "Damn those Germans!" Two of our party went up to the Etoil[e] only two squares away & of course got there just at the right time for a house had just been bombed just a few minutes before. We heard the barrage some distance off & some nearer guns, but every now and then we would hear several big explosions. We asked at once if they were bombs but Capt. Mowry insisted that they were the guns of defense, & when two huge explosions sounded near in the direction of the Etoil he insisted that they were the anti-air craft guns on the Arch [*sic;* Arc de Triomphe]. We stupidly believed him, having none of us been in a raid before. He knew all along that they were bombs.

*Paris*
*Feb. 7th [1918]*                                                                                          *XIII*

To Nell

I forgot to number my last letter so I will this one. I have kept the dates & numbers of all so I will know if any are lost. I got a letter from Pinckney Herbert, most doleful. He has had his 3d attack of trench fever & this one lasted 3 weeks. He is just sitting up & for only one hour a day. I asked him if his knees could be as beautiful as the public thought Julius' when he gets into his kilts. He says his poor legs are so pitiful just now that he can't bear to see them.

The Smith Unit sent over by Smith College & composed only of graduates has been taken over by the Red Cross. The various things the women are told to do before coming over is very amusing & of course the very thing which you would least associate them with, they are either told to do or not to do. One was told not to "allure" but to "attract," another to be cheerful & sunshiny, still another to bring an atmosphere of home, etc.

*Hotel Balzac, Paris*
*Feb. 20th [1918]*

To Nell

Yesterday I was requested by the A.R.C. to go down this morning & see Mrs. Vanderbilt, that they wanted me for canteen. I took myself down & Mrs. V. said that they wanted me to leave as soon as possible & asked if I could leave tomorrow morning at 8:14 A.M. I decided to do it, although I hesitated as Pinckney Herbert was to come through this week and we were to talk ourselves to death. I decided leaving was my duty, so here I am writing at 1. A.M.

*American Red Cross Rest Station, Bourges*
*March 1st 1918*                                                                                         *No. 18*

To Nell

Well, here I am at work & enjoying myself hugely, as it's a big improvement on Surg[ical] Dress[ing]. I wrote you a hasty note Feb. 20th saying that I was going to leave Paris. Monday evening Miss Rochester, who is in charge at St. Didier, informed me that I was wanted for canteen work & to go & see Mrs. Vanderbilt next morning which I did. Mrs. V. said that she wanted me to leave immediately upon which I asked what that meant & she replied 8.14 next morning.

We are on duty from 7.30 to 9 in the evening & working two shifts; consequently we are off either in the morning or in the afternoon according to the week. Miss [Sophie] Berger is a Jewess from New York & impresses me as a very unusual woman, in appearance a feminine Norward Hastey [*sic;* Norwood Hastie]. She has been the head of the N.Y. club for Jewish girls, something on the order of the Y.W.C.A. She is an ardent Zionist & I am looking forward to hearing her on this subject. After working in Canteen a while she wants to do work among the refugees as she expects to go to Palestine & work with the Jews there.*
She is a delightful woman to work under, so efficient & human in her method of doing things, quite the contrary to most of the directresses of canteens.

Our canteen is simply charming. The color scheme is orange & blue with some mural paintings by a French artist (funny but not much from the art standpoint), a friend of Mrs. Tiffany who had the furnishing of the buildings. It is rapidly becoming very popular with the surrounding camps, particularly the cadet aviators at the French Aviation School near here. The last train had only about 65 but I never saw men more eager to see & talk to American women. After we served them they surrounded us, at least ten deep around each woman & seemed as if they couldn't see or hear enough when it happened to be an American. I never realized so fully what it meant a lot to these men, our being over here. We were the first American women they had seen since they landed.

The hotel is not particularly warm & no private baths or running water, consequently I feel that I am in Europe for the first time. It is any thing but clean & the water brought to you is always luke warm. My bed is a good modle [*sic*] for the Jung Frau. It is a beautiful old town & the cathedral one of the finest in France. How I wish you could see the wonderfully beautiful stain glass windows. It is almost as beautiful grey days as on sunny days. Such fascinating streets & old houses to paint you never saw except perhaps in Bruges. The church was begun in the 11th century by St. Louis.

    * In 1912 Sophie (or Sophia) Berger of New York City founded the American Zionist Medical Unit for Palestine.

*Bourges*
*Mar. 7th [1918]*

To Nell

I am finding Canteen work very delightful & still feel that I am extremely lucky to get into this one the very first. As I wrote you we have half a day off & as long as possible each week, but if no more workers are sent us when these three leave we will not have our day. There are always two women on duty, one at the counter & the other in charge of the kitchen. As I know nothing about cooking I have the counter.

    It was a perfectly heavenly day, our very first balmy Columbia day & I felt as if I could never get enough sunshine.

*Bourges*
*Mar. 14th [1918]*

To Nell

We saw a whole lot of German prisoners & they were a pink healthy looking crowd clad in white coats, pea green pants with huge P.G. in white on the seat. Not long ago two American soldiers had a German prisoner bringing him to camp. The two guards fell from grace in the town & the German prisoner escorted the two drunks to camp. One of the canteeners told us that it was mortifying to find how much better the Germans were in the kitchen than our men.

    It was perfectly lovely view of the surrounding country from the haystacks. There was a blue haze over everything so the little villages looked like warm spots of color & the

inevitable church steeple would make just the right break in the horizontal lines of the trees & fields. There was a beautiful sunset.

*From George [C. Taylor]*
*March 18 [1918]*

Nell has just gone to bed and is I fancy about going to sleep with the others upstairs. They all looked very healthy and pretty tonight as they lay in their little beds, Edmund begging for marshmallows and getting one and Eliza & Mariana each having just swallowed one, begging for me to tell them a story and offering to tell me one. They are a great little crowd and very often speak of their Aunt Anna.

By this time I hope you are outside of Paris as the enemy seems still more and more bent on its air bombing of cities. I was very much relieved to hear that you had moved your quarters before the great raid of our squadron over Paris the other night.

I wonder if your health is still at its best. Keep it so if you possibly can. A steady stroke on your part will do more damage to Germany than feverish effort. Then besides it will be more likely to bring you back safe and sound to us. Somehow I feel that neither side is going to make any wonderful progress against the other this spring and summer. The Allies and Germany are both too well prepared. Each Army I fancy is getting to have considerable respect for the strength of the other. When each knows the other to be absolutely ready it must be tremendously hard for either to take the initiative and launch a big offensive. I hope we are right in our belief over here that Germany <u>must</u> break through the Allies or she is lost; because that she certainly cannot do. Ah God what a privilege to be over there to help stop her when she does attempt to wipe up the Allies! Anderson Clarkson, your first cousin from Eastover, is I think on his way over towards you now. Our best after all even under the prescription [*sic;* conscription?] plan are the ones that are going over. That is the pity of it; but that is the finest thing for the army and that is what will help mightily to prove the undoing of the German army.

I must say goodnight without having given you much news. Nell gives you that. Somehow nowadays no news seems really news except the big events. Ordinary matters have no longer much interest. They have shriveled into insignificance beside the great happenings, and the great happenings move so terribly slowly.

*From Nell*
*March 21 [1918]*

The war news is awful!* I really could not sleep last night after reading the paper. George went up to the State office about bedtime, but we could find out very little more. We hope you are not in the section where the shells are falling. I'm terribly afraid we have not enough men over there to count. The idea of the British being pushed back twelve miles is a horrible one.

---

* The German spring offensive of 1918 began in March and was decisively defeated in July with the Second Battle of the Marne.

*American Red Cross Rest Station, France*
*Palm Sunday, Mar. 24th [1918]*

To Nell

Everybody is on the alert these days with the big [German] offensive on at last & the bombing of Paris all yesterday in broad daylight.

    This past week has been most interesting & I have had some genuine thrills. Last Saturday afternoon I was having a very sleepy & lazy time in the canteen when who should blow in but two English aviators, one a very handsome & very charming fellow, the other one an older man of more ordinary type. After a little chat during which I learned they were from Alvord & that we mutually knew of each other through the cadets over there, I at once invited them to have a real English tea with me. It seems that they had become very curious about the American Canteen to which all the cadets seem to streak every chance they had. Mrs. Berger & I were on duty & we had a most lovely time with the men.

*Easter Monday, April 1st [1918]*

To Nell

Everyone is on a strain these days. I dreamed last night that the Germans were moving on Paris, but the real news is that the British are holding. Trains of our wounded from the front come through every day, of course these are mostly cases from the hospitals being moved out for the freshly wounded & gassed men. Our troops are being sent up, however mostly as supports for the British than for offensive fighting, I hear.

    We have a new Canteen worker Mary Chesborough, but I believe I mentioned her before. We are rooming together now. I have a chance of getting a room at a beautiful place quite near this station. The house has a most beautiful big garden & large meadow with this river & a brook running through it & is run by charming well bred French people who have lived there a long time. If the room is big enough for two Mary Chesborough & I will still continue to room together.

*France*
*April 15th [1918]*

To Nell

Our canteen is growing in leaps & bounds. Yesterday we served 878 French & several 100 Americans. Several times lately we have served over fifty at a meal. We only serve drinks & bread to the French & only meals to Americans passing through. We have a delightfully congenial crowd now. Mary Chesboro[ugh] & I room together & expect to move tomorrow to a private house which has a charming garden.

*From Nell*
*April 19th [1918]*

Your letter of March 25th came a few days ago. The terrible slaughter goes on & we can't see why someone cannot come to help the poor British. This drive started four weeks ago & it looks as if someone could get to them.

George goes to talk to the farmers down in Dillon tonight. It's been pouring all day—so am afraid he will have no audience. Charlie Chaplin was here for the Liberty Loan parade. He stayed at the Robertsons.

We have been busy on a big order for the front packages. There were 69 of us working this morning over at Harper College.

*April 25th [1918]*

To Nell

I have just received a letter from Pinckney [Herbert]. He says they are working like the devil also seems upset that America hasn't taken a bigger part in the offensive. I suppose he doesn't get much American news. That absurd Capt. Wheat, a country Texas man, has asked me to go to the theatre to night! Tell George that I am finally veering around to his viewpoint. You know how we have always laughed about the common friends he has among men. I am beginning to feel that I have most decidedly been the loser & not the gainer in not knowing men of a different class from my own. I am getting to know some of these signal corps men awfully well. Picture Uncle Barney or Mother's faces if they knew I were on an intimate footing with the man who put in the telephone or perhaps the line.

*France*
*May 6th [1918]*

To Nell

Miss Berger very kindly let me off in time to catch the 12:30 train for Tours, where I spent my two days. It was a lovely ride down, part of it along the valley of the Loire. You could easily have imagined yourself in the States because the entire country seemed inhabited by American soldiers. They were everywhere, in fact you saw hardly any French. You passed R.R.'s built by us, telephone lines, camps, warehouses, etc. Such wonderful looking men I never imagined, so much energy & vigor in every movement.

I met the girls on the outside & we started off to see the Chateau & [town of] Blois. It was a perfect Spring day & for about the 3d time since being over here really felt that I had on too many clothes. I removed my winter underwear yesterday!! May 5th!!!

The Chateau is beautiful but you miss the setting which it ought to have. In the old days it had a big park but now the town is built up all around it. It is the most beautiful & best restored chateau in France, that is, the interior. Catharine de Medici [Catherine de Médicis] was imprisoned here by one of her sons & Mary, Queen of Scots lived here at the same time, her apartments being just over her sweet natured mother-in-law's. Catharine escaped out of the window by a rope & she must have been an agile old girl judging by the tremendous distance she slid down the rope. The Duke of Guise was murdered [here] by the King, his brother. I think that they were both sons of Catharine's. Henry of Navarre was married to Catharine's daughter in the chapel. You never saw any thing more beautiful than the tile floors & the gorgeous designs on the walls & ceiling, & marvelous setting for the rich costumes of the Renaissance.

*May 13th [1918]*

To Nell

They told me that Monroe Johnson was their Lt. Col. so I sent a greeting to him—here came a delightful letter in about a week's time. He wants me to spend my leave where they are stationed which would be loads of fun as there are a wonderful crowd of men in that regiment. However if I can get some other girl to go with me & if it's where going is possible[,] I may try it. I am due some leave after May 20th but haven't decided where to go & will probably have to go by myself. I may try Biarritz which combines the sea & the mountains—or if it is not too warm try the Riviera, however the latter would be fine for next winter.

We are living sinfully high these days. We have a delightful Negro cook named Thomas, who has been in Paris twenty years. He is down teaching Claire how to cook. Consequently this week has been like Xmas at home. Every body now eats & feels stuffed up all the time.

*St. Jean de Luz*
*May 27th [1918]*

To Nell

I didn't write my last week in Bourges because there was very little to tell about except that Alfred Huger, of Charleston came in for supper one evening. I had just received a letter from Frances Dill telling me of his being over here with the rank of a major. I had never met him before but know his wife very pleasantly in Charleston. I have also had some delightful long talks with Andrew Zundel & find him more interesting than ever. From his own accounts he was as spoilt a potato as ever was, being an only child, & it's amazing to hear of the things he has done & have him to develop into a man who gets on so wonderfully with other men. Miss Berger asked me the other day how he happened to be a sergeant, not that an officer in the outfit had the appearance or breeding of Zundel. The evening before I left he & I had a long talk & I got him on his trip up through Africa. These four fellows started in at Cape Town & worked their way up, worked in the Kimberley Mines, in gold mines, went to Victoria Falls, saw Albert Nianga & Victoria Nianga, & took 3 weeks to cross the Sahara with a caravan which also had a flock of 3000 ostriches they were driving to Northern Africa.

Tuesday—this place [St. Jean de Luz] is charming, the Pyrenees coming right down to the water. There are many lovely old homes all around the village & of course many of the natives are dark & Spanish looking. Mrs. [Louis] Taylor lives in an old palace in which the Infanta, who married Louis IV lived & they passed their honeymoon here.

On Saturday Jane [Britton] had Mr. & Mrs. McWilliams, the U.S. consul at Biarritz, Lt. Terrier & another officer, over for lunch. We had an awfully jolly time. The men had to go back right after lunch but Mrs. McWilliams stayed, so we picked up Mrs. Cochery & went to the golf Club where I astonished myself & them by a good shot sometimes. I have thought so much of all of you & Columbia since I arrived. It is just like home in the Spring. I only wish that you could be with me to enjoy everything.

*St. Jean de Luz*
*May 31, 1918*

To Nell

This is my second letter from here (on vacation). I am still having a perfectly delightful time, for so many of Jane Britton's friends have invited me to their houses. The lunch was simply delicious & you would never dream that a war was on except for 3 meatless days & a lack of sugar. All these people drink a lot of cocktails & wine so I am becoming a drunkard in addition to a gambler. No one in Europe ever plays Bridge for the game, but always for money. I am having most extraordinary luck, when I don't win I come out even!

Tuesday afternoon Mrs. Louis Taylor invited me over there. She lives in the house where Louis IV's bride, the Infanta, spent her honeymoon. It is an interesting old house, more Moorish in type, I imagine, for I have never seen any Moorish architecture. However, it isn't at all Basque, which all the old houses around here are. It is beautiful inside & the salon has one of the most beautiful inlaid floors which I ever saw. The Taylors have been collecting some fine old things so the house is very beautiful. He is a painter & has some fine paintings on the wall. John Lavery [1856–1941] comes down here a good deal & is a great friend of Mr. Taylors. Lavery has painted here a good deal. However his things are so cold that I doubt if he could handle these rich warm beautiful subjects.

There is a communist woman here the Hon. Mrs. Campbell, he [her husband] being a younger son of [Frederick Vaughn Campbell] Lord Corda [sic; Cawdor] family of "Macbeth" fame. Every one thinks she must have been a bar maid.

Today I climbed La Rhone, the big mountain near here. It is 10 kilometers from Asconi to the top. La Rhone is the last mountain in France, the others being Spain. It was a warm day & my skirt too long & heavy. As our guide was an old man, we turned up our skirts to our knees. Tell George that I may not have the aristocratic spindle but mine are admired at times. The old man remarked when we were almost down that I was a fine walker, that I had such splendid legs!! However Mme. Menderraga's were much more aristocratic.

The Belgian, Mme. Peltzer, was so interesting. They are well born people of Liege & people of means. One afternoon, just after Germany declared war on France, she was out in her motor & on returning saw two mounted soldiers in the square. She remarked to the chauffeur that, she had never seen uniforms like that, that the Belgians must have changed the uniform, there upon she made him drive up close & to her amazement they were speaking German. In a short time the Germans began pouring through & continued to do so for days. Until then they did not know that Germany had violated the neutrality of Belgium. You see the Belgian army made its stand further back.

The Kaiser afterwards occupied their house & had two cars riding the entire time round & round the house, night & day. She has some old aunts who first had their townhouse taken from them & all their beautiful things in it & now their country house has been taken & the last she heard they had gone to Brussels to try to find some place to stay.

*Bourges*
*June 6th [1918]*

To Nell

Here I am back again much rested, looking splendidly they tell me & quite ready for work. As you know I never can stand very long bridge, etc., & nothing else.

I wrote you Friday about our trip up Mt. La Rhone. The next day we took a trip to Dax. It is in the midst of the pine forest which extends from Bordeaux down to the Pyrenees & was planted by Napoleon to reclaim the hundreds of miles of sand dunes. At Dax there are some hot springs & a Roman bath, of course built by [Julius] Caesar. When an historic monument isn't B.C. it is bound to be by Napoleon. The water is boiling hot. The poor patients have to spend uncomfortable minutes in hot black mud & most of the people there are taking cures. However not our troops, but they have sweat baths cutting timbers. It is going to be good & sizzling this summer, just as if you spent the summer in Lexington County.

There are various camps of ours dotted all the way down & also Canadian companies who have been there for 2 & a half years. Our men & the Canadians are as thick as two peas in a pod & the funny part is that the Canadian baseball team has licked everything in sight "except the company we were visiting." Of course our men have a grouch because they are hopeless about ever getting to the front, otherwise are enjoying themselves.

I found that I made rotten connections getting back to Bourges unless I travelled at night therefore I decided to spend the day in Biarritz & take the train from Bayonne. It is only 20 minutes on the train from Bayonne to Biarritz. When I called on Miss McMary & the Darbys before leaving, they urged me to be sure to call on the Misses Pringle, who have a villa in Biarritz. They are the Charleston family, "the Pringles" & I had told Miss McMary how near we came to being Pringles & not Taylors. They are first cousins of Mrs. [Frances?] Pringle Ravenel who has chaperoned me several times at the Balls in Charleston & close relatives, of course, of Fanny Hume's.*

After lunch in solitary grandeur I strolled around until 3:30 when I went up to Villa Pringle. It's a lovely place, large garden & built by the Pringles. They have been living over here 40 years & are 5 sisters, only one being married & she accomplishing the feat twice! They are 4 of the nicest women above 60 whom I ever met. Much of the Charleston atmosphere still clings & all of them the image of Mrs. P. Ravenel & Fanny Hume. They showed me family pictures & asked lots of questions about the family. I could give them news as I hear through Frances Dill.

---

* The Pringle sisters were Maria Pringle, Catharine Pringle, Charlotte Pringle Radcliffe, Susan Pringle, and Mary Motte Pringle. They were the daughters of John Julius Pringle (1824–1901) and Maria Duncan Pringle (1826–1908). The family settled in Biarritz, where Pringle had built Villa Pringle.

*Bourges*
*June 27th [1918]*

To Nell

You write as if I were right behind the trenches, as a matter of fact most of the time we don't feel much nearer than you do. Sometimes some fellow drops in who is right from the front but most of the men here never smelt gunpowder. My, but you do thrill when some one tells you what wonderful fighting they are doing! The other evening a French non. com. came in & showed us a letter written him by his brother who was fighting with our men at Chateau Thierry, I think. He said that they were such wonderful looking men & fought like devils, there was absolutely no scare in them. There must have been two pages in praise of them. It was at Chateau Thierry where the Americans practically saved the day, this we hear from both English & French. They fought to a man & were not seasoned troops. The French are dumbfounded at the seasoned way in which our green troops fight & call them "fighting fools." I forgot to tell you that the French soldier also said in his letter that we were much finer fighters than the English, however I can't believe that of the Colonials. Anderson Clarkson has been at the front for some time & under fire. He seems awfully proud of his men. Inness Hartley is over here now.

My first week I was on with Marion Einsteine [*sic;* Marian Einstein?], quite a nice Jewess from N.Y. It's fine if some Americans come in but ghastly if only French, they are mostly station men. One night a whole train stopped over, that is 90 men & 57 officers, needless to say we made a night of it. The officers were in & out the canteen all night & six of them spent the night in the canteen. One was too clever & funny for words, Chesley Ker, by name, from Penn. somewhere. Four of us played bridge all night, from 12 until 5 o'clock. The others hung around & K.P.ed for us, grinding coffee, mixing chocolate, waiting on Frenchmen, in fact Marion & I didn't do a hand's turn. Well, they actually had the time of their lives, having only been over one month & ours the first canteen they had seen & we the first American women.

As we had 35 truck men to feed at 5:30 we woke them at 5 o'clock. Out came their little bags & I never saw one bag contain so many things in my life. The tin basin & kitchen towels came into play again & both men had a shave. It was too provoking to see these men in 10 minutes look as if they had stepped out of a band box while we looked like the end of a misspent life.

*July 16th [1918]*

To Nell

Our latest acquisition is a negro cook who hails from Greensboro N.C. She says that she came over with some theatrical company, she doing the dancing & singing & like all Southerners "had plenty of money before the War" but now had to take to cooking!

A train load of German Prisoners came through day before yesterday & also another yesterday. If they all look like the ones I saw yesterday, they look so mild & young, one fellow not looking over 14 years. They looked in pretty good condition. The men tell me that when first taken they were ravenous & they simply pile over to be taken. In almost every car

there is one who speaks English. As far as I can gather none seem to try to escape & in some cases the French don't even guard them.

*July 27th [1918]*                                                                    *No. 16*

To Nell

Our work grows in leaps & bounds, in fact there is a difference every week. In the first 3 weeks of this month we have served over 25,000 men & last Sunday we served over 500 meals, which does not include the sale of drinks & sandwiches to French & American.

We hear all kinds of stories from the men from the front about the Germans surrendering in numbers. But there are millions who have not surrendered. Train loads of prisoners have been passing here & a bigger fine looking crowd I never saw, no underfed youthful soldiers but mature sturdy men. They have not the beautiful figures or height of our men but are very thickset. I certainly would hate to get up against them.

*Bourges*
*August 7th [1918]*                                                                   *No. 17*

To Nell

I can picture the rejoicing in the States over the glorious news of this past week & everyone here gives us the credit of stopping the drive on Paris at [the July 18 Battle of] Chateau Thierry. The French & English can't say enough of the way our men are fighting & think of ours being pitted against the crack Prussian & Bavarian troops. The wounded have been pouring into Paris, hospitals full & at times the men on stretchers on the courses waiting to be placed.

I have moved to a charming house right on the river which has a fascinating walk running right along the bank, with lovely herbatious borders. At the end are some lovely trees making a shady little corner.

We served over 11000 meals in our canteen during Aug., also 40,000 troops at the train & heaven knows how many drinks & sandwiches in the canteen.

*From Nell*
*Sept. 2 [1918]*

George came by for two days on his way home from Boulder [Colorado]. Had two weeks of grand fishing & has gone back to plow with Alex & Jno. Daniels. Says the increase in prices is appalling. He rode on day coach for <u>4</u> nights from Boulder here. Can't you imagine how his neck felt?

Everybody we know on all sides are still sitting up waiting for weeks to do Red Cross & Y.M.C.A. work for which they have volunteered overseas.

Eliza had her birthday yesterday. George gave her a china doll that opens her eyes for which he paid $7.00 in Chicago. I almost fainted.

[Robert Archer] Cooper [1874–1953] was elected [governor] over [Langdon Dinkins] Jennings & [Nathaniel Barksdale] Dial [defeated Coleman] Blease for [Benjamin Ryan] Tillman's place in the Senate. [Niels] Christen[sen] was also defeated for the short term.

The new law is in effect, every man from 18–45, to register this month. The government has requested that no machines be used on Sundays except for business—to save gas. The result was George had a time getting to the depot yesterday.

*Bourges*
*Sept. 14th [1918]*                                                                                          *No. 19*

To Nell

Another evening we went to a café about 2 miles up the other side, Charlie Cronin & I walking & the other two riding. Another hilarious party, & the French women simply amazed at a party consisting of 3 women & one man & all having so much fun. I mentioned him before as having had a brother killed & one burnt at the same time. He is just too absurd & companionable for words & you would never believe it because he is an ordinary looking little Irishman but he evidently has a good background. He was a professional motorcycle racer & loves diamonds! We howl over his love of diamonds.

Isn't the news glorious, & to think that we are doing it!! But they say that our men fight like the Devil incarnate & no quarter given. It is curious to meet a mild charming looking fellow & hear him speak of killing Germans as he would of pigs. I received a card from Anderson [Clarkson]. He has been in the thick of it since June & not a scratch. Inness [Hartley] is in it & says his work is right behind the front lines, carrying ammunition. He has been recommended for a Captaincy.

*From George to Nell*
*Oct. 10 [1918]*

Your letter written Wednesday came just this minute. I don't want you to come back right now. Hendersonville seems to be free at present of Spanish influenza; Columbia full of it. Little Doug Sloan died yesterday; Brens very ill. Others dying here every day. Two of the children have a cold, Mariana & Eliza, and the train is worst place in every way for you and them. I will be recovered entirely by time Mariana & Eliza are over their colds. So prefer you to wait. If George Valentine comes back with it sick you had better wire me at once or rather phone me. Try both if you have trouble with either. Yesterday I walked to the post office to get your package from Anna; had to pay big tariff before I could get it, so that is why I walked to post office. Two lovely little blue woolen caps and two beautiful little red ones two. Hope one is for Ed, but maybe they are for Julius children too, also two interesting pieces of cloth with French war designs on them.

I am awfully sorry the children are sick. Mariana's cough looks bad to me, but if she is not expectorating or getting ready to she has not Spanish influenza. If she and Eliza have <u>no</u> fever they are safe. Aspirin and liquid and semi-liquid foods like very soft-boiled eggs or boiled milk on toast are the only things to do. As long as Mariana & Eliza have no fever don't bring in the doctor; he may have the Spanish influenza on his coattails.

Isn't the war news grand? Germany getting groggy evidently. Solar plexus is coming for them soon I believe. The Allies now have the punch and are pushing Germany to the ropes fast. Lord what a universal shout will be raised when the knockout does come.

*From Nell*
*Oct. 13 [1918]*

As I have no news am sending you George's letter with some news. All we can think & read about is grand war news & this awful influenza. People dying like rats on all sides of pneumonia. No doctors & no nurses.

George Valentine's brother of 36 died in Asheville yesterday after five days illness. In the east, Massachusetts seems to have had most severe epidemic. Between good war news & influenza, we are having a time floating 4th Liberty Bond campaign. I see in the papers civilians can get no milk, all taken for the camp. Fine for children, isn't it?

*October 20, 1918*                                                                 *No. 21*

To Nell

I had six trains to day between 6 & 7 o'clock A.M. & 3 were in the station at once. One train had 1400 men from upper N.Y. City & of all undisciplined troops I have ever encountered they were the worst. Even their own officers said that they had no control over them & they had no non-coms at all. I would have refused to serve them if I hadn't known they were they were probably going to be put at once in our new drive & probably most of them get killed.

Oct. 23 The most interesting [new acquaintance] to me was a very handsome Russian, Victor Sakaroff. His life history is symbolic of Russia—a tragedy. He is the nephew of Gen. Sakaroff [Vladimir V. Sakharov?] & his father was an officer killed in the Russo-Japanese war. This fellow is 26 but he looks much older & is an extremely striking looking fellow, my idea of an aristocratic Russian. He was studying medicine when the Balkan war broke out & he was swept into it & was fighting two years before this war began. His people have been soldiers for 500 years & are from southern Russia. He has 22 machine gun wounds, a bayonet wound entirely through him & one in the lower part of his abdomen, a wound in his side & his right arm paralyzed. You would never know it because he is powerful in his left hand & uses it just as we do our right. He was captured by the Austrians & says that the German doctor put pepper in his wounds. It seems too awful. He escaped from Austria by strangling his two guards with his left hand. He came to France 5 months ago & joined the Foreign Legion, going to the front at once. He has been 2 or 3 months in the hospital. He has most charming manners. If you could only hear him talk! He speaks German very well but knows little French, while I speak some French but little German. The others are always highly entertained when we begin talking & I address him as "Victor Michelovitch." In Russian I am "Anna Walterarena" [according to my patronymic name]. His mother & sister were murdered during this revolution in Kiev, his 4 brothers killed in the war & one sister who was a Red Cross nurse, was wounded in her leg & died from blood poisoning. He knows nothing of his estates which are probably destroyed & confiscated. He hasn't a cent in the world except the salary of a Lieut. in the French Army. I asked him one day why he didn't learn to speak English & his answer was a shrug & "Why? I shall be dead in 2 months!" In fact I believe he really wants to be killed, says he has nothing but a revolution to go back to, only his uncle living & doesn't know if any of his friends are living. They tell him that if he has massage & proper electrical treatment he can recover the use of his arm,

but time is precious & there seems to be no one to push the matter & have him sent to some properly equipped hospital. How I wish some of our men could get hold of him.

*From Nell*
*Nov. 5th [1918]*

Two letters written in September came last week. I was really worried not hearing for as long & was afraid maybe you had the "Flu" over there. I see Ben Beverley died on shipboard. I imagine from pneumonia.

Let me tell you the end of our summer trip. All three children & myself got sick. Eliza & myself with Flu & the others fever & upset stomachs, calomel, etc. No nurse, no cook! I phoned for George & he & Anna came up & stayed four days until the children were well enough to come home.

Cotton has fallen off about $47 a bale. All the Negroes have been sick with "Flu" & only part of cotton has been picked. George says he does not know what he will do if he splits even. He paid out $1,100 for fertilizer besides money advanced to hands, etc. The war news is fine. I do wish the miserable thing was over.

I hear in the epidemic Heyward Gibbes lost 13 out of 19 patients with pneumonia. Sister & McIntosh none. Did better than any of the doctors I hear.

I just hope you won't get flu. If you do—stay in bed—take aspirin, plenty of laxative, liquid food, as long as fever lasts. I have never heard of such a plague during my lifetime. People dying like flies on all sides.

*From Samuel [Gaillard] Stoney**
*318th Field Artillery, France*
*Nov. 7 [1918]*

I am now a Gas Officer though just what that is I don't exactly know—not chemical warfare service—just regimental. My task so far has been shoving men with #5 faces into #4 face pieces and trying to persuade them that not only were they fitted but that they were perfectly comfortable. This is varied by having 'em spit—literally spit through their flutter valves on me while I am inspecting them. You look sufficiently fool in a mask—and it certainly spreads saliva—but now I am being vulgar. For the rest I have no standing, social or otherwise, and go in fear of my life that I may really have to wear my mask for a long time and become a sort of grotesque on a fountain in consequence.

Give my very best to any Charlestonians that you see—and to those who live in the state sanctified by that city's presence all the proper compliments.

---

* Samuel Gaillard Stoney Jr. (1891–1968) was a Charleston native and author of works on lowcountry history, culture, and architecture.

*Paris*
*Nov. 27th [1918] Thanksgiving*                                              *No. 24*

To Nell

Here I am in Paris again, this time with something thrilling in view. As you know I returned to Bourges temporarily & was only there a week or less when a telegram came ordering H[azel] & me to Paris. Hazel had just left two days before for a leave in Paris so walked in to see Mrs. Vanderbilt, much to Mrs. V.'s surprise. She returned at once & said that we were selected to go up with the army of Occupation which would go into Germany! About 12 women were selected, all directresses except myself.

I am getting very much interested in the political situation over here. There is a great deal of discontent & unrest among the poilus—in fact all classes but the bourgeois who have feathered & are feathering now their pockets. Many of the French think that the most serious time of all is coming after the war. Major Hinkley is a very fair just kind of man & his viewpoint has absolutely changed. He came over thinking the French such wonders, etc., & tells me now that he has changed & thinks pretty much as I do. They only wanted us to win the war & feed them, & just as soon as that's over, clear out, & I can assure you few Americans will care to remain! It is just a case of seeing how much they can get out of us. As for the women, heaven spare us.

Two months after the armistice was signed on November 11, 1918, Taylor visited the battlegrounds she had long wished to see. Her father, Dr. Benjamin Walter Taylor, had been a surgeon in the Civil War, and his experiences whetted her interest in battlefields. She witnessed horrors of war that equaled those of war-torn Virginia in 1864. ∽

*Paris*
*Jan. 12th [1919]*

To Nell

On Tuesday (Nov. 26th) we started out in a Ford truck in the pouring rain for Varennes expecting to land in Souilly, but ended by returning to Vaubecourt & making a fresh start the next day. Varennes is in the Argonnes Forest & just below where that fight began. The town which must have been about 2500 inhabitants is a total wreck. However, a good many of the walls are standing. Just here is where you see the fierce fighting our wonderful men did. It was a dreadful sight to see those steep hills simply covered with places where our men had dug in advancing inch by inch, finally taking in a rush over the top. Probably every hole at sometime during the battle had a dead soldier in it. These hills the French had sat at the bottom of & refused to take for 4 years. They claimed that the Argonnes couldn't be taken. However, the Mort Hommes (Dead Man's Hill) near Verdun was the scene of frightful fighting, the beginning of the war & resulted in 800,000 men killed & wounded for the two armies. There are skeletons unburied there now. Next morning we started for Souilly where Mrs. Gardner said there was a building in which the Army wanted an officers club. We went to the R.C. & asked for money, getting double the amount asked for. Then we had two hectic days shopping for the Officers Club, but got everything & had them delivered, to be convoyed up.

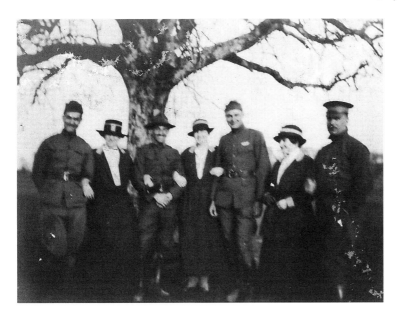

Anna (second from left) with ARC co-workers and officer friends in France, 1918. Courtesy of South Caroliniana Library, University of South Carolina, Columbia

We spent two nights in our dreadful chateau then we moved to our airy, leaky room at the club. The army finally got every thing fixed up so that now we are delightfully comfortable. Souilly was in the hands of the Germans during the beginning of the war, but not since. However, it was subject to air raids so you see the caves for refuge. Well, we returned Thursday and 1 o'clock Sunday (Dec. 8th) the things arrived, having been brought in a truck from Bar-le-Duc. We started to work at once as I decided we must open Monday evening, for the Artillery had just received orders to move & expected to get out Tuesday. We worked like mad to get things done. If you could only see how the poor fellows, living in muddy dugouts further up, come in & expand & almost purr, they can hardly tear themselves away. In many cases this club is the 1st thing like civilization which they have seen in months. There certainly is a need of such places in that God-forsaken, devastated country. I wish you could have seen all the men turn in that Sunday & help. We had Col. Polk, Capt. Clark & Lt. Henderson all sewing like mad hemming curtains & sewing rings on. They were so busy that they couldn't talk, but fully made up the next evening when we had our housewarming. Not a single man was left unintroduced to the particular curtains that these men had made.

I really made some awfully good friends & never realized how much I must have meant to the club until I decided to go to Germany. They were lovely about not wanting me to go & seemed to think that the club would be quite different. I talked everything over with Capt. Kraft & he decided with me in thinking it best to leave Souilly while I hated to go & not when I was glad to leave. My best friend is Capt. Kraft, who is the most interesting delightful man I have ever known, but alas married, as almost all the others are. How I wish George could know Capt. Kraft. Both of his grandfathers were Maj. in the Prussian army but left Germany in '48 with other fine Germans of that day. He is one of the cleanest, straightest, finest men I ever knew & absolutely worshiped by his men & officers.

*Paris*
*Jan. 15th [1919]*

To Nell

One of the first [battlefield] trips we took was with Col. Stout. He took us up to Verdun, through the city & out towards the north beyond Samogneux which is absolutely nothing but a pile of bricks & stones. The town (Verdun) isn't as shot up as you would think & with the forts, underground, 50,000 troops can be accommodated. There is a bakery which alone turns out 40,000 loaves at a clip. Just think of it. Just as soon as you leave the city limits you get out into no man's land with shell holes, trenches, barbwire on every side. In the distance we saw Dead Man's Hill, the one the French & Germans fought over in 1914. I forget when the great offensive was made, at which time the French held it for just 30 minutes. One evening a very charming General was having dinner with Col. Stout and he gave such a pathetic instance of some of the French women returning to find the grave of their dead. He was riding along towards Verdun when he saw an old French woman & a young woman trudging along in the rain carrying a small bundle & one of the grave decorations. He stopped his car & asked where they were going. They told him that they were looking for the grave of a poilu who was the son & husband of the two women. The authorities had told them that he was buried near Samogneux & they had come some incredible distance to find his last resting place. The General picked them up & took them to the village & almost the first grave they looked at was his. He said that he could not help crying himself when he saw the two women throw themselves on the wet grave in a paroxysm of weeping. He waited & took them as far along their road as he was going.

Our road wound up the hill & all along the slope were dugouts. We investigated some & really it was surprising how well fixed up they were, but at best dreadful places to live in. We saw them just as they had been left except for most of the ammunition. We saw a good many rats running around. Of course all the bodies have been buried & most of the big ammunition picked up. On top of the hill we left the car & Capt. Craddock, who didn't want to go over the ground again as he had fought all along here & said that he couldn't bear to see it again, it was too awful. Right on top were the trenches which we followed, wire entanglements, machine gun advanced posts, listening stations, all just as the boys left them, boxes of ammunition & hand-grenades everywhere. I tell you we had to walk turkey to keep from stepping on one—if we had, everything would have been over. They are thickest right by the barbwire. I brought back one of the dig in shovels & a shell (75). If we had followed the trenches about a mile further we would have found some German skeletons. The village of Esnes [en-Argonne] has nothing to mark the place unless you look carefully.

Our next trip was up to Varennes to spend Sunday with the officers of the Tank Corps. It is the only Tank Corps which operated with our forces, the others operated with the French using larger tanks. Of course they [the tanks] are all of French make. All are camouflaged & arranged on either side of the road awaiting the President's arrival, but he never came. The men were too lovely about getting one started to ride us in, they tried 20 before one would go! Finally when it was getting late one started & Ruth & I each had a ride inside, then we two & two officers piled on the outside & had another. You sit on a swinging

strap or stand in a kind of turret which has slits & turns, there is also a glass to look through. On either side are shelves of shells. They have fake slits, painted, but the men said that you could not fool the Germans, they always knew where the right ones were.

The men lived in the dugouts built by the Germans in the side of the very steep hill. They were concrete and completely furnished, even to wallpaper with giddy flowers & birds. Of course a piano was in one. They all had deep inside places of safety.

We motored through the forest, seeing signs of fighting everywhere, also took out parts in the treetops. When we were near the top we looked toward Mont Falcon & saw a most wonderful sight; the entire landscape in shadow with the hill of Mont Falcon in brilliant sunshine, the ruins standing out in a marvelous manner. Mont Falcon is where the Crown Prince had his headquarters. We went all over the chateau where he lived & climbed up in his concrete tower which is two feet thick. He also has a concrete dugout connecting with this chateau by an underground passage. Of course we explored it all. Our trip was over the ground where only the Americans & Germans have fought, also Mont Falcon. There are still shot-up tanks & overturned cars & trucks.

*From Will Beebe*
*New York*
*Jan. 21 [1919]*

I sail for Guiana on the "Guiana" on Feb. 21. I am taking nine people with me, six of whom are to stay only a month. Six or eight more are coming later, including I hope Inness if he can get [illegible word] & married before autumn. Can't you get clear? We shall stay down at least until October & perhaps keep the Station open for good. Write me to the Zoo if there is a chance this year. We shall have new quarters at Kartabo Point & a great old time.

*Coblentz*
*Jan. 27 [1919]*

To Nell

[After leaving Paris] we arrived at Metz at 12 o'clock next day where our baggage had to be rechecked. We couldn't locate any so flew back, pulled our hand luggage off, deciding to stay there until all was located, a very wise decision on our part, judged by the fate of the other girls' luggage. We had a nice walk around Metz, then took a 7 o'clock train arriving in Treves [Trier] at 10:30. Next morning we were sent on to Coblentz. I found myself well-known in Germany. I was at once greeted with "So you are Miss Taylor!" It seems that Anderson [Clarkson] was hot on my trail & was the raison d'etre of my being sent up here. Miss Heppelfinger is [illegible word] up here & A[nderson] had seen her and been doing the polite. She is a direct masculine type with really no manners, just straight up & down & terribly impressed with the military importance of everything, hence more fool rules than enough. Here is an example of them, supposed never to go out alone, can't drive with a man alone, always another woman along, can only eat at Y.M.C.A. hotels, wouldn't let us start a little mess of our own for some unknown reason, can't ride in a car, must bring along a chaperone on all occasions, etc. Everybody is disgusted because there is no obvious reason

for them. The population is more than not hostile, it is very friendly & anyhow our men are everywhere which means perfect safety for any American woman. I find my German is coming back.

Anderson [Clarkson] flew in last Friday & stayed until Monday. He had another officer with him, a nice fellow but not to the manner born, in fact very few are. We really had lots of fun & it's the first time that I have been in a sightseeing humor since being over here. There is absolutely no hostility on the part of the population & they all feel that their only friend is America and Woodrow Wilson. The territory which we are occupying is pretty well off for a conquered country. The Germans can go & come as they please, on the streets, at any time & seem to be treated in a very considerate way, which to my way of thinking is the proper way. Of course, they have to billet us & the Army takes over such buildings as it needs. However, in the British occupied territory the Germans have to be in by 9 o'clock & no traveling without permits. As for the French they are making the population feed them & keep them under pretty much the same rule as the British.

*Coblentz, Germany*
*Feb. 4th [1919]*

To Nell

Anderson Clarkson came in Saturday morning for a little visit before starting on his leave of 2 weeks. We had just heard that Nat Barnwell was here so he hunted Nat up and left a note telling him to meet us for lunch. There was a dinner dance at the Officers Club to which Nat wanted to take Margaret Davis & me, but as I said we were out of luck. However, they came for us at 11 o'clock & we had a nice little dance for an hour. The Club is one taken over by the Headquarters officers & is a beautiful place. The floor of the ballroom is wonderful & so slippery after dancing on tarpaper at Souilly that I almost fell down. About eight of us piled into some Col.'s car & were taken to our various billets. Of course Johnson [Hagood] wanted to take me somewhere but nothing doing, I have to ring him up when I know my change of shift & then we are to go out to dinner with him at his castle. Nat is also planning to have a little dinner & theatre party, just as soon as I have my evenings. Monroe Johnson is stationed not so very far from here so he is to phone him & let him know I am here. I have never been anywhere where I knew so many men. Jack Crawford isn't very far off & I saw him yesterday when he was passing through. All the men look so much older; the war certainly shows in their faces.

I have been talking to Frau Wolf, landlady, this afternoon. She says that they knew nothing of the sinking of the Lusitania & nothing of the way the submarine war was waged. Also that they never believed America would come in & when we did, could not understand, then the speed with which we got men & supplies over was simply staggering.

*Coblentz*
*Feb. 18th [1919]*                                                    *No. 25*

To Nell

Your letter telling about Lee's [Lee Hagood] adopting the Russian twins arrived a few days ago & I regaled [his brother] Johnson with its contents. Nat Barnwell gave me a most lovely

dinner & theatre party. It was at his Club, The Casino, which is a huge beautiful building & was the latest thing in sweldom up here & the envy of the bourgeois, consequently most of Coblentz was enchanted when the Army took it over for a club for the Army Hq. officers. Mrs. Perry is always delightful & Monroe [Johnson] was too funny. We went to the opera & saw "Mignon." The orchestra was the best part. After the opera I had some wine & cake in our sitting room.

We motored back to Coblentz that evening after dinner. Last night we were all invited out to a dance at a schloss, owned & lived in by some Hohenzollern Prince. He is the brother of the queen of Belgium. The general & his staff are billeted in the castle. There are two rather plain flaxen-haired princesses who peep out curiously at the strange American officers & their women. They have actually written notes to some of the officers!

As for me I never realized the plight France is in, how utterly prostrate, simply nothing left, until I came up here. I am now beginning to get sick of the personal irritation with the French & am realizing what they are coming back to. [P.S.] The A on the paper is the insignia of the 3d Army & we wear it on our sleeves.

*From Frances [Dill]*
*Stiles Point [James Island, S.C.]*
*March 2 [1919]*

Of all remarkable things! the casual way you speak of that most important thing, a "life partner," no name or anything like that. Please write a little more in detail about him, and do be sure you really love him and not "sometimes do and sometimes don't" for it seems to me it takes a lot of love to make matrimony successful. Anyway here are my best wishes for the greatest amount of happiness if you do and hoping there will be no regrets if you don't. Anyway, I know you know of my love, and interest in anything you do.

Frank Lesesne did very well indeed in France, Captain of a Negro troop which he managed beautifully. He was made, though, to black his face when he went into action as he would be too conspicuous against all the blacks, and he made one of his friends swear to wash his face if he was killed as he "would not be buried as a nigger."

*From Nell*
*April 1 [1919]*

We are now agitating a bronze tablet at Trinity [Cathedral] for the men who went from our congregation. Only three so far have died. The Committee appointed (don't faint) was Sophie Sylvan & Temple Seibels. They wrote to <u>Gorham & Co.,</u> costs about $450.00 with the 100 names, will have the insignia of U.S. on top. Certainly yours & Y.M.C.A. workers, including Mr. Finlay, should be included.

*From Gilbert Archey**
*26 Oct. [19]19*

I am just about to leave Washington for my jump west, & must send you those photos before I go. I saw Miss [Catherine] Critcher yesterday.[†] Unfortunately she was away when I called first and so I was able to see her for only a short time yesterday.

I hope your Batiks are getting along famously and that New York is not proving too heavy a weight for you.‡

* New Zealander Gilbert Edward Archey (1890–1974) was a zoologist, a sculptor, and an expert on Maori art.
† Catherine Carter Critcher (1868–1964) operated an art school in Paris in the first decade of the twentieth century and taught at the Corcoran Museum, Washington, D.C.
‡ In fall 1919 Taylor resided at the Parkwood, 40 Gramercy Park, New York City, N.Y.

WILL BEEBE HAD SPENT SEVERAL WEEKS IN FRANCE during the summer of 1918, flying as a crew member in the aerial photograph reconnaissance planes that lumbered out over German artillery to snap a few quick shots of artillery emplacements and trudge back, escorted by fighter planes. The unwieldy planes, protected by their small escorts, reminded him of parasitic cuckoo or cowbird nestlings being fed and cared for by their tiny-warbler hosts. This eccentric friend visited Taylor in France, and they planned another South American expedition. ∽

# 9

*Back to British Guiana, 1920*

ONE GAP IN TAYLOR'S CORRESPONDENCE extends from the summer of 1919 to January 1920. During those months she resided at the Parkwood Hotel in New York City. She reconnected with her Provincetown and New York artists' circle and was busy creating batiks based on artwork from her British Guiana expedition. She learned of Beebe's plans for a 1920 expedition and joined the group of Inness Hartley, Alfred and Winifred Emerson, John Tee-Vann, and J. F. M. Floyd as an unpaid volunteer. The staff artists were Isabel Cooper and Mabel Satterlee. Taylor's willingness to work without a salary and even to pay for transportation, room, and board affirmed the value she placed upon scientific illustration and the natural world as subjects of art. She painted and drew plants and animals, collected specimens for the Charleston Museum, and painted on her own. Several letters contained drawings of campsites and renderings of flora and fauna. Few of her scientific drawings survive, but fortunately she used them extensively in her batiks and prints.

Traveling south, she stopped at Saint Thomas and Saint Croix in the Virgin Islands, as well as the French Caribbean islands of Martinique and Guadeloupe, and busily painted. The journey whetted her appetite for a longer stay in the Caribbean. ∽

*From Will [Beebe]*
*New York*
*Jan 2, 1920*

Happy New Year to you. I am planning to sail about April, and Agnes [Hartley] & Inness [Hartley] have decided to go with me "on their own." No wage money will be available until next year, so we will have to crawl along as best we can. The average cost last year was $20.00 a week, which I charged everyone except John [Tee-Van] and Isabel [Cooper], who are on salary. I am planning to put every penny of my own into a movie camera this year, & try to get rare splendid pictures of hoatzins, army ants, etc.

Do you want to go down? I shall probably put up a big tent for overflow cots & hammocks, & you girls can have that for your boudoir or one of the big rooms as you wish.

I hope Prof. Britton will come down this year, & I believe he will be tremendously interested in any botanical work you do. I started Isabel on it, but had to lend her to Lualui's[?] eyes, as more important to my work.

*From Bertha E. Perrie [1868–1921]*
*Arts Club of Washington*
*March 8, 1920*

I find we shall have to change the dates of exhibition in April as one that was spoken for Mr. Marrin's [*sic*; John Marin's] drawings—which has been in different museums and will be here soon, will have to come immediately after the Society of Washington Artists April 10th to 20nd [*sic*] and put yours up on April 23rd Wednesday to April 30th Friday.

We have just opened the Exhibition on Saturday with a large gathering of friends. The Society always has an opening day. But the other exhibitions usually do not unless the exhibitor wishes it and arranges it for themselves.

Do you expect to come on? Please let me know and can you give me an idea of how many things you will have? Perhaps if you come on you would care to arrange them yourself on the walls. It would be a good idea. I am sure Mr. Baker's portrait is very fine.* He is a genius isn't he—the real thing and I think so interesting. I hope he will do some sculptures—not the queer drawings but lovely figures like the ones he did years ago—they are so poetic and beautifully modeled. The War upset him and I suppose made him draw those curious things—exquisitely done but so queer.

* Born in London, England, Robert Peter Baker (1886–1940) was a Boston-area sculptor. A pacifist, he immigrated to the United States to avoid military service in World War I. He created busts of Taylor's father and her cousin Ray Taylor and in 1920 was at work on the Great War memorial for Trinity Cathedral in Columbia.

*Saint Croix*
*May 15, 1920*

To Nell
We are now at St. Croix, having made the trip during the night. Just now I am waiting for the boat to take us to shore, I to paint & the men to go fishing.

Our day in St. Thomas was most enchanting yesterday. It is certainly the most beautiful group of the West Indies, though I haven't see Martinique yet.

After a long search for an umbrella I finally located one & armed with it began to climb the high hills at the back. It was a hot rough walk but I felt more chirpy with each yard, for I felt too cramped & horrid for words after our six days at sea.

For one thing, as you have heard me say before, the Negroes occupy a much better position here, in the Indies, than they do in the States. There are many old self-respecting Negro families in all the Islands who are merchants, clerks, professional men, etc. Now these people demand & receive the very best treatment, & furthermore have exceedingly good manners, in fact all the Negro leaders are much better mannered than our Negroes.

Today we are lying off Antigua & have been waiting since 10 o'clock for a launch Will ordered [the captain?] to take us to a dandy bathing beach where we expected to spend the day. Had a wonderfully interesting talk with a French man, Count Saint Croix de la Ronciere, who is from Guadeloupe. His father came out as a young man. He looks as if he might be "de couleur." I have never heard a foreigner speak with such fluency in my life, never hesitates for a word & talks at top speed. He gave me a most wonderfully interesting account of the [1902] eruption of Pelée. He was in Guadeloupe & immediately chartered a boat & went to St. Pierre which was completely destroyed. There people were more fortunate than those of Pompeii, for these died instantly. A friend of his lived near St. Pierre & saw the whole tragedy. He said that suddenly a huge ball of fire composed of gases & vapor poured out of Pelée, & after remaining suspended over the summit a few minutes rolled down the mountainside on the city. Almost immediately with the horrifying spectacle of the suspended ball of fire there went up the most bloodcurdling sound of wails & screams which continued until the ball reached the city, & an instant afterwards absolute & utter silence. Then a terrible earthquake, followed by a tidal wave, the latter sweeping everything as clean as your hand in some places. The only human being left alive in the city was a Negro criminal in a subterranean cell.

The Negro was found after being undiscovered for three days. The only opening was a little window about 2 ft square, way up above his head. All he knew was he heard the screams then a few minutes after a flame came in & swept around the cell, burning his face & arms. He fell down & knew nothing for sometime. He had only a little water & bread on which he lived until located by his groans. Barnum had him in his show for three years!! There were no records of his crime & he never told, so was freed. The mountain in very early times was called by the Indians "The Mountain of Fire," although there couldn't have been an eruption since many centuries. There were forests up the sides & a lake in the crater. For a month before the eruption there had been rumblings & earthquakes, much more than ever before.

Next fall on way home will stop at Martinique and paint.

*Georgetown*
*May 29 [1920]*

To Nell

When I last wrote I hadn't landed at any of the French Islands. They are enchanting not only in their natural beauty but also in the dress of the natives & the towns. The women are wonderful in their brilliant head handkerchiefs tied in fascinating ways & their Mother Hubbard effects in bright calicos. The market was a sight to behold.

I spent a morning & afternoon wandering around the little town in Guadeloupe & managed to get two good thumb box sketches.

We didn't get to Martinique until 2 P.M. so it was too late for us to consider going to St. Pierre which is some 30 miles away over mountain roads. I got up early next morning & went ashore at 6:30 in order to make some sketches in the market. I managed to get two done before 9 o'clock, when I had to get back to the ship as we were sailing at 10 A.M. I am

thinking of stopping over between boats at Martinique next fall & do some painting. We only had a few hours stop at Dominica so didn't have time for a trip into those lovely mountains as I did with Nickie & Mr. Greenwood. We also stopped at St. Lucia. I stayed down to paint the flamboyant tree & also to see Mr. Rodway, the funny little man at the Museum who knows all there is to know about the botany down here.* He married a woman who had Indian, Negro & coolie blood. Consequently he has an ethnological type among his children of every race! He has been down here 50 years!

I am having a delightful stay here in Georgetown & have found myself so busy that I decided to catch the Thursday steamer instead of the Tuesday. It is lucky I did for now the Hartleys will go up on that boat. My day's program is to get up at 6 A.M. & a little after that time the maid brings up my coffee & fruit. Then I start out with my sketching things & go to the market & paint some interesting flamboyant tree. If I am doing flowers, as I have been doing the last two days, I work here. Our trip was cool all the way down through the islands, & of course everyone told you how awful the mud flats of Demerara are, the best thing being something awful. I arrived to find Georgetown much more beautiful than I remembered & the flowering trees wonderful. It has been a very late rainy season, in fact it has just begun so I am here exactly the season for flowers.

Sir Charles & Lady Major are here so I had dinner there, en famille, the other night. The Majors were having fits because of the Governor's Ball this Thursday. He had to dance some formal dance with Mrs. A. P. Brown, the de couleur wife of the Negro M.P.!!

There is a most fascinating sounding character by the name of [Henry P. C.] Melville. He is a man of 60, a southerner by birth but his people moved to Jamaica after the war & he is a British subject. He has been all over the world, finally settling up in the interior & raising cattle. He & two other men own something like 20,000 sq. miles of grazing land in British Guiana & Brazil!!! He is married to an Indian & sends his half-breed children down here to be educated. They say that he lives in perfect comfort up there, having about six English & American men as managers & cattlemen. The cattle trail leads down through the bush for many miles until the cattle are put in river steamers. It takes six weeks to go up there & only two to come down because they shoot the rapids on returning. How I would love to take the trip!!†

---

* James Rodway (1848–1926) was the author of *In the Guiana Forest* (London: T. F. Unwin, 1894) and *Guiana: British, Dutch, and French* (London: T. F. Unwin, 1912).

† Dadanawara, or Melville's Ranch, is one of the largest cattle ranches in Guyana. It is also an international resort.

*Katarbo*
*June 6 [1920]*

To Nell

This place is a wonder, simply not to be mentioned in the same breath with Kalacoon. The house is smaller & not so good but the situation is superb, right on a point with a big river on each side & looking down one a mile wide. You step right out into the jungle, but not the primeval jungle, for that is six miles away.*

Any overflow of men & women go either in our tent or Johns. The bathing in the river is delightful but we can only go in at high tide (2½ miles up river). It simply makes life another thing, & then we have none of the awful glare of Kalacoon—in fact a little more light wouldn't hurt. It is delightfully cool. I sleep under an army blanket & my Roman blanket, yet am not perfectly comfortable early in the morning, not a mosquito or fly. We keep a lantern burning outside the row of tents to keep the vampires off. No red howlers have come right up yet, in fact the game is scarce just now. We generally live on bush game, but Will hasn't been able to find an Indian hunter yet because most of them have gone up in the bush hunting diamonds this time & not gold. Consequently we are getting meat from the Settlement, but do get fish caught in the river sometimes.

The rainy season is late this year, lucky for me so that I can complete the life history of most of my plants.

Have jumped in full tilt, more work than I can possibly do, everything seems blooming at once. We are getting fixed by degrees. Dr. W [William Morton Wheeler, 1865–1937] has found 61 species of ants!

* Taylor included a floor plan of the headquarters, a drawing of the campground, and eleven photographs of the staff.

*Kartabo, British Guiana*
*June 12 [1920]*

To Nell

We are now settling down into our routine of work which is getting up at 6:30. We sleep in a tent & dress in the house, consequently have to air ourselves before the entire male population clothed in wrappers & alpagotos which are the slippers the natives wear. I sometimes take a stroll around the clearing where I find loads of things to do. In fact I feel quite snowed under, there is so much—a lifetime is nothing to put into this work. I have done three studies larger than anything I did before & feel very much encouraged for they look stronger & more direct in treatment than those I did before, however they were all vigorous kind of flowers. However the other one I did was a very delicate & subtle specimen, one of the Bignonias (like our trumpet-vine). Am having rotten luck trying to identify the flowers in this Manual of the British West Indies. For example there are some 20 Bignonias here & he has about six. Again with the Allemandes, there are several & he has only one. I am sending specimens down to Mr. Rodway & getting him to identify them for me.

I work until 11:30 when everyone for the past week has been bathing (in the mile wide river). The tide is supposed to change like all tides, but somehow we went in the same time for a whole week, however today we started at 3 o'clock. It is simply marvelous to have this swim in a fresh water river. This alone makes Kalacoon seem like an impossible place. After lunch everyone gets back to work until tea at 4 o'clock, after which I go for a walk in the jungle armed with a butterfly net & a bottle in which to put the specimens. I am collecting butterflies for the Museum in Charleston. After dinner we all do some writing.

Isabelle [sic] Cooper does all of Will's drawings, mostly the heads of snakes & also frogs & caterpillars. She is the most self-centered person I ever saw, but much easier to get on with

than I expected. Alfred Emerson is working on termites, the white ants which live on wood! He seems to discover marvelous things everyday. Today he discovered intestinal worms in some termites & they were unknown before. Winifred, his wife, is doing the dissecting of the birds for the men. Inness is working along his old lines, John Tee Van on butterflies, I on flowers, & Agnes Hartley is trying her hand on insects of some kind, ants I believe. She can't do much as she hasn't the education but she has to have something to interest her. One of the studies which I did is the Mocca-mocca [also called mucka-mucka, a reedlike plant], on which the Hratzers feed. It grows on the edges of rivers & is one of the main means of holding the shore & making new ground.

Bauxite seems to be the booming business down here. L[loyd T.] Emery says that there is more here than any other part of the world, as far as it's known. There is only about enough in the U.S. for 10 more years work.

*Kartabo*
*June 15 [1920]*
To Nell
We are all settling down into regular work & our days are very full. On Sunday the Emersons, Hartleys & I had the boat & went some four miles up the Cuyuni River & landed. It was low tide so the landing was muddy to say the least. I was the first girl to get out & stepped, as W. directed, on the slippery muddy log & the expected happened! There was no trail to follow, just cut our way through. The forests are not as beautiful as the woods at Kalacoon, for these have been cut over, all the huge mora trees with flying buttresses are gone. The Emersons went off hunting termites & Agnes & I trailed after Inness.

Inness was looking for gourds & studying birds while Agnes & I were out for butterflies & flowers. I am getting quite expert catching insects & can see a flower a mile off. The amount of work to do is overpowering. I find it almost impossible to identify the flowers in the manual Will has, unless it belongs to some very distinctive family. So I am sending the specimens down to Mr. Rodway to name.

Inness went ahead armed with a knife & cut the trail, cautioning us not to step on a bushmaster after informing us that one cannot tell them from the leaves!! The place to get butterflies are the spots of sunlight in the forests, so Agnes & I would stand guard over a spot & sometimes get insects & sometimes not. It is very difficult to catch the beautiful blue butterfly, the morpho.

I got lots of beautiful flowers, one a lovely begonia. I could only get two studies done yesterday & today, for the flowers don't keep. I get the drawing in as soon as possible & then work from memory to a certain extent. My experiment of working on tinted paper, using white water colour as a medium, seems to be working out splendidly. So often white flowers are not suited to using ink line with & working in this way gets around that difficulty. We are all so scientific these days that yesterday when a strange humming sound was heard under the house all the men jumped to attention, then rushed out to find the strange new bird or animal! As they rushed by the little half-breed girl who was paying a visit, she remarked in a low voice, "It's my brother with a top." However the eager scientists never

noticed if they heard, but eagerly followed the new sound, then came to with a start when the trail led up to a humming top! I simply whooped.

*Kartabo*
*June 22 [1920]*

To Nell

Life is really getting more and more interesting as we get deeper into our own work & more in touch with the work of the others. Such conversation as goes on! If we only had a dictograph & could record everything!!

By degrees we are becoming familiar with the various pet words & expressions of the members of the party. Inness has developed a penchant for "nit" & "fetid," everything is a "nit" & just as soon as any odor is off the sweet it becomes "fetid." Alfred gets a whole batch of new termites & one hears, "Oh! the cuties, little dears, etc" as he pours over the microscope observing their gyrations. When at white heat of enthusiasm he calls on Will to come & take a look. Again it is when he discovers some intestinal flagellates in their insides, & never before has such a thing been found. The other morning Sam the Negro major domo came in & announced that there was an ant movement in progress. Will & Alfred made a dash & then returned to finish breakfast, having a heated argument the whole meal as to whether the rare movement should be stopped at once as the house was in danger or whether an hour or so of observation would make no difference. Personally I considered Alfred right, who didn't wish them disturbed. Will gets the wildest ideas at times! This is the first time recorded of a whole termite nest moving bodily. They found queen, king & guest beetles all in the procession & got some movies of the whole procession. The guest beetles are curious little creatures which during the ages have gradually acquired the characteristics of the termites, their wings have become rudimentary & I could hardly distinguish them from the ants. Very little is known of them or their habits & no explanation of why they have become guests. The queen was found to be laying eggs, which process Alfred observed & timed under the lenses.

Of course you hear shouted all times of days, "Are they molting? What sex? Are they breeding? Save the stomach! etc!"

Isabelle is so in love that if she ever had any sense of humor it's departed, & Winifred never has had any. The other evening we each had a little drink of rum & at once proceeded to get in a gala. The more shocked Winifred became the drunker we got. A few nights before we had some absurd little fish which were caught in the river. They had a way of swelling up in the most extraordinary way when touched. John & I tried to make them puff up by tickling them but it ended in our killing them. Consequently I instituted the game of trying to make the girls puff up like the fish. It was a quite a success as a sport & convinced Winifred that we were off our heads.

Am getting a good many flowers done, & with Mr. Rodway's help don't feel quite so at sea.

*Kartabo*
*June 28 [1920]*

To Nell

The expected has happened with the bride. For the last ten days or two weeks has been ill & finally thinks it is indigestion & the tropical climate! I am awfully afraid that she will play the devil with herself taking medicine. None of us dare suggest the other to her & we can't make out if she knows. I did suggest that if she didn't get better soon to go down to G[orge-town] & see a doctor.

Mr. Rodway wrote an encouraging letter to me about my Botany. I am getting some idea of the big families down here. Have done some very interesting studies & everyone seems to like them.

On a trip up a creek the other day we stopped at an Indian settlement. It was very interesting seeing how they lived, absolutely no change since Columbus, except the clothes & an iron pot. They were making pievarri, their drink made from cosavo [cassava]. They were also preparing the cosavo for cakes. It is the poisonous cosavo which they grate on a roughened piece of wood then put in the long basketry tubes, pulling these until all the poisonous juices are squeezed out. Then it is made into their cakes & dried in the sun.

This weather is frightful on drying flowers. All of my specimens are moldy.

*Kartabo*
*June 30 [1920]*

To Nell

One of the lines along which Will is working is making a comparative study of the syrinx of the different birds. That is the organ of song. Last year several birds were placed in different genera owing to their work.

Night before last I expected to pass from this world! It seems that army ants were sighted in the clearing so everyone was on the lookout for them. I, having no mosquito net, could only know of their presence when they should begin to chew, however they were diverted and invaded some part of the forest. While writing last night we heard a near scream from Alfred [Emerson] which was the result of a tarantula dropping on his arm, no harm done though.

*Kartabo*
*July 14 [1920]*

To Nell*

It rains every day, consequently I don't get in the forest everyday and then it seems to be in between the flowering season. At least there are plenty of flowers, but no very decorative ones. However the longer I work the more interested I become, but I must say that it has been a case of my working it out by myself as Will shows very little interest in plants. He certainly is a queer duck! His interest will increase now that the Harvard men have arrived on the scene and have seemed to find it of interest and have been most forthcoming, which state of mind I hope will keep up for my sake, also will show Will I can do work with no

assistance and have it worthwhile. Tomorrow I shall get Bailey [Irving Widmer Bailey, 1884–1967, Harvard University botanist] to criticize it from the scientific angle. He has been very kind already, not only about my stuff but in explaining his particular problem in such a way that I can understand. He is working on the relationship between flowers and insects, therefore is a botanist but says he is no systematist. It seems that the very common tree down here, the cecropia, has developed a relationship with a family of ants in order to protect itself against the leaf-eating ant which is very destructive, eating, or rather cutting the leaves off a tree in one night. The growth of the plant is very much like the bamboo, having hollow divisions in the older parts. There is just one spot on each node which is quite thin and the ants cut through, put a queen inside and begin a nest. These ants are great fighters and attack the leaf cutters on sight. Now the plant secretes a number of little glands just under the place of the leaf attachment and the ants feed on them. There are several problems connected with this which he is working out.

Nothing exciting except that Alfred was bitten by an amphisbaena which is a kind of lizard-snake effect. He had just caught it swimming in the water and was holding it while John was getting the box ready, when it slipped through his hand and proceeded to nab his finger, and a good hard bite it was. It was very rare and he didn't dare let it go, a martyr to science!

* This letter was typewritten.

*July 19 [1920]*

To Nell

My darn little Corona [typewriter] is working so badly that I can't write on it, I will have to take it down to Georgetown & have it gone over thoroughly.

Bailey is the usual type of a rather brusque Yankee, very nice otherwise. He seems to be making wonderful finds among the Cecropias ants. I will make some drawings of the interior of the internodes which can't be photographed very clearly.

*From Nell*
*[Columbia, S.C.]*
*July 19th [19]20*

Now that all the trouble about getting the monument [created by Robert P. Baker] is over Julius moves it to his house (for which I'm most delighted) and is asking people there over night to see it. A good idea I think. He told Geo[rge] he thought it too fine for the [Trinity] church & thought the State House the place for it. G. suggested that it better go where it was designed for. He has written Baker to see if he cannot make a small one for himself, for his house I suppose. G. says he's getting to be a regular Lorenzo de Medici. He was here last night when we were eating supper and got furious because I had sugar in the bowl they gave me two years ago. I told him I thought people ate off of the most expensive kinds of china & pottery if they wanted to!

*Kartabo*
*July 26 [1920]*

To Nell

How often I have wished for the children. We have three baby monkeys! I had written you already about the African monkey from St. Kitts who is very shy & suspicious, even after two months of captivity. But now we have the dearest little Cebus, called "Jello." They are the easiest to tame & this one is just as gentle as can be, but we haven't tried to do more than stroke it because it was wounded in both hind feet & has been more or less sick. It has finally begun to eat, but at first no work was done in the laboratory for everyone piled out to see the forced feeding. John would hold Jello while Will poured milk down his throat with an eyedropper. Every time he opened his mouth to howl, down went a dropper full of milk. He now eats papaws, bananas, potatoes, rice & bread. Then the Indian hunter brought in a young howler who is most amusing, makes the weirdest noises you ever heard. He never has been off his feed but began eating rice, milk & potatoes at once. No red howler has ever been kept in captivity, but the way this young one has taken to food makes Will hope that he may get this one up to the Bronx Zoo.

Dr. Bailey has been finding other species of plants which are inhabited by ants. In this case the plant has an enlarged mid-rib of the compound leaf & the same species of ants which inhabits some of the cecropias also inhabits these plants. In all the plants there are little scale insects called coccids, which the ants tend. The ant digs little pits & plants the coccids in them, & the insects live on the juices secreted by the soft tissues of the plant; the ant strokes the coccid with his antennae & sucks up the juices secreted by the insect. In some species the mid-rib is hollow clear to the end. In these plants there seem to be no food bodies on which the ants feed. I have been making a drawing of one of the leaves showing the opening used as entrance & other holes where they have cut through the wall to the outside by mistake & had filled them with bits of pith. They seem to dig their pits & groves between the vascular bundles.

I am now sleeping in a tent more like an umbrella than anything else. It is just big enough for my cot & a box.

My specimens are drying much better owing to Dr. Bailey's suggestions. In fact they are turning out pretty well. The very fleshy specimens are put in some solution to preserve them instead of trying to dry them. All this rain has brought out the new leaves on many trees & the forest looked like a beautiful rich carpet ranging from bright green to a red, pinkish brown.

I am expecting money from Beverley [Herbert] in this next mail. I have no idea when I can get a boat back or if I can arrange to stop in Martinique as I planned. I will return in Oct[ober] if possible.

*Kartabo*
*July 29 [1920]*

To Nell

A new man has arrived on the scene; he is Mr. [J. F. M.] Floyd, connected with the University of Glasgow. Seems about 30 years old, big fine looking fellow, not particularly refined in appearance. He only came last night so we haven't doped him out yet. He is to work on embryology.

Bailey & I go around & work a lot together. He certainly is a peach of a fellow. He thinks that we have found a new species of Marcgraavia, this one blooming much later than the other M. umbellata & very purple. I have made a painting of each showing the difference in color & form, then we are to have a series of drawings showing the developement of both. We can't find it blooming, it is either in a stage of being just about to bloom or of having been fertilized. We are going to bag a lot to see if they fertilize themselves or if it is true that the hummingbird fertilizes it—as commonly supposed. We have seen the birds sucking the necteraries of the M. ruyschia but not the M. umbellata. I have gotten dried specimens of nearly all my photos, something over 50. He has about 250 specimens for the [Harvard] Herbarium. He is going to take them back & give them to the Herbarium man & have them identified & photos taken of the shrubs & send them to Will.

I have more fun with Bailey. He simply doesn't know how to take me, never knows if I am joking or not, consequently I have gotten some good things off on him. We frequently retire to the Hartleys' tent just before dinner & have gay times. If you could see Dr. Wheeler pussy-footing around the laboratory & picking ants & insects off the panes of glass. He is so expert these days that last night ants kept crawling over him all night & he identified the species by their crawl. He has been working on a tree cut down & he has found 59 species on the one tree!!

So Julius got off on the books & china tangent. What did George say? While this whole lot isn't worth the [Thomas] Sully [painting]! Well I must get down to the Mora swamp & paint.

*From Robert P. Baker*
*Boston, Mass.*
*2nd August [1920]*

Thank you very much for your nice long letter. Your description is fascinating & quite clever.

I am looking forward to seeing some intoxicating & lascivious details of wonderful flowers, insects & landscapes. Those tropical flowers & their gorgeous array are enticing & gloriously wicked just like women are, almost more so—flowers have a feline psychology, they are courtesans—they toil not, neither do they spin.

I resent the impeachment that I care too much for money you are having a bourgeois paroxysm about. The stuff it isn't that I care for it. You insist on having the ridiculous stuff in our system of life & anyhow I haven't got any. I'm broke—now will you be good?

Now I suppose I've compromised as you asked me to do. You think you can see it in my work. Well anyhow the commission I executed for your family is as good as [Augustus] St.

Gaudens would do, that demigod of bourgeois respectability. My renaissance is pretty good considering the lack of harmony I've endured. It is an effort on my part to be normal & in these abnormal days of the New Era it is not easy to discover what is normal except by harping back to the pre-deluge days of St. Gaudens.

The post-bellum flappers of sixteen interest me considerably. There [sic; their] modesty is conspicuous by its absence & strange to relate. I thoroughly enjoy their emancipation but they are silly, shallow, inane, asinine, & therefore do not hold me beyond a spasm—I took lunch at Mr. Hall's House at Gloucester the other Sunday, quite a wonderful house. Mrs. Hall is quite a personality. The soap stone carvings are delightful & the little porcelain Chinese gods & godettes give a bizarre & palsied quality like the fainting breath of a mad tiger lily.

I am trying to model Ray [Taylor] & let me say it, it is awfully difficult & she sits as still as an explosion of dynamite. However if I succeed it will be worthwhile to hear you condemn it—that is your mission on Earth—only please use that unrespectable language that you write about in your letter. Hope to see you soon. Cheerio & many thanks for your favours.

P.S. [August 30] I have discovered this drivel in my pocket & hasten to amend it.

Ray's portrait is finished in the clay & is about to be cast in bronze. I have unscrewed the inscrutable & succeeded in getting a compliment from [Ray's mother] Mrs. Tom Taylor. Speaking ex cathedra the result is quite charming & entre nous, also respectable, & for that reason I must be careful to evaporate into the blue haze when you cast your connoisseurish optic upon it, as I am anxious to continue living merely out of pique.

*Georgetown [British Guiana]*
*August 3 [1920]*

To Nell

We have another monkey! A little sackewinki [squirrel monkey] (have no idea how to spell it so am doing some phonetics) which is full grown. The Indians brought it in, having wounded it slightly with an arrow. It's almost too much monkey, for our end of the laboratory smelt all Sunday horribly of the monkeys, just like the zoo. I smoked cigarettes all day to drown the odor. "Georgette" the howler, is still as grumpy as ever but doing well otherwise. "Jello" is very tame now & is going to be a joy as he loves petting. "Jimmy" is as stupid & greedy as ever.

The others paired off, but I strolled alone along the forest road. It is not as open as I had remembered & not so many big trees. One is so surrounded by people, about as much privacy as a goldfish, at Kartabo that it was with a sense of relief that I got away from them all & strolled along the Agolath road. I noticed a Malostima with an enlarged petiole & on examining it found that it was in flower, however the petiole didn't seem to contain ants. I picked it thinking it was exactly like the plant Bailey was scouring the country for. If you could have seen the joy with which he clutched it for it was his exact species & above all in bloom! It was harboring ants but in the dark forest I didn't see the species. I was the only one who made a real find.

Will declares that he can get passage for me in October but no chance of stopping at Martinique, however if it's not too expensive I think that I will go down to Surinam (D[utch] G[uiana]).

*Georgetown, B.G.*
*August 8 [1920]*

To Nell

Georgetown is lovely & the flamboyant trees are still in bloom. I am doing some big things & also some thumb-box sketches. I find it very cool and nice, a fine breeze most of the time, but these people think that it is quite hot just now. I tell them just to come to South Carolina & spend a summer.

You know I am always having more or less interesting experiences with Englishmen. Well this time it's the botanist, Stell[?], an Oxford man. Not particularly attractive person, but it makes my visit down here rather exciting.

Upon inquiry I found that Sprostons (big company which operates in all ways) was culling timber at Neismar, which is just a day's journey up over the interior, a steamer running most of the way. One hot afternoon I took myself down there & had an interview with the manager & it seems as if it's just the place Bailey would want & had been looking for. I got all the details as to expenses, permission & wrote him to that effect so he may be down on the next steamer. He certainly wears well, a peach of a man to be out in the open with, but no drawing room man, no small talk. His father [Solon I. Bailey] was an astronomer and built, & was in charge of, a big observatory [Boyden Station at Arequipa] way up in the mountains of Peru. The first part of his life was spent out there. Just my luck, he is married!

*[Kartabo]*
*August 19 [1920]*

To Nell

Somehow the work I did in Georgetown looked so strong & brutal, however it may look different when I get back to America. If you could have seen me start for Kartabo. I had nine bundles consisting of a clothes bag filled with loaves of bread, a large glass affair filled with notes & plants containing some of the huge tadpoles found in the trenches about the town. Will wanted to study their eyes. Of course baskets & crates of fruits & vegetables, easel, canvasses & my bags! There were actually ten white people on board & one was a huge fat man dressed just like a racetrack man, had on a huge plaid suit, green socks & other things along that line. He was most talkative so was soon talking to me.

I am finding my work more interesting & Bailey & I are getting along famously. We go out everyday getting specimens, mostly skirting the riverbanks in the canoe. We are pressing a lot of the plants in bloom here. He thinks that we have found a new species of the curious Marcgraavia umbellata.

*Kartabo*
*September 5 [1920]*

To Nell

Bailey has finally found the Marcgraavia umbellata in bloom, & it is evident that the drawings of it were merely imagination. It is not fertilized by hummingbirds because it blooms at night, sometime between six & 10 P.M. He paddled over about nine o'clock & the flowers were in bloom but most of the pollen gone & insects flying around. The stamen fall before morning. They found a bee which bored a whole in the nectary. This is a profile drawing of the fruit & flowers.* They grow in a circle making a wheel & underneath hang the nectarines, about 5 or 6 in the green M. umbellate. In all the other descriptions the stamen are said to be yellow, but in fact they are red when mature.

Dr. [William Morton] Wheeler is really charming & a most delightful raconteur, his anecdotes of the great scientists from [Louis] Agassiz to the present time are a liberal education in itself. Agassiz seems to have had quite a habit of not only stealing collections but of stealing the credit for other men's work.

The new man, Floyd, seems to be half English & half Scotch. He stopped several days in Georgetown & we are sure that he was stuffed full of all the gossip about the station, past & present, so his eyes are popped & ears flapping for all kinds of interesting peculiarities & lack of morals too, I imagine! He seems very quiet & reticent but sometimes thaws a little, on painting with me. He has evidently worked a good deal in watercolors & from something he did I imagine he is quite artistic. But his fingernails! He seems very neat in other respects.

The Harvard crowd leaves tomorrow & I shall miss them awfully, for I have seen more of them than any of the others have.

* Taylor inserted a drawing of the fruit and flowers of the *Marcgraavia umbellata.* She later used this flower design in prints and in batiks.

*Kartabo, B.G.*
*September 9 [1920]*

To Nell

It would have been great going back with them for, of course, Bailey & I are great friends & Dr. Wheeler seems to have developed a real affection for me. (They are part of Harvard group.) He's a nice old sport. Needless to say Bailey leaked everything to me so I was highly entertained knowing the inside workings of the Harvard crowd. Will, as usual, made one of his bulls. One day the triumvirate (Isabelle, John & Will) thought that Bailey had gone out instead of which he was seated on the steps working, out of their sight. They got on him & finished him up in proper style! He told me about it, highly amused, & was big & fine enough to overlook personalities, for I heard him afterwards offer to do various things to help Will along with the Station, even offering to stop over in New York & see some man specially! Now Will seemed to want to stand in with these men, for their coming down means a lot for this place. In two weeks Bailey had gotten enough material to make his trip worthwhile & Wheeler the same way. Wheeler ended by finding 67 species of ants on the

tree I wrote you about. The Englishman [Stell] seems to be thawing a little, actually got funny with me! However his nails are still the kind Edmund used to have before he began cleaning up for the girls. It is extraordinary because he is quite neat otherwise. However he is very British in not waiting on & helping the women as much as our men do. He never thinks of helping me in & out of the boat, & if there is a vacant chair he expects you to take it, never thinking of offering his comfortable one, if he happens to be in one. The other day Bailey, Floyd & I went on a long walk down the Peruni Trail & I think he was quite disgusted because Bailey always waited until I came up to help me up & down ditches, over trees, etc.

I am getting anxious to go home & hope that I can get passage the 1st of Oct. If Tom & Sue [Ames Taylor] are still in Boston I think that I will run up there for a few days. I am crazy to see some of [Robert B.] Baker's things & also the work Wheeler & Bailey are doing at Bussy. I want Baker's criticism on the things I have done here. The only flowers blooming now are in the high trees & I have pretty well done all the decorative flowers around here. I am pressing all the new ones I can get, but few are interesting. Am working on sketches of the big trees but I have really all the material I want. Did you ever hear from Alice Atkinson? I sent her the batik clothes she wanted & hope they weren't lost.

*Kartabo, B.G.*
*Sept. 9th [1920]*

To Frances Dill

My plans are uncertain because I don't know when I sail. The agent wrote that he could get me passage in Oct. but couldn't name boat or date so I am awaiting his reply.

This place is a wonderful spot for a station. In two weeks those Harvard men got enough new material to make the trip worthwhile.

Rachel [Hartley] was told by Charlotte Nolan that she had to have an extra teacher & had no room for her. Mr. C[hase] has made other arrangements & wants Rachel to come back but R. is holding back. She would be foolish not to go for it is a wonderful market for her pictures. They would never sell like that if she had competition.

What are your plans for the winter? Just as soon as I hear the date of sailing will write you. Leave your address at the Martha Washington [Hotel] for I shall go there as my trunk is there. If you are at a cheaper place see if you can get me in.

*Kartabo, B.G.*
*Sept. 14 [1920]*

To Nell

I am trying to get passage on the Guiana which is due here Oct 1st so I will get to New York about the middle of October. If I can't get on that boat I will try for the next. I think that I will run up to Boston if I can possibly afford it & spend a few days. I am anxious to get [Robert P.] Baker to look over my things & criticize them for me, then I want to look over Bailey's photos of cross sections of wood & select some to put into textiles. It will be interesting trying & then quite a new stunt. Some of them will lend themselves wonderfully to Batik.

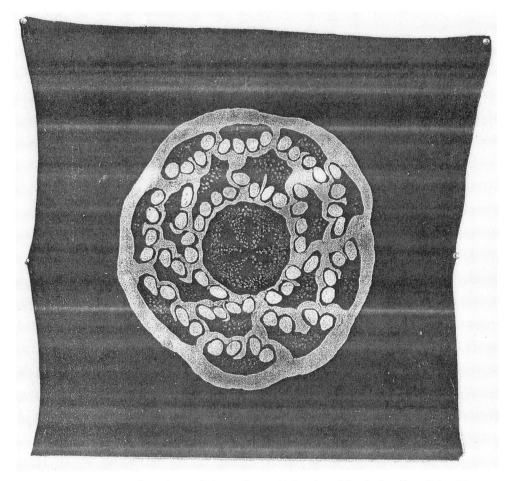

Batik pattern. Courtesy of South Caroliniana Library, University of South Carolina, Columbia

*Kartabo Station, B.G.*
*September 19 [1920]*

To Nell

I have finally gotten passage in the "Guiana" sailing Oct 1st and arriving some time between Oct 11th & 14th. I shall go to the Martha Washington as my trunk is there so drop me a line. I shall probably be in New York a few days, then I am anxious to go to Boston to get Baker to look over the stuff I have done & also to see his things. I also want to select some of Bailey's photos of wood sections to put into batik. I wrote Sam Harper to come on to Boston too if he were in those parts. It would be fun to see Baker's things come together. I think that he, Sam, has changed his mind about going to Rome.

Floyd is coming out these days, now that we are taking all day trips up the Peruni Trail, however he is anything but valuable, yet but he does surprise himself at times. It takes about three hours each way which allows us from three to four hours up there. I have done two

paintings which I really feel are good. I am getting hold of my new medium better. He is very artistic & does the most charming things. If you could see us! He leads the way with his bag containing part of the lunch & his painting outfit, slung on his shoulder & his gun in his hand. I follow about 25 yards behind so as not to flush any game. I have my bag strapped around my waist & am armed with a butterfly net. He always seems to get game when with me. The other day we had gone about four miles out when I suddenly saw him fire & then gesticulate wildly to me in the direction the bird fell, & take down the trail on the run. I dashed forward & picked up the trumpeter which was squawking bloody murder with a broken leg. He fired again & brought down another, in the meantime I was standing in the middle of the trail holding the yelling bird. He came up & remarked that I better stay there & hold the bird as that kept the others around. With that he took to the bush to hunt the others. Of course he never got anymore, but I was almost walked over by some!

Two days after we went out again & ran across a fresh peccary trail & it was certainly fresh, fairly smelt to heaven. We soon came across our Indian hunter, Dagas, who fired five shots a few minutes before we came up. He had killed a big peccary, a small one & had wounded another he was then looking for. Dagas carried the 125 pounds the five miles back to camp.

Am crazy to get home. I shall squeeze in with you until I get in my house.

*Georgetown, B.G.*
*October 2d [1920]*

To Nell

If the children could only be up at the camp! Our latest is the most precious little red howler you ever saw. She was just a week old when we got her. She is fed with an eyedropper on condensed milk & barley water every three hours. Just before feeding such a row as she raised, grunting & making other queer noises, tail & hands are poking out all the cracks in the johnny basket she is kept in. Just as soon as Winifred picks her up she wraps her tail around Winifred's wrist, clutches one finger & then sticks her mouth out for the milk. She is doing so well that they may manage to raise her. Mr. Floyd & I spent the Thursday before I left up the trail painting. He is getting humor, actually got off a joke about thinking me a "dear" breaking through the bush! I took a squint at him out the corner of my eye to see how he meant it but decided he didn't intend to get funny. Don't you believe he let it pass, for next day he got it off & it was very obvious he intended to be gay. This time I reacted properly!

Francis & Sir Charles Major are the only men whom I should call really well-bred English gentlemen. Such charming low voices. Francis has been on the island of Cypress [*sic;* Cyprus] for the last ten years. We expected them to have swizzles with us so hurried back, taking Francis with us. As luck would have it the Harrisons had already arrived. Dr. Ireland was giving a farewell dinner the next night on board the "Chenah" & he invited us & Inness who was to arrive Tuesday afternoon.

It was the gayest dinner I have been to since I was in Paris! There were Mr. & Mrs. Tant, Mrs. Claphan, Mr. Francis, the boat's captain (full as a tick!) we three, Dr. Ireland & later Mr. Delafonse came on board. We started off with various swizzles, then champagne was

served all during dinner, later port wine & finally liqueurs. Coffee seemed to be served about every half hour. The only ones we liked were nice old job Dr. I[reland] & Mr. Francis. However everybody got mellow & very gay. We went over in a rowboat about 6:30 & returned about 12:30. It was very thrilling returning. The tide was so strong that the sails could hardly get beyond the steamer, finally they made it & we managed to get across. Then we went to Mr. Delafonse & drinks all round again!

Sunday—We are hearing more things than enough about the Prince [of Wales]'s visit. To begin with the dinner was something awful, the worst ever served at Government House. During the evening the Prince asked one of the waiters for a whiskey & soda & the Negro replied that it was against orders to serve drinks there that he would have to go to the bar! It seems that he saw Pat Auld & was attracted by her so asked for a dance & opened the Ball with her. Everyone noticed that the music started but the Prince seemed to be waiting for some reason, consequently no one could dance. When the dance was about ½ over he began dancing. The delay was caused by one of Pat's garters breaking & they had an awful time getting her clothes arranged, meanwhile the Prince was waiting. Another girl with whom he danced two dances running had the heel of her slipper to come off in the middle of the dance so had to go & exchange slippers with her mother!

*From William Beebe**
*Kartabo, British Guiana*
*Nov. 30 [1920]*

I am so glad the live stuff got there safely. The Park people were delighted with it, and the Dominica parrot was sheer luck.

If the money holds out I shall remain until February. When I return I will see Mrs. Whitney and let you know about the exhibit. If you wish it I am sure it can be arranged.

Thank you for attending to the money. I wish I had the knack of getting big gifts from people, so that we need not go into our own pockets at all. I am bad enough at all things but as a financier I am at the very bottom! I think your last check may have been in one of the letters I returned.

     * This letter was addressed to Anna Taylor, on Gregg Street, Columbia, S.C.

WHEN TAYLOR ARRIVED IN THE UNITED STATES, she was loaded down with painting and other equipment and her sketches and watercolors. She also brought in live animals for the Bronx Zoo. Several years later she told a newspaper reporter that her passage through the New York customs office had been eventful. "In the first case of my luggage which the inspector saw, there were fifteen fer-de-lance, one of the most poisonous tropical snakes. He was so completely unnerved that he hustled me through the customs without looking at another thing" (*Charleston Evening Post,* March 26, 1939, C-2).

The jungle made a lasting impression on Taylor's life and art. She described the influence of her expeditions in two articles she published in the *Christian Science Monitor* on December 22, 1920, and January 17, 1921. These are believed to be her only published essays. She earned the nickname "Jungle Artist" because she often lectured when her Guiana works

were exhibited at the American Museum of Natural History, the Brooklyn Botanic Garden, and other museums and art galleries. Selections from the articles revealed that she thought deeply about natural science and about the connections in her life between science and art. The articles revealed that Taylor used her letters as sources for the narrative in ways that corresponded to her use of her sketches for her artwork.

Taylor's "British Guiana Jungles" was published in the *Christian Science Monitor* of December 22, 1920. ∞

## British Guiana Jungles

*Before going to the tropics one has usually visualized the jungle as being entirely different from the reality. Personally, I thought of it as being an impenetrable mass of vine and large llanos, and, of course, expected to see the monkeys forming a bridge across the rivers just as they did in the geography picture I used to hang over as a child. I was to be disillusioned, however, as far as the monkey-bridge was concerned, but when it came to the jungle, I found it the most dramatic landscape of any that I had ever seen.*

*My introduction was not as I would have wished, wandering alone in these marvelous primeval forests, long since path-tracked by Indians, long antedating Columbus, absorbing the grandeur of it and hearing the social and musical calls of the birds and insects, but it was riding in a Ford along a newly-cut road in British Guiana.*

*The great fact which impresses itself on the observer is the stupendous struggle for mere existence. Heat, light, and moisture have been abundantly bestowed, yet few trees can get room to assimilate as much of the two latter as they need. The forest is densely populated, more so, in fact, than any modern city, therefore, every possible contrivance to gain an advantageous position has been developed. The trees have succeeded in defending themselves against almost every animal. It is true that the sloth and certain species of ants and caterpillars almost strip them of their leaves, but not a single animal appears to gnaw at their bark. Even the young seedlings are free from outside enemies, and have every possible opportunity of gaining a position if their elders give them a chance. The struggle is, therefore, one between tree and tree; not even species, but individuals. No species is armed in exactly the same way as another, but every one made his selection in some past age, and goes on year after year making improvements—as the need for protection grows stronger.*

*The large trees are not as close together as one expects, but sometimes there are quite large groups of them. These giants, with their buttresses and superb arches overhead, remind one of the dim, misty interiors of the English cathedrals, particularly when a shaft of sunlight comes shooting down, increasing the gloom and mystery of the surrounding forest. All are on the same level. No individual can afford to let another get above him. Every one is pushing upward to obtain a little more sunlight. It is very rare for a giant mora or silk-cotton tree to rise above its fellows, so that, looked at from above, the surface is a uniform level—a verdant plain, undulating with the ground on which it stands. Here and there a great river produces the effect of an embankment, as the forest slopes down into the water.*

*Most plants in the tropics have two fruiting seasons and millions of seedlings start, but few ever get sufficient foothold to develop beyond the first stages of plant growth. But the one that does can almost be seen to grow. Their upper leaves are all on a level and glow with the most*

*beautiful tints. The branches of the different trees are so interlaced that it is impossible to distinguish which flower and leaf belong to which tree.*

*Nowhere in the world, probably, are there such enormous climbing and scrambling plants as in South American forests. Like the trees, they aim to get upward to obtain enough light for their gorgeous blossoms, but having such limp stems, can only do so by climbing trees. Some twine round the trees like monster pythons, others produce aerial roots which cling to the bark; some push themselves through branches and twigs, and then spread out their arms, as it were, to prevent falling back. In time the vegetable python constricts its host more and more: the tree withers. Then the victor covers it with a veil of flowers, spreads over a dozen other trees and is triumphant. Later when atmospheric agencies and termites have done their work, we see the empty soil of the monster hanging in midair and helping with others to produce the effect of great cables hanging from tall masts.*

*There is another class of plants which has overcome this fierce struggle upward toward the light by commencing at the top. One is the fig, the seed of which is provided with a pulp, very pleasant to the taste of a great number of birds; by means of the birds it is carried from tree to tree and deposited in the branches. Here it germinates, the leafy stem rising upward and the roots flowing, as it were, down the trunk until they reach the soil.*

*After the rainy seasons the trees shed their leaves and put out new ones. This is the time to see the forest for the first time! It is the most marvelous mixture of rich red, pinks, brown and greens that one could imagine, the colors being so intense that often one can't tell a tree in flower from one in leaf. It is more like a wonderful Persian rug than anything I know.*

TAYLOR'S "BRITISH GUIANA FLOWERS" was published in the *Christian Science Monitor* of January 17, 1921. ∽

## British Guiana Flowers

*The first question one is asked on returning from the tropics is "Weren't the flowers marvelous and weren't there masses of them?" I am sure that when I went to British Guiana I expected to see the large trees on the river banks festooned with most gorgeous flowers, one plant succeeding the other without intermission. One does see masses of flowers, but it is in the cultivated gardens of private houses or in the botanical gardens.*

*In the depths of the forest one finds very few flowers for the simple reason that the shrub is so dense that few plants flower, all their energy being consumed in the struggle upward, seeking sunlight. The forest has three divisions of its plant life, each depending on the elevation. First are the plants common to the floor of the forest, which are comparatively few in number. Next are the plants attached to the lower limbs and branches of the trees, which can thrive in the half light. But by far the greatest number are the trees themselves and the huge liana, scramblers, epiphytes, and the millions of plants which live and flourish on the top of the forest.*

*The floor of the forest is covered with leaf mold ever so deep, the top dressing being the freshly fallen leaves, lively red, brown, and yellow leaves of all shapes and sizes. Constantly one walks over a carpet of pink and yellow flowers, but try as you may you seldom can find the tree or vine from which they fell. It is the same with the delicious perfumes which you detect suddenly. If you start out with the avowed intention of looking at only the tree tops, it isn't long before a*

*brilliant bit of color is seen out of the corner of your eye and you find yourself on your knees exclaiming over some strange mushroom or puffball. Whenever the forest admits enough light, the ground is often covered with the dearest little plant bearing lilac flowers and blue fruit, a close cousin of the partridge berry.*

*The banks of the river are where one sees anything like masses of flowers and the best way to collect herbarium specimens is to paddle along the river banks and up the creeks in a canoe. As for getting the flowers in the tops of forest trees, that is entirely out of the question unless one be where timber is being cut. It is impossible to cut a tree and be certain it will fall. The trees are so overgrown with lianas which are interlaced, crossing and recrossing from tree to tree that in most cases it would never come down but just hang suspended.*

*In addition to that difficulty there is that of the ant which infests the trees and plants. Just as soon as one attempts to climb the tree they come out by the myriads and the climber makes a precipitous descent. With our party was a well-known professor who was making a study of ant-harboring plants, one being a species of the Melastomaceae which harbors ants in the swollen petioles of its leaves. One day I was strolling along one of the Indian trails and suddenly found myself gazing at the identical plant and the joy of it was that it was in bloom. I broke open at once the swollen petioles but could see no ants, it being cloudy and quite dark in the forest. However, I gathered specimens of it thinking that I had missed out on finding the exact plant. When the party met a little later there was no question about my having made the find of the day.*

*Along the rivers and creeks one sees very beautiful bignonia in all shades of pink, purple, yellow, and some white. It is quite a woody scrambler so it manages to scramble to the tops of the highest trees. One of the Marcgraavias (ruyschia souroubia) is more common, in some cases almost covering the tree. It exudes a delicious perfume at times and attracts hummingbirds and insects with its nectarines. But the most curious and interesting is the Marcgraavia umbellate, which is almost as common as the others. I found it one evening when out in the canoe, and on my return found that it was equally as strange to the others as to myself. As luck would have it the professor arrived that very evening, and on learning that he was a botanist, I produced my curious inflorescence. It proved to be the example usually given of plants fertilized by hummingbirds. The inflorescence is green, in one species, purple green, the flowers are on the end of slender stalks growing at right angles to the stem, forming a circle, making it resemble a wheel. Underneath, in the middle, hang the nectarines.*

*Then when did it bloom? Some authorities said it bloomed at night, others on cloudy days, anyhow, never in sunshine. A month passed and one afternoon I suggested to a friend that we paddle over and have a look at the purple M. umbellate. We rounded the corner of the island and to our amazed eyes we saw one bloom, then another and another until we saw five inflorescences.*

*Next afternoon we went over and there they were blooming in brilliant sunshine just as they had the day before in cloudy weather. We all three then perched in the canoe and began our observations. The obliging umbellate actually bloomed while we waited, I sketching it as it pushed off its cap and spread its stamen and my friend standing with outstretched hands to catch the cap as it fell.*

*One very beautiful plant, the Posqueria, hangs like shooting stars over the creeks, frequently having the mature yellow fruit along with the flowers. It is one of the plants given as*

*an example of flowers fertilized by moths. The most striking shrub is the clusio, so much like our southern magnolia that I thought it must be the same family. Its thick leathery leaves shine as if polished, making a wonderful decorative motif with its big white fleshy flowers.*

*By far the most dramatic of the smaller trees is the Grias cauliflora. It has a crown of leaves from three to four feet long, radiating from the top of the stem, and on the dark slender trunk, about 30 feet high, are bunches of heavy white flowers drooping in the most charming fashion.*

*Just before leaving, the moronobea came into bloom. The flowers looked more like clusters of bright red satin balls, which women wear on their hats, than anything else. There were several trees blooming on the river near us so the professor managed to get some beautiful branches for me to paint. The flowers were very effective against the rich, dark-green foliage.*

*I returned to the United States with a glorious collection of brilliant colored suggestions for textile designs and woodblock prints.*

From March 6 through March 19, 1921, Taylor exhibited watercolors at the Grace Horne Gallery, in Dartmouth, Massachusetts, that she had painted in Guiana and batiks that she had made from Irving Widmer Bailey's photographs of plant cross sections.

Among the ephemera of the Anna Heyward Taylor Collection at the South Caroliniana Library is a copy of Will Beebe's *Edge of the Jungle* (1921), which recounted the activities of the 1920 expedition. It was a gift from the author, who inscribed it "To Anna Taylor who knows all that I wish I did about Kartabo flowers. Will Beebe Christmas 1921." ❧

*From Will Beebe*
*[Kartabo, British Guiana]*
*May 17, 1924*

The death of my mother took the heart out of planning for the big trip as I was hoping to take her along. So I gathered a party and came here for a few months. Expect to return in August and to begin work on the New Guinea trip at once.

The rains have begun and Kartabo is at its best—Cassia, Paraqueria, Wild Guava, Stabelli and Marcgravia [*sic*] all in full bloom after two months of solid drought.

No dearth of new species—as many as ever. Shall be ever so glad to see your new exhibition. Returning in August.

# 10

## A New Grand Tour in 1925

In January 1925 Taylor received her mail at the National Arts Club, 15 Gramercy Park, New York. By June she was at the MacDowell Colony at Peterborough, New Hampshire. During 1925 fifty-two "colonists" spent time there. Taylor was one of the few visual artists in residence that year. Most were composers and writers.

In July she was aboard the TSS *Martha Washington* crossing the Atlantic for a three months' grand tour of the Mediterranean and France. The chief reason for her tour was to accompany Susan Greenough Hinckley Bradley (1851–1928) on the elderly woman's final visit to Europe. Born Susan Greenough Hinckley in 1851, Bradley was an amateur artist who as a young woman had studied art in Europe and with William Merritt Chase. Taylor had met her son Walter Bradley as early as 1903 when they too were Chase's students. Bradley was seventy-four years old and Taylor forty-seven when the group made its tour.

This trip proved to be Taylor's last to Europe also, but she did not give up rambling. For the rest of her life she traveled to the Virgin Islands and Mexico. There she rediscovered the joys of the natural world and sharpened her vision of the "primitive" lives of Caribbean peasants and Mexican campesinos. ∽

*On board T s/s "Martha Washington"*
*July 27th [1925]*

To Nell
I got off from the [MacDowell] Colony without any mishap & arrived at Manchester at 7.30, Ray [Taylor] meeting me, looking very pretty & Frenchy in black & white. I caught the 6.24 from Manchester & ran into Ralph Bradley just as I got off the train.

Of course it was hours before the boat sailed so I went to his office with him & waited while he attended to his mail then we went on together. Mrs. B[radley] was there with her daughter [Margaret Bradley Swaim]. The rest of the family came later & Walter [Bradley] told me to be prepared for his mother to loose [*sic*] something at the last minute, go up in the air & then find it!! Met Walter's wife [Florence Royer Bradley] & can't say that I am

bowled over by his choice after waiting all these years. They are living in Cambridge & he has a mill in Maine.

Mrs. Bradley is certainly fascinating & a perfect scream. I know now why Walter always said I reminded him of his mother. She comes out with the most unexpected fits just as Mother used to do & has a keen sense of humor also as remote from N.E. in background as it is possible for a New Englander to be. She fixes here eye on some passenger whom she wants to meet & informs me I am to pick up an acquaintance. They are mostly men & are at present frequenting the smoking room.

George is right in thinking her a sport. She is a dead game sport!! Harold Parsons is to meet us in Venice & some where down the line his car is to meet us.* The villa is evidently a simple affair & in a most interesting and paintable setting. Fortunately Mrs. B. likes to be let alone so I shall have plenty of time to do as I please. But we land much later than I thought, Aug. 8th. In that case it looks to me as if we will go to the Palio first & the Parsons afterwards.

We are now in sight of some islands of the Azores. We land there tomorrow & it sounds now as if we will have some time on land. The most interesting looking person on board is a very handsome elusive looking steward whom we think must be an archduke. Austrian nobles are doing all kinds of things.

All the letters came & were much enjoyed particularly Edmund's which I gave to Mrs. B. to read. It is certainly a letter I shall keep. I do hope things work out in C[hapel] Hill.†

*July 30th*

We landed at the Azores. They are of volcanic origin & their form very lovely in outline & color. The little town is lovely with its pink, yellow, blue, green & lilac houses. There were many paintable sites. I went out with the Montevarchis, who are delightful. We took an auto & road [sic] around for about 2 hours. Franco M[ontevarchi?] wanted to go out to look in a pit he had heard of, where there are wild dogs. It is very deep & dark below. It seems that long time ago some dogs fell into this extinct crater without being killed. There they remained & have bred ever since. All the dumping from the slaughter pens are thrown down there on which they live. Men have been let down on ropes to see what was happening but didn't dare land as the dogs are very fierce. I am really enjoying this trip more than any I have been on in years. There are only about 100 1st class passengers. The most interesting man on board is a handsome Portuguese named de Castro. He belongs to one of the very old noble families & of course is a royalist therefore living in Paris & Argentina. He is the doctor on board in charge of the Portuguese emigrants. He has the most charming polished manners, Latin in the extreme & radiates scented talcum powder & some perfume. How I would love to see Ray with him!

---

* Harold W. Parsons, a 1905 Harvard graduate, was an American Red Cross administrator in Rome during World War I. Later he was an art dealer and expert on Italian art.

† Professor George C. Taylor returned from the University of Colorado to begin a distinguished career in the English department at the University of North Carolina.

*Naples*
*Aug. 4th [1925]*

To Nell

I don't believe I mentioned that we went ashore at Madeara [*sic*] after dinner therefore could see nothing but the lights of the city off shore & very little on shore. How the children would have enjoyed the slide down the mountain. I thought we were sent down a regular course but instead each sled had from one to two men running along side who guided, held back, or pushed it. I saw the hideous tomb of the Austrian ex-emperor, Charles, who was there in exile & died about 2 years ago.*

Our next stop was Lisbon. We entered a river & went several miles up. The country had the usual bare hills of this part of the world. Nothing but a little corn seemed to be growing but this may be an off season. The city was most enchanting! Lovely colored houses with tiled roofs, climbing up the hill side. It looked like quite a prosperous city but we saw nothing of it as we drove straight through. We had the usual typical day ashore, cheated out of our eyes teeth, saw nothing we want to see or ought to have seen. The one thing we all wanted to see were the Royal Gardens of Montserrat at Cintra. We got to Cintra, our car taking the wrong route—arrived after the rest of the party had gone in the palace with our guide. We tried to get in but the fat man refused to let us in without paying a $1.00. Then we all had brain storms, half the party got in somehow but still Mrs. B., myself & a little girl were kept [out]. Another brain storm between the two guards, Mrs. B. had one at the top of the stairs & I one below. Finally our united storms got us in without paying the dollar.

Then we were taken & deposited at the hotel for ¾ of [an] hour while some of the party filled up on a second lunch. We demanded to be taken to the gardens but were quietly informed there was no time. About a dozen people had brain storms at once! Finally we started for the city, we telling our man to stop at the Duomo, instead we were taken to the boat wharf!!

We had to go down some rather slippery steps to the launch & then step across to the boat. Mrs. B. demanded a board to bridge it for it was really dangerous for a person of her age. Nothing doing & no extra men so she just sat on the step where she expected to remain until something was done. I saw some men from above looking at her so called them & the 4 men got her on very safely & quickly. She says that she has found out that that is the way to do, simply sit down until she makes them do as she wants.

*Aug. 6th [Naples]*

All of the boat got up at 4 A.M. to see Vesuvius & then take a drive around the city. We were the only exceptions for we had been to Venice [*sic*; Naples] before & saw no use to spend the money. We sailed about 10 A.M.

It wasn't long before I picked up one of the nice looking Englishmen & the girl & had a game of [deck] tennis. They proved to be English families who had lived in Greece for several generations. We passed Cephalonia where [George Gordon, Lord] Byron lived for 6 months. It is a very beautiful island, so Mr. Hancock said. He pointed out Parnassus in the distance just to the left of Patras where we landed. Think of seeing Parnassus & being actually on the soil where all those wonderful men landed!!

I forgot to say that after leaving Naples we were passing islands & seeing the mainland in the distance all day. We passed Sardinia & I was amazed to learn that it is 150 miles [in length]. It also has rich mineral deposits including the only coal Italy has. Then came Strombolli [sic] which is merely a volcano rising out [of] the sea. It is smoking & one side has been completely blown out & the only land part is a small area to one side & there is actually quite a good size town in the place!!! If it erupts there is absolutely no place to flee but the sea. Just after dinner we passed Sicily & saw the lights of Messina & was supposed to see a shadow in the direction of Mt. Etna which was the volcano.

We decided to land at Patras, rather I did for Mrs. B. couldn't manage it as one had to get into little row boats. The small boats were very lovely colors & some of the sails most marvelous reds & browns. The town was not very interesting on close inspection but from afar was enchanting. It is at the foot of the most lovely red sapphire mountains. On a hill above the town is an old Norman castle built by the Crusaders. It is nothing but ruins now, only the walls standing.

*Aug. 7th*

We landed at Gravosa which was formerly Dalmatia & Austrian & now Jugo-Slavia. We had the most beautiful scenery all the way, the beautiful bare mountains coming down into the sea. Gravosa is the port now used so we motored over to Ragusa [Dubrovnik]. It is the most perfect walled town in the world, not a single break to mar the walls. It was a lovely drive of 2 miles over there. I have sent you a postal from there. It is the most paintable place I ever saw. I certainly would love to return to paint there for a month. We get to Trieste at 2 P.M. & then take the 5 o'clock train for Venice where Harold Parsons [will] meet us.

* Charles Hapsburg (1887–1922), heir apparent to the Austro-Hungarian Empire after the assassination of his uncle Archduke Franz Ferdinand, abdicated the throne in 1916 and relinquished his right to rule as part of the armistice on November 11, 1918. Exiled to Madeira in 1921, he died the next year and was buried in the Church of Our Lady of Monte.

*Villa Van Marle, Perugia*
*Aug. 19th [1925]*

To Nell

We are having a perfectly wonderful time, Mr. Parsons not sparing himself in any way when it came to adding to our pleasure. He tries to put the brakes on Mrs. B. & it has been absurd. He would quietly put her in her room for the usual siesta, having taken her home from some thing interesting. One day I almost passed out for she was awfully up in the air. Said she had always had her own way & never been managed, she would not stand being put to bed, etc.

Well, we left the villa Friday at about 10 A.M. In our car was Parsons, [John] Spink, Camden & me. In the other Mrs. Lee, Mrs. B. & Gardiner. We took different routes so didn't see each other until reaching Siena. It is a most beautiful drive, very hilly with mountains in the distance. Almost 20 miles from here is the famous Lake of Trasimene where Hannibal defeated & completely routed the Romans. It was perfectly marvelous in color. I have only seen such colors in Honolulu. The Sortello's home [has] a villa on it & over a very large estate

along the shore. We stopped for lunch in a fascinating little town perched up on a very high hill, Montepulciano. Mr. Parsons pointed out a charming fortress-villa belonging to a friend about which I will tell you later. Spink & I were sitting together & got very friendly which ended in our doing Siena together. Of course being an art dealer he knows a tremendous lot about the artists & their art & is particularly interested in the Sienese artists who belong to the primitives. His view point, of course, is not exactly that of the artist but it doesn't disturb me as much as Mrs. B. Mr. P. would put Mrs. B. in her room where she would sleep a short while then gnashing her teeth she would "sneak" out get a cab & go off some where to sketch until the time he was to come for her. In the mean time I would brush my teeth after lunch & then [go] out. Mr. Spink & I would really see Siena without a single American in sight. We usually walked to get some exercise for of course Mrs. B. always has to ride. She has a little 3 legged stool which she always takes with her & proceeds to sit down any where!! It may be in front of the high altar or it may be in the middle of the principal "Via."

We arrived in Siena just in time to get washed & dressed before dinner after which we took a cab & went out to see the city. Mr. S. & I went out for a walk & had a delightful time wandering in little unlighted streets & passage ways, arriving in time at the Cathedral which looked very beautiful against the dark star light sky.

Next morning was high mass at the cathedral at 10 A.M. We had seats right in the front. It was most impressive for there were many extra ceremonies & much taking off & putting on of the most gorgeous robes & vestments. The arch bishop is quite an old man. He had on purple robes of the heaviest silk & an attendant held a green silk umbrella over him as he emerged from the dim light of the cathedral to the brilliant light of the piazza. Mr. S. & I walked back so as to get a close view of the Italians. Of course the city was jammed with the people from the neighboring country, all classes.

In the afternoon we went to the Palazzo Publico which is the town hall & on this piazza where the [Palio horse] races are run. It is a most beautiful building & said to have the most perfect tower of its kind in Italy. Mr. S. & I climbed the tower during Mrs. B.'s Siesta, 420 steps!! In the hall are some very fine paintings, one of the frescos I found perfectly enchanting & have a photo of it. After seeing these pictures we started out to hunt up Miss Caroline Sinkler[,] she having enclosed a letter of introducing [sic] in a note to Mr. Parsons. She & Miss [Fanny] Wharton were staying in an apartment owned by one of the Picolow inns but rented by Mrs. Jastrow (wife of the Hebrew scholar) for one week.* I told Mrs. J. how much I had enjoyed reading "The Gentil [sic; Gentle] Cynic" also asked Miss Fan Wharton if the man next to her with the Semitic nose was Dr. Jastrow, but was informed he has been dead several years! I then asked Miss Fan after her mother who was most charming to me when I was in Phila. I almost sank through the floor when she told me she had died, but she went on to say [it was] since she came over. The family insisted on her staying over as she could do nothing. Mrs. W[harton] was 88 years old. I ceased to inquire after people!

We knew that there was to be a trial race at 6 o'clock so we went at once to the piazza & located some seats. The [race] course is irregular in shape which makes the running difficult. One side has a L curve & also on the downward grade. It is all padded on the sides with mattresses. The course has several inches of dirt put on it but the uneven stone

pavement makes it a rotten, uneven surface for racing. The horses are cab horses & chosen by lot, consequently no ward knows which will win. In the trial race a very good looking little grey horse ran, ridden by a man whose costume looked like pink pajamas. The favorite held back his horse & came in last. In the real race he came out second & the pink pajamas way down the line. Last year it was very thrilling because one jockey fell off or was pushed off, his horse kept on riderless & came in first. In these races the jockey isn't essential so that the horse won.[†]

Next day was Sunday. There was nothing on the Palio program so we went to the galleries also the library at the Cathedral. There one sees the beautiful Pintur [Bernardino di Betto, called Pinturiccio, 1454–1513] frescos & some marvelous illuminated books. Our siesta-jaunt this time was to see the market back of the Palazzo Publico. It was deserted but we discovered the beautiful rear of the Palazzo & the lovely loggia on top.

The real race came off at about 6 o'clock. We went down & got in our seats about 5.30. The center space was literally jammed with people also the race course. It didn't seem as if the center could hold more but eventually they all squeezed in it. A gun went off when a squad of police, on horse & on foot, slowly began to walk around the course pushing the people before them. When it was cleared the procession took place. Each ward had its dress & banner, the latter decorated with its insignia. The banner men manipulate them in a marvelous manner, throwing them way up in the air & catching them. The handles are leaded & quite heavy.

I forgot about the blessing of the horses. That takes place Saturday afternoon. In the church of each ward the horse is taken & blessed & then they are all taken in the cathedral & blessed by the arch-bishop. We didn't attempt the cathedral as we knew we could never get near. But when returning from our siesta jaunt we saw the crowd in the piazza near our pension. It proved to be the contrada. We saw the horses all being dressed up & the jockey putting on his armor. With drums beating, the procession started down the narrow street to the church. In about a minute they all stopped, the banners were played with then the entire company except horses entered a court yard, we included. The party entered a place like a club room—there had drinks. It seems it was their club & they went for a drink all around. They let Mr. S[pink] & me feel their suits also the banners, in fact were very cordial. We all came out & processed to the church of St. Dominico. There the ceremony of blessing the horses took place.

To get back to the final race of the Palio. The Palio itself is a banner all painted & decorated.

The race starts with a gun shooting for them to get into position. They draw lots for position then they start & go round three times but don't stop until the gun shoots. This time the Snail [team] won on a small black horse, the favorite jockey coming in 2d. Each jockey has a mean looking whip with knots in it & he can beat the other man & his horse too. And they actually did for the two winners in the middle of the race turned & beat each other as hard as they could. Two men fell off, one man getting on again & finishing the race. They ride bareback. Of course the crowd whooped & howled & stood up (the few who were seated). The winners were pawed over & had the times of their lives. The first winner then paraded with all his attendants. That night things went wild in his ward & they had a feast.

On Monday they spent the entire day parading all around the city & stopping every little while throwing their banners.

On Monday we looked at pictures there being a Belle Arte, of course. Research has shown that Duccio [di Buoninsegna, ca. 1255–ca. 1319] was much finer & antedated Cimabue [Benvenuto di Giuseppe Cimabue, ca. 1240–ca. 1302]. In fact there are actual records of his being a real man & of the fact that his Madonna the "Marta" was paraded through the street with the scattering of flowers. There is no actual record of any such thing taking place in Florence. It is now believed that the Florentines (who detested the Sienese & Dante always [illegible] them) simply stole the incident. These primitives were the pictures that struck me most when I was in Italy last time & [it] was a joy going around with one who knew as much about them as Mr. S.

To go back to the Art. In Perugia is a very fine crucifix which is considered one of the very earliest. It is very beautiful in color, quite decorative & Byzantine. I am afraid you & George will not like them until you see some thing of them & get away from the realistic. This man Van Marle has done a great deal to discover & dig out the artists of this period. His works are the last word from the critics.‡ [Bernard] Berenson in Florence is another authority. He is a little greasy American Jew, as Mrs. B. describes him. He married a well born woman & they have a beautiful villa in Florence.§

I sent a letter from Siena & a lot of P[ost] C[ards] so you will understand & visualize this letter. Some of the words in this letter are spelled wrong & I can't bother to look them up.

* Morris Jastrow Jr. (1861–1921) was the author of *The Gentle Cynic, Being a Translation of the Book of Koheleth, Commonly Known as Ecclesiastes* (Philadelphia: J. B. Lippincott, 1919) and books on the Song of Songs and Mesopotamian religion and history.

† See Titus Burckhardt, *Siena, City of the Virgin* (Bloomington, Ind.: World Wisdom, 2008), chap. 8, "The Palio."

‡ Raimond Van Marle (1887–19936) was author of *The Development of the Italian Schools of Painting,* 19 vols. (The Hague: Martinus Nijhof, 1923–38).

§ Bernard Berenson (1865–1959) was the author of fourteen books. He was both a scholar and entrepreneur in the fine-art world. Villa I Tatti, his former home outside of Florence, is an art research center associated with Harvard University.

*Villa Van Marle, Perugia*
*Aug. 21st [1925]*

To Nell

Two days ago I mailed a letter with an account of the Palio. This will be of our trip back. We left Siena at about 10 A.M. & headed for Montepulciano. We were invited to lunch with the Paolinis who were friends of Mr. Parsons. They owned a beautiful villa right on the pinnacle of the town. It had formerly been a fortress but had been turned into a luxurious villa according to Italian standards. [Paolo] Paolini started life as a professional violinist but changed to antique dealer.

Paolini is a large fat ordinary looking man, the last person to associate with anything esthetic. The lunch was delicious, with real Italian food. The entire villa seemed tiled & the rooms large. It was heated by a several tile stoves or fire places, totally inadequate for

keeping the house warm. However they only spend their summers there, wintering in Rome. After lunch they gave us directions how to reach the Marquessa de Origo, who is the grand-daughter of an old friend of Mrs. Bradley. [William] Bayard Cutting [1850–1912] married the daughter of the Earl of Passmore [sic; Dasart], Sibyl [Marjorie Cuffe]. He developed T.B. & died after a few years. This young girl [Iris] was the only child. Her mother married an Englishman named Scott so is now Lady Sibyl Scott. She is a cousin of [Joan] Lascelles & she it was who lent the Villa Medici to [Henry, Viscount] Lascelles & Princess Mary [daughter of King George V] for their honey moon. The villa was bought with Cutting money. Old Mrs. C. wanted Iris to marry an American but she chose an Italian Marquis [Antonio di Origo] & is now living in a farm house turned into a villa.* We then motored home. The country is very beautiful & again we passed Lake Trasimene however this time the color was not so beautiful.

On Thursday we went to Assisi. It is enchantingly situated across the valley & half way up the side of the mountain. Every street is a stiff climb or steps. We only went to the church, there being two, one over the other. The lower one is so dim that one can hardly see the frescos except for one chaple [sic]. But it is very impressive with its numerous arches & look of mystery. The upper has the Cimabue frescoes but they are a fearful wreck, only the under-painting showing. The nave has a series, attributed to Giotto [di Bondone, ca. 1267–1337] for a long time but now only two are considered entirely by him. One is St. Francis feeding the birds. I sent Edmund a [post]card of it. Will write from Florence.

* Iris Cutting Origo (1902–1988) was a writer of novels, biographies, and children's books.

*Florence*
*Aug. 24th 1925*

To Nell

It is a beautiful trip from Perugia to Sortello, for the [road] soon gets into the Apennines. The mountains begin & have more forests on them.

The castle is, of course, on the top of a small size mountain with a well kept road winding up. The grounds & the surrounding country are in beautiful condition, the wide valley being very rich. The castle has always belonged to the Sortellos & dates from before 1000!! The high bridged crooked nose of the Marchese does in judging by him it repeats itself in numerous family busts around one of the large halls. It has a tower, turrets, crenelations(?) [drawing of crenellations] all around the top, dungeons etc. Of course it is a mixture of periods, the last being when some person tried to turn it into a villa. There are some modern conveniences but I doubt if it is really luxurious. They stay until Nov. 1st then it gets too cold for there is no way of really heating it. The Marchese is short, with a broken shoulder & the family crooked nose, but a most attractive personality, evidently a keen sense of humor & quite a tease. Mr. Parsons says he has a very free mind. I was crazy to ask him a lot of questions about Italian farming for he has large estates & knows a great deal about the running of them.

The Marchesa is a very fine looking woman. Mr. P. says is the one who wears the pants. She is the person who first started reviving [production of] the old embroideries & laces.

After lunch the men & I climbed to the top of the tower & saw how the steps had been worn by the lackeys used to carry up the food. Also saw the cells where prisoners were put into—not quite enough air so in 25 days they died. It was a unique experience & the only fly in the ointment is that the Marchesa gave me some p[ost] cards of the castle & forgot to give Mrs. B. some. I have insisted on her taking mine but she continues to get all over-come each time she remembers. We didn't get to Florence before 10 o'clock but we all stopped at some place to see a very wonderful frescoe. We passed Arezzo too late to see any-thing. Of course this place [Florence] seems very modern after Siena which hasn't any street cars & Perugia which seems to have one track, from the station up to the Piazza. We have seen all the important things & I am certainly surprised at the way my taste has changed since 15 years ago. When I was here years ago I found that the primitives interested me much more than the later men & of course that learning is increased [by] my seeing the very finest in Perugia & Siena. What formerly seemed grotesque in its absence of realism, I now find very beautiful in color & design.

Mrs. Bradley knows the Berensons here so wrote them before leaving Perugia. Mrs. B[erenson] replied & invited us to lunch with her in a villa she has rented up in the moun-tains, over an hour's run from here. It is also near the house where Boccaccio [Giovanni Boccaccio, 1313–1375] was born.

Berenson was a little Jew educated at Harvard & a protégé of Mrs. Gardiner [sic; Isabella Stewart Gardner, 1840–1924] who started him on his career as art collector & dealer. Mrs. B. [Mary Smith Costelloe Berenson, 1864–1945] was an American who was supporting herself & two daughters lecturing on art. She employed him [Berenson] as her secretary then they married after Costello's [her estranged husband Frank Costelloe's] death. Mr. B. has a very brilliant mind & has written serious books on Art & Italian history. He doesn't look Jew-ish at all.

Both are exceedingly agreeable people. Two other people named Spelman [were] with them, he [Timothy Walter Spelman, 1891–1970] being a composer & has a villa here. We had to get a motor to go out & the road led right up the valley of the Arno on up into the moun-tains. The villa is about 3,000 feet up & very beautifully situated. The views of the moun-tains are glorious. Mrs. Bradley came for summers & studied with Voight, right up in this neighborhood, consequently she was constantly exclaiming over scenes she had painted.

The villa near Florence "I Tatti" is the most beautiful modern villa here. It rises beau-tifully terraced, superb avenue of cypresses, beautiful flowers & [illegible] etc. We didn't get in the house but it is full of superb paintings & other works of art.

We leave tomorrow at the awful hour of 6 A.M. We have our tickets through to Paris with a stop over in Verny where we will be two days then take a night train to Paris, a wagon-lit this time. Mrs. B. has an old friend there with whom she expects to spend the day, I going up for her.

The Sortellos & Berensons were so interested in Will Beebe having read a lot about him so I shall send them each a book of his. Give any of my books which you have to Camilla [Sams] to keep for me. Also the 3 corner wash stand which George said he would lend Miss [Laura M.] Bragg. If you dig in the out house I want my chair & posts. I wonder what you are going to do with all your furniture!

I have a beautifull gold colored shawl for you & two white linen dresses embroidered in the Perugian cross sti[t]ch for the two girls. I will send to you in Chaple [*sic*] Hill for you all must make a fine impression.

*Verny*
*Aug. 28th [1925]*

To Nell

Such a trip as we had up from Florence. We left at the dreadful hour of 6 A.M. getting up at 4.30. It wasn't such a bad trip for a younger person but utterly silly for a person of her [Mrs. Bradley's] age. For the first time we had 2d class tickets, I not realizing the difficulty of an older person. The train was terribly crowded being "com peto." In addition poor Mrs. B. is having trouble with a bunion. If she weren't so uncomfortable it would be awfully funny, then I remember limping through Italy. I always think of Letty & hers. It was pret[t]y hot but we got to Milan without any extra discomfort except Mrs. B lost something every few minutes, ending by losing her remarkable little address & note book. Why she selected such a place to pull such a priceless possession out I don't know. She made a fat lady move off the seat & asked me to try to pull the entire large seat up. I raised it an inch or two & refused to do more. No book. Finally, I squinted under the seat & way back was the book. The break down delayed us just long enough for us to realize we would miss our connections. We arrived & the usual hectic rush but Mrs. B. saw a Cook's man & got hold of him. He said we had missed our train which would have taken us through to Verny that night. But to hurry & we would get one as far as Domodossola, the border [between Italy and Switzerland]. We would have to spend the night & take one out later. Such a mad dash we made. Mrs. B. limping like Letty! My biggest suit case had its handle torn off in one of the excitements. I told Mrs. B. I insisted on going 1st class & paying the excess. I realized she was too old for such mode of travel. We were literally thrown into a 1st class carriage. Of course she was losing some damn paper or the tickets or God knows what every few moments! She would not let me have them! We finally reached the border to find no checked bags & it was out of the question our going on without them [illegible] from there was no train out until 2.25 A.M.!!! We staggered down at 1.30 & when the train came [the bags] were on board so were inspected & we got on. Mrs. B. went to sleep so did not have time to lose any thing. Of course we got to Verny sooner than we expected so once the train slowed & the English man & I pitching the bags out as no porter was in sight. We arrived at the hotel at 6 A.M. to find every body asleep. Finally the clerk came out partially clothed. They had expected us the evening before. I got breakfast at 7 o'clock in my room then went to bed & slept like the dead for I just wouldn't hear one or two knocks on my door as I suspected Mrs. B. was wanting me to find some lost paper! It was she but I knew she had to leave early as her friend Mrs. Vanyan expected her up before lunch.

We got some side lights on the Origos. He is the husband of the Cutting girl & is living on the farm we stopped at for tea on our way from Siena. Mr. Berenson told me his father was a very charming wonderful looking man but was considered something awful. Well [the elder] Origo ran off with the 1st wife of the Duke de Lit[t]a! You remember he married one of the [illegible] Perrys in Charleston & used to be there. He it was who replied to his wife

when she remonstrated about his using a tooth pick that his ancestors picked their teeth when hers wore skins! Well, the Duke married Miss Perry but it was never really legal as he was a Roman Catholic & no divorce was granted. The Duchess & Origo lived together in Florence but no one would have any thing to do with them. This young Marchese Origo is said to be the natural son of these two! Mrs. B. asked M. Sortello who the Origo were & he replied "Sea pirates from Genoa who came in with V[ictor] Em[m]anuel!"

I went to the Am[erican] Exp[ress] & got my letters. I found 3 from you, one on the back of George's. Columbia will certainly seem strange without you! I don't think I will stop in Chapel H[ill] but go right through & see what arrangements I can make for getting settled working for I want 2 months of printing. I still expect to go to the Virgin Islands. I will have to spend several days in N.Y. before coming south.

Mrs. [Camilla Scott] Pinckney & [her daughter] Josephine are in town.* Mrs. P. was taken ill at Lake Como & was flat on her back for 5 weeks, not being allowed to move. The doctors think it is ap[p]endicitis. Dr. Hardin of Washington is in Paris & saw her today, so now they will get some scientific information. She is about 75 so an operation would be no light affair. She [is] much better than I expected. Mildred Frost went to her when she heard of her illness & is with them now, which must have been a relief for Josephine.

Mrs. B. took me on a Latin Quarter expedition this afternoon which I found most interesting, & took me into the two famous Art Schools, one being open so we peeked in & saw the class working from a model. I would love to have been on that side of the [Seine] river & must come over some day & see something of the life.

Mrs. B. is talking of going to Giverny (where all the artists live) & I hope she does before she sails & gets her nerves calmed down.

*Paris, Aug. 31st [1925]*

We left Lausanne that morning & managed to pass a very comfortable night arriving in Paris at 8 o'clock Sunday morning. [Mrs. Bradley] is a liberal education in many respects & very delightful when not excited, generous yet selfish, insists on her own way in every respect & tells me so constantly although I cross her on nothing & express no opinion unless I am forced to the wall. She [is] really trying to give me every op[p]ortunity & pleasure yet I almost suspect she wants to be free of me yet when I tell her I [am] a very independent person & have been for years etc. she will keep me with her. As a matter of fact I would like a good breathing spell of being left to myself for she goes up in the air about every thing & I find it an awful strain. The city seems to excite her fearfully. However don't <u>mention all this to anyone. Also keep quiet about Origo being illegitimate.</u>

---

* Josephine Lyons Scott Pinckney (1895–1957) was a Charleston-born poet and novelist. Her only volume of poetry, *Sea-Drinking Cities,* was published in 1927. From 1941 to 1958 she published five novels, including *Hilton Head* (1941), *Great Mischief* (1948), and her most famous work, the comedy of manners *Three O'Clock Dinner* (1945). Her mother was Camilla Scott of Virginia.

*Paris*
*Sept. 4th [1925]*

To Nell

We are settled in the Buckingham & it looks as if we are going to stay put. Mrs. B. got up the excitement of going down to Giverny (where Corot & all the artists went) but changed her mind. I told her that I preferred to stay here until I sail also that I didn't care to go to any extra expense. My return passage cost me $300!!! I certainly hated to pay out that extra $75 but Mrs. B. found it the only boat she could get passage on. Mrs. Pinckney & Mildred Brawley had tea with Mrs. B. the other day. She looked so miserably & you know she felt badly when I tell you she didn't talk much. Mrs. B. is buying various things & all the time speaking of how poor she is! I am spending money in hearing the opera for less than <u>one dollar</u>. Mrs. B. can't understand why I don't make a mad dash after every American I happen to know I can't make her understand that I am finding myself quite delightful. She is a scream! However, she is really brilliant & fascinating in a way M. isn't. Her reactions & enthusiasms are those of a girl of 16. She never said so but I bet she was wild to have Walter & me make a match.

I expect to land in N.Y. Sept. 24th in [the ship] "Paris." I will make the [National Arts] club my headquarters as I have to be in town several days. Write to the club 15 Gramercy P[ar]k.

*Paris*
*Sept. 9th [1925]*

To Nell

I have been seeing some wonderful museums I never saw before. They have beautiful things from the Far East & one has a fine collection of Japanese prints. I have my usual luck at the Louvre, what I go to see is closed or if it isn't I walk myself to death before I see it. So many of the attendants are blessé [wounded war veterans], it's too pitiful.

Mrs. B. & I have just returned from a visit to Mrs. Pinckney. She leaves for the cure on Friday. Josephine flew to England last week & returns by train tonight. George [Lamb] Buist has just landed so was at the station to meet her. Every one thinks she is going to marry him.

Have been poking around the Latin Quarter. Yesterday Mrs. B. & I went to the Grand Chaumiere étalier [*sic*] where they have the models to choose from. Just for the sport of the thing we went there & drew from the figure. I was amazed to see the girl undress right before the class. In New York there is always a screen. Of course it was a mixed class.

Paul Gardiner left a few days ago & thank goodness he wrote a note to Mrs. B. saying he would meet the boat. I am enclosing a clipping Mr. Spink sent me from London of the Palio.

I saw in one of these papers about Roy [Chapman] Andrews. I want to write to Clifford [Pope] & see what has happened to him. Sent [William Beebe's] "Jungle Peace" to Mrs. Berenson & Marchesa di Sortello. Send your letters to the Nat[iona]l Arts Club, 15 Gramercy P[ar]k.

*Aboard "Paris,"*
*Sept. 22d [1925]*

To Nell

Our leaving Paris was without any incident except Mrs. B. was on "high C" & things were tense. Just as soon as we got on board & were seated she calmed down & seems to have enjoyed the trip. Miss Caroline Sinkler, Miss Fanny Wharton & Mr. Wilson Ayer are on board.

I will be in N.Y. a few days, then go home. I wrote Mary Etta from Paris so [I] hope she will say she can take me in. I asked her to reply to the Club. As I have no money the customs have no terror for me.

I can hear your screams of laughter & George's gentile [genteel] laugh & will join you when I run up for a visit. Many details are now missing which I will supply then. However I have to keep my mouth shut to everybody else for it would be awful for a suspicion of it to drift back. If some old man could only marry me now I would be ideal!! I will get to Columbia either the 26th or 27th.

# II

⤫

# *Caribbean Sojourn, 1926*

THREE MONTHS AFTER RETURNING FROM EUROPE, Taylor headed for the Virgin Islands with her friend Rachel Hartley. She remained six months at Saint Thomas, Saint Croix, and Saint John islands. She immersed herself in the social life of the islands but soon discovered challenges to her southern attitudes. The political and social milieu of the islands, especially those governed by France and Denmark, were multiracial to a greater degree than she had ever experienced. Her South Carolina upbringing had ill equipped her to deal with so much interracial socializing at dinners, dances, and card parties. Swizzle parties were very frequent as she and her friends hopped from island to island in a painter's paradise.

Taylor joyfully worked hard to capture the riot of tropical shapes and colors around her. In her first letter from St. Thomas, she stated, "I feel as if I could stay here & paint the rest of my life" (p. 188). In the same letter she affirmed, "I see Siena dwindling in the distance" (p. 189), a comment that suggested her veneration of Renaissance painters such as Simone Martini and Duccio di Buoninsegna was giving way to an appreciation of the bold styles of her teachers Charles W. Hawthorne and B. J. O. Nordfeldt. ⤫

*St. Thomas*
*Jan. 16th [1926]*

To Nell*

The Gods are with us in every sense of the word. Everything seems to break our way even to having a fine crossing. We got to St. Thomas at 7 o'clock & Com[missioner] Baker [Cecil Sherman Baker, Secretary of the Virgin Islands] was down in his Ford, having left his family sound asleep. After seeing to all of our stuff being gotten off, he then took us into town to see the market. It was enchanting & a marvelous background to paint against. San Juan we thought lovely but nothing to compare with this. In fact I feel as if I could stay here & paint the rest of my life. It is just too beautiful. The Negro so much more picturesque than the Americanized Negro of P.R., along the coast.

The Bakers' house is on a high hill overlooking the bay & across from the city. When we arrived Lilian (Mrs. Baker) [*sic;* Lillian Holley Baker] & Ellie [their daughter Eleanor

Baker] rushed out to meet us. The house is an old rambling one story house & they eat out on the terrace or piazza all the time. A most sumptuous breakfast was served starting with my favorite—papayas. They are a delicious yellow melon which looks like a cantaloupe but doesn't taste like it. After looking at some stunning sketches Sherman [Cecil Sherman Baker Jr., b. 1906] did last spring we all piled in the car & went to town, leaving Com. B. at his office. The hotel is a white rambling house, high off the ground & a larger veranda where we will eat all our meals. The Bakers had engaged our rooms which are ideal. They are a little dark—on the cool side, consisting of two bedrooms, sitting room which we will use as a studio & a larger inside room which we will use as storeroom. We have our own street entrance. The wallpaper in the studio is awful but we will tack a strip of burlap all around so as to have some kind of possible background for our sketches. Mr. Reynolds has given us the service rates so we get all of this for only $60 (each) a month!!!! We expect to get up early & go out painting so will get a thermos bottle & have hot coffee fixed the evening before. I see Siena dwindling in the distance! There is good bathing so the Bakers are coming by at 4 o'clock to take us. They have a special Service Beach with bath houses. The tennis club is near so Ellie & I expect to play and I will try to get my hand in to play again. They also take horseback rides.

Dinner this evening seemed most romantic. We were all seated at small tables in the large piazza of the hotel overlooking the bay. I had a beautiful view of the sunset glow just beyond a mountain rising out of the sea at the base of which were the lights of the houses. Rachel [Hartley] had a view of the western sky with royal palms & houses silhouetted against it. High up was the new moon & a wonderful star.

Now to go back to Puerto Rico. Somehow I had always overlooked P.R. but did know it was paintable from a stunning watercolor I saw some years ago of Gifford Beal.[†] It is simply superb up in the mountains.

Gov. Cooper[‡] & Judge Croesus[?] came for us at 7:30 Thursday & took us for an all day trip ending with dinner with the Thomas'. The first part of our trip was along the low lands among the sugar plantations. We passed various large estates & large factories. We had lunch with Signor José R. Aponte. He is a Cuban & she a Spanish Puerto Rican. He is a lawyer & also senator. The house was a simple one story rambling house with vines of flowers. Signora is a very handsome woman, speaks excellent English, having attended Wellesley for two years. After lunch the Judge took us back through the mountains. They are not heavily wooded, in fact just patches here & there. The crops of the island are coconuts, coffee, sugar, tobacco & pineapples. On the mountains one finds the tobacco & "pines" sometimes planted on their very tops & just as steep as they can be. Such marvelous color in the soil & different crops. It was very dramatic late in the afternoon for a heavy storm came in from the sea & over the mountains. We had dinner at the club & met a good many of the people there. Everyone was cordiality itself & really seemed to want us to stay. I find people are always interested in artists & our enthusiasm did the rest.

On Friday the Byards & ourselves had a wonderful trip up into the mountains of a different part of St. Thomas. Mrs. Gay had told of Mr. MacDonald whose wife has a boarding house. He is a nice Virginian and drives beautifully. He took us on a trip which I know equals Colorado in beauty & showed it to us as if it were his own handiwork. We three were

mad to paint & Rachel did make two quick sketches. I want to go back & get Mr. MacDonald to take me on a painting trip, however it is quite expensive so it may be some years off.

* This letter was addressed to Nell at 240 Rosemary Lane, Chapel Hill, N. Carolina U.S.A.
† The painter Gifford Beal (1879–1956) studied with William Merritt Chase. He also frequented Provincetown.
‡ Robert Archer Cooper (1874–1953) was governor of South Carolina from 1919 to 1922. A progressive Democrat, he had ties with Puerto Rico and in the 1930s was appointed a federal judge there by President Franklin Delano Roosevelt.

*St. Thomas*
*January 20, 1926*

To Nell

Things are still happening as if ordained by the Gods themselves. Such things to paint! One has only to stand in one place & turn a degree in any direction & behold, a new subject. One can look up at the mountains and town or look down on the hills and houses.

Sunday morning I went to the Anglican Church with the Bakers. Think of a high church congregation composed almost entirely of Negroes of all hues! The choir boys were all shades & looked most paintable in their red cassocks & white collars. They are against the white wall & in a flat light so there was very little melding & their features looked like an interesting design. One boy was very black & only the whites of his eyes showed. After church the Commander ran me out to their place & back. In the afternoon (on Sundays) they are always "at home" so sent their car for us. It was very beautiful, the lights changing in the town and hills as the sun went down.

We have a thermos bottle of coffee put in our room the evening before, then we get up as early as we please, usually at 7 o'clock. There is no use to get up earlier because there isn't enough light. Later on it will be glorious when we have longer mornings. We either explore for a while or go direct to the market & make sketches of the people. They dress much more interestingly here than in Puerto Rico. They are too Americanized over there, also San Juan has too many modern buildings but very beautiful in spots. These people are very primitive still. My hand is awfully out when it comes to landscapes as well as doing figures. My figures sit like stone walls, have no movement, & Rachel's houses dance around the landscape & seem awful drunks. In fact we are an excellent pair to work together for each is strong in what the other is weak in.

The Commissioner of Education is a very nice man from the state of Washington. Our acquaintance began with Rachel crossing with his two children who were studying at art school. It seems he goes off on trips of inspection to different parts of the island. He took us last Tuesday over on the other side of the island leaving us at the ruins of an old house, then returning about 12 o'clock. We had a lovely time poking around & ended by doing two little sketches of the ruins in between showers. He is going to take us over to St. Johns this coming Tuesday. It is an island one mile off the extreme end of this one, making an 18 mile sea trip. The island is little visited & the people very primitive. He pointed out an island to us which is rapidly being populated by two men, one has 30 children & the other 17.

Of course each has several wives or so called. Judge [George Washington] Williams (Susan Brown's friend) is in evidence but scarce around us. In fact he is behaving in such a funny manner that Rachel & I are highly amused. We can't make out if he thinks us dangerous or if he is shy. However he doesn't seem the latter about the other women. If he were a Yankee I would understand his lack of manners & savoir faire but he comes from a small Maryland town & all southern men are more or less at their ease & generally know what to do. He comes of very plain people & has made himself. The Browns admired him for his efforts to get an education. He is the only unmarried young man except a young man or two.

Wednesday afternoon a Mrs. Mattison asked us to play cards so Lilian & Ellie came by for us. There we met some new women among them a Mrs. Hallet who is fascinating. She is simply Emily's twin sister. She is of Italian parentage. The entire party adjourned to Government House which has an "at home" every Wednesday. Gov. [Martin Edward] Trench [1869–1927] and Mrs. T. [Helen Trench] were most cordial, saying they had received a letter from Goodwyn in reference to my coming. They had most delicious refreshments & we met some very agreeable new people. We already knew enough to have a very entertaining time. Among them was a Mrs. Schurr from St. Croix. She knew Gertrude Atherton when she was there getting native feeling for "Conqueror."* Mr. [Arthur] Fairchild was there so Lilian brought him up at once. He invited us to come up Thursday afternoon. I don't believe I could have recognized him as I remembered his house [called Louisenhof] & garden much more distinctly.† He is building the house very slowly & overseeing every stone which is put in. He has a native stone mason & is building the walls just as the foundations of the very first house on the site was built. They use the beautiful volcanic rock then fill in with pieces of old brick or bright colored stones, sometimes pieces of coral. He has stones embedded in the wall from all parts of Europe and South America. I can't describe it except that the house will resemble a miniature castle, with two rooms on the same level & no two terraces the same. Every window frame had enchanting views. The garden is pure Italian & piled with native or rare plants. Of course an enchanting pergola. If you all could only see it!! He has lived in Italy & goes back very often so he has some very old & very rare Italian furniture and ironwork. As for him—he is small or rather my height, most obviously a gentleman & very artistic but most people would say he is not very masculine. I am sure he is very set in his ways. Judge Williams spoke of him to me as "that queer cockroach up on the hill" & his peculiarity, in his eyes, was that he invited his relatives to come down for two weeks & expected them to go at the end of the time & when the boat came. I told him I fully sympathized with Mr. F[airchild] for I had suffered from some of this guest relatives staying for months. It seems Mr. F. had a very attractive niece down here last summer & only expected her to stay the two weeks, then the Bakers asked her there for two more. Judge W[illiams] was quite smitten. There was a fancy dress ball Wednesday at the hotel. I went as a Turkish woman & Rachel as a Hindu in my two sarongs.

* A California native, Gertrude Franklin Atherton (1857–1948) wrote more than fifty books, most of them historical novels and women's literature. In 1902 she published *The Conquerer,* a novel about Alexander Hamilton.

† Arthur Fairchild of Stockbridge, Massachusetts, was a publisher and Wall Street investor. He constructed Louisenhof as an eccentric tropical castle and later donated his estate to create a public park named for him.

*St. Thomas, Grand Hotel*
*Jan. 26, 1926*

To Nell

We are now almost settled and am hard at work. Our studio is being fixed up by degrees & will have to be finished by this next week for Gov. Cooper, the Thomas', two other men are coming over from San Juan & we have to do something for them. It is so much more intimate & personal having people in our studio & they are always wild to come. Rachel has stuff to show them & she does delightful little street scenes & people always take some interest in sketches with figures. We are both studying hard, she trying to get some drawing in the buildings & I trying to get away from the drawing & I also trying to get movement in my figures. The three best sketches I have made were memory sketches painted in the line sketch I made. I hope soon to have my hand in. Ten big liners touch here within the next 3 months & we may sell some of our things. I am taking my time a little more than Rachel for I have so much longer to stay. Sunday afternoon Gov. & Mrs. Trench invited us to go over to St. Johns. It is the island just off the end of St. Thomas. In 1733 there was an uprising by the slaves & every white person on the island was massacred, the only ones escaping were several who had gone over to St. Thomas for the day. No one but negroes live there now & nothing planted, only a few cattle. There is a doctor & his wife, Dr. and Mrs. Richardson, some Marines & that's all the whites. We went in a launch built for Gen. [John J.] Pershing & a very poor boat it is when it comes to comfort & sightseeing. The Richardsons seem very much interested in art & owned some very interesting paintings which had been gotten in Mexico & also he thinks one is a Rembrandt.

The color in the rocks along the coast is very beautiful. I forget to tell you that Saturday morning Lilian gave us a nice card party & had just about everybody in town. Both Rachel & I got great prizes which were bottles of delicious Coty perfumery. The commissary orders things & they come in free of duty as just now we operate under Danish customs laws. That afternoon we went swimming & met a friend of the Bakers, Mr. Hamilton. He was going there for dinner & we were invited too. He is a most interesting Irish "gentleman," the first I ever met. He is in the Colonial Service & keeps check on all the banks in the British West Indies. He was in Africa before the war & also during & after. We had a marvelous time talking African. He joined us after dinner, then we went out & sat on the wharf. He has been in the Great Crater Land of East Africa too. He wants Rachel and me to come to Antigua and paint, also he is going to take us to Dominica & while there take a horseback trip around the island. He lives in Antigua & wants Rachel to paint his little boy.

My head hurt all Sunday evening, turning up again Monday morning so I declined. It was glare & sun so took a dose of saltz, declined the card party for the afternoon but was well & gay & ready for the dinner that night. It was a dinner given for us & I sure talked to some interesting people. I sat between Com. [Vilhelm] Laub & Dr. Knut Hansen. Com. Laub is a retired naval officer & also was on an Ar[c]tic expedition. I was simply enthralled

as he told me about it.* Dr. Knut Hansen & I talked on about Danish (Scandinavian) literature. I quite surprised myself as to how much I knew about it. Just across was Com. Baker & he is always charming. After dinner we played cards but neither of us won a prize. No one plays for money down here so I am quite in my class. In fact I was an excellent player compared with some of the others.

Jan. 30th—We had been invited by Mr. Lenborg to go on a tour or inspection of St. John's Island. When I heard he was going to make 5 stops I couldn't resist & we got up & were ready to leave by 7 A.M. It looked cloudy but everyone said it never "rained all" day & I knew it didn't from experience. Mr. L[enborg] said he was sure it was smooth for he could see no whitecaps at the entrance to the harbor. I wanted to back down but just didn't feel that I could play the coward. Well, we got off, two other women, Dr. Kelly & we three. We hadn't passed the entrance before it was very evident that it was rough. [When] we got to the wharf where the Richardsons live Rachel and I made sketches, then went up to speak to the Richardsons. Dr. Richardson decided to come with us. We started around the other side of St. Johns. Saw the ruins of the house where some of the planters made a stand in the slave uprising. Sometimes it would be frightfully rough & I would swear I would never get in anything smaller than an ocean liner again! We made the next port intact, then we made some more sketches. The color was beautiful in the mountains & water. My sketch was very good. Now came an awful passage around the point of the island to Corral Bay. We finally entered an enchanting little harbor where we sketched again. Then we started for home. We had the wind with us so it wasn't so rough but by no means a calm trip.

---

* Vilhelm Laub was a member of a Danish Arctic expedition in 1909. He published his experiences in the expedition leader Ejnar Mikkelsen's *Lost in the Arctic: Being the Story of the "Alabama" Expedition, 1909–1912* (New York: George H. Doran, 1913).

*St. Thomas Grand Hotel*
*Feb. 5, 1926*

To Nell

I wrote you about the trip to St. John. We saw the Gov. next day—he said he had heard about what fine sailors Rachel & I were, that we certainly deserved to be decorated. Lilian Baker had a bad accident a week ago. She & Miss Miller were out riding on horseback. Her horse was a pretty mean one with a hard mouth & bolted 2 before the accident. The 3rd time she was so tired that she couldn't hold on & proceeded to literally race off & of course being on St. Thomas she fell on a pile of stones. She was very badly shocked & bruised up, anyhow she is a very high strung nervous person, consequently she has been very slow in recovering.

The excitement has been the French training ship coming in with 60 or more cadets. They do all the work, cooking, stoking etc. The French counsel [*sic*] is a negro here so the question arose what to do about the dance he was expecting to give to the officers. Well, every body considered it official & we all went. The Counsel & his wife are just about the color of the Flynn's Hattie [in Columbia]. Of course the "high yellows" were there but needless to say we didn't meet them.

My work is beginning to be more as I want it & I did a very good canvas yesterday. I find I have been working too small & it worried me, however I got some nice things. I am working in oils but later will work in watercolors. I think that I will always work out of doors in oil, & watercolors later on from the sketches. It is such a problem out of doors of one's paper drying. Rachel is having a spell of discouragement so has stopped for a day or two. Everybody wants to see our work which I find a horrible nuisance but Rachel takes it very good naturedly. I trail behind. As I am not strong on figures, hers prove more diverting for the company.

Monday afternoon the Trenches took us to the beach to swim. Just as we drove up we found the "cha-chas" on the beach and on boats—seining a school of fish. It was very beautiful for the water was glorious colors. By the time we had swum a little the net was almost in so we collected around it & saw them drawn in. They got a boat load of lovely blue & silver fish, a species of mackerel. The Gov. & Dr. Kelley were buying strings so we thought it would be nice to send the Bakers one, as it is difficult to get fresh fish at times. The Gov. kindly offered to send it over in his car. That night we were at the Hoars for a dance for the young crowd, however we were to play bridge. Mrs. Knut-Hansen said that some of the fish of that kind are poisonous but that all the cooks knew the difference. We were highly entertained with the idea of sending the Bakers poisonous fish! Next morning when we went upstairs for breakfast there was the Com. who had dropped in for breakfast as he had come to town very early. I asked him how he liked our present. He didn't seem enthusiastic saying they said they were poisonous. But the proof of the pudding is the eating & both Ellie & Lilian ate theirs as they had done before. The Lenborgs had some for dinner & I tasted them & they tasted like delicious fresh mackerel.

Of course we are in the midst of official life with circles within circles. I find that it is not tactful to criticize the government in anyway. I mean U.S. & St. Thomas, for of course I wouldn't discuss this adversely.

Feb. 8th—I am on such a go that I didn't get this off on this Saturday boat so planned to send it by Gov. Cooper to San Juan but in my excitement about seeing the party off I forgot it so this will not get off until next Saturday. Before continuing I will tell you who the "cha-chas" are. They are French people who came here & have been living to themselves for over a century. They don't mix with the negroes & make a living fishing and making hats. Their village is off on a peninsula & is most picturesque.

Saturday night the Bakers gave a supper party for the St. Croix crowd who came over for the tennis tournament. In spite of Lilian's illness she insisted on going on with it. There were some 40 people invited, mostly the young unmarried crowd. They probably had many swizzles before coming & they were served all during the supper. It was a gay party. After the supper we all went to the Tennis Club to the dance. Rachel & I didn't stay late for we were going over with Gov. Cooper & his crowd to St. Croix next day & have to leave at 7:45. We went over on the Government boat the "Grebe." Com. Baker was the host & entertainer. Three cars met the boat & Lieut. Hines [sic; Hoar?] took Rachel & me in his car, we being followed by a car with the two other ladies & Mrs. Harris. We went on a sightseeing tour. The island is about 15 miles long by 7 wide, a flat place surrounded by low mountains. The chief crop is sugarcane but the crops are uncertain on account of the long drought. The Gov.

is constructing water sheds for the houses & hopes in time to get enough reserve water to irrigate the crops. We landed at Frederickstadt & motored to Christianstadt where the Government is. It is under Gov. Trench & Com. Shimmer[?] is his representative. It is lovely in some ways but nothing like as beautiful as Puerto Rico or this place. The homes aren't very interesting although there are spots in Christianstadt which were interesting. The cane fields which are a light blue green, were beautiful against the purple mountains in the late afternoon. Mrs. Shimmer had us in for tea which proved to be a supper. We met some of the army & navy people, also two wives of the planters. Capt. O'Neal was there & was most agreeable. He is from Charleston. We motored back to Frederickstadt & got on board at about dark. Of course there are no railroads on this island. The planters & others have a very gay time. There they love nothing more than a party & everything is wide open. I forgot to say that on our way to the boat we stopped at one of the large places & had swizzles.

Feb. 10th—Today Mrs. Lenborg took us to a school she had to inspect. It is up the ridge & down on the other side. You never saw such a road in your life. Nothing but a Ford could have made it. We walked a part of the way where it is steepest. We got lovely views of the ocean & distant islands & I have made two memory sketches.

*St. Thomas*
*Feb. 15, 1926*

To Nell

Gov. & Mrs. Trench invited us for dinner en famille the other evening & then took us to a concert two U.S. negroes were giving. The man is a Canadian but educated in Boston. He was pure yellow negro but the woman was almost white & had a very pleasing manner. She was from Texas but a Boston product. He sang every thing from negro songs to Paliaicci (?) [*sic;* Ruggero Leoncavalli's 1892 opera *Pagliacci*] & in German, French, Italian, Spanish & English!! His voice was good but she was a much better pianist. She seems to be interested in collecting the folk music through the islands. I thought of you as I sat there, however there weren't more than 30 people there & we were in official seats so not close to the negroes.

Our latest excitement were two men who were here last week. Unfortunately we didn't know them until the day before they left. When they arrived they were very sunburned & that coupled with one of them staring at me during the entire lunch made me think they were Italians or Latins of some kind. That theory was dispelled when I heard them speaking perfectly good English. One also had on a beautiful brilliant tie & a superb ring with a large green stone. I told Rachel I just had to talk to a man who could wear such beautiful things, that he must be artistic. I discovered they were Mr. Fairchild's friends & he said something to one about their being interested in the flora here. The opportunity presented itself when Rachel was cutting a large "sour sop" & the surrounding tables were all taking a taste. They were just next & seemed most interested so we offered them some. Once conversation started & I promptly asked Mr. Furness what he was collecting and everything ended in our inviting them down to our studio after lunch to see our things. They know everyone I know in Philadelphia & [Joseph] Downs (the one who stared) had been struck with my likeness to Leila Waring whom he had known at the Felix du Ponts, is also a great friend of Emile du Pont, consequently knows Elise well! Had also remarked to his friend

that he bet I was related to Miss Caroline Sinkler when he heard my accent. Mr. [Horace Howard] Furness [Jr., 1865–1930] was the interesting one & is the son or grandson of Howard Furness [Horace Howard Furness, 1833–1912, a Shakespeare scholar], the English scholar. He is a horticulturist & has a farm at Oneida[?] near Philadelphia. I wish you could see his charming artistic catalogue, one of which he gave me. He was thrilled when I told him I had been with Will [Beebe] & what I did. Seems most anxious to see my flowers & also my block prints for he collects block prints. Actually says he is coming to S.C. to see them! However if I stop with Emily he wants me to come out and have tea with him. They came down after dinner the next evening & joined us at the dance where we introduced them to Gov. & Mrs. Trench. Downs is in the same company with Nicholas Roosevelt.

I am going to take things easy this next week & play tennis, walk & be entertained. I find myself a little stale in painting & not being pushed for time will just stop awhile.

*St. Thomas, Grand Hotel*
*Feb. 24, 1926*

To Nell

Well life is very entertaining & exciting. We seem on the go continually & continual fascinating invitations. Mrs. Thomas is very anxious for me to go to San Juan with Rachel when she starts for home. They have a beautiful new car & will take us on painting trips into the mountains of P. Rico. The [illegible] will be blooming & there will be wonderful stuff to paint. I have decided to go over & stay the 5 days & return on the next steamer. I will get some interesting subjects to do. Now, day before yesterday some friends of the Bakers came over from Tortola (a British Island within sight of this) en route to the Colonial Counsel in Antigua. They were Capt. & Mrs. Hancock, he having lost a leg in the war. They are two of the charming types of English people. He is Commissioner in charge of Tortola & the other 40 islands in the group. They were enthusiastic about our painting just as Mr. Hamilton was & are anxious for us to come to visit them & paint. We are certainly going if the invitation is renewed & I am sure it will be.

We painted a "Gauguin," I doing the South Sea landscape & Rachel the naked islanders, signing it with a copy of his own signature. It turned out so snappy that R. wanted to keep it. Lieut. H[oar] is very much interested in painting & had done some very good sketches but doesn't see any color here & can't be convinced there is color here.

We got all dressed up & as usual were the first arrivals [for a dinner party]. First came the Kanut [*sic*] Hansens then Barhams, all white. But then came the high yellows with whom was Dr. Christianstad who is a Dane born out here. One H.Y. most discussed is a "Vallie" Miller. I never would have suspected he was colored. His brother & his wife show it decidedly. As fate would have it they gravitated towards us. Rachel was at one circle talking to Mrs. Miller but moved to mine where I was talking to Dr. Christianstad, in order to escape. In a little while Mrs. Miller joined us & then V. Miller sitting right next to Rachel!!! That was the cosy supper party. The supper was delicious & we carried the situation off. After supper some played cards & some danced & we selected cards!! We actually were all four white! Rachel & I left early & all the way home were discussing how our different families would take the incident. Of course it means that we will not accept any more

invitations there without know[ing] who the party includes. I neglected to say that V. Miller seemed quite taken with Rachel & I mean to tell her the reason is, I look too much like an English slave owner!!

*St. Thomas, V. Islands, Grand Hotel*
*March 6, 1926*

To Nell

Lee Stuart writes she wants to come down now so as her letter was delayed I called her today to [tell her] to take the "Dominica" which sails March 18th. She will be here only a month & using the money she made doing commercial [art] work.

Last Tuesday we went on an all day picnic to Santa Maria, the site of a plantation which now has a small house replacing the old one. The Lenborgs took their car & Chaplain Lyman took his and family. We carried lunch from the hotel & we carried our sketching things. It was a hard 2 mile climb up and then down. The place being a beautiful bay on the Atlantic side. I walked the entire way both ways but the other ladies rode some. It was a stiff day's walk.

*March 13 [1926]*

To Nell

Last Sunday Gov. & Mrs. Trench took us on a beautiful drive over to the other side of the island to Coki Point. It is the most paintable spot we have been to outside the town. It is a point jutting out into the sea with the beautiful purple mountains of the small islands & Tortola in the distance. It has a coral bottom consequently the color of the water is marvelous. The hill has several thatched cottages which together with the beautiful cacti & century plants against the water & mountains makes stunning subjects. The wind was so strong that it blew my cracked palette in half. That ended my sketching on the spot but I got a drawing which I painted on my return.

The negroes on this island are very insolent & in spite of the Gov. & Mrs. Trench their manners are not all they should be. It seems strange that there is no record of assault on this island yet there has been dreadful treatment of the negroes. Com. B[aker] says that when they took over the islands [in 1917] that they still used medieval methods of punishment. One was a cell in the fort where the victim was made to crawl in face downward & there he stayed! Since our occupation, their insolence has increased ten fold. Everything is in a state of excitement on this island & St. Croix because they are petitioning Congress through three representatives they have sent up asking that they be allowed to propose the officials & pass on them when appointed. They seem to be very unintelligent, so the R[ed] Cross workers & officials tell me & indeed they seem very much lower than our negroes. The better class of white people & "high yellows" are finally aroused & in St. Croix have had meetings & elected one of their best men to go and present things in their true light to Congress. They haven't gotten so far on this island, but the Gov. is anxious for them to do so. If it does happen, the white people in business are planning to get out. The people I am sorry for are the "Cha-chas." Coki Point is also the place where the boot leggers live which probably accounts for their insolence.

We returned by a road along the side of the mountains on the other side (of the island), having glorious views of the mountains & sea. We stopped at a place used by Dr. Morton-son, a Dane, who came out here as a young man. He is about 79 years old & lives there with his animals & servants. He seemed very patriarchal with his cows, horses, sheep, peacocks, chickens, & wild birds coming to feed in his piazza. The birds which flocked to feed are a kind of hummingbird he said. I have seen a good many of them around the flowers. Tell Ed to see if it is in his book.* He also told us that the American mockingbird was unknown here until 1916 when blown here by the hurricane! He hears them frequently.

The British Gov[ernor] of the islands is coming to spend a week & the Hancocks have to get out of the house! He arrives in a battle ship with his supplies & a whole retinue of servants. The house was not completed because the money gave out so Mrs. H[ancock] sold a pair of candlesticks & out of their own pockets bought curtains etc. in order to make the place more presentable. Rachel & I are hoping they will renew their invitation to us to come over after the official visit.

The Bakers are fearfully upset because Sherman's synous [*sic*; sinus] trouble has started up all over again & the doctors advise his leaving for the South at once. He lands on Tues-day. It's the end of his going through college as the commander wanted him to do. I am delighted for he can go on trips with us & be another person painting.

Am now working on an afternoon subject which is by far the most difficult thing I have done. I don't know how it will come out. Some Porto Rico people have been over here, among them a Mrs. Faber, who paints. She is an attractive looking Virginia girl & seems so enthusiastic about our work. The few artist[s] who come seem to be decidedly 3d rate, so she seemed overjoyed to know us. She just about lost her mind over the beautiful stuff to do over here. Rachel leaves on April 5, for P.R. & stays there ten days. I have vacelated [*sic*] between going & staying but I have decided I haven't the money. In the meantime she in-vited us to stay in her big room at the top of her house. The Thomas' are planning some lovely auto trips all of which Rachel will enjoy.

* Taylor drew a sketch of a hummingbird, labeling the back "greenish black," the belly "yellow," with "white-stripes" on its head.

*St. Thomas*
*March 19, 1926*

To Nell

Of course everyone was up at Gov. House this Wednesday to greet the Trenchs. They had also received a long letter from Louisa Stoney Popham telling of my being here! Evidently Sam [Samuel Gaillard Stoney?] had just remembered to tell or write her! Gov. Trench in-troduced me to the Holtz, Danish banker here. They have been decidedly off the Americans here and hadn't called on any for several years until very recently. One bond of [illegible] is that he paints and is interested in art. Mrs. Hoar had told them of me being here so when he expressed a wish to see our things Mrs. Hoar arranged to take them down to our stu-dio. He seemed to know what he was talking about & was tremendously interested & actu-ally seemed to like my things. I thought that the color would floor him but he liked my most

brilliant colored painting. He works in watercolors & has some kind of special stretchers for stretching the paper wet. He offered to give me one. If we make a hit with the Holtz we will make a bullseye with Gov. House! They also have collected some wonderful furniture & from accounts the house must look like the Babcocks when they lived at the [South Carolina Lunatic] Assylum [*sic;* in Columbia].

Lilian is having a picnic for us tomorrow & on Wednesday the Com. is taking us over to St. Croix, just for the day but hope he can arrange it so we can get some painting in. Have just finished reading the "Glorious Apollo" which is Byron's life.* What a wreck he made of his life! It is certainly true that a man's creative ability is a thing apart from his actual life, so I am beginning to believe the more I meet creative artists. You might [wish] to read it. I am also reading his poems and enjoying "Childe Harold" at present. It's about so much of Europe I have been to & my little glimpse of Greece put me quite in touch with Greece. I saw Missolonghi which is where he died and only 36 years old! What poem of his was it that George read out loud to you and me?

* Using the pen names "E. Barrington" and "Lily Adams Beck," the British writer Elizabeth Louisa Moresby (1862–1931) published more than thirty novels and studies of Asian life and culture. *Glorious Apollo* (New York: Dodd, Mead, 1925) was a fictionalized account of the life of the poet Lord Byron.

*St. Thomas, V. Islands, Grand Hotel*
*March 27, 1926*

To Nell

Sunday morning the Hoars came for us early & took us out to Coki Point where we all four painted. In the afternoon we walked up to the Bakers as it's their afternoon "at home." There we ran into a party of scientists from the Museum of Natural History. Anthony [Harold Elmer Anthony, 1890–1970], the zoologist, being among them. They are down here in the islands looking for fossils, however they couldn't find much on the volcanic islands. They tell me that Roy Andrews came out of Mongolia for a short while but soon settled things & was allowed to return. He had no news of Clifford Pope directly.* They came down in our studio next day and we all got on Will Beebe. What they did for him wasn't a thing. All the museum men detest him & consider him a colossal liar.

Theodore Douglas Robinson [1883–1934], Ass. Sec. of the Navy, has just been in town. He is Roosevelt's nephew & the brother of the rough looking one eyed man I entertained in Columbia in Oct. 1917. This man has better manners but just as common looking. He came in on the cruiser, Memphis, yesterday. Every officer turns out in full regalia & the Marines present arms. A salute was fired & he came ashore.

In the afternoon Sherman, Rachel & I went in swimming. While in the water one of the naval officers off the boat swam with us when we were bobbing up & down talking to Gov. Trench. The man came up & was introduced as "Mr. Donovan." I took one look & when I saw his bright blue eyes I knew it must be Col. Donovan of the Rainbow Division & Col. of the old N.Y. 69th Inf[antry].† I immediately exclaimed & told him my name & we fell on each other's necks. Don't you remember his being down in 1923 just before I sailed with

Ray & Elise? There was a R[ainbow] Div[ision] reunion. There was a dance at the Gov. House later where I saw him, then as he wanted to see my paintings, the Com., he & I hopped in the Gov's car & ran down & looked them over. He is a most attractive man & living in Washington now as he is Ass[istant] Attor[ney] General of U.S. I hear he is going deep into politics. I asked how he was getting along & he said he was mostly being investigated. His wife has just been in Charleston. I'll send George the $1.50 for his book which I wish sent to Mrs. McDowell.

   * Roy Chapman Andrews (1884–1960) was an explorer, a paleontologist, and an adventurer. He wrote more than twenty books on the origins of mankind, ancient societies, and fossil hunting. Clifford Pope (1899–1974), a herpetologist, accompanied Will Beebe in British Guiana and later joined Andrews in Mongolia.
   † William Joseph "Wild Bill" Donovan (1883–1959) was a World War I veteran who established and directed the Office of Special Services (OSS) during World War II. That espionage organization was the precursor of the Central Intelligence Agency.

*St. Thomas*
*April 24 [1926]*

To Nell
The [Akwamu African slave] insurrection [on St. Johns] took place in 1733 & the island has never amounted to anything since. Com. Baker brought along a book of the history of St. T[homas] and St. J[ohns] for me. I did not get any reading done that day but have since. I wish you would read the appalling punishments to which the slaves were subjected!! Red hot pincers, cutting off legs & hands, branding them on the forehead, cutting off ears & noses & breaking them on wheels!! Did we practice such barbarities! I am certainly going to look up the history of slavery when I get home.

*St. Thomas*
*May 2, 1926*

To Nell
All kind of exciting things happen down here. The latest is that Connie Rice got in a rage with old man Rice & beat him on the head with a bottle necessitating the attention of a doctor, several stitches being taken! Mr. Rice lives in Bluebeards Castle & he is a kindly unpretentious old man but his daughter is a perfect virago it seems. The Bakers & others have been trying to help her along socially (why I don't know!) but I think this will end things.
   The daughter in law of the Gov. of Porto Rico was here last week end & as she seemed a lovely looking person I was nice to her, not dreaming who she was. Mrs. Trench had introduced her but I did not catch the name & if I did it would have not made any difference. She met Rachel in San Juan & asked if I had meet Mrs. Towner [Hartnet Cole Towner] when I was over there. "Probably so for I meet a good many ladies when I was there. The name is very familiar any how!" was my reply. She drew her self up & said "She is the wife of the Gov[ernor Horace Mann Towner]!" I fairly fell all over my self trying to cover it up.

Thursday we went over to St. Johns for lunch & cards with Mrs. Richardson. Dr. & Mrs. R[ichardson] are the only white people on the island except two ministers. He is gov., doctor, judge etc. & seems to enjoy the job. He once had means & collected some very fine paintings. He has a fine [James M. W.] Turner & others among which a poor thing by Turner, which R[achel] thinks spurious, also one he claims is a Rembrandt.

Friday the Kelley's gave a picnic at East Point which I thought more of a success than the one Lee & I gave assisted by the Bakers. We had invited all the unmarried men we could find & such a collection of sticks you never saw!! Sherman & Cecil were the only attractive men that we would give a second look at. It was beautiful moon light so most of the party went in bathing except Lilly & Mrs. Miles and me. When they were all coming out I suggested that she, Lee & I go in au natural to which they agreed with eagerness. Then all the rest of the women insisted they wanted to do it . Consequently all the men were sent up to the house & we pealed off & went into the surf. It was a glorious feeling.

I have decided to go to the French islands on the "Dominica" which will get here about May the 20th. It will cost me about $100 or more so Tom's check, with Dr. Knut-Hansens will make $75 & I add the rest trusting to luck about selling some more pictures.

*St. Thomas, V. Islands*
*May 10th [1926]*

To Nell

Your letter came today. I am delighted that George's book will get so much advertisement.* The enclosed clipping you sent me before so I will return it. I got a long newsy letter from Evelyn Lyles also a newspaper "Record" containing Henry Bellamann's article in Columbia with very favorable mention of me.† I hope that what he says is true & that my stuff will make a hit this winter. I am going to try to get into everything when water colors & oils are taken. If I can get the time, [I] want to cut some blocks just as soon as I return. Sherman & I have been painting a negro woman in a bandana & figured dress out in the banana plantation. Everything was quite successful but the head, that is the face for the bandana is fine. We are going to do others which is fine practice for me. I believe that I can get something after a little practice.

Lee Stuart made a most charming impression & I certainly enjoyed her. She has improved in many ways since she was in Provincetown. She was just beginning to do stuff worth looking at when she left.

---

* George C. Taylor's *Shakespeare's Debt to Montaigne* (Cambridge, Mass.: Harvard University Press, 1925) was a revision of his doctoral dissertation.

† Henry Bellamann mentioned Taylor's works in his "The Literary Highway" column in the *Columbia Record*, April 11, 1926. A Missouri native, Bellamann (1882–1945) moved to Greenville, South Carolina, in 1893 to teach at Chicora College, a Presbyterian school for women. In 1915 he moved with the college to Columbia, where he taught music and literature and wrote art and book reviews for local newspapers. In 1924 he left South Carolina to become head of the Juilliard Foundation in New York City but continued his column in the *Record*. Later Bellamann wrote novels, of which *King's Row* (New York: Simon and Schuster, 1940) was the most famous.

*St. Thomas*
*May 22d [1926]*

To Nell

I see a great deal of the Bakers these days, in fact not a day passes they don't drop by to see me or to take me out there. I can never repay their kindness. Things are a little more entertaining these days for there is a rather interesting tall Englishman whom I see something of. He is rather serious minded so we discuss everything in heaven and earth, & he being an idealist, we find we agree on many points. He was in business in New York but got so fed up that he staggered his family by giving up splendid prospects & taking up Bacteriology! He wants to settle somewhere down here preferently connected with the laboratories in San Juan & study tropical diseases. He came down to the studio after lunch (about one o'clock) & stayed until five o'clock. I had a beautiful time smoking, talking, & having tea. I am too sorry he is leaving. Father Whitehead left last week. All the interesting men only pay pop calls to St. Thomas! Such is life!

I am working on big canvases so things go more slowly. I hope that little snip, Eliza, will like the dress I sent & not prefer a store bought thing from Durham. It is a French dress.

*St. Croix*
*June 19 [1926]*

To Nell

We came over last Friday on the "Grebe." I wish you could have seen our get off. The children would have been crazy about it for we left with full Naval honors. All the staff were down in full regalia, all the Marines drawn up in a double line presenting arms. At the landing was just about the fanciest launch you ever saw waiting to take us over. The Marines fired 3 vollies then we departed. On the boat we went to our own little exclusive deck, while the others were on the deck below.

I have the annex which is a nice little apartment over some of the offices. It is very cool as it catches all the breeze. The Trenchs are in the main building & not so cool. It is a very extensive building, running around 3 sides of a quadrangle. The Danes had the dining room & banqueting hall down stairs, with huge old time kitchen & pantries. But the Americans have everything on the top floor, were using the kitchen & using the dining room & hall for offices. They brought over 4 negro men to do all the work & a white man as chauffe[u]r. Everything runs on greased wheels & such delightful but fattening food! I shall be afraid to weigh on my return. Mrs. T[rench] thinks I eat very little & I feel that I stuff.

This island has fine roads & as it is about 20 miles long so one can take long drives. In the first week we took about two rides a day & have now taken about all the different routes. It is much greener than what it was in April, as they have had some good rains in some parts of the island. Up in the mountains they get rains every day and it's lovely and green there. That is where I would live if I were here. For 300 years these people have gone through the agony of prolonged drought & then plentiful years, always on the verge of going bankrupt every few years. They are that way now & are having labor difficulties with all the negroes who can get away pour[ing] into the [United] States.

*St. Thomas*
*June 27 [1926]*

To Nell

We returned on the "Grebe" Thursday, arriving with due Naval honors. We had a very smooth crossing & no discomforts except the smell of onions cooking. Our trip was terminated abruptly by the death of an islander & who occupied a very prominent place & who was connected with a good many of the families. A Mr. Mervin, a Conn[ecticut] Yankee, who came down as a young man. He seemed the most alert & up & doing person on the island [St. Croix]. However he had that curious dread of the negro & what he might do. It seems perfectly inexplainable to us who dominate so absolutely. They don't dare antagonize the negroes yet they are perfectly safe from any fear of an uprising because of the Marines stationed there. They, the negroes, hate them & are afraid of them. The whites are afraid of their being boycotted for they are short of labor. It's the same old story. As soon as they get any education they refuse to work in the fields & all want to go to the States.

[David] Hamilton Jackson [1884–1946] is the black agitator who has caused a lot of trouble. On one of his trips to the States he tells this story himself. It seems that he wanted to ride on a Pullman but knowing a negro couldn't buy a ticket he got a white friend to do it. (I was under the impression that it was only south of Washington where they refused negroes.) He got on the train armed with his ticket & the porter informed him he had made a mistake. Forthwith he produced the ticket & the porter unwillingly letting him pass, saying that colored people were not allowed. He got on & got himself all comfortably fixed when a big burly white farmer got on & just as soon as his eye fell on Jackson he walked over & said, "Nigger, what are you doing on this car! Get out!" Jackson remonstrated & produced the ticket, all the farmer was doing during the explanation was saying "Get out" & pointing to the door. Finally the farmer walked off & remarked "Don't le me see you here when I return!" Jackson, thinking he had gone to get help to put him off decided to leave so gathered up his things & left! Isn't that delightful, yet they go up seeking social equality!

I wrote you that they have been agitating all winter in Washington, a group of the radical negroes being up there, for independence, which means Negro government. They got some response, but not what they wanted, that is an investigating committee to come down this summer, which is just what the Navy wants. When they went blustering to the Sec[retary] of the Navy they had a jolt for he informed them that instead of the Navy feeling that it is a rare priveledge to be down there, they anything but liked it & much preferred putting the $300,000 expended each year on the islands into battleships & they needed the men on the ships.

There is something like 12 doctors on these 3 islands & free medical attention to anyone who will come. What the Navy had done down here fills me with admiration. Gov. and Mrs. Trench & I inspected some of the schools in St. Croix & they seemed well furnished & in good buildings. Nothing so dilapidated as the old Howard School [in Columbia] nor many of the Negro country schools of former years. The teachers looked fairly intelligent all being mulattoes.

The girl's sewing was excellent. Very few make the high school & of course the [white] islanders think they are being entirely too highly educated. The best part of the island has been bought over by degrees as the different plantations have failed & is now owned by a Danish company.

*St. Thomas*
*July 4 [1926]*

To Nell

Sherman & Cecil left early this morning on an all day fishing trip so I am up at "Havensight" spending the day with Lilian. Ellie is over on St. Croix staying with the Armstrongs but returns this week.

Cecil returned last Monday looking tired but thinner, which is more becoming. He will be a Captain in the fall & will be given a different post, for he wishes to be near his mother, as he is the only son on whom she can depend. One is very exotic & perfectly unstable, due the family thinks to a nurse who drugged him for some time when he was an infant. I always have my doubts about these infant cases, more than likely inheritance. The other son was shot to pieces & gassed during the war. Captain Baker [Asher Carter Baker, the father of Cecil Sherman Baker] seems to have been quite a character. After resigning from the Navy he took up exposition work & was one of the Boss dogs at the Chicago World's Fair, Paris, San Francisco, St. Louis & was chairman one in Philadelphia. He galloped all over the world, loved being in the lime light, had about the largest calling list of European notables of any living American!!

Friday was Gov. & Mrs. Trench's wedding anniversary so I was invited to the dinner Mrs. Knut-Hansen gave for them. I presented Mrs. Trench with a sketch I made out of one of her windows, her favorite view. I had it framed properly & not ruined as R[achel]'s sketch was. I also framed a Gov. H[ouse] one Wednesday so I am very much in there these days, not to speak of dinner & lunch en famille.

I return in September & wrote McMully I wanted my house from 15th or [illegible] Oct. 1st. Of course I know nothing about sailings yet. I will be a little while in N.Y. & then go right home if I can get my house if not I will stop by & see you a few days.

*St. Thomas*
*July 9 [1926]*

To Nell

I have been reading some of [Ralph Waldo] Emerson's essays & found his writing on the "Poet" & "Nature" quite inspiring. Also read some short stories by a French writer Remy de Gourmont & found them too degenerate & awful. Don't ever touch him. A short story of [Leo] Tolstoi's called "Death of Ivan Illyvitch [*sic;* Illyich]" & the whole time I thought "what ignorant doctors" & overlooked the author's point entirely! The man evidently had cancer & not a doctor thought of operating but filled him full of medicine. Tolstoi's theme was that Ivan's God had been the material theory of life & had nothing to sustain him in the hour of his death. I am too modern & scientific! Also read the story of the pirates & such awful cruel creatures they were, in fact the book is so revolting that I put it down.

I am now working in water colors & am very much interested. They are very brilliant in color which is what I am trying for, also a sparkling quality, which practice will bring.

*St. Thomas*
*July 18 [1926]*

To Nell

I am having a lovely time splashing on water-colors & am beginning to get hold of the technique. Hope to get some good stuff before I leave. I am working in my studio entirely. Have certainly done some studying this year & feel that I have taken a real leap forward. For one thing I can now work a great deal from memory which I couldn't do before.

Senator [Hiram] Bingham is due tomorrow, to investigate things. He ought to be very agreeable. Was a professor of Economics at Yale & is filling a recess appointment. He has travelled a great deal & made a study of the negro problem, I believe.* In fact everyone is delighted that he is the one to come. If you could hear these dyed in the wool Yankees on the subject of the negro! Uncle Julie is conservative by them!

I think that I will sail from San Juan Sept. 16th getting to N.Y. Sept. 20th. Stay there a few days & then go home. My address in N.Y. will be the Nat[ional] Arts Club.

* Before entering politics, Hiram Bingham (1875–1956) was a professor of history and a pioneer of South American archaeology. He explored the Inca site Machu Picchu and published *Inca Land, Explorations in the Highlands of Peru* (Boston: Houghton Mifflin, 1922) and *Lost City of the Incas, the Story of Machu Picchu and Its Builders* (New York: Duell, Sloan and Pearce, 1948). He represented Connecticut in the United States Senate from 1924 to 1933.

*St. Thomas*
*July 24, 1926*

To Nell

Our latest excitement was the outskirts of a hurricane which struck on Friday morning. I was at a dinner at the Gov. House Thursday evening & there we heard that the Porto Rico Station had reported a hurricane brewing around St. Lucia, but it wasn't going to come near us. We all went home serenely only to be awakened with the news of its coming. Various people were notified at 4:00 A.M. that it was coming, & the flag run up which is red with a black center. When I came up for breakfast at 8:30, everyone's eyes were as big a saucers, & all informed me it was coming this way. The Baker's started in the cold grey dawn to get their house ready & closed before coming to the hotel. Their place is very exposed & some distance from town. Our part of the house had a tin roof, which would certainly go in a storm, so everything had to be moved into the other part of the house. These all had to be off the floor & covered, as the water would pour in for there are leaks in various directions. They were wrecks then they landed at the hotel. All stores closed & business stopped, in fact, the town was absolutely deserted.

Cecil, the Governor, and Senator Bingham drove over to Cha Cha Town & said it was a sight to behold. It is a village of little one room or 2 room houses with tin roofs. Each house was tied up like a package with ropes the size of one's little finger up to the huge cables

ships use. Every door & window shut tight. Most of them, the Cha Cha, were in the church on the top of the hill in the most exposed place! Well, everyone waited breathlessly for the three guns & another flag to be run up, but nothing happened & by 1:00 everyone knew that the hurricane had passed us by except for high winds & high seas.

Senator Bingham of Conn. is down here investigating so it looks as if the hurricane was staged for his benefit. He is a most charming appearing & seeming man. His people were some of the first missionaries in Honolulu. He is a Yale man, taught 2 years at Princeton but left as he didn't like [Princeton president] W[oodrow] Wilson, went to Yale where he was until he went into politics. He was Lieut. Gov. of Connecticut until appointed to fill some unexpired term in the Senate. He is running for reelection. His specialty is S. American history, had traveled & studied all over the world & the South Sea Islands. In fact, a better man couldn't have been chosen.

I have been reading "With Lawrence in Arabia" & found Lawrence was excavating in Syria with [Leonard] Woolly one of Emily's beaux.* We used to be entertained with Woolly's letters also saw numerous snap shots & photos of him. In fact I feel as if I knew him. He also speaks of Jack Bassett, another beaux of E[mily]'s. The book is not very interesting, too journalistic & cheap in some ways. I saw Lawrence & Feizal [sic; Abdul Aziz Al Saud, King Faisal of Saudi Arabia, 1876–1953] in Paris when they were at the Peace Conference. Am enclosing Helen's letter. It's so absurd do keep it!

* Lowell Thomas (1892–1981) was a newspaperman and pioneer of radio and motion picture journalism. He covered the Middle East during the Great War and produced the news film *With Allenby in Palestine and Lawrence in Arabia* in 1918 and then published *With Lawrence in Arabia* (1924). His film and book made Thomas Edward Lawrence (1888–1935) internationally famous. Prior to the war Lawrence worked on archaeological sites with Leonard Woolly (1880–1960), the British archaeologist who made important discoveries in Syria, Sumer, and Iraq.

*Saint Thomas*
*August 15, 1926*

To Nell

My plans are as follows: address your next letter to the Nat[iona]l Arts Club, 15 Gramercy P[ar]k [New York City]. I leave here September 12th & go to San Juan, where I will stay in the same house with Mrs. Thomas. She wants to give me a tea and exhibition in her apartment. I sail on the San Lorenzo, September 16th, getting to N. Y. September 20th. I will be there a week but may find I have to stay there longer then go straight home.

I wrote to Mrs. Cain this mail to see if she would get in touch with Rachel. I wrote Margaret [M. Law?] a long letter in June & in it asked her to see if Rachel expected to come to me but I have yet to receive an answer to that one or the one I wrote in the winter.

Please put the sleeves in my dress & send it to the National Arts, for I am landing looking like the 4th of July, as I don't possess a single dark dress. As usual I will probably have no money to put into clothes, for if I exhibit, I will need it all & more too for frames & expenses. I am willing to pay $600 or $700 to get an Ex[hibition] in N.Y. & hope to get some back in sales.

It looks as if I am going to sell some of my things down here which will help along. If I could get my transportation both ways, it would help, say $225.

Kilpatrick [Aaron E. Kilpatrick?] is in Mexico City taking a course in Spanish. He seems to be having a perfectly glorious time, for he doesn't even mention the religious war going on down there. He says it's the most delightful summer climate he has ever experienced & of course it is glorious to paint, so I will have to go there some summer.

*St. Thomas*
*September 7th [1926]*

To Nell
This will be my very last letter from this island for I leave myself on the next mail from Porto Rico.

Sunday morning Mrs. Gillette had a breakfast on the beach. We started at 7 o'clock for Brewers Bay & had a fine swim. She took the maid so breakfast was almost ready when we [were] clothed & in our right minds. The others stayed later but Cecil & I had to go back for a nine o'clock service. I wanted to go before I left for I like Phillips so much. After church Cecil & I went out to Havensight & he stretched off in the hammock & studied while I wrote letters. He has his exam for Captaincy on the 15th. It was a perfect day & the little town looked like pink & white jewels in a green setting.

Yesterday was Labor Day so everybody had holiday & all stores closed. Cecil, Mrs. Gillette, and I left at 6:30 for Havensight & had breakfast on the terrace. It was very beautiful in the morning sunlight. By 8:00 we were on our way to Megans Bay which is across the mountains on the other side. It is the most beautiful beach on the island & the water is perfectly swimmable. We undressed in the bushes & had a glorious dip for one can't really do any swimming in these waters. As it was they saw a big barracuter [*sic*] about 30 yards from me.

I sold ten of my sketches which will help along hugely with exhibition expenses. It makes $245. But do you know my ticket cost $146 to Columbia so you see that doesn't cover travelling expenses.

I am landing in New York looking like 4th of July. I hope the tan dress will be there with the long sleeves. Inness Hartley has a son. Rachel is coming up to New York when I land.

## 12
⤴

# *Taylor Makes Her Mark, 1920–1929*

RETURNING FROM THE GUIANA JUNGLES IN 1920, Taylor wrote in a *Christian Science Monitor* article, "I returned to the United States with a glorious collection of brilliant colored suggestions for textile designs and woodblock prints" (p. 174). Her South American images and the way she used them in creating batiks and prints have constituted a considerable part of her artistic legacy. Her studio was in Columbia, but she traveled frequently to New York and New England to exhibit her "jungle art."

During the summer of 1904 when studying with Chase in London, Taylor and her fellow students were keenly interested in the art and artistic techniques of the Far East. Chase and most of the impressionists were fascinated with the art of China and Japan and incorporated features of those traditions in their works. Chase, James A. M. Whistler, and John Singer Sargent were powerful influences in Japonism. Whistler was also a gifted etcher and printmaker. With her academic training, her sojourn in Japan and China, and her immersion in the botanical wonderland of South America, Taylor was ready to become a master printmaker.

In 1916 in Provincetown she studied painting and printmaking with Bror J. O. Nordfeldt, the pioneer of the Provincetown print. Taylor also took quickly to printmaking just before the Great War. Her British Guiana studies proved valuable sources of inspiration for her prints. She was already a successful woodblock printer when she donated her monkey print *Red Howlers* to be the frontispiece for the 1929 *Yearbook* of the Poetry Society of South Carolina (fig. 1). Did any of her fellow Poetry Society members realize the prospects for satire in printing the work?

The two following firsthand recollections of Taylor's life in Provincetown recount her place in the life of the town and also highlight her generosity to friends and family. These accounts, by editor Edmund R. Taylor and his late sister Mariana Taylor Manning, also fill a gap in Anna Taylor's correspondence. ⤴

## Personal Memories of Anna in Provincetown in 1928
Edmund R. Taylor, M.D.

*My sisters, Eliza Shockley and Mariana Manning, and I all agreed that Anna was the most interesting woman we ever knew. Her many nieces and nephews were fascinated by their aunt. She had been all over the world. There was Will Beebe in the unexplored jungles of South America with panthers, eight foot long poisonous snakes, huge vampires, bloodsucking bats, pet monkeys, howling baboons, the ocean and great rivers, and the Southern Cross at night. She knew all kinds and colors of people and places. She had been in the Great War, and was chased by submarines, bombed by planes, and knew the Germans' gun, Big Bertha. She had seen battlefields, rats, shell holes, trenches, and ridden in tanks. In her living room sat a huge shiny brass artillery shell and a bayonet was used as a fireplace poker. Many colorful paintings and interesting books decorated her walls. She smoked cigarettes and sipped cocktails, wore big riding breeches from the Orient and, on occasion, wore a long blue cape. The spirit of adventure surrounded her. She was straight as an arrow, tall, strong, and very vigorous. She was quite social, and she loved to laugh, as did Nell.*

*Anna was an inspiration and influenced us by showing great interest in our lives. In addition she was very generous, giving all of us interesting presents and financial contributions, in hard times, to our education. Furthermore, she encouraged our natural interests. I fondly remember the summer that my mother, sisters, cousins, and I spent with her at the artist colony in Provincetown (1928).*

*Goody Taylor, my first cousin, and I were eleven years old and our chores were to bury the garbage and dry the dishes. We were given a room upstairs across from Anna's north-facing studio where she worked. Her aim that summer was to produce 12 woodblock prints, but Goody & I interfered with this plan. We discovered a remarkably delightful pastime. The inside of our room was unfinished and the rafters provided our entertainment. After swimming, while still naked, and while Anna was "pulling" her block prints, we would bound on our spring bed, jump up and catch the rafters, swing on it, then hurl ourselves across the room, landing with a house-shaking crash. Cutting her prints was not to be. One day the door flew open and, naked like Adam, we hid. She, however, when entering, convulsed with laughter at these two boys trying to hide. "Boys, you don't need to hide. I know anatomy. I've been drawing nudes for years! You are just like those monkeys I used to see with Beebe in the jungle." Mariana reported that with five children visitors, Anna said it was her most unproductive summer ever—only one block done out of twelve.*

*The navy used the beautiful harbors at Provincetown extensively. Goody and I were fascinated by the four stack destroyers and occasional big battleships visiting. We were reading Henty books on war and Tarzan. Anna often knew the officers, perhaps from her World War I experience and the Charleston Naval Base. She knew people everywhere. She said Eliza and Mariana needed "contacts" so would introduce them to the sailors. She also introduced them and me to General Tecumseh Sherman's nephew. I recall not knowing whether I should shake hands with him after his uncle's behavior. He had burned Columbia and two of our Taylor homes. I knew that much then! Well I did shake hands, and he took Goody and me sailing in that beautiful harbor. He was a slim gentleman who was painting. He wanted to paint magnolias with*

*Anna's help. She was the best at that. Such is life; his uncle loved to burn magnolias and he to paint them! Then I held no grudge. About 80 years later, I wish him well with his magnolias!*

*As Anna helped Mariana with her art, she encouraged me in my interests in birds. As a boy, I visited her in Charleston where she arranged for me to meet the fine ornithologist Alexander Sprunt and E. Milby Burton with the Charleston Museum. They took me out to heron rookeries on islands where we banded young birds, an exciting experience. Later in my zoology classes, she encouraged me to learn to draw.*

*Our close contact with Anna's art stimulated in Eliza and me an interest in drawing and painting. Eliza thirty years later, to her amazement, taught herself how to paint. Her game roosters and wildflower watercolors are good. Many hang in our family homes.*

*During World War II in England and North Africa, no cameras were allowed at times, so I bought a pad and watercolor box for a shilling to paint the brilliant Mediterranean. I was a young surgeon with the 9th Evacuation Hospital. I sent my paintings home and they were passed around the family. Anna saw my paintings and sent me a pair of [Eliot] O'Hara's brushes and good paper, and criticism. When I returned from Germany, the University of North Carolina Art Department had an exhibition of my watercolors.*

*Anna's finances were limited. Her father left her $20,000 in trust administered by R[obert] Beverley Herbert [1879–1974]. In addition she had income from her art and teaching. Her home on 79 Church Street had four stories. During "the season" when northerners would visit Charleston, she would rent out a room. She was frugal but always generous. On her travels she was always sending home to her family interesting toys, colorful kimonos from Japan, hats, scarves, necklaces, rings, and other unusual presents. Anna was never rich by material standards, yet she was rich by creating a treasure through her life and art in the hearts of men and women.*

*I end my memories of Anna with two observations. She was very sociable, loved people and parties. People to her were clearly seen and she outlined them as boldly as she used her cuts in her woodblock lines.*

## Personal Memories of Anna in Provincetown in 1928

Mariana Taylor Manning

*The summer of 1928 was a propitious one. George Coffin Taylor [her father] was off to England by steamer to work on his "Milton's Use of DuBartas" at the British Museum. From Bedford's Place on Bloomsbury Square he wrote to us almost every day! The rest of the family consisted of Anna Heyward Taylor, Nell Taylor [her mother], Goody [Goodwyn Rhett] Taylor, Edmund Taylor (both eleven), Eliza aged fifteen, and myself aged thirteen. The game plan was for Anna and Nell to drive the six of us up the Eastern seaboard to Provincetown, Massachusetts, situated on the hook of Cape Cod. Anna had been there as an art student and knew it was a renowned artists' colony. It seemed to me the car was an old grey/green Buick. Anna was a terrible driver, and mother even less coordinated and experienced! But Anna being a seasoned world traveler thought nothing of the undertaking. How we made it through the hearts of big cities like Washington, Philadelphia, and New York I'll never know.*

*We did make it down the length of Cape Cod and arrived at Provincetown intact. Anna was visualizing a quiet summer to turn out eight or ten woodblock prints for an autumn exhibit in New York City. Little did she know. Our house was in the middle of Provincetown*

*and up a delightful wooden walk uphill for about sixty feet to the cottage built against the sand dunes. It consisted of a screened front porch, a big living room, and kitchen behind and two small bedrooms. Eliza and I had one double bed and Nell and Anna two single beds. Up a flight of incredibly steep steps lived Ed and Goody on the left side in a big, huge kind of attic room with beams above, and Anna had the big room on the opposite side with a northern light and beams—"her studio."*

*And so, the most glorious, sun filled and happiest summer of my life began! Carefree. The arrangement was this: Eliza and Anna worked together on the meals one day, and Nell and I, the next day. The food was sumptuous and the huge round loaves of Portuguese bread were absolutely delicious! Anna was great at vegetable salads, and mother was good at the meat and vegetables. We were all ravenously hungry all the time. Sunshine, swimming in the ice water of the bay right below us every day, sleeping soundly and happily, and drinking gallons of milk. Anna had a knack for making a room cozy and attractive with a few bright sofa cushions and a gorgeous deep red Japanese batique which covered the big table when we weren't eating. The sun poured in, the air was like wine, cool and 72 degrees all of the two months we were there.*

*Anna took me on the second day to E. Ambrose Webster's studio a block away to the left on Commercial Street, the street we lived on. The studio was a grey shingle two-story building located on the yellow sand of the Provincetown bay (he rented the downstairs apartment) and up a steep flight of stairs on the outside we climbed up to his studio. It was a huge high ceiling room 60 x 30 feet with marvelous north light and a huge skylight in the center above the model's stand. I was introduced to Mr. Webster, a forty, plump, brown-haired, bright-eyed agile gentleman I loved immediately! He called me "Mayne" and could not pronounce his "r's." Red was "wed" etc.*

*"Well, Mayne, let's set up a still-life and see how you get along." He produced paints, a palette and a canvas and two brushes, sat me down in the small room overlooking the water, turned the canvas board over, and made a quick small 4 x 4 sketch of the teapot and round vase he had put on the table for me. The little room was filled with all sorts of objects to paint, bricks, teapots, little Greek statues, etc. I had the white china teapot with pink flowers and im-mediately plunged on to paint! Such joy! In an hour I had drawn and painted a good free fresh little painting and he praised me! And so my career begins, that summer! In the afternoon there was always a fine nude model posing, tactfully handled and controlled by Mr. Webster. His class that summer consisted of about eight students, professional artists. One, Katherine Critch[er] of D.C., a teacher at the Corcoran Museum [Corcoran Gallery of Art], and others I can't remember. In the morning with these he had a noted Portuguese model and in the after-noon the nude for the life class. My brother, Edmund, posed for twenty-five cents an hour and said it was most uncomfortable sitting still. His very blond hair and skin contrasted sharply with the Portuguese model's. He remembers my painting him and being shocked to see his face composed of nothing but colored triangles!*

*So, each day Mr. Webster took me out in the town with my easel and stand and equipment and sat me down, drew a small charcoal composition on the back of the canvas board and left me alone for three hours to paint this composition. This went on for six weeks, paint in the morning and charcoal during the afternoon of the fine nude model! There I learned to begin to draw. He was a marvelous teacher.*

*After class I would go home and take a nap. Eliza, meanwhile, was spending every morning taking piano lessons from a fine concert pianist named Jonas. Then she'd practice.*

*Poor Anna only produced two prints the whole summer. She had agreed to divide the expense and we ate her out of house and home. But we had fun! Isadora Duncan's biography had just come out and she had it and turned it over to Eliza and me when she had finished. There we learned the "facts of life," a great book, Eliza and I thought. Then she introduced us to* Jane Eyre. *Every night after supper we walked into the heart of town and to the library, a puny, stuffy little building. Then we got an ice cream cone at a drugstore and weighed. I weighed 100 pounds to begin with, but 114 pounds at the end of the summer. Poor Anna!*

*The two boys rented a small row boat and fished and swam all day. Their job was burying the garbage in the big sand dunes behind the house, sometimes sweeping the floor and setting the table. Their in-house sport was shooting the Portuguese cats that walked along a wooden fence below their room with slingshots made of dried dogwood and beautiful round stones picked up on the ocean side of the Cape. They stretched out on the swing on the porch and read* Quo Vadis *and* Henty.

*And so the summer progressed nicely. General Sherman's grandson, aged twenty, Sherman Baker [Jr.], was a friend of Anna's. She had become friends of his father [Cecil Sherman Baker], a naval officer stationed in St. Thomas, Virgin Islands, while she was there painting. Sherman Baker was an aspiring artist, tall and dark and skinny and handsome, and was trying to paint magnolias. Anna was an expert on magnolias and he would come upstairs and take lessons and see about the progress of his watercolors.*

*This was also the golden summer that Anna's friend, Sarah Cowan, a distinguished miniature painter and watercolor portrait painter, was spending her time in an apartment across the street from us, on the water. Anna wanted her to have commissions so persuaded mother to let us pose for her and buy the results! These now hang in our three houses, unfaded and fresh as the day we sat. Later she was asked to do a miniature of Uncle Tom in Columbia in his plum-colored velvet smoking jacket (a handsome man!). She was doing a superb job but he was so picky and critical that she lost her temper, took a brush full of water and wiped it out! End of plum jacket!*

*We had a picnic basket with white enamel plates and cups and Anna knew how to fix a great repast! Lemonade I remember and Portuguese bread. Jacky, our Boykin spaniel, loved to chase the seagulls on the flats at low tide. Anna had friends. Poesy Hall, the daughter our age from New York City would go on picnics with us across the mile-long breakwater on scorching summer noon days over to Race Point where the lighthouse stood on the point. Then over a sand dune and there was this fine white beach, the ocean flat and still, and the crystal clear water filled with tiny jellyfish, beautiful, little balloons! Swimming we had, and then visits to the lighthouse manned by a good-looking Coast Guardsman, up metal steps to the spotless top and the Fresnel crystal prisms of the light and the many minor reflectors. We could see the huge curve of Provincetown Harbor ending in the breakwater and toward the east the stretch of ocean and beach—what a sight. We were looking in the ocean at the spot where the submarine, the U2, I think it was, sank a few years before.*

# 13

## Taylor and the Charleston Renaissance

THE YEAR 1927 was a turning point in Taylor's career. As a founding member of the Southern States Art League, she attended the organization's inaugural exhibition in Charleston. League president Ellsworth Woodward (1859–1939) praised the culture and art of the coastal cities of Savannah and Charleston and exhorted regional artists to undertake a cultural renaissance that would restore the artistic reputation of the South. A painter and printmaker, Woodward was also dean of the Newcomb College School of Art in New Orleans and a tireless promoter of fine arts in the South.

Taylor heeded Woodward's call and acquired a studio on Atlantic Street in Charleston where Alice Ravenel Huger Smith and other artists had their studios. Smith was the leader of the emerging group of artists, which included Elizabeth O'Neill Verner, Leila Waring, Emma Gilchrist, Alfred Hutty, and Antoinette Rhett. They were painters and printmakers, and all of them paid constant homage to the people and places of the lowcountry. Taylor moved to Charleston permanently in 1929 when she bought a house with a good studio at 79 Church Street, on the corner of Church and Tradd streets.[1] In addition to the siren call of Charleston's artistic community, Taylor kept her eye to practical considerations. Ever the realist, she told a newspaper reporter several years later that she had moved to Charleston "because Columbia was not very interesting to paint and there was no buying public there."[2] By 1932 she had established her studio upstairs.[3]

Taylor immersed herself in the cultural life of the city and region. She had been civic minded in Columbia, especially as an arts advocate. She took up the same role in Charleston as she joined the Poetry Society of South Carolina and was a trustee of the Gibbes Art Gallery and Carolina Art Association. She also had a lively interest in the Footlight Players, the theater company that performed at the Dock Street Theatre up the block from her home.

Taylor was a vivacious member of the Charleston art community. Her life story and her approach to art offered a contrast—perhaps a complement—to those of her friend and fellow artist Alice R. H. Smith. Alice Smith was born and raised in the lowcountry and was

permanently enveloped in its history and charm. She rarely and only briefly made excursions outside the region. Smith's travels were intellectual and artistic, rarely geographical. In her paintings and woodblock prints, she sought to capture a delicate, mystical feeling that pervaded the Spanish-moss draped, misty landscapes and the lives of lowcountry African Americans. She was actively interested in Chinese and Japanese art and artistic techniques. She owned and studied the writings of Ernest F. Fenollosa (1853–1908), in particular his posthumous *Epochs of Chinese & Japanese Art* (1912) and took inspiration, through Fenollosa, from the artistic and aesthetic writings of Kakki, an eleventh-century Chinese landscape artist. Smith's annotated copy of *Epochs of Chinese & Japanese Art* is in the collections of the Gibbes Museum of Art. Helen Hyde and Bertha E. Jaques visited Charleston, where they taught Smith printmaking and mentored her. Taylor, on the other hand, had visited Japan and China and had met Hyde there. She also conversed with Anne Heard Dyer and Louise Norton Brown, who had worked with Fenollosa and others to bring Asian art to Europe and America.[4]

Smith and her father, Daniel Elliott Huger Smith, were pioneers of historic preservation. They documented in words and pictures such notable buildings as the Miles Brewton House on King Street and Chicora Wood Plantation in Georgetown County. The pair wrote and illustrated a pathbreaking work of architectural history, *The Dwelling Houses of Charleston* (1917), and she created the remarkable series of watercolors that illustrated Herbert Ravenel Sass's *A Carolina Rice Plantation of the Fifties* (1936). Smith found all she needed of the world's inspiration and art subjects close at hand.

Smith found inspiration in local history and muted tones of nature; Taylor traveled the world, immersing herself in exotic places far from Charleston and in experiences likely unimaginable to lowcountry gentlewomen. Smith masterfully used washes, graphite, and etching needle; Taylor painted exuberantly in watercolor and oils. Her prints were bold in execution and bright with color, and her batiks were truly exotic in form and execution. By the time Taylor settled in Charleston, she had studied at the Art Students League in New York City, with Chase in Holland and London, and with Nordfeldt and Hawthorne in Provincetown, and she had traveled to the great museums and art centers of France, Italy, and Germany. She had been an artist-explorer in China and Japan, South America, the West Indies, and Europe and had served with the American Red Cross in wartime France and Germany. She was always true to her artistic vision, but she knew well the forms of modern artistic expression and had friends among the modernists. Through training and practice, she had been a scientific illustrator and was more keenly aware of botany and other natural sciences than her fellow Charleston artists. Few other modern South Carolinians could point to such a varied life in service of her art.[5]

Art historians and connoisseurs have accurately observed that with few exceptions southern artists between the two world wars more closely identified temperamentally and aesthetically with their native soil, its flora and fauna, and the agricultural traditions of cotton and rice planting than they did with business enterprise, government, and industry.[6] Indeed, many, including Taylor, embraced a conservation-minded, nostalgic conservatism that had both good and bad effects. Along with their love of the lowcountry's natural beauty and picturesque landscapes, they harbored racial prejudices against African Americans even

as they created myriad images of them at work, at worship, and at leisure. Former slave cabins on outlying plantations and scenes of black street vendors of Charleston provided classic visual images of the Charleston Renaissance just as Beatrice Witte Ravenel's *Arrow of Lightning* (1926), Dubose Heyward's *Porgy* (1924), and Julia Peterkin's *Scarlet Sister Mary* (1929) defined the literary dimension of the era. However, these artists and writers rarely expressed interests in improving the material conditions, advancing political and economic equality, or bettering the social status of the people who were their favorite subjects. Many publicly opposed New Deal programs that built the Dock Street Theatre and a state parks system, funded oral history and public records projects, and most of all created the Santee Cooper Public Service Authority because those programs challenged traditional relationships between whites and blacks, wealthy and poor in their state.[7] Colonial and antebellum principles of deference and noblesse oblige had controlled economic, social, and political relations between the races and economic classes in South Carolina for two and a half centuries. Many white South Carolinians resisted the rise of government regulation and the nascent stirrings of civil rights and economic justice activism. Artists and writers harked back in time and resisted radical innovations in styles and content.

Taylor's work fit within the artistic and cultural styles of the Charleston Renaissance. She had her own vision of these styles—bolder in color, stronger in line and volume, and more cosmopolitan—but when it came to aesthetic and social values, she made them all her own. For example, in 1931 she exhibited images of thirteen African American cabins at the Berkshire Museum, Pittsfield, Massachusetts. A friend from Charleston, Laura Bragg, was director of the museum and had sponsored the show.[8]

Within the limits of her subjects and of her attitudes toward them, Taylor's palette had a variety of colors, and her subjects—azaleas, magnolias, lotuses, great turtles on the beaches, graceful herons, black skimmers, ducks, and wild turkeys—set her apart from her neighbors. Her colored block prints of the extinct Carolina parakeet and her bold prints of magnolia blossoms and South American flowers set against black or deep blue backgrounds are distinguished works of art of any region, era, or medium.[9]

Taylor's move to Charleston landed her in the city much like Buh Rabbit found himself thrown into his own briar patch. She immediately entered the social life of the city and visited friends who lived on nearby plantations. Her home and studio at 79 Church Street were comfortably furnished with her family furniture. Objects from her trips about the world added interest, along with her paintings and prints and those of her colleagues. Such items as a two-foot-tall brass artillery shell from the Great War stood on one side of the fireplace, and on the other a bayonet served as a poker. Books of every description lined the walls. In the small backyard was her flower garden with a tree in which a painted bunting nested and sang. Across her back wall rose the steeple of St. Michael's Episcopal Church. Its chimes rang out across the city.

The beauties of the lowcountry were hers to enjoy. Charleston had famous gardens, formal and informal, great and small, along with fine architecture, churches, and well-proportioned homes. All these and more offered compelling subjects (figs. 3, 19, 24 and representative plates 16, 17, 26). As was obvious in her previous descriptions of British Guiana, she was fascinated with the beauty and teeming life of tropical jungles. Near

Charleston she had another junglelike paradise, the great southern swamps. Taylor and her nephew Edmund Taylor often paddled through black-water swamps between massive moss-draped cypress trunks. Gold lotuses and birds were double imaged in the dark water. Herons, egrets, and wood storks nested overhead.

Legendary birds had lived there—the extinct Bachman's warbler, the Carolina parakeet, which Taylor painted, and the bird of greatest mystery, the ivory-billed woodpecker. Anna and Edmund Taylor vainly searched for parakeets and ivorybills in Santee Swamp in 1937. Some of her finest prints are of herons and great wood storks (ibis) flying with wings out-spread through the cypress trees. One of her rare screens also depicts Cypress Swamp with herons (plate 26).

One night Anna and Edmund went into the countryside to watch and hear an African American church service. They were powerfully affected by the Gullah church choir and fascinated to see congregants performing ring shouts and other dances. Gathered around a great flickering fire, they danced with abandon amid a dark forest netted with Spanish moss. Taylor's *Spiritual Society, Campfire* (plate 25) depicts the scene.

In the following excerpt from the *State* newspaper of December 21, 1930, Henry Bellamann comments on Taylor's career to that date. His essay elaborated contemporary opinion of Taylor's work and the values of the Charleston Renaissance. ✐

### The Work of Anna Heyward Taylor

*It might be said that the outstanding characteristic of her painting is a magnificent exterior-ity. She is the opposite pole from mysticism. She is concerned with the appearance of things quite as much as the older impressionists were, although her painting is not impressionistic. There it is, she seems to say, hard and brilliant and flooded with hot sun; my job is to make a pattern of it and let it speak for itself. She is not concerned with interpreting it; with injecting her feel-ing about it into the finished picture; or with any other intent than adequate and effective pres-entation. There is an admirable honesty about all of this.*

*One hesitates to use the word "decorative." It is a word that has been too much used to cover a multitude of artistic shortcomings, and to explain something that isn't painting at all. Painting is one thing and decoration is another, and a very great deal of contemporary painting attempts to be decoration because it is unable to be painting. But in the best sense of the word Anna Taylor's painting is decorative. By that I mean very simply that her colors are bold and high, and that her arrangement and compositions are satisfying as pure design, in addition— always in addition—to answering the demands of painting as well.*

*I said something about the value of a hereditary association with a region—that satura-tion with the feeling of a country that informs any expression of it with something that lies just beyond analysis. Perhaps the abused word atmosphere says it, although most people mean just one kind of atmosphere when they use the word. There are many kinds of atmosphere.*

*Those who greatly love the South Carolina coast country are well aware of two opposed aspects of it. One is mysterious in the sense that Maeterlinck is mysterious—gentle, elusive, and subtle. This characterizes the poetry of Dubose Heyward and the painting of Alice Ravenel Huger Smith. The other is equally evident. It is deviant, flamboyant, realistic, and sinister. And*

*this quality characterizes passages—passages only—in the prose of Julia Peterkin, and it certainly characterizes the painting of Anna Taylor. To make a little clearer what I mean, it is only necessary to mention two of the most famous gardens near Charleston, the Magnolia and the Middleton. The Middleton Gardens are all poetry and over them hangs that perpetual reminder of a past life. It is the super-imposed beauty of a poetic idea that interprets the place to the observer. They are the gardens of nostalgia. Such gardens as these have been painted adequately and beautifully many times in this country, in France and in Italy.*

*Magnolia Gardens represents the other side of the shield. These are the enchanted gardens of Klingsor in "Parsifal." These are the heartless azaleas, subtle and intricate of design but of no emotional implication. The spell of Magnolia Garden is no less pronounced, but it is different. It is a dramatic beauty, and I suspect that most of the failures to transfer these gardens to canvas is due to the effort to infuse a wrong kind of poetry into an interpretation of them.*

*This illustrates exactly what I mean when I speak of the colorful exteriority of Miss Taylor's painting. She is the kind of personality tuned to a certain kind of perception. She has had the discernment and the good taste and the artistic integrity not only to understand herself but also to adhere strictly to her own kind of vision.*

*It is interesting to observe how this artist has turned with such facility from one medium to another and always carries over an increased dexterity and cleverness to the new medium. Her textiles have very much the quality of very old Oriental fabrics.*

*Miss Taylor's color prints of South American flowers are among her best-known things. They have been widely sold. Museums and galleries and discriminating private collectors such as Mrs. Vincent Astor and others own examples. It is probable that these things have been as well done by Miss Taylor as they can be.*

*The new black-and-whites of Charleston are highly effective. She has chosen subjects all suited for that medium. Charleston has long been the haven of etchers but many of these artists are simply good etchers and there is not always evident the quality already spoken of that doubtless derives from the special vision of those who are traditionally of the place. Some of these black-and-whites show influences of the etchers but this doesn't happen often. In the main, Miss Taylor keeps an eye on the limitations of the particular medium she is working on for the moment.*

1. Elizabeth Verner Hamilton, "Four Artists on One Block and How They Got Along; or, A Partial History of Atlantic Street, 1913–1936," *Carologue* 25 (Summer 2009): 15–19.

2. "From Guiana to Tehuantepec, Anna Heyward Taylor Brings Strong, Bold Paintings," *Charleston Evening Post*, March 26, 1939, C-2.

3. Her nephew Edmund R. Taylor recalls seeing her at her upstairs worktable by then, deftly carving woodblocks from which she printed her distinctive color and black-and-white prints.

4. Martha R. Severens, *Alice Ravenel Huger Smith: An Artist, a Place, and a Time* (Charleston, S.C.: Gibbes Museum of Art / Carolina Art Association, 1993), 50; Daniel E. H. Smith and Alice Ravenel Huger Smith, introduction to *Collector's Edition of Dwelling Houses of Charleston* (Charleston, S.C.: History Press, 2007).

5. Lana Ann Burgess, "Anna Heyward Taylor: 'Her Work Which Is of Enduring Quality Will Remain to Attest to Her Reputation as an Artist and Her Generosity as a Citizen'" (master's thesis, University of South Carolina, 1994), 65–66. Burgess contrasted Taylor's works with those of Smith

and other Charleston artists, concluding that Taylor was only by proximity among the artists of the Charleston Renaissance.

6. Mariea Caudill Dennison, "Art of the American South, 1915–1945: Picturing the Past, Portending Regionalism" (Ph.D. diss., University of Illinois at Urbana-Champaign, 2000), chap. 1, 17–30.

7. Stephanie Y. Yuhl, *A Golden Haze of Memory: The Making of Historic Charleston* (Chapel Hill: University of North Carolina Press, 2005), 14–15, 55–58; see Walter Edgar and others, *The South Carolina Encyclopedia* (Columbia: University of South Carolina Press, 2006), s.vv. "Ball, William Watts," "New Deal," and the "South Carolina Public Service Authority (Santee Cooper)."

8. Dennison, "Art of the American South,"420–21; Louise Anderson Allen, *A Bluestocking in Charleston: The Life and Career of Laura Bragg* (Columbia: University of South Carolina Press, 2001), 168–69; Gibbes Museum of Art, Artist Files, Anna Heyward Taylor, folder 5, clippings.

9. "Exhibit of Anna H. Taylor's Works Large and Varied, Columbia Museum," *Columbia (S.C.) State*, November 30, 1930, 6.

# 14

In Mexico, 1935–1936

TAYLOR UNDERTOOK HER LAST BIG EXCURSION to Mexico when she was in her fifties and still very energetic, but sales of paintings were so few that she considered becoming a writer. In particular she planned to publish a guide to Mexican flowers and considered writing a guide to flowers of the American Southeast. She certainly had the skills to write and illustrate such books. She knew botanists who could assist her with taxonomy and nomenclature. The projects never found a publisher, however, so she gave up the plan.

Mexico was in political turmoil in the 1930s, with frequent insurrections and strikes. Her friend and mining engineer Norman Kurtz carried two pistols after bandits attacked his Indian workers and cut off their ears. Not only Mexico but also much of the world was torn by violence. Adolf Hitler was elected chancellor of Germany in January 1933, and his National Socialist Party took over the nation within six months. Benito Mussolini, the Fascist dictator of Italy, had been in power since the 1920s and invaded Ethiopia in 1935. Joseph Stalin used brutal, near-genocidal measures to impose totalitarianism in the Soviet Union. In the United States there was much discussion of the impending war and American unpreparedness. In the face of this global turmoil, Taylor boldly went to Mexico to experience firsthand the culture and natural beauty of that great Latin American nation.

Taylor's letters and diaries are filled with descriptions of Mexican customs, costumes, and topography and with character studies powerfully written and visually depicted in her strong watercolors. Her Mexican letters are divided into six sections corresponding to the places she visited.

While in Mexico, Anna kept a small notebook in which she recorded her expenses from May 22, 1935, to February 12, 1936. The account book is among the ephemera in the collection of her papers at the South Caroliniana Library. Entries recorded payments for travel tickets and tips, purchases of art supplies, rent at Kitagawa House, and many meals. Given the diligence with which she maintained this reckoning, it is likely that she kept similar account books, now lost, during her other travels. ∽

**Guanajuato, June–September 1935**

*Guanajuato*
*June 7th [1935]*

To Nell

Well, here I am after a few adventures. I had thought of Oaxaca but a good many tourists were going there this summer & no excavating going on during the rainy season, so I put off that visit. Mrs. [Fanny] Wharton showed me a postcard of Guanajuato which was too lovely for words. She also wrote to Mrs. Butler, who lives here, & I received such a nice letter from her before I left home. When I discussed this place & showed the letter to the Noels, they said by all means to come here as it was just as beautiful as Taxco & not overrun with Americans as it was off the beaten track.

The place soon became mountainous & very beautiful, climbing up to over 7,000 feet again. This place is right up on the side of mountains, is a lovely pink & white town, about six beautiful churches & bells ringing every hour. The large church has a beautiful deep bell which strikes every hour & chimes too.

My room opens out on a gallery flat tiled roof, big door & no windows. All these 3rd story rooms open out this way but the ones on the street have windows. I look right over the most lovely covered dome of a pink church, all against a sapphire & emerald & lilac hillside & that against the sky.

All Sunday morning I spent in Chapultepec Park. It is a very lovely place with the cypress trees that are perfectly enormous; larger than any I have ever seen in South Carolina. We had some originally, but all have been cut down. These are where Montezuma's park is, so they saw Mexico in its ancient glory & also Cortez. They are said to be several 1000 years old. I wish you could have seen the thoroughbred horses & the wonderful looking Mexicans riding them. I wondered if they were all dressed up for show, but it seems there is a club they belong to & they are the big ranch owners who still wear the native costumes. Saw one girl riding sidesaddle all dressed up in brilliant spangled costumes such as you would see in the circus. The costume is very expensive.

*Guanajuato*
*June 13th [1935]*

To Nell

Please keep my letters as you have always done. I go out with numerous sheets of paper & sketch in heavy pencil the figures as they go by, & in that way am getting my hand back & also getting active in the figures. The band plays every Sunday and all the young people collect & walk round and round, the young men & boys on the outside & the girls with chaperones on the side. Round & round & looks are passed, winks, & the matches begin. It is really the only way they have of seeing each other. The boy gets an introduction through his family or a friend, & if he is acceptable he is allowed to call. They talk to each other with chaperones or through barred windows. The boy is said to "play the bear" while this kind of flirting is going on. I have just been reading a book by Wallace Thompson who has written a lot on Mexico. This is *The Mexican Mind* [1922]. The Mexican youth, Creole &

Mestizo (Spanish & Indian) is extremely bright up to maturity then he goes flighty. He is suddenly obsessed by sex & for the rest of his life all his energy goes to the pursuit of sexual gratification & nothing creative or stable is left. The women have nothing in their lives but the family life & of course are kept very close so haven't the chance to run riot on the sex question. The Mexican seems unable to pursue anything to its logical conclusion, have no imagination can only imitate; this applies to the Indian also. I didn't realize before that it was the policy of the Spaniards to mix with the conquered people, their theory being to make them Spanish by blood, but it didn't work out because the dark races have steadily risen & submerged the Spanish type. We Anglo-Saxons are the only ones who haven't mixed in the manner of the Latin. The French also never have drawn the line as we have. Just look at the French Islands.

I have been exploring the city, & everywhere one turns are exquisite bits or wonderful compositions of the mountains, near hills, the churches & houses. The women dress in bright colored dresses with "rebosos" on their heads. These are long shawls of two yards or more which they wrap around the head & shoulders & carry the babies in, always in dark colors. Little girls have shorter ones. I am perfectly disgusted at the urrupes[?] or blue overalls most of the men have on. They wear sandals on their bare feet & they are nearly all made of old tires! In the market & on the streets they are for sale in all sizes. Why doesn't the Negro do that in the country? There is a little street here with all kind of handmade pottery, some glazed outside & some not, nice simple design. All is brought in, packed in huge baskets on the backs of burros. In wandering around up & down, the poverty I see is extreme. Some huts seem to have no furniture. They sit, sleep & cook on the floor. A Negro cabin is a palace. To the Indian, money seems to have no value & time means nothing "Mañana" tomorrow.

The Butlers have quite a nice friend with them who came from the same place in Ohio [Chillicothe] that John Bennett [the novelist, 1865–1956] came from. He takes beautiful photos.

It is too bad about Tom Waring's death. He will be a great loss to Charleston, especially along creative lines.* You all take turns writing to me so that I can get the low down on the family.

* Thomas R. Waring Sr. (1871–1935), editor of the *Charleston News and Courier* from 1897 to his death, was an officer of the Carolina Art Association, a president of the Poetry Society of South Carolina, and a leader in Charleston's historic preservation movement. In 1898 he wed Laura Witte, the sister of the poet Beatrice Witte Ravenel (1870–1956) and of Fay Witte Ball (1868–1971), wife of the newspaperman William Watts Ball.

*Guanajuato*
*June 19th [1935]*

To Nell

Mr. [Norman] Kurtz [a mining engineer] is still proving very amusing & promises to continue so. I wish you could see his seal ring. His name is German, [his family] came over in 15th century & was granted the arms by Elizabeth. It is a figure standing up holding half a

sun, something very important. It is gold on black & looks exactly like Montezuma, which I thought it was. I wondered what an Englishman of his class was doing with a Mexican ring! We have been fighting the war over. He went over with the Canadians, was a sharp-shooter, was shell-shocked, very nervous & high strung. It has been decided that he remain in the house. I think the doctor was relieved, as he is Scotch & loves the pennies.

The dinner was delicious & the conversation mostly taken over by Mr. Young who has a mine up on the Great Divide. He is a Britisher who has been a perfect soldier of fortune. I think I wrote you he says he has eaten human flesh. I bet he read Conrad's story [Joseph Conrad's "Falk"]! He is very entertaining & the others even did get in a word sometimes. All these silver mines men are very uncertain about conditions because [former president Plutarco] Calles has withdrawn & he was much less radical than [President Lazaro] Cardenas who favors labor. Everything labor has asked for except polo ponies has been granted. This is no joke, for they did ask for them. The labor here is very ignorant, not the intelligent class of England & U.S.A.

*Guanajuato*
*June 25th [1935]*

To Nell

Your letter came with the fine article Clem[ents] Ripley [1892–1954] wrote on Tom Waring. He certainly was a charming man & a terrible loss to Charleston.

Well, the old "Doc" [Hislop, a local dentist] got off for Canada yesterday afternoon. I never saw anyone have such a time tearing himself away. He had been here 29 years without leaving. Mr. Kurtz gave him a farewell dinner, just the three of us. Mr. Kurtz was in a perfect gab & was teasing the old thing about everything he ever knew & much he made up. It seems that he had a Mexican young woman keeping house for him before his marriage. Then Mrs. Hislop appeared on the scene, evidently having come down with the idea of getting a husband. When she arrived here she found a bed to be filled & met the doctor in that way. It was love at first sight, he 49 & she 35! Neither slept that night!! In three weeks they were engaged & married. By that time the housekeeper was jealous & proceeded to try to poison him!! If you could see the repressed uninteresting virtuous old thing, good as gold but My God. Well, Mr. Kurtz just had a grand time with that episode. I told them that I had been awake until 3 o'clock twice last week & I hadn't yet decided whether it was one of the men or a mosquito!

Last week we had four days of clear perfect weather. I just about worked my fool self to death sketching the landscapes & painting in some. I got plenty of materials for working during rainy days as it is doing now. When it rains it simply pours & the streets become rivers.

I have started on Spanish lessons. I have a young student who comes 4 times a week at 12 o'clock & we read & talk in Spanish. He understands no English. His name is Octavio de Lolos & belongs to one of the nice Mexican families.

*Guanajuato*
*July 9th [1935]*

To Nell

Well, I wish you could see [Octavio]. He is in mourning for his aunt & he is black, his suit black, shoes black, tie black & a wide black hem on his handkerchief! He can't go to a thing, not even the movies or the silly fiesta at de la Presada[?]—for one whole year. Tell Edmund that I hope that he will go into mourning for me. He would certainly catch all the girls, it would be most becoming

I am writing Rachel [Hartley] to see if she would like to come down & take a house in Taxco with me. I shall get Minnie [Mikell] to look around when she goes there in August. I would like to try some portraits of Indians & I am sure I could get modles [*sic*] there.

*Guanajuato*
*July 17th [1935]*

To Nell

I wrote to Natalie Scott about going to Taxco. She is a very attractive writer from New Orleans who lives in Taxco. Also seems to rent houses.* She tells me that she has a lovely big room which she wishes to rent with board & says her price is 40 pesos which is $12 American money so Mr. Kurtz says. If two have the room it is 35 pesos a piece. I have written Rachel to see if she wishes to come down for the winter. I wrote at once to Miss Scott saying I would like to come and if I couldn't get a friend to go in with me would she take me if I agreed to stay 6 months & paid a little more. In her house I would meet all the interesting people & should have a lovely winter. In fact I am quite intrigued with the whole arrangement. I would get a studio or room outside where I could work & things. I am anxious to try some heads of the Indians & also want to try my hand on some wood cuts such as those of de la Selvas[?].

* Natalie Vivian Scott (1890–1957) was an author and a hostess of literary and artistic salons in New Orleans and Taxco. She and writer and silversmith William Spratling (1900–1967) established the Taxco colony in 1930 and, in addition to hosting visiting artists and writers, did much to improve public health and economic opportunities in Taxco. Her pension was called Kitagawa House after the artist Tamiji Kitagawa (1894–1989), who resided in Taxco.

*Guanajuato*
*July 29th [1935]*

To Nell

Minnie Mikell leaves on Thursday & after 3 days in the City goes on to Taxco. I got another letter from Ben telling me his new New Orleans friend Dorothy Spencer [Collins, 1908–1974] knows Natalie Scott. We saw Valencian[a] from all angles, each was more beautiful than the other. V. is the beautiful old church which was built over the richest mine in the world. The facade of the church is by far the most beautiful & most refined of any of the churches I have seen.

Mr. Kurtz has been in town now for 2 weeks. All kind of things seem to keep him. He is just as erratic & unstable as he is charming & clever—Just too restless & nervous for anyone to live at peace with, in fact a very pathetic person in many ways. If his life had been different he would have made a superb character, finest type of an English gentleman, not quite a Sir Philip Sidney but with some of his qualities. Now he is damaged goods. He, like Arthur Coles, regrets he has never married & here I am regretting that I never married & so goes life. The more I learn of Mexicans the less I like them. Thank heaven Mexico has not been incorporated in the U.S.A.

*Guanajuato*
*Aug. 9th [1935]*

To Nell

I have decided to go to Taxco from M[exico] C[ity] & get settled then go to Oaxaca when the weather is settled also by that time I shall know what medium to work in. I have finally gotten in the mind for work as we have been having some sunshine, also time is pressing & I am just beginning to see things I really want to do. I am working in oil on pink & yellow charcoal paper & have at least worked out my technique. The papers have just the quality of color of these lovely pink, yellow churches. I am doing big things 20 x 24. I have never really gotten used to this altitude and feel very tired most of the time; in fact there have been very few days that I have felt like my usual very energetic self. Never have I lived in such unbecoming lights. My hair has made me pass another milestone! The other night Mr. Kurtz was feeling very confidential & said, "I want to talk to you as I would my mother!" To have a man about ones own age say that is truly a shock.

Speaking of my "divertissement" [Norman Kurtz] he has been having a most exciting time of it this week. By the way he no longer spends his week ends in town but almost all the [words missing] & I don't know if it really [is] his business or me! So Patty Butler asked me!! He didn't get out until Wednesday afternoon. It seems that there is a good deal of unrest, with the Indians & hacienda owners, land & various things. Last week just about 25 minutes walk from his house a party of 40 men attacked two Indians & cut their ears off, one being one of Mr. Kurtz's miners. Well he has been running around like a chicken with its head off, armed to the teeth with two pistols. He was interviewing government men, police & heaven knows who else, ended by getting permission to arm some of his miners. Why he should get permission I don't know because every other man has from one to two pistols on him & they think nothing of shooting a man. In fact a former miner of Mr. Kurtz's wrote him a note saying he was in prison just for killing a man, couldn't get Mr. Kurtz get him out. Well Tuesday night just after supper he blew in looking perfectly wild & very excited. He sank in a chair next to me, I being seated at the dining table playing solitaire, & handed me a pistol asking me to keep it for him. I put it in my lap & calmly went on with the game while he let off steam & talked about the "damn Mexican rascals."

Beth [Elizabeth O'Neill Verner] writes me that there is a good [deal] of activity in real estate in Charleston. The house Carrie Douglas [rents] has been sold but I hope she doesn't have to get out. It brought only $8,000. Also Van der Horst Row for the same amount. That

is the beautiful old dilapidated house on East Bay just across from Nick Roosevelt's place. Also says it looks as if the Santee-Cooper project is really going to happen. It will ruin the waters of the harbor & rivers, turn them red.

*c/o Sra Maria de Bacmeister, 140 Ciprés*
*Aug. 19th [1935]*

To Nell

You need not get nervous about my "divertissement" because I shall not write about him after this letter. As a matter of fact he was the only really amusing person in Guanajuato & my letters would have been too dull for words without him. My stay in Guanajuato was really deadly as I couldn't paint & couldn't do much with Spanish. No fear of my marrying him for he is not the type to get thrilled over a grey-head woman almost his age, Mariana & Eliza would be the ones he would look at. His interest in me rather savored of the "desert island" because I was the only white woman of his own class he had seen anything of in months. I don't think of the Mexican being white. He is too erratic & unstable ever to make any woman happy & frankly says so. But I shall miss him a lot & am really fond of him, but probably will never run across him again as he is too involved trying to spend his money on getting his mining mill started to run around Mexico after grey hairs.

**Mexico City, August–September 1935**

*Mexico City*
*Aug. 27th [1935]*

To Eliza Taylor

Well, Guanajuato & the charming engineer [Norman Kurtz] are behind me & I really miss him a lot, both the excitement which always accompanied him, something always happening, & also our long evenings over the fire when we settled the problems of Europe & this pending war. What he predicted from the very first is happening. It certainly looks very ominous but I do not believe that England is going to let Italy fight because it would at once have echoes in her black races. Musilini [sic] has left him self a loop hole which was in today's papers, that he would consider stopping if other colonies offered him self [an exit]. Our situation is pathetic if a general war does take place, totally unprepared & our empty treasury. However Mexico will be flooded with people who can't go to Europe, so the end of Mexico for the artist, but no use to paint because there is no one to buy. I have decided to change my profession when I return because I can't see any income from art. I shall try my hand on writing while down here. Katharine Ripley succeeded, so I may.*

* Katharine Ball Ripley (1892–1954) was the daughter of William Watts Ball and Fay Witte Ball. She was wed to Clements Ripley and was a prolific writer of historical fiction. Her novels *Sand in My Shoes* (New York: Brewer, Warren & Putnam, 1931) and *Crowded House* (Garden City, N.Y.: Doubleday, Doran, 1936) portrayed lowcountry South Carolina life.

*Aug. 28th [1935]*

To Eliza Taylor

Here I am at Ameca Mecca [*sic;* Amecameca] on the slope of Popo[capetl]. Have done some big watercolors of volcano and Sierras. Of course quite cold up, like late November. Do write me about your visit to Charleston. Have been with the Noels all day & saw a game of Polo between the Mexican Olympic team & an Army team from Texas.

*Mexico*

*Sept. 7th [1935]*

To Nell

I waited to write until the wedding day of Carlos de Bacmeister. I never saw a R[oman] C[atholic] wedding before. I sent Señòra a bouquet of violets to wear, which she wore at the luncheon & not at the wedding. She is a very handsome & distinguished woman & looked marvelously today in her mourning. These Mexican women wear black as the French do & also show their gift for draping the veils around their faces as the French do, in fact they are quite intriguing. Somehow they are not so good looking in colors, I think it must be their complexions. The music was lovely, at one time a harp & violin played "Meditation" from "Thais."

I bet I have a marvelous winter in Taxco, particularly as I shall try my hand on writing. I believe the art world is dead for some years to come. Beth [Verner] writes me that the exhibit in Buffalo which we were to have is off, & that's a sure sign. I certainly selected just the year to be away from C[harleston]. I am going to write a short story about Norman Kurtz, but I can't sign my own name because it could be so easily recognized. Some day I shall write a book about him. I haven't told you half about him. His whole family background is marvelous & he believes in transmigration of souls so I shall begin it in the 18th cent[ury] with his slave trading gentleman ancestor, the conflict in his character beginning right then. Consequently I saw a cheap copy (our old friends the Tauchnitz [paperback editions]) of Virginia Woolf's "Orlando," which I always intended to read. It begins with Elizabethan times & the character is brought right down to today.*

There is an excellent bookstore run by some awfully nice people. I know the son in the shop. He tells me there is a great need for a small pocket edition of the flora of Mexico, he is constantly asked for one. It is simply a matter of compiling & making the flower plates. So please ask Bill Coker [William Chambers Coker, 1872–1953, botanist at the University of North Carolina, Chapel Hill] when you can to order one of those pocket size flora of Eastern U.S. I want to see how it is made up & how many specimens are in it. <u>Do this at once</u>. You will have to pay for it. Ask him if he has any ideas to suggest. I hope to get any Indian or common name for each & also any logical connection with each. A good year's work or more. I may spend the rest of my life down here. I shall get Norman to working on this too—He could get a lot of stuff from the Indians. I am to talk it over with Mr. Noel who knows a lot about such things. Of course I shall go on with my painting as I only work ½ day anyhow. Perhaps I can sell some short articles or stories. I must use up my painting

materials as I have them. I may do the best work I ever have done as it will be done absolutely to please myself.

* Woolf's *Orlando: A Biography,* published in 1928, was a novel in which the main character does not grow old and is transformed from a man into a woman.

## Taxco, October 4, 1935—March 24, 1936

FROM GUANAJUATO, Taylor went briefly to Mexico City, then to Taxco. Many prominent people rented houses there and stayed for long periods, as Taylor did for six months. Writers, mining engineers, actors, and socialites all together made it a lively place, so lively that Taylor struggled to find time to paint. Many painters were there. She met and enjoyed the company of Eliot O'Hara (1890–1969), a distinguished watercolor artist and author of books on watercolor techniques. ❧

*Taxco, Mexico*
*Oct. 4th [1935]*

To Nell

Well here I am in Taxco & it is really a most lovely place. The house is some little distance up the side of the mountain, & just below my room is a deep "barranca" where everything empties & much garbage is thrown, but the shrubs & trees hide it all. My room has a wide door & window opening down to the floor. Outside you have a glorious view of the Cathedral, trees of the Plaza & tiled roofs of the houses, the mountains beyond, range after range. The steep slope is terraced & all kind of flowers planted—The house is a dark plastered over, of course tiled, but every room has no ceiling so I see daylight through it, but it evidently doesn't leak as I see no signs of leaks, but I did find a worm on my bed & small leaves seem to blow in on the bed, some times a bird flies in.*

Miss [Natalie Vivian] Scott keeps a delightful free & easy house, having people unexpectedly in for meals, so a young Scotch mining engineer had supper & stayed for the party. The company came about nine o'clock & consisted of the "judge" & the music, the latter being a family of four ranging from 25 to 15 years old. The little boy played on a huge bass violin & could hardly reach the "frets" to tune it. I don't recall the name of the things you turn to tune it. There were two banjos & one violin. They all sang & played at the same time including the judge. I wish you could have heard them for all the songs were lyrical Mexican music. I would like to send records of some of them. That was all very well but the hostess was supposed to supply the brandy & during the performance the company consumed 2½ quarts of the brandy & numerous cigarettes. The one who had the fine voice got quite full of brandy but was harmless & continued to sing. About 12 o'clock the judge left saying that he better leave! About that time I decided to evaporate so sneaked out. They stayed until after 2 o'clock!!

Miss Scott is a woman about my age or possibly some [years] younger. She was overseas serving as interpreter in the French Hospitals up at the front—Got out a book on New Orleans cooking—Has done newspaper work, traveled a lot in Europe & taken some wonderful

trips in out of the way places of Mexico—Is good looking but not much of a dresser & must have been very handsome as a girl, sense of humor, lots of pep, not at all conventional, in fact strikes me as being a delightful person.

I took a walk this morning & found the most beautiful wild flowers. The marigold, lantana, zinnia, poinsettia are all native. I am going to start right off on the drawing & pressing of the flowers & expect to go on all day trips out in the mountains both on burro & on foot. I hope I can find someone who wants to do this with me. An old craft of making things out of tin has been revived here, & I shall have a tin botanist's box made to put my specimens in. Dr. Gandara & Mr. Stein, both botanists, said they would be glad to identify any plants for me.

The church is one of the [most] beautiful churches of Mexico. Some friend of the Noels was standing in front of it when a tourist said, "Is there anything in the world to see in this place?" "No" he replied "Nothing."

Isn't the European situation dreadful? I am depressed whenever I think of it. I think Eng[land] has done just the right thing. I hope that the opposing party in Italy gets the upper hand. It is backed by Lombard St. in London, & headed by the crown prince [Umberto Emmanuel] & [Italo] Balbo. Italy is poor & England has money. The Italian staff told Mussilini [sic] when he started in [his invasion of Ethiopia] that it would take 1,000,000 men five years to take Ethiopia. It took France & Spain 20 years to subdue northern Africa!

* Taylor drew a diagram of Kitagawa House and grounds.

*Taxco*
*Oct. 12th [1935]*

To Nell

Well, I have landed right into a gay life but I am afraid too gay for me really to fit into, numerous cock-tails, brandies etc, & poker. I am not particularly taken with any of the people I have met, Miss Scott is the most entertaining & interesting person of the whole crowd. The nicest man is an English or rather S. African named Teddy Wolf [Edward Wolfe, 1897–1982], a painter, he has more breeding than any, all 2 class & some 3d class. Most of these people are writers & painters, some hotel keepers. One couple are the Hirschs [sic; Hersch], of course Jewish. She seems quite nice & her mother was a Moise from Sumter, Jessie Moise, who is a great friend of the Gov. [Richard Irvine] Manning is her aunt. Miss Moise married a Jew named Davis who had a large store in San Francisco. She is the Virginia Hirsch who wrote the novel about a Jewish family in Charleston. It came out just at the time of the [illegible] so the sale of it was pretty well killed.* This place is like Charleston, in that people are streaming in all the time particularly for week ends from Mexico C[ity].

The nicest person I have met is a lovely looking young married woman. She married Mrs. [Caroline Wogan] Durieux's brother, Dan Worgan [sic].† He is pretty much of a stick & no manners yet from New Orleans. She was from New York & is very graceful & charming. She is coming down for the winter if they can sub-rent their apartment. His job is professor of romance languages & is here working on his degree. He will come down weekends.

However I forgot Miss Furguson, who is charming, about 60 years old, gives all kind of delightful horseback trips, & wrote a book on the fiestas of Mexico—a really well-bred person.

Miss Furguson gave a wonderful description of the flowers she saw on trips she has taken. On some trip out from the Pueblo she saw thickets of Zinnias several feet tall as large as dahlias & marvelous colors—also hibiscus, datura & strange flowers. If I never do get anywhere getting out the pocketbook edition, I shall have lots of fun for I am determined to go on some of these trips if I have to go alone with a guide. The trips really don't cost so much so Natalie tells me.

* Virginia Davis Hersch (b. 1896) was the author of *Storm Beach: A Novel of Charleston* (Boston: Houghton Mifflin, 1933) and of novels based on the lives of El Greco and Saint Teresa of Avila.

† Caroline Wogan Durieux (1896–1989) was a New Orleans artist. She became famous for her cartoons of New Orleans celebrities. Her brother Daniel Spelman Wogan (b. 1909) published *A literatura hispano-americana no Brasil, 1877-1944; Bibliografia de crítica, história literária e traduçies* (Baton Rouge: Louisiana State University Press, 1948).

*Taxco*
*Oct. 21st [1935]*

To Nell
Your long letter & Mariana's [from Smith College] came & were much enjoyed. She certainly dwells in the heights & I hope that she will never have to come down. No use to send my letters to M[ariana] because I shall be writing her from time to time any how I don't want mine lost as they are my diary, in a way but I don't tell you everything.

The market this weekend was delightful & very paintable, so just as soon as I get through with the flowers I shall start on figure & landscape. Of course the flowers are all over by the end of Nov. I really am to have the house & two servants as Natalie leaves on Nov 3d for the horseback ride for 3 to 5 months, with some man connected with a Museum.

As to the crowd down here, it reminds me of [the MacDowell Colony at] Peterborough & again I am on the outside looking in.

I am doing a wonderful flower now, called "Golden bowl" by the Indians. They brought me a whole bunch today & I expect to have them open in the morning. It would make a stunning block print. The more I learn about what hasn't been done on the flora of Mexico the more remote my idea of a pocket edition becomes. Anyhow my plates can be used by me in various ways & I may get some systematist to work with me.

*Taxco*
*Oct. 28th [1935]*

To Nell
My old Ford seems to have given great pleasure [at home in Charleston]. Heaven only knows when I get another because I simply have to fix up my 4 story. Perhaps I can do without it & I shall not be painting out in the country, but I am thinking of doing a book on the S[outh] C[arolina] flora. Bill C[oker] sent me Miss Holland's copy of the western flowers.

It is just the thing to do on Mex[ico] & I shall certainly look into it very seriously when I go up to Mexico City Nov 15th to see about my passport. Jack Noel knows a lot about that kind of thing, I mean publishing. There are only 250 specimens in the little book so all I would have to do is to pick out the very obvious ones. I am painting the flowers now, plates. I brought in some beautiful poinsettia yesterday, perfect ones growing in the barranca leading to the mine near here. They are much more beautiful in the wild state, look like pools of red blood. I saw these stunning flowers at a distance & couldn't tell exactly what they were. There is a handsome white one too.

Well, I am in the midst of the gay sporting life down here. Natalie is a dead game sport & can carry her liquor as well as a man.* I was at two poker supper parties last week, one lasted until 4 A.M. & one until 3 A.M. Too late for me & of course one can't work next day. They, Natalie & her friend, are at one now, but I am not a perfect fit so don't get asked to all thank goodness. I don't get any kick out of it. N[atalie]'s friend is Mrs. Sherwood Anderson [Elizabeth Prall Anderson], the 3d.† He [Sherwood Anderson] is a coarse person and I have always heard this & this one is certainly a lady & I don't think a perfect fit any more than I am. Sherwood has a fourth wife & this one looks as if she still wants him back. I met no. 2 at [the MacDowell Colony] Peterboro[ugh, New Hampshire], Tennessee [Mitchell] Anderson, just the type to suit him, dead common. The weird [*sic*] part is that they all keep his name!

Joe Waring married Bill Legare's sister Gertie Backer. She went to N.Y., married a rich Jew, two children, he died. They have bought the old Wm. Whaley house on Legare St.‡

* Taylor enclosed a copy of Ernie Pyle's "Story of a Girl Who Was Afraid and Who Won War Medal," about Natalie Scott, published in the April 22, 1936, issue of the *Washington Daily News.*

† Elizabeth Prall Anderson's autobiography, *Miss Elizabeth* (Boston: Little Brown, 1969), contained several chapters on the Taxco artist colony. It highlighted the colony's riotous lifestyles.

‡ Doctor Joseph Ioor Waring Jr. (1897–1977) wed Ferdinanda Legare Backer (1895–1985), whose first husband was William Bryant Backer of New York. The Warings then purchased the Simmons-Edwards House at 14 Legare Street. Dr. Waring was a Charleston physician and historian of medicine. One of Ferdinanda Backer Waring's children, Ferdinan (Nancy) Backer Stevenson (1928–2001), was the first female lieutenant governor and first woman elected to statewide office in South Carolina.

*Taxco*
*Nov. 8 [1935]*

To Nell

Well, my plans have changed & I am to have a little house of my own. There were several reasons which made me think that some change would be advisable but I was going to wait until Natalie came back from her horse back trip but she beat me to it. Her friend Elizabeth Anderson came for a visit & decided she would like to spend the winter & offered to rent the house & Natalie stay with her when she returned. So Natalie came to me very apologetic & said she knew of a little house I could get for $23.67 which was nearer the Plaza & also a Lovely view. She lived there when she first came to Taxco. I jumped at it & I doubt if she realized how pleased I was at the idea of the change.

I am really working these days. I have been working on the flower plates & am now doing watercolors of the view out of my window. Your little book has come & Bill sent me one of the Western Flowers, it belongs to Miss Holland. I have ordered the two books he suggested. I shall discuss the whole thing again with Jack Noel, also see the men at the Agri. Station. I believe it will be a fine thing if I can get it published. I would select 250 of the most common flowers & most interesting flowers which a tourist would see. I shall have to find out how to get in touch with the publishers & when. Perhaps I should have my material well on the way. Things are too upsetting here to try to do any writing so have let that slide until I am in my own house.

This past week has been the Feast of the Dead & was continuing through the whole weeks. Lots of new booths & Indians selling all kind of sugar things, crosses, figures, skeletons, skulls, animals, etc., of course all kinds & sizes of candles. They also put little shrines in the houses & burn candles & put flowers in front of them. It is a mixture of pagan & catholic practices. The Indians had a feast of the dead where they offered flowers & food, & when a chieftain died many slaves were sacrificed & burned with him, then at intervals others were killed to help the chief along in the other world, also food was put in the tomb. Today was the great day everyone goes out to the graveyard & flowers & food & candles are put on the graves & they pray (fig. 15). We went out about dusk but most of the candles & flowers had been removed. They eat the food later.

How fine that the Footlight Players seem to be going off with a home [illegible] Robert M[emminger, 1905–79] lost out but fortunately finally got a consulate appointment in Toronto, Canada. If Mariana spends next winter with me she must take part in the Footlight Players. She would be crazy about it & so many interesting nice people are in it.

*Mexico*
*Nov. 18th [1935]*

To Eliza

Well, here I am again in Mexico (they always speak of the city as just "Mexico"). I came up on Friday with two newly made friends Mr. & Mrs. Krieg, he a German sculptor. I had to come up to see about getting an extension [of my visa] of 6 months, & of course allowed myself a week on account of delays & red tape only to find that the Gov[ernment] holidays begin on Wednesday & everything closes until after Dec. 1st.

I ordered "the State that Forgot" & got George De Merrell to have Billy [William Watts] Ball autograph it* & gave it to Mr.' Parry, [who] is the English Walkers cousin & he hopes to live in C[harleston] when he retires.

Well we had something on hand the whole week before I left Taxco. I hate going out or having company every night. Natalie was leaving on Saturday, or rather putting off her departure from day to day & I felt a rotten deal for nice Don Ardley. For some reason she really didn't wish to go, but she should have said so at once & he could have made other arrangements.

Kim & Tamara [Schee] gave a supper party & others coming in afterwards.[†] I never laughed so much in my life, everyone pulling off shouts & more or less making fools of

themselves. Don, Elizabeth Anderson, & I being the only ones not imbibing a bierera & tequila.

No poker this time, dancing. We left at 4 o'clock & I didn't get to sleep until 5:30, getting up 7:30 & leaving for Mexico at almost 12 o'clock. The drive up was beautiful, such glorious sparkling days we are having. Saturday morning when I went out the air felt like wine & just the days one has in New York the end of October or first of November. Mr. Krieg is from southern Germany, was in a shock troop in the war, then when that was over, went back to sculpting. He came to the States in [19]24 & has done amazingly well. During the war he captured an American Maj. Patterson, & some of his men. He & the Maj. became great friends & gave each other their addresses, so the first person he looked up when he came to America was Maj. P[atterson]. He is now living in Hollywood. His wife is an American & quite nice.

I am delighted to hear of how well the Footlight Players are going. If M[ariana] spends the winter with me I hope that she will take some part in the productions, perhaps with the costuming or stage sets. She would have a fine stage presence but her height might make a difference.

---

* William Watts Ball (1868–1952) of Laurens, South Carolina, was a newspaper editor of the *Columbia (S.C.) State* from 1913 to 1923 and the *Charleston News and Courier* from 1927 to 1951. He was a social conservative, and his book *The State That Forgot: South Carolina's Surrender to Democracy* (Indianapolis: Bobbs-Merrill, 1932) disparaged the New Deal and popular democracy. Ball wed Fay Witte in 1897 and thereby became brother-in-law of the poet Beatrice Witte Ravenel (1870–1950) and Laura Witte Waring, wife of *Charleston Evening Post* editor Thomas R. Waring Sr.

† Kim and Tamara Schee settled in Taxco in the early 1930s and were among the bohemians who lived there. Kim Schee wrote a novel, *Cantina* (New York: Coward-McCann, 1941) about life in the colony. His wife, Tamara Schee, a former Russian ballerina, managed a dance studio in Taxco and was a model for paintings by the painter Edward "Teddy" Wolfe.

*Mexico City*
*Nov. 20th [1935]*

To Nell

There is a fireplace in the sitting room but wood is hard to get. However Aubrey [Mary Aubrey Keating] found two burros worth, which is to come today.* It is all brought in on the backs of burros, two bundles on each. We will have a fire in the evening.

She has a superb voice, studied with Sherman Heik [*sic;* Ernestine Schuman-Heineck], & sung in opera & gives concerts, etc., & does fine strong colorful modern work. She has been a godsend as she speaks Spanish & is a most likable person. She has been hunting up pianos to play on & sing, found one in a cantina & another in a private Mexican house— All the Americans gather & they have a grand time singing.

I have just met a perfectly charming man, one of our own kind from Greenville, Miss. He is a very able lawyer & has also written some excellent poetry. He is a friend of Teddy Wolf[e]. He was at Sewanee with Buzz Jervey & is certainly 50 & over.† He has visited at the Jerveys in Charleston & knows so many people I know, very simple & cultivated, musical. I had a cocktail party for him yesterday but he had taken a cold which he had been

fighting all week & couldn't come. Teddy was painting a portrait of him & it wore him out. I was too sorry.

My house doesn't get as much sun as I would like & I was sitting on the front porch steps getting warm. The Schees came in to say "hello" & Aubrey with friends so I think he must have the impression that I live in a whirl. I asked him in for the cocktail party I was having for Bill Percy.‡ I can't explain it except that he thinks all my hair is blond & none white. Well, I hope it goes on, but I don't go out alone to the hacienda without asking Bill Spratling about it.

I hope to really start painting tomorrow for I find Aubrey really inspiring. I saw Dr. Gandara about identifying my plants & took him the dried specimens & my plates.

* Mary Aubrey Keating (1894–1953), a native of San Antonio, Texas, was a self-taught painter who specialized in Hispanic themes. She painted in watercolors and oils and created murals in San Antonio buildings. At the 1933 Chicago World's Fair, she exhibited twenty watercolors.

† Charleston native Huger Wilkinson Jervey (1878–1949) was a Sewanee graduate and taught classical languages there briefly. He obtained a law degree from Columbia Law School in 1913 and was later a professor and dean of the law school. Walker Percy (see the following note) considered Jervey to be a mentor much as his uncle had been.

‡ William Alexander Percy (1885–1942) was the author of *Lanterns on the Levee: Recollections of a Planter's Son* (1941) and an uncle and a mentor to the Mississippi novelist Walker Percy (1916–90). Before publishing *Lanterns on the Levee,* Percy was editor of the Yale Young Poets Series and author of poetry volumes *Sappho in Levkas, and Other Poems* (1915) and *Selected Poems* (1930). His *Collected Poems* was published in 1943.

*Taxco*
*Dec. 10th [1935]*

To Nell

All the church bells are banging which reminds me that these eight days have been the feast of the Dark Madonna of Guadalupe. She has the dark Indian skin & is much worshiped by the Indians & is the patroness of the [Mexican] revolution. The church has been filled with flowers & the Guadalupe Church up above Natalie's has been opened. It is usually closed. Last night they had quite a fiesta & had a "castillo" which are fireworks attached to a pole & were very beautiful, quite amazing. A local man makes them & his father before him. He also makes the toritos & we had a fine one last night. One boy had his hand badly burned. Why all their eyes aren't put out I don't understand. We were in the door of the cantina & many times had to dash inside & sometimes close the doors. Whole wheels [of exploding fireworks] sometimes fly off.

Dec. 15th. The final fiesta was on Thursday & took place up at the Guadalupe church, bells constantly ringing. Unfortunately I missed the morning dance as I knew nothing about it but Kim, [and] Tamara [Schee] & Teddy [Wolfe] went up at 11 o'clock & stayed until late that night, eating all this Mexican food. The dance took place in front of the church, about 12 men taking part & dancing a shuffling kind of step rather like Negroes. An old man was playing a violin, the same tune over & over. They would dance then turn around, cross over and touch shoulders. They wore bright handkerchiefs around their necks

& large hats. A make-believe bull bursts past, the man blowing a horn for the bull roaring, & the man acting the part of a toreador was more elaborately dressed. The "Castillo" was simply marvelous. Every section had dolls, or birds or animals, which the fireworks started off, some as acrobats & some shooting, all whirling in the air; huge balls whirled, then opened & dropped candy. One whirling bird almost landed on us who were sitting on the hillside alone.

*Taxco*
*Dec. 10th [1935]*

To Nell

It's a damn nuisance running up to see the doctor every two weeks. Some thing due prob-ably to nervousness induced by the altitude has made my blood pressure go up. My arteries are in excellent condition but the doctor wishes the pressure to come down. Consequently I am on a diet, an easy one to help, mostly fruit & vegetables & not too much of any. I am to go up next week & I hope not again for a month. Of course only moderate walks but horse back rides are alright. Bill Spratling has a very nice horse so I find some one to ride with. Of course the riding is all up & down hill, no walking—2 pesos a day!!

*Calle Sierra Alta No. 8, Taxco*
*Dec. 28 [1935]*

To Nell

Tell Alice Jones to bring something to ride horseback in as it is one of the things to do as horses are only 58 cents a day, of course astride.

Natalie is coming back for a rest & is expected any minute. There will be a round of parties when she hits town but I doubt if I shall be included in many as I don't drink & don't like poker, however I shall pull off a cocktail party for her.

Very little was going on Xmas. Mexicans don't make anything of it unless they are thrown with Americans. There were "pasadas" in the church & in the homes. I have found out that the "Pasada" is to represent Joseph & Mary knocking at the Inn & trying to find some place to stay. The guests come & knock at the door & after being refused are allowed to come in, then it ends in a real party for young & old. In the church there is a procession of children with candles & jingling things; they go around the church to the different altars then end at the one with Joseph & Mary. Xmas night I went to the mid night mass. The church looked beautiful with its candles & masses of poinsettia. The priest came out with the acolites & was presented with the Christ child on a pillow by some lady who evidently is the head of some society. They formed a procession of the members of the order & pro-ceeded around the church, then sat down in front of the high altar holding the Christ Child on his knees & all the congregation came & kissed the child, however none of the men. They kissed so long that I got exhausted & left.

*Taxco*

*Jan. 6, 1936*

To Nell

New Years Eve the Adams, who are just across the barranca, & the Harpers had an egg-nogg party in the afternoon on their little lawn. Of course all the people we knew were there, only one Mexican & Kitigowa* & Mrs. K[rieg]. On New Years Day Mrs. [Grace] Mané had a cock tail party.

I am seeing something of the Adams whom I like immensely. Her mother's name was Goode & they left Kentucky before the [American Civil] war, moving into Ohio. They decided they couldn't own slaves any longer so sold their lands, freed the slaves & settled in Ohio—an interesting history I thought. Mrs. Adams graduated from Smith in 1911 & has some of the earmarks of a college woman, is very feminine, the kind men will always care for & take care of. Mr. Adams is one of the experts in the world in copper mines. Mrs. Adams has just started painting, Kitygowa is criticizing her things. We have been painting together up at Teddy Wolf's who has gone to Acapulco for a week. There are beautiful views from the hill. I am going full tilt at last on the painting line. Am doing watercolors on the largest sheets & using the largest brushes. They seem strong & full of color & I may have some good stuff. I have done six already. If I keep on at this rate my materials will give out. I ought to be going strong when I get to Oaxaca, which I hear is lovely in a very different way. Mrs. Adams rides so we are planning to ride over to some of the villages & paint, returning in the afternoon.

I heard from Doubleday-Doran about the book but they don't wish to publish it so I shall write to Putnam, then Dutton. I may end by publishing it myself—who knows.

* Tamiji Kitagawa (1894–1989) was a Japanese painter and printmaker who studied at the Art Students League in New York City. In 1921 he settled in Mexico. During the 1930s Kitagawa directed a state-sponsored art school in Taxco. He returned to Japan in 1936 and had a distinguished career.

*Taxco*

*Jan. 25th [1936]*

To Nell

O'Hara [Eliot O'Hara, 1890–1969], the watercolor painter has been here & just reeled off the paintings, fine strong colorful things. He wanted to meet me as Bob Whitelaw [Robert N. S. Whitelaw, 1905–75] told him I was here & he had seen some of my things in Charleston. He got mixed on the name & was asking for "Anne Morgan"—I told him it was just too bad I wasn't because I could buy a lot of his things but the rival Anne would not because she was a very ardent admirer of Alice [Ravenel Huger] Smith's things & the two would never go together. He is so much nicer than I thought. Somehow his wife & Miss Michelin[?] have advertised & pushed him & his work so that it prejudices me against him. He is quite simple & very generous with what he knows. He came over here to paint on my piazza & it happened the Rudolph [*sic;* Ralph Adams] Crams wanted to call so I told them to come on & have tea & habaneras. Mr. O'Hara dashed off two watercolors & then the Crams came & we had a very delightful & interesting time. The Crams are simply delightful,

he a charming cultivated Bostonian, no common airs about him. O'Hara was a business-man, ran some factory, & discovered about seven years ago that he had this amazing sense of color & aptitude for watercolor—His career has been meteoric but he shows the lack of the back ground Mr. Cram has, just the kind Mrs. Bradley had & Mr. Chapman's friend. To my way of thinking O'Hara will never be a great artist; he paints too fast to give his things proper consideration. He falls down on composition & solidity. However he gave me just the jack-up I needed on color. He showed us all the things he had done & came one morn-ing & painted from the modle [sic] with us, of course not as a teacher merely a fellow artist. His wife was a very clever newspaper woman—she arrived in Mexico this week & he & she are to return tomorrow & I expect to do something for them.

Grace Mané & I had a wonderful day yesterday. I wrote you about Mr. Ramirez & his hacienda. Well we got horses & rode to his place, expecting to go through on our way to a village beyond, for the road goes right through his place. Such a road as it is, rocky & the remains of a pebble road, on only foot or horseback can the place be reached. We had superb views climbing up & then the long descent into the valley which is extremely well-watered. There are only the remains of the huge hacienda, a part having been repaired, which he lives in, & the chapel in perfect condition, but not used now.

We rode on to the village over an awful path, but I am quite used to my horse leaping like a mountain goat up the boulders or jumping down. I just cling to the pummel of the Mexican saddle. We returned about 1:30 & Mr. Ramirez Sr. took us to the garden on a high terrace & there the tables were out for dinner. I suppose that there were about 15 people & some looked like full-blooded Indians, evidently men about the place as managers or some responsible persons. They treat Indians like equals when they are educated, & the attitude is never like that towards a Negro, the Indians will not stand it, have a great deal of pride. We had a real Mexican dinner & Mr. R. Sr. showed us how to eat with the tortillas. They fold them up into little spoons & dip up the sauces. The chicken was delicious with a sauce of real cream.

The place has some stunning things to paint so Grace [Mané] & I are to go out again & paint. I told Grace she must take off her hat so he could see she didn't have grey hair like me, she is very handsome & blond, just what the Mexicans like. I don't know whether that got the dinner invitation or not, anyhow I hope he takes to her & does some other nice things for us. He said that in the mountain of rock just above his place that there is an Aztec burial ground which has never been excavated. I would like to explore it. I ought to hear from Alice [Jones] in a few days. If she stays several weeks in the City I can go up to meet her & bring her down here. It looks as if I am going to have a very nice N.Y. woman [Joy Hansel] to take my room. She is painting in Weyman [sic] Adams' class.* Also wishes me to give her water color lessons.

* Indiana native Wayman Adams (1883–1959) was a student of William Merritt Chase in 1912. He settled in Austin, Texas, and was a leader of the Brown County Art Colony. He also resided in New York City. His wife, Margaret Burroughs Adams, was also a Chase student. Adams conducted sum-mer classes in Taxco in 1935 and 1936.

*Taxco*
*Feb. 5 [1936]*

To Nell

Your letter with Mariana's long one came two days ago—I am terribly worried about Julius. If some rich man were hanging around me I would be tempted to marry just to help out the various members of the family.

Since I last wrote I have been on a wonderful trip over to a distant village to attend a fiesta. Pat Ross knew about it & asked me to come along. The party was Pat, her friend, a Mexican young fellow & Chucho, the brother of my neighbor from whom I get the horses. He knows the country like a book & is a superb horseman.

We met Indians all along the way going to it, some riding horses & some walking—Of course all the children were along. We finally reached the village & found it full of natives with booths or sitting on the ground selling all kind of things to eat & wear. I at once looked around for my party. Several Indians said they had seen Chucho with two "senoritas" in "pantaloons" like mine. Neither of us could find them so I got some bottled lemonade & some coffee & some fruit then started for the "rodeo" where some man said Chucho was.

Of course there was a lovely large church surrounded by the Plaza.

The others arrived about 12 o'clock & saw the dance of Death & the Soul, a kind of morality play & dance. I was tired & also I knew the boy & horse were too tired for a return trip, anyhow it meant reaching Taxco in the night. I decided to spend the night as I wished to see the dance of the "Moors & Christians" which is one of the old historic dances of the Indians, then there was to be a big "Castillo" in the Plaza. So Chucho took me to a friend's house, right at the Plaza gate. They had a cantina & a huge backyard where numerous burros & horses were parked & I discovered next morning numerous families were sleeping on the ground there too.

To return to myself & story. I was the only white person in the village except one other, a little albino Indian boy of 4 or 5 years.

There were hundreds of Indians and some very beautiful types. You saw no men & girls together, the men all with each other & the women the same, except the families. Frequently the men carry the ladies. One went with the greatest politeness & consideration. Of course there were some drunks, but all harmless & not noisy. There was a band & I only wish you could have heard it. It became more & more remarkable as the night wore on, & when I went to bed at one the tequila was working fine so every instrument was on a different key & all playing solos. Dotted around were groups of three or four Indians playing on violins & guitars & singing. It was a glorious moonlight night & just about sundown they had a procession parading some sacred images from the church & a yellow canopy over one. All the people carried candles & sang. Finally they went in church & some small children, girls, dressed in white with veils & flowers in their hair & staffs, danced & sang. Also the actors in the Death & the Soul play danced too. About 9:30 the Moors & Christians was danced in the Plaza. First there was only one Christian who was dressed in white with a helmet with three feathers & holding a staff of white flowers with a cross on top. Opposing him were the Moors who wore masks, very grotesque. Two had huge crescents of colored metal paper

surmounting the masks. Two had huge high head dresses. It seems to me that I have seen them in pictures of the early bishops in the Greek Church. Then there was one who had a funny headdress & mask. He was the clown & the crowd roared at him. In fact the Moors were the ones who indulged in the horseplay. Later another Knight came to the assistance of the first. He was dressed in blue & silver & rode horseback, the horse being around his waist! All carried huge machetes & there was continual fencing & much talking back & forth.

Finally one Moor was captured & there was a lot of horseplay about rescuing him—In the end all Moors were vanquished.

The idea of these plays are Spanish but most of the dancing is Indian from pre-conquest times, so I am told. There was a good deal of dancing in this & a variety of steps.

The Castillo [fireworks] was not pulled off until almost 12 o'clock. There was a good deal of dynamite in it & the explosions were very loud, which the Indians seem to enjoy hugely. It wasn't as beautiful as the ones I have seen here. Explosions had no effect on many Indians who were stretched out just asleep on the ground. However they couldn't spend the night there, & next morning at 6 o'clock it was deserted.

At about one o'clock I went back to my Inn & they had fixed a bed for me. It consisted of a frame on which was laid a mattress of canes tied together & a pelate laid on it, also a pillow. By that time I could sleep on any bed so I unbuttoned my collar & laid down & covered with the cotton blanket the Señora gave me. All the family & friends were lying around the room either asleep or arranging themselves. The cantina opened into the room & was full of Indians talking & drinking & outside the band was on a tequila debauch & the burros were braying in the backyard. So you think I was kept awake? Not on your life, I slept like a rock & woke when someone came in with a light about 6 o'clock. I got up & saw that there was light in the east. I went over to the church where there was a service & the little girls dancing again. I came back in a little while & we had our breakfast of coffee, rolls & eggs, then started for Taxco at 7:15. Just as soon as I reached Taxco I turned into a trail leading up to the town. We arrived at almost 1.45.

No message had been sent to Joy Hansel who has my extra room. Joy Hansel is a pupil working in Weyman Adams' class. She is very attractive & most considerate, seems charmed with the house & with Emanuela's cooking. I feel that I am most fortunate in getting such a nice person. She rides a great deal & is evidently a fine horse woman. She spent 5 months last year traveling in Ireland so must have money.

I am still painting hard.

*Taxco*
*Feb. 6 [1936]*

To Nell

Tell George to suggest Julius to write articles on the history of medicine. His article on Razes, the Arab physician, was extremely well written & wonderfully interesting. I believe the Atlantic Monthly would take it. George knows [Ellery] Sedgewick, [1872–1960, owner and editor of the *Atlantic Monthly*] personally & could introduce him & at least have it read. If he [Julius] could do something like that while getting well it would take his mind off of things & he may drift into writing.

I really feel & look like myself these days & probably in a few weeks may not have to diet, mild as it is. The trip I wrote you about was a tester so I am sure I am perfectly normal now. Am still painting hard these days, some good things & some not but can't tell now.

*Taxco*
*Feb. 29th [1936]*

To Mariana Taylor
I have written to Francis Taylor who is head of the Worcester Museum which is doing splendid work. Read his article in the Jan. or Feb. Atlantic Monthly on the "Problem of the Artist Today." Mr. [Ralph Adams] Cram (the big architect) tells me that you have a much better chance of getting into a smaller museum than in one of the large ones where they have many volunteer workers.

Alice Jones is here, she is sleeping in my bed & I on a lounge with canes for springs. She seems to be enjoying everything immensely & our violent arguments add to the pleasure. I have a charming girl [Joy Hansel] staying with me & she & Alice hit it off wonderfully. I put off having people until she came so have had a series of guests in. Just at present my priceless maid is sick, of course took sick the day I was off in a nearby town spending the night & seeing a fiesta. I sent her home so shall be doing all the work until she returns on Monday, I hope.

We rode on horseback to Acapulco which is about eight miles over the mountains. Five of us women & Chucho, the livery stable man went. Alice decided she couldn't ride so far. It was beautiful & we kept almost entirely off the main road, & followed the old Spanish road. The Spanish built this road in the 16th century from Acapulco on the Pacific to Veracruz on the Gulf. The Spanish Galleons would land the oriental cargos in one port & it would be transported to the other. Well we traveled that road & had most glorious views of the mountains & the sunset as we didn't get to Acapulco until dark, then we roamed around to find some place to sleep & to tether the horses. We finally found a large stable yard which had a shed in one corner. Chucho conversed & we got a huge bundle of corn shucks (beautifully put up) to spread under it & then we put down our serapes & covered ourselves when we finally retired. The horses were tethered around the lot & just at our heads with a wire fence between were tethered two burros. If you could have heard them at various hours during the night give their fearful bray. Of course water was just almost nonexistent for there is none in the town, all being brought from Taxco on burros or in trucks. When Chucho watered the horses he walked 1½ miles to do it.

Well, just as soon as we got ourselves placed for the night we started up to the town which was right on top of the very high hill or mountain. The Church & Plaza is there & is very lovely from every direction, just standing out from among the other mountains. This church has pictures which were the ones which inspired Diego Rivera [1886–1957]. He returned from Paris a cubist then happened to go here & was so struck with the Indian paintings uninfluenced by European art that he began painting like them. I thought that they must be mural but there were nothing among the altar pieces which differed from the usual conventionalized Virgins & Saints of the Sienese school, which always make one think of Ducio [Duccio di Buoninsegna]. Evidently he was influenced by the "retablos" which are

paintings by the native artists of various incidents in the people's lives, such as a desperate illness, accident, etc.

It was really more picturesque than the other village I went to because of a more beautiful situation. We went up to the center along a side street lined with the vendors sitting on the ground or booths. There was quite a level area filled with them on top. We reached the church plaza by rather high steps then had a lovely view of the surrounding mountains and looked down on the crowd. They danced the old "Tiger Dance" which dates to the Aztec days. In fact all these dances had their origins with the Indians & then had a veneer of Spanish. However in the case of the Moors & Christians, it had its origins in the Spanish, & the Indians have introduced steps & rhythms purely Indian. Some of the old morality plays & dances have been treated in the same way. We saw the Apache dances where women & men dance, all with headdresses of feathers & their bangles were the tops of soda bottles!! The dance of the Fish I missed but saw the children in their costumes. The Moors & Christians had on masks, at least the Moors did, all carried machetes & fenced most of the time & did a lot of talking. Pickpockets were roaming around & picked Pat Ross' pocket 10 minutes after we reached the crowd. She had 25 pesos in her pants pocket, a silly thing to do. I had mine pinned to my girdle except a small amount in my purse which I clutched. This was a more interesting fiesta than the other town in some ways but the other was much more primitive. The Indians better mannered & I & the Indian albino the only white people in town. Too many people from Taxco & Aguilo in Acapulco.

*Taxco*
*Mar. 10th [1936]*

To Nell

Well, I went up to Mexico City & met Alice [Jones] at my pension & we came down together. She seemed in fine form & had seen everything possible. We took the trip out to the pyramids & found it quite thrilling. They are wonderful looking & must have been gorgeous when they had all the colored plaster on them & the Indians in their gorgeous dresses of many colored feathers & gold & silver ornaments.

I received a letter from Mrs. Caroline Sinkler [of Philadelphia, 1860–1949] sending me a check for $25 to buy something for myself. I at once went to Spratlings & told him I wanted a necklace of Jadeite & silver beads. The jadeite beads are found in the old Aztec graves & are a lovely grey green & all sizes & vary in shape. So one afternoon he turned over his tray of jadeite & the other tray of silver beads of all sizes & I had a grand time picking out the beads & matching them & selecting the size silver beads which suited best. I ended up getting a chain for myself & one for your girls to be worn by the one having the right dress. It has fewer beads of jadeite & those of curious shapes & silver beads graduated to rather small ones. It is really more unusual than mine. I couldn't buy necklaces for all so you will have to pass it around.

The afternoon we went to the fiesta I had asked some people in for tea who wished to see my paintings. Of course I couldn't give up the Fiesta so Alice managed the show & was such a success & so professional that the Jaroches wanted to buy some of my water colors. Mrs. Jaroche wrote me a note offering me $75 for the two which I took promptly as that goes

a long way here. Of course it is illegal to sell anything so one has to keep quiet about it. Also the Eschweilers[?] from Milwaukee wrote asking me to get something for a friend who had a house furnished Mexican style. She said she knew I wouldn't consider $25 for a water color but to select something. I promptly wrote & said I would let her have a water color. It will be good publicity & may lead to other sales as the house is in Florida & the people wealthy.

*Taxco*
*Mar. 24th [1936]*

To Nell

My last letter told of Alice's visit—She went out to Oaxaca & seemed to enjoy it but found it warmer than Taxco. I am curious to see if I find it paintable because there is such divergence of opinion, some think it more beautiful for a painter than Taxco.

Joy [Hansel] gave a beautiful picnic, inviting the Crams, H. Adams & the Weyman Adams, Oscar Ramirez & Mr. Stevens [Kelly Haygood Stevens, 1896–1991], who is about stone deaf & a student in Adams' class. I selected a marvelous spot on the top of the mountain behind Taxco, about two miles up the road, & it overlooks the entire valley with Taxco just below & a view of Popo on one side & distant ranges on the other. Some rode up in cars & some walked up the short path. Everything was truly delicious & the company most congenial, the two single men being the only sticks & we left them alone so they ate a lot. Mrs. W. Adams [Margaret Burroughs Adams] is most unprepossessing at first but wears extremely well; he is silent & contributes absolutely nothing. The Crams & the H. Adams are people of the world & always add tremendously. After lunch Elsie Adams [wife of H. Adams] & Mr. Cram tried sketching & some others strolled off, pillowed their heads on rocks & went to sleep. I talked to Mrs. Cram & H. Adams. About 3:30 Mexicans who sing & play delightfully came up & sang for us over two hours. It was a perfect afternoon. Joy, the two men & I stayed after the others left & walked down when the sun began to sink, seeing the mountains & sky with glorious colors.

The biggest Fiesta of the year has been this past week at the Veracruz church which is below us within sight, & is the church I have painted most. It comes against a golden hill in the most beautiful manner. Both streets leading down from the Plaza to the church were filled with booths with all kind of things to eat & wear. Every night they shot off fireworks & had "toritos" & "castillos." However they came so late that we only went the big night which was Friday. They also had the old historic dances, but I had seen them in the other villages. I did good size watercolor of one of the short streets with the booths & people.

I have been terribly busy because a group of students in the [Wayman] Adams class & some others were very anxious to get me to give them more lessons in watercolor for my paintings seem to have created a mild sensation, some people thinking them more interesting than [Eliot] O'Hara's, having some depth & more composition. However I have lived too long to have my head turned or to believe all people say. However an old artist friend of mine, Susan Knox [Susan Ricker Knox, 1874–1959], is here & I do value her opinion & believe she says what she thinks & she does like mine better than O'Hara. Well, I told the women that I would give them three afternoons so the first I showed them my brushes & told them a lot about O'Hara's tricks of the trade & gave them addresses, etc., for supplies,

also went over all my paintings & told them what I thought was good & what bad. Also made Joy bring out her sketches & have them torn to pieces. They seem to feel that they got a lot out of it. Then next day I painted the scene from my piazza before them & did one of the best watercolors I have done! Several days after they came with sketches they had done & we all criticized them & again looked at mine. They paid me $5 each which will help with buying supplies.

I leave next Monday for Mexico City, & then Oaxaca. I dread all the packing, particularly seeing about the frames. These shops here make beautiful tin frames & my strong watercolors look quite stunning in them so I have gotten about two dozen. I have begun now trying for some shows next winter in New York, Philadelphia, Buffalo, Pittsfield. Hope I can. This year has been very satisfactory in the matter of meeting people.

Did I tell you that Mr. Holland who owns the little double house next to mine [at 79 Church Street], wishes to buy the end of my lot for $300 & I wrote to William Means to go ahead with the sale. It still leaves me the ground my garage is on & the house on Tradd St. may want that some day. I have to complete my 4th story this fall & that money will help.

**Oaxaca, April 1936**

*Oaxaca*
*April 8th [1936]*
To Nell

I left Taxco on the 1st & turned the house over to Mrs. Cooper who has taken the house with Joy for a month. So ends my winter in Taxco. I was quite ready to leave as the people I liked left except Joy. I had painted all that interested me & wanted some new scenes.

I had various things to see to in Mexico City including the dentist & doctor. The latter said he was quite satisfied with me which I am not, because he has reduced me to 145 pounds! I have a divine figure, little hips & beautiful legs, but heavens my face & neck!

I took the 6:30 A.M. train next morning for Oaxaca. It is a beautiful trip most of the way. First we were several hours going down, then several hours riding through a hot dry country & I never saw a dustier trip. Right in the midst of it our train ran into a large truck & threw it off the track. The nice friendly conductor was talking to me when I saw the overturned truck & called his attention to it. At once the entire male travelers dashed to the door, we being the last car. The train is a narrow gauge & rattles & goes on so that I can't understand why the driver didn't hear it. One man had his head crushed in & everyone seemed to think he would die. After about 20 minutes we went on & another bus was to take him back to Tehuacan. We then climbed up again, beautiful views.

We got here at about 6 o'clock & I went to the Francia where friends of mine had stayed. After dinner a nice older gentleman came up & started to talk then we walked to the zocala. It proved to be Mr. Waterhouse, an engineer H. Adams had known down here years ago & had mentioned him to me. He was one of two friends of H's who had gone back to Oaxaca to spend their last years. He told me that there was an American lady who had been here about a month who also painted & said if he saw her in the morning would tell her about me.

I was at breakfast when Mr. Waterhouse came in with the lady who happened to be Dr. Jamison whom I had known in Taxco. I think I mentioned her as having known Connie Guion [Taylor's New York physician, Constance Guion, M.D., 1882–1971]. She has retired & has taken up painting. I spoke of my room so she told me of the nice place where she was staying which was quiet with two patios & ideal for work. I went around at once & met both the van der Veldes. He [Peter Van der Velde] is a Belgian & since coming over here years ago has taken up archaeology & the study of the difficult languages spoken in Oaxaca. His wife is American but talks very English. He has been collecting books & they have one of the finest collections of old books in Mexico. He is also a writer on Mexico.

This place is simply marvelous in color. The houses are washed with the most vivid beautiful colors & the churches are made out of a beautiful jadeite green stone. Mountains surround the town but the place itself is rather level. The Monte Alban ruins are quite near & the Mitla ruins are 25 kilometers away. I shall stay out there several days as there is a nice little hotel there.

I don't believe I told you that I got a wire from Beth Verner [Elizabeth O'Neill Verner] wanting to buy the right-of-way to my drive way. I at once wired Nat [Barnwell?] to look into it & find out what she intended doing to the place, also said I had no confidence in her. I followed the wire with an air mail letter giving the above details. I wired her that Nat would look into the matter. I haven't heard anything yet. Mr. Holland, who owns the little double house had offered me $300 for the end of the lot which I own & I said I was willing to sell but I find moving the toilet [in my house] seems to cost more than William Means & I thought. I just fixed it over last year to the tune of $35 & now [Julius] Smith [the plumber] says it will cost $55 to move it where I don't want it. I have written back to know why it can't be put in my basement. There must be some way of putting it there. He wants to put it exactly where it will have to be moved again if any [one wants to] buy the rest of my lot which is back of the apartment house facing on Tradd. I would have sold my right of way to Mr. Holland if he had carried out his plan of doing over the houses for his winter home but I can see what a mess it would be if Beth got hold of it & had a lot of studios & all the cars dashing in & out & all over my plants & breaking down the gate etc. & no redress. So I am waiting to get some news of the plan from Charleston.

*Oaxaca*
*April 16th [1936]*

To Nell

I am very comfortably fixed here with the [Peter] van der Veldes. He is a Belgian who came out here some years ago, seems to know a lot about archaeology & has done some work along that line, as a matter of fact he was the first person to insist that there might be priceless treasures in the Monte Alban range of hills. Then he & Dr. Caso [Alfonso Caso Andrade, 1896–1970] worked together but a split came, just after Dr. Caso made his wonderful find of the finest jewels found on the N.A. Continent. Now the government is giving Caso a rotten deal, but he is doing some excavating here still. But the arch criminal was an American, Baitry [*sic*; Leopoldo Batres], who was down here 25 years ago & at the head of the

Museum.* He used dynamite! I wish you could see the places he blew up, complete wrecks & no possible hope getting anything out. Also used the money traveling in Europe, sold treasures out the country, etc. In fact behaved in a very Mexican way.

Dr. Jamison knew a young archaeologist here from the Newark, New Jersey Museum who is working under Caso. We went out there on his invitation & he took us all over the place, showing us first how they worked & explained the difference of the three civilizations. I wish you could see a man swimming, a perfect example of the Australian Crawl & long before Australia was discovered. It is a scream—highly funny piece of sculpture. I want to get a rubbing or photo of it for Edmund. All of the hills have manmade terraces from the bottom to the top, tombs everywhere & temples on top. All of the labor was done by men because there were no beasts of burden until the Conquest. In all the tombs which haven't been disturbed they always find bones of slaves sacrificed at the time of burial.

Mr. Bauterman also told her of a secret procession of the Christus on Friday at JoJo, a village a few miles out. So the doctor & I got a car and drove out. It seems that the government is doing all in its power to crush out religion & processions are not allowed, nor are the dances but they manage to pull them off at times. All the gates entering the Plaza of the church were filled with green branches & only one small opening to let the people in. The procession started with Christ leading[?] the Cross, held up by four men—Centurions all dressed up in helmets & every color of the rainbow, four of them, walked by the figure. Six of the apostles, with a black handkerchief tied across one shoulder & black sashes, walked also with the Christus. The lay reader walked just in front reading & the people followed. They evidently had certain places to represent the seven stages of the Cross. At each place everyone knelt & made their responses. After the Christus came the Magdalene carried by girls. Another procession was formed carrying the Virgin & St. John. They turned around & the two met in front of the church & Christ & Mary were made to salute each other, bending three times until their heads met. We were the only white people there. All seemed very serious & deeply religious.

There is a priest here, Father Ricard, a Scotsman, who was converted by an old nurse he had as a child, his father being British Consul & a dyed-in-the-wool Presbyterian. I was most charmed with him, undoubtedly a gentleman. We wanted to know if there were to be any processions in the city. He tells me that only one priest is allowed to minister to the people, & there are 60,000! But for Thursday, Friday & Saturday of Easter Week two more priests are allowed to officiate. They are not allowed to train priests for the priesthood so they have to do it secretly, meeting at different places. He holds mass in his own rooms but can't do it in church.

Bauterman also told us that there was to be given the Pleasure Dance which is one of the old dances preceding the Conquest. There are Montezuma & six dancers, all dressed in huge fan-shaped headdresses & costumes of marvelous colors. They all dance at times & then different ones come out & dance. We drove some miles out to the so called village & the dance took place in front of the school. It was quite superb when viewed from the side which had the mountains & golden hills for a background. I want to try to compose a watercolor of it from memory & from Bauterman's snapshots. The dance was put on for Frances Toor who expects to use the movies of it in her talks on Mexico.†

It begins to cloud by two o'clock & by four it is thundering & shortly begins to rain. Late in the night it clears off. So my painting outdoors will have to be in the morning. I have to work from memory anyhow because the people crowd around me so. They are not used to painters as in Taxco. There isn't as much material as I had hoped to find. Most of the painting will have to be composed.

* Leopoldo Batres (1852–1926), a native of Mexico City and head of the Mexican National Museum, excavated and reconstructed Aztec and Zapotec sites in the first decade of the twentieth century. His rebuilding of the Pyramid of the Sun at Teotihuacan has long been considered erroneous.

† In 1934 Frances Toor (1890–1956) published *Frances Toor's Guide to Mexico: Compact and Up to Date.* Her *Treasury of Mexican Folkways: The Customs, Myths, Folklore, Traditions, Beliefs, Fiestas, Dances, Songs of the Mexican People* was published in 1947. She also edited a magazine, *Mexican Folkways,* to which Natalie Scott contributed articles.

### Mexico City—Mt. Popocapetl, Jalapa, May–June 1936

*Mexico [City], 140 Cypress [Street]*
*May 1st [1936]*

To Nell

Of course there is an awful lot of demonstrating the "International" today, no cars or buses this morning, all stores closed & no bread. At present there is a strike on with the railroads. The workers are demanding the 7th day leisure & ½ pay for it. A law to that effect was passed this year & the railroad is perfectly willing to give the day but have no money to pay for the holiday. If the railroads aren't running how will I get out of the country? There is also a strike on since March 19th of the chauffeurs & guides for all the Transit Agencies. They are demanding higher wages. The Agencies will have to come to some settlement very soon because the season begins very shortly & I believe that the situation in Europe will simply make people pour down here, open roads or not.

A nice ugly little person turned up in Oaxaca whom I had met in Taxco, Miss Van Derburg. She had traveled a lot & I found her most interesting. She had been out in our southwest & had become interested in the archaeology there where there are strong links & the scientists are trying to find others & stronger, with this Central American Culture. Did you know that there were found in manuscripts in Thebet [*sic*] accounts of a landing of Buddhist priests on the coast of Mexico? One of the reasons of the fight between Mr. van de Velde & Dr. Caso is that V[an de Velde] has the European view that these civilizations are due to contacts with the East or West in some way & Caso thinks that it is indigenous. I forgot to tell you that when Caso was excavating at the site of a Tomb, & he cleared the building above, a workman's pick sunk in the ground & a stone was raised showing an opening, evidently a tomb. He tried to get in but couldn't, so the smallest member of the party found he could slip in so down he went. In a minute they heard exclamations & he cried "I see nothing but gold." With that Caso slipped into the hole with perfect ease! When he wanted to come out he simply couldn't begin to get out so other stones had to be moved!! Mr. Bautermann was to have had supper with me the night I left but something evidently

prevented his coming for we had a perfect cloudburst. Mr. van de Velde had to come for us in his car as we couldn't have gotten across the streets. He may have been tied up with his work because he told me the day before that it looked as if the mound he was excavating had a tomb. They had found two skulls, evidently of sacrificial slaves, & that day had uncovered what looked like the corner of a tomb! So I had to leave without knowing.

Mr. van de Velde's family were connected with the Belgian Congo. His two uncles were the first governors of the Congo & his father was there as governor too. He has a marvelous collection in the house of all the natives' weapons. They have been exhibited all over the world. His mother got tired of taking care of them & shipped them out here to him. But it is a crime that they are not in a Museum. His father is a marvelous looking person, quite the type of a European aristocrat.

However I am leaving tomorrow for Cuernavaca which is a village on the slope of Popo where one gets wonderful views of the volcanoes. I shall be there about four days & then return here where I shall be until I leave for Jalapa about June 1st.

This afternoon Carlos Bacmeister took some of us out to a wonderful Hacienda, Santa Maria, which is one of the few old large places which hasn't been destroyed. It was built in the 16th century & was given by [Hernando] Cortez to some friend. It belongs to a friend of Carlos & he is planning to put it on a tourist trip for it isn't far from the Pyramids & very convenient for the lunching place, instead of the perfectly hideous Cave & awful lunch they now give one. He plans to have the kind of meals Americans like & in time fix up rooms for weekend visitors. It is quite a lovely drive & quite close enough for tea or lunch. In fact it ought to be a go. There is a lovely old garden which would need very little done to it. There is a tiled bath which is said to have been built for Marina who was Cortez's Indian mistress & was really the one person who made the Conquest possible. She had been sold into slavery in Guatemala, a princess, then given to Cortez by a friendly Indian chief. She knew the various languages & translated to a Spaniard who had been captured some years before by the Guatemalans & knew their language. Without her, Cortez could have done nothing. He had a child by her but I can't remember what became of him. She was very beautiful.

*Cuernavaca*
*On the slope of Popo*
*May 6th [1936]*

To Nell

I left the city Saturday afternoon & came by bus up here, an hour & a half trip. Being one of the cheap bus lines it was jam full of natives, mostly Indians, but I had one Mexican on the seat with me who must have weighed 200 pounds & I had a large flat bag with my watercolor papers, etc., & a small handbag with my personal things, all on one seat! It was a lovely ride up & the air was like a November evening, just as soon as the sun went down. I don't know what the elevation is, but Mexico City is 7500 feet. It is very cold at night & of course this little country hotel has no modern conveniences, but of course a radio! It has a little patio filled with lovely flowers & flowers everywhere that a pot can stand, about six cages of different songbirds & a parrot that talks. The toilet is right in the middle of the garden & covered with bougainvillea & plumbago in full bloom. They wash the whole place

out everyday & select an early hour which leaves seat & floor soaking wet. Of course no plumbing! My room overlooks the garden & has a little piazza where I am sitting now. In front is a high hill, 500 feet, called the Sacremonte because there are two churches on it & the Stations of the Cross all the way up. From it one gets wonderful views of "Popo" & the "Sierra." The latter has some awful name meaning the sleeping woman, but here they call it "Sierra." It really does look like a woman lying down.

Every morning I staggered up the hill with my traps & made myself comfortable on tombstones, excellent places to paint on. The views going up are superb for the path is lined with huge cypress trees & one sees the mountains between or above them. I did some big watercolors of them & the volcanoes but I have to get back to Mexico City to decide if I like them or not. I am leaving this afternoon. Luck was with me because yesterday afternoon & this morning are the first time there are clouds & haze over the mountains.

Before I left town I heard that the law is still in effect which requires every painting to be photographed and have four prints each & each signed!! Did you ever hear of such a damn fool law? Those parvenues once had some painting detrimental to Mexico go out so passed this law. I heard it had been changed, but let us hope it is by next September because I expect to have some 150 paintings. If it is still operating I shall have to select a certain number & leave the rest in Mexico to be sold here at a gallery which is being opened by someone I know. However I shall see if Mr. Parry can work his rabbit foot & get the man to pass on them all & give me a paper.

*Mexico City*
*May 15th [1936]*

To Nell

I thought that I would have to write you to send your letters airmail as it looked as if the railroad strike would come off on Monday. Joy Hansel went down to see about getting tickets for a trip she wanted to take & the men told her she better get out by 18th, so this morning she went to see the head man & he said he had seen Cardenas (Pres.) who said there would be none. The Mexican Government owns one-half of the stock & it seemed perfectly suicidal for them to permit it as they are bidding hard for tourists & for foreign capital.

We also went to see a revival of the Aztec performance given last summer & last fall & I never got to them. There were some 2000 people taking part. The reproduction of the temple and costumes were authentic & were simply superb in color. The dancing steps were the ones that the Indians used & are still danced in the villages. The pageant was the Gladiatorial Sacrifice and the Worship of the Sun. It is simply impossible to describe but you get an idea of it in the book I am having Ben mail you when he & Julius finish with it, *Mexico before Cortez,* also Bernal Diaz's [del Castillo's] account of the Conquest, he being one of them, and Mme Calderon de la Barca's [Frances Inglis, Madame Calderon de la Barca, 1804?–1882] letters in the 1840s. I heard a talk, or rather a reading, on Cortez & Marina, the Indian mistress he had who had been a princess. Cortez was kind of forced into a marriage with some lady in Cuba before his expedition. After his conquest & things were sitting pretty she picked up & came to Mexico much to his disgust. Of course she was jealous of Marina who was very beautiful & she & Cortez much in love with each other. The Senora pestered

him so that he strangled her or some say poisoned her. Another reason he wanted her out of the way was because he wanted to marry a woman in Spain of high rank as he was then Marquess of Oaxaca & heaven knows what else. He proceeded to do it.

*Mexico City*
*May 28th [1936]*

To Nell

I bought the Sunday Times & found [and enclose] this review of [the Harvard surgeon] Harvey Cushing's memoirs. Isn't it a beautiful fine head with clean-cut features. It is for Edmund & I hope that in the next war he will be the great surgeon Cushing is & a drawing of Ed's head will be equally fine as he has the best features in the family except Ray. Personally I have always felt he should go in for medicine & surgery after seeing him skin birds during his cave-man period. Edmund's personality would count much more for success in medicine than in zoology.

*From Norman [Kurtz]*
*At the Mine, Guanajuato*
*May 28, 1936*

Lately I have had a terrible attack of the blues–perhaps caused by living alone so long, but I never feel right unless I am "triste," & so "It is written."

The world is going to pot, and in my estimation civilization is on at the brink of one of the worst catastrophes in history.

England ought to change the color of her flag and make it bright yellow, and the United States is going slowly but surely to Socialism.

Germany will eventually dominate the whites, and Japan will eventually dominate the world, and then the only salvation will be "death."

Whenever I leave here I shall be awfully "triste" without being able to take the male raven with me as he has become so tame that wherever I go on this mountain he follows me, and when I am alone he gets on my shoulder and tries his best to talk, and seems to know instinctively how I feel at times. I have taught him to take a bath every morning in a bucket of water & he thoroughly enjoys it. Animals and birds have always been my best friends, ever since I was a kiddy. A raven is far more intelligent than any other species of bird & higher than an average dog. So few people have taken the opportunity of making pets of them because of their mischievousness, but if they did they would quickly understand how intelligent they are. I have kept magpies, jays, falcons, crows, hawks, etc., when I was a youngster but none can compare with a raven. I am enclosing you a photograph of The Mari Sanchez rock that is on the entrance of the mine to prove to you that I have found it.

*Jalapa*
*June 2d [1936]*

To Nell

I left Mexico at 8 A.M., taking a bus to this place, but it proved to be a car as there were not enough for a bus. The whole ride down was very beautiful, first with Popo & the Sleeping Woman on one side for miles, & later Orizabo, at one time going quite near, but from here it is some distance off. Some of the road was very bad but when rather near here we got onto a real highway. We crossed riverbeds & some times went a little distance down them, two very large savannahs, which I hear are salt. There had been heavy rains so there was a good deal of water & very marshy. In one we got stuck.

June 4th. I wish you could see the Senora, a perfect [Charles] Dickens character, mouth full of ill-fitting teeth. I had to finish out my day at the hotel so had my first meal tonight which was exactly what I wanted, tomato & cucumber salad, rolls, delicious pineapple & plums. Of course this is the country for "pina," no one gets them perfectly ripe. I believe she is going to give me just what I prefer, a nice old ugly thing. My room has a large window opening on the street & to reach it one passes through a kind of anteroom where I am now writing as the light is better. I shall dump all my painting stuff in here.

The town is very lovely, very hilly & surrounded by mountains. From the park, which is on a high terrace, one gets a glorious view of Orizaba, the summit covered with snow. I took an exploring walk early this morning & found many interesting places to paint. The houses are lovely colors & have overhanging eaves. Flowers everywhere—on hanging walls, on patios. There are numerous small towns nearby & quantities of buses going in & out all the time. I expect to explore them all and some we passed through coming down. Mr. Parry gave me a letter of introduction to a Mexican who speaks about as much English as I do Spanish. However I believe I shall make progress in this house with no English to hear. He found me this place. Also helped me about finding a suitcase containing all my U.S. watercolor paper! I shall relate this episode later. Mr. Parry suggested that I meet the Boones, to whom I had two other introductions. I thought he was a descendent of our friend Daniel, but it seems he comes from Daniel's brothers or uncles & they all settled in Peru after leaving England & Mr. Boone's family stayed there while Daniel removed. Well, we called in the morning & found young Boone [William K. Boone Jr.] in, a charming looking fellow in his twenties, very agreeable manners. Of course our conversation was half & half, English & Spanish. The house is about 250 years old & was a cigar factory & then changed into a residence. It was filled with all kind of beautiful china, Sheffield plate, pewter, old English furniture & other kinds, books, etc. The garden was entrancing, full of all kind of flowers & many orchids in bloom. I shall go over & paint plates of a lot of them & am already digging into the books Bill Coker told me to get. Mr. Boon Sr. was out so we returned in the afternoon & I found him a most charming man, same kind of alert, collecting kind of person as Mr. van de Velde but Mr. Boone much more charming & probably not so scientific as Mr. van de Velde with his Germanic mind & manner. [His mother] Mrs. Boone has just left for the States, first visit in 11 years. However Mr. Boone was cordiality itself & invited me to come any time & paint. They take paying guests when she is at home but the

price is too much for me—8 pesos a day & worth every cent of it. I shall suggest to Julia & Pauline Dill to stay there. Jalapa & the Boones would be ideal for them. However Mrs. Boone doesn't return until July 15th. In fact I am so enchanted with this place that when I really get started on my work I may not want to leave except to go to Tehuantepec.

June 4th. I was interrupted by Mr. Modina coming in to ask about my bag with all my watercolor paper, which turned up yesterday afternoon. I believe I told you that I had had a rubberized bag made for my papers while in Oaxaca. Practically all the paper I expected to use was in it, also all my brushes, so I clutched it when getting into the car for Jalapa, but it just wouldn't be contained in the back seat with the fat Indian mother & a little man, so the nice Indian son put it in front of him, he being on one of the middle seats. On our way to Oaxaca the car heated up so that the chauffeur got another car there & all of our baggage transferred to the other car. I was away about five minutes & then returned & looked in our car to locate my bag. Not seeing it I asked the chauffeur if he had put it on top of the other car & he said he had. I didn't have it removed but decided to take my chances about rain. When we got to Jalapa I asked about my bag, not seeing it. It was nowhere to be found! Evidently left in Oaxaca, so he phoned Mexico & found it had returned in the other car & arrived here yesterday safe & sound. I found a lot of fine subjects to paint today. This afternoon I went to the Boones & drew in an orchid I wished to paint. I shall probably paint there in the afternoons.

Am at Papantla, there is to be a fiesta & the pre-Conquest game of Indians swinging around a pole, like a Maypole, very dangerous.

*Jalapa, Veracruz*
*June 16th [1936]*

To Nell

I am seeing a lot of Mr. Boone [William K. Boone Sr.] these days as I paint there almost every day for part of the day. Beautiful & weird orchids are constantly popping out. In fact I know that I shall not get all painted because these very accurate paintings are hard on the eyes & take time. He is a very interesting & intelligent person, has been here some 36 years or more, put in the first power plant built in Mexico & the government has practically confiscated it as they do all foreign owned companies. Fortunately for Mr. Boon & his company there was a flaw in the confiscation & he is being paid in part for it. His job at present is getting down here & collecting the money as it comes due from the State of Veracruz. If he were not here they wouldn't get a cent of it. He certainly has an earful to say on the subject of the Mexicans. He says they are extremely bright. He has taken & trained numerous men and always found that their moral character couldn't keep up with their intelligence. While they were still developing mentally, a time comes when they broke down morally, couldn't stand the strain of responsibility & ended by stealing & being crooked. One wonders why they have ended this way for the Spaniards were brilliant great people in the time of Cortez & the Indians had a far higher standard of morals than the Spaniards had. Stealing was unheard of & lying unknown, to the astonishment of the Spaniards. The uncontaminated Indian today is truthful & honest.

*Mt. Popo [postcard]*
*June 1936*

To Eliza

Here I am at Jalapa on the slope at Popo. Have done some big watercolors of the volcanoes and Sierras. Of course quite cold up here like Columbia in November. Do write me about your visit to Charleston. Have been with the Hochs all day and saw a game of polo between the Mexican team and an Army team from Texas.

*Jalapa*
*June 28th [1936]*

To Nell

I wish you would not write to me unless you have time to write out your words! I have complained of this before. I couldn't make out who was at the wedding [of Eliza Taylor to Martin Staples Shockley] nor who sent Eliza presents. The telegram I sent was addressed to both of them but quite Mexican to get it wrong. The wedding seems to have gone off without a hitch. Tell Mariana not to tie herself up for the winter in the room she has engaged as she might want to make a change. I wish she & Mary could get a two room apartment or a studio apartment with bath & kitchen near. It would be loads of fun for them & some private place to receive their friends.

I sent Mariana from the publishers the book of universal poetry. I was particularly interested in her reading the Greek, Indian, Persian & Chinese. Some of the most delightful poetry I ever read were Kalidasa's. His "Sakuntala" [*The Recognition of Sakuntala,* probably fourth or fifth century C.E.] is the great Indian drama & he is considered the Shakespeare of Sanskrit. I also want her to read some of Tu Fu [ca. 712–ca. 770 C.E.] & Li Ti Po [also called Li Bai, 701–762 C.E.] & see what they were thinking in about the 8th century China. The library must have some of [Arthur David] Waley's translation of Chinese.

I have met some Mexicans here, the Gutierrezs who are the upper class. He [Alberto] is a beautiful type of the aristocratic Spaniard, fine clear-cut features & is quite a brilliant fellow, so Mr. Boon tells me. He teaches English & French in the public schools here. Also a fine scientist. They own one of the few haciendas near here which is not a wreck, however has been largely stripped of everything in it during the several revolutions since 1910. Also the government takes off a piece of land every year or two so the acreage is much reduced. His grandfather & great grandfather were warm friends of Santa Anna & one was on the committee who signed the treaty. The grandfather had 20 children by one wife & no one knows how many natural children, in fact he & his sons just about peopled the country both high & low. The wives don't seem to resent it; in fact everyone is rather proud that a man is so virile. Alberto is really wonderful looking when he puts on a green velvet smoking jacket. I wrote Bill [William Matby] Sykes he better come down & paint Alberto. I see a lot of Mr. Boone & some of the Gutierrezs, but only in late afternoon & night as I am working all the time. Haven't yet decided whether I am doing good work or not.

**To Veracruz and Home, July 1936**

TAYLOR HAD ANOTHER TWO MONTHS in Mexico as her journey was winding down. However, she was going strong and visited new places to paint. Among them were Papaloapan, Santa Lucrecia, Tehuacan, Tehuantepec, Cordoba, Tuxtepec, Cuernavaca, Orizaba, and Truxlipei.

But, finding few places that suited her, she spent much of her time at Veracruz. At sea level she felt better. She met a continual stream of highly individualistic men in each place. ∞

*Palaoapann [sic], Veracruz*
*July 12th 1936*

To Nell

I saw a good deal of the Gutierrez's at Jalapa & like them more & more. Mr. Hamilton was charmed with them. One day Mr. Boon & I walked out to a hacienda near town, San Bruno. They have a large cotton mill & at one time owned large property, but it has been confiscated. The house is very old & at the back they have the remains of a beautiful old 18th century garden. It really would take very little to get it into shape again as all the brickwork is in place. There are many large Japonicas azalea bushes, but none of those plants seem in the fine condition of ours in Charleston. They are Mexican aristocrats & look it. The Senora's father was for many years ambassador to England so she & her sister speak beautiful English. Both her family & his have been very distinguished people. Leave tomorrow for Santa Lucretia.

*Tehuantepec*
*July 15th [1936]*

To Nell

I took the train at 4 P.M. for Santa Lucrecia. The mountains we crossed are the Andes which form the Sierra Madres in Oaxaca just outside of Mitla. It was dark before we rolled into town. The train just ambles along & stops for ages at each station. Mr. Jimenez gave me a note to the hotel owner, La Perla, the only one here. Just as soon as I walked in the Senor informed me that there were two Americans, & when I asked what they did, he said "Animales," so I concluded horse traders or such. He piloted me across the patio to their room where they were. They proved to be two men from the University of Michigan studying reptiles. One is Dr. Hartwig, the professor, & the other a perfectly lovely looking tall blond boy who just graduated in June, Jean Oliver from St. Louis, quite the gentleman & has charming manners. The other is just ordinary American. I at once asked if they knew Clifford Pope & they knew him well. He was out there last year awhile and thinks his [Pope's] book on the reptiles of China a very fine piece of work. Mr. Hartwig also knows all about Mr. [J. M.] Valentine & his blind beetles. Right after supper they left for the riverbank to collect frogs which only come up out of the ground at this season to breed, appearing at night. I wish Ed could have heard the squawking when they came in with their bags. All were labeled & pickled at once.

The town is certainly a deserted place & the arrival of a stranger creates a sensation. I find Miss McKee perfectly uninteresting so far. Am not getting any work done as I seem to find it hard doing the figures as I wish them. I am making a lot of pencil sketches & taking photos so later may work up something. Anyhow they are fine for block prints.

About two hours out from Santa Lucretia I saw the natives in their native clothes & they are very stunning, brilliant colors, mostly gold & red. I went to the market here & they are very beautiful. I hope that I can do some good things of them. They are very polite & don't seem to object to being sketched. I am not painting in the market but making pencil sketches, expecting to make colored designs in flat hues & black outline. I must get some smaller watercolors which will sell.

I didn't tell you I met Miss McKee who is working on the history of the Zapotecans. She taught English in the schools in Mexico & knows Spanish & also Zapotecan. She is undertaking a huge piece of work & one I feel a Mexican could do much better than a foreigner. With such a wealth of material in Mexico one wonders why the foreign-educated Mexican doesn't get to work on it & not leave it to foreigners.

*From Walter Taylor*
*July 18, 1936*

Just thought I'd drop you a note to say that Ed heard from the Hotchkiss exams today and they have given him a scholarship. We sent the letter on to Pop at Manchester this morning by airmail special, don't you know Pop will be thrilled. I declare he has dreamed of that very thing ever since I can remember. I would give anything to see him when he opens that letter.

*Tehuantepec*
*July 25th, 1936*

To Nell

I am making a lot of pencil sketches & snapshots to work from later. Since here I don't seem to want to paint them. I see all in colorful block prints which means that I will have to do some on my return if possible. The American men & I can't get over the beauty of the women & the scrubby looking men. However, it was explained by the fact that all the Zapotecan men were killed out during the revolution & all these are Indians from other parts of Mexico who have drifted in.

There has been a fiesta all week at one of the barrios, villages just outside. The Leland Stanford man & I walked out there the other night to see the dance. It is quite a shock to see these lovely barefoot girls & ugly barefoot men dancing just as Edmund & the girls do! Also their own variety of Mexican music, the equal you have never heard. There were two bands playing on the "merimba" which was evolved from a very old instrument. It is triangular in shape, on three legs & has strips of metal on which they play with sticks, having a ball on the end. Four play at one time. This is rather good music but the band of several brass instruments is something to draw about. The women wear gold ornaments. Some are real gold & others are imitation. In the afternoon I had walked out alone & ran across a

procession going to the church. It is a fiesta asking for a beautiful heaven so they proceed with flowers & fruit. The women in groups of old & young wear the huipil (upile) grande which is of starched lace covering the head & shoulders. The huipil chico is [worn at] the waist usually of red but also black, blue & yellow. It is embroidered in brilliant designs of flowers, but the cheaper are just yellow, black or red stitching in all kinds of line designs. The stitch is the lock machine stitch. The first procession I saw was led by an ox cart in which ride three children, one dressed as a queen & the other two attendants, the whole cart covered with green leaves. The second one I saw had about four ox carts with yokes of oxen hauling the decorated carts & in them were trees with the fruit. All the older women carried on their heads the large hand-decorated gourds which they use here & contained green leaves & flowers. The girls carried vases in which they had roses. Of course the band was playing all the time. They ended at the church & all went in & put the flowers on the altars, also the bananas. Yesterday they started at 6 A.M. & danced all day, & late in the afternoon had horse races. I saw some dance the Fandango which is a pre-Conquest dance, not much of a dance however. The girl holds her skirts out & steps from side to side & the man dances in front of her & around her in simple dance steps.

*Tehuantepec*
*July 26th [1936]*

To Eliza Taylor Shockley

Your nice long letter came & was much enjoyed and the list of presents most interesting. But what interested me most was the way your marriage is working out! It looks as if [your husband] Martin [Staples Shockley] is going to develop into a real spineless Taylor husband like my brothers, Cousin John & Cousin Richard Singleton. The only reason that George isn't exactly like them & pulls some type of rebellion is that he suddenly comes to and remembers the state of the others. Better not read this to Martin because he may decide to develop along the other line & be a real he-man. He better stick to Shakespeare and not Modern Literature because you have taken a course in that and will tell him what to think. P.S. Don't call me "aunt" any longer, so tell Mariana too.

*Cordoba*
*August 12 [1936]*

To Nell

Here I am in Cordoba & found it a delightful change from Veracruz which was very hot & humid. That night I ran the electric fan all night after stopping it for a while & finding that I roasted. This is not quite as high as Jalapa but the same lush vegetation, plenty of rain & a wonderful view of Orizaba Mountain which is much closer than at Jalapa.

I left Tehuantepec last Friday & found that I really would not have minded staying longer. It certainly was amusing the people who drifted through. Four or five days before I left a tall, very handsome Spanish-Mexican arrived. We noticed that he seemed very much interested in our talk & must know English which was spoken most of the time except by the Japanese dentist. I tried to get the two Americans to speak to him. That evening in the Plaza he was sitting on a bench right next to us & still they refused, so I walked up to him

after supper & spoke in English & he replied in beautiful English. He, like Mr. [Alberto] Gutierrez, has the long face of El Greco's figures, the blackest eyes & hair you ever saw, & deep olive skin. He proved to be one of the most charming men I have met in Mexico— very literary, in fact writes, was educated in Canada. Knows English & French as he knows Spanish. All of us liked him immensely so he spent his time with us. He had expected to leave the next day but stayed on until I left. He & Mariana would hit it off wonderfully. He writes poetry & has a play that he wrote while in Chiapas which is the theme of [Joseph] Conrad's *Heart of Darkness*. I shall get it & send it to him, he had never heard of it. He uses such wonderful English, always selecting the exact word just as if it were his native tongue. We think he should write in English or get a translator because he should have some price- less material. For the first three years he has been in Chiapas, which is the wildest & most unexplored state of Mexico. It is said that there are parts no white man has been in & the natives very savage & primitive, not at all like the Indians in Oaxaca. Three of them bought a banana plantation & he went down to run it, just the last person in the world to do such a thing. For two years they came out very well, then the government raised wages so that a common illiterate savage is paid 2 pesos a day!! As I told him, if we had to pay Negroes $2 a day on the cotton plantations we would be bankrupt. The value is the same in the two countries. They spend it on drink because they have no needs at all, live on tortillas & leaves & bananas; houses built out of palm leaves. But the people in the States are eating up all the trash published in Mexico & would be crazy about anything real coming from Chiapas. It was in Chiapas that the "chikle" chewing gum was gathered & the labor conditions so perfectly frightful. The men were gotten drunk with liquor which contained some narcotic, shanghaied to the swamps & never came back. Three years was their limit of endurance, they worked in water up to their waists & food & living conditions frightful. I had heard all of this before, so asked him about it. The government put a stop to it & it is now gath- ered in British Honduras under government regulations, however Dr Hartwig tells me that a synthetic gum is being made in the States.

He lived in the usual Indian house which has the palm leaf thatch & the sides of cane. Of course this place is subject to overflow during the rains. He gave an absurd account of the river rising & he ending by climbing up on the rafters along with rats & iguanas. I asked about his books, he laughed & said they all went down the river including his accounts, which he was glad to get rid of. I am delighted to say that the doctor in Mexico says that he can't go back. If he does he will have T.B. A crime for a man of his temperament being put down there. Most of the coffee & banana fincas are owned by Germans or Japanese. The Japanese botanist I wrote you about had a finca up near the Guatemalan border. The Germans always live with their cooks or sometimes marry them. Some of the men are well- born, one is the brother of Count Bernsdorf [*sic;* Johan Heinrich von Bernstorff, former German ambassador to the United States], but gone completely native. While he was there a young German couple came out to take charge of a banana finca. He was about 25 & she 22 years old. They had been there about three months when he developed lockjaw. These places are all far away from each other & she was about the only white woman in the state. The poor boy got worse & worse, his suffering beyond description. Of course all the men nearby hurried down as soon as they got word & when they arrived they found she had

stood his agony as long as she could then took the gun & shot him in the head. She was in a completely demented condition. They knew that there would be an investigation, so got together & agreed to say he killed himself. The Judge came down & took the testimony & he knew, & all knew, he couldn't have killed himself. They think he got it from currying his horse. She was sent back to Germany.

We went in the largest launch which has an upper deck. The party came down from Textepec in another launch & joined us. Besides we two there were two other married women & four girls & a bride & groom. These poor brides can't dance with another man unless he asks the husband's permission & no one dared dance with the bride. All day long she danced with the tall grim looking husband. There were about eight men so the girls had plenty to dance with. All were dressed in silk & one a dark red silk! The day was a little overcast so the awning was taken off & put on shore & we continued on our way, finally moving under a big shady tree. Each couple had about a square yard to dance on! All were dripping.

It was a lovely trip up the river & I saw lots of birds, white heron & a blue heron, & lots of smaller birds. We got back about dark & they all came in to Mrs. D.'s surprise & danced at the house & of course the D's had to scratch up & fix supper over at the mess. I had been eating meat for two days & it was too much for me. The night before I had a delicious duck Mrs. D. had killed. There are plenty of duck for this time of year. Well I retired & poured down water & was fine next day when I left for Veracruz. Margaret Law & I may over[?] visit in Mex[ico City]. She gave Eda my books which George sent. The Dills are there but I am hoping not [given] the [illegible] the rude letter crazy Pauline wrote me.

This place, Veracruz, is lovely & I am exploring & hope to find some good watercolor subjects. There is a damn strike planned in Mexico City for Aug 15th but I hope it doesn't come off because I don't wish to be caught there. However I have to be there for a week.

I may have a show in New Orleans in December. I shall go down for it, as it always helps and I wish to see New Orleans. I ought to have a good time with Ben's friends & mine there.

*Toluca, Mex.*
*Aug. 28th [1936]*

To Nell

There isn't much to write about. I sail on the "St. Mary," Standard Fruit & SS Line, which is a freighter & has a few passengers, not as large as the one I came down on but the date suits me better. It sails Sept. 25th or 26th & gets to New Orleans either 28th or 29th. I have to see Mr. Koch about an exhibition there during the winter so shall catch a night train out. I have written Ben's friend, Dorothy Spencer [Collins] that I am passing through & hope to see her.

I expect to get home Oct. 1st & at once start in on some block prints & work like the devil so I am hoping to feel like my usual energetic self. I saw Margaret Law the night before I left, had supper with the Noels where M[argaret] is staying.

I am here painting & expect to leave on Tuesday for Temancingo which isn't so very far away by bus. Then it looks as if I shall have to go back to Mex[ico City] in order to go to

Cuernavaca where I shall stay at a nice place Margaret was at. Her sketches interested me so I think I shall go there as the road is impassable to Ixtapan.

*Cuernavaca*
*Sept. 12th [1936]*

To Nell

I arrived here Tuesday, riding on 3 different horses to get here & beautiful scenery all the way, however I didn't see the volcanoes as they were covered with cloud. I got a wonderful letter from Ben's friend, Dorothy Spencer [Collins] of New Orleans. She has asked me to stay there even if she may be in Guatemala. However if she isn't there I shall get the first train out after seeing Mr. Koch about the dates for my show there. I hope I have it during the Mardi Gras. It will depend on what dates Marie Sterner can give me.

I came here for Margaret [Law] had some nice sketches made here. She says that all my friends are roaring because the whole of Charleston came to Mexico to be with me & no one has seen me!! All landed in Taxco. I need some more tin frames so go there Tuesday & return to Mexico Saturday. I sail Sept. 25th or 26th on St. Mary, Standard Fruit SS Line. Arrive either 28th or 29th.*

*Taxco*
*Sept. 19 [1936]*

To Nell

Am here again, needed some more frames & had 4 extra days so came, also got 4 good water colors of a green Taxco. Leave in the morning & sail Sept. 25th. Have run across various old friends. Josephine P[inckney] & Lina Huger are here.

# Conclusion

## Taylor's Last Decades, 1936–1956

AFTER TAYLOR RETURNED FROM MEXICO, she continued her energetic career. World War II enveloped the globe. While her nephews were in combat, she volunteered on the home front to welcome and assist Allied servicemen in Charleston. She helped organize and maintain the Union Jack Club for British enlisted men and entertained officers and men at her Church Street home. After the war she sold her large house at 79 Church Street and moved down the street to a smaller house at 56½ Church. She resided there briefly and moved again to 30½ South Battery, where she lived from 1950 to 1955. At the time of her death in 1956, she made her home at 3 Lamboll Street.

One of Taylor's foremost artistic achievements was her creation of twenty-three linoleum block prints that illustrated Chalmers Swinton Murray's book *This Our Land: The Story of the Agricultural Society of South Carolina,* published on April 11, 1949, by the Carolina Art Association. That day the Gibbes Art Gallery hosted a reception and exhibited her prints. She was sixty-nine when *This Our Land* appeared. "Chal" Murray (1894–1975), a native of Edisto Island, South Carolina, was a novelist, newspaperman, and short-story writer. During the 1930s he had been an interviewer for the New Deal Federal Writers' Project and recorded the life histories of former slaves on Edisto Island. He used that material to publish *South Carolina Folk Tales: Stories of Animals and Supernatural Beings* (1941), and he also wrote the novel *Here Comes Joe Mungin* (1942). Murray's wife was the artist and Edisto Island native Faith Cornish Murray (1897–1984).

The Agricultural Society of South Carolina was founded in 1785 and was one of the oldest surviving societies in the United States devoted to scientific farming. Thomas Heyward, one of Taylor's forebears, was its first president, and the Heyward family was prominent throughout the society's history. In modern times the society has advocated conservation of natural resources and the preservation of agriculture as a way of life. Commenting on Taylor's contribution to agrarian preservation, one writer said, "A noted artist and a member of a great family of planters, Miss Taylor has added careful research to her inherited understanding and memories of plantation days."[1]

In preparation for illustrating *This Our Land,* Taylor collected a variety of photographs and images of lowcountry farm work, visiting plantations to make her own photographs and studies, and consulting with lowcountry farmers to ensure the veracity of her representations. Her linoleum prints for *This Our Land* are among her most recognizable works.

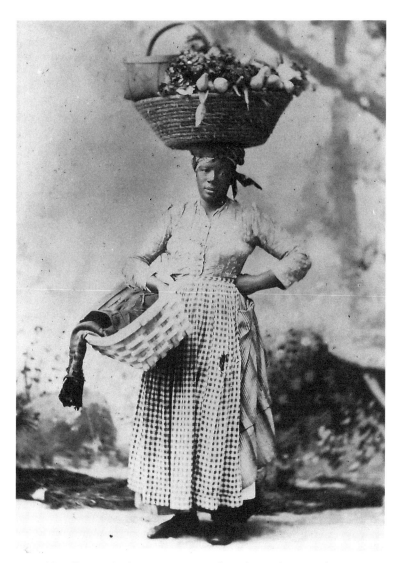

Vegetable seller in Charleston. Courtesy of South Caroliniana Library,
University of South Carolina, Columbia

She printed a number of them independently of the publication, and those prints are prized
holdings in museums, galleries, and private collections. Figures 21, 22, 23, 24, 25, and 26 are
reproduced from these prints. Among them are depictions of African Americans plowing,
picking cotton, harvesting and flailing rice, digging potatoes, and hauling cabbages to mar-
ket. She also included images of a boll weevil, cotton blossoms and bolls, a cutworm, and
a loggerhead turtle. These prints are among her best-known works. They are often repro-
duced in books, exhibition posters, and promotional material. ∽

1. Publication flyer, Chalmers Swinton Murray Papers, South Carolina Historical Society, Charles-
ton, 21/229/6.

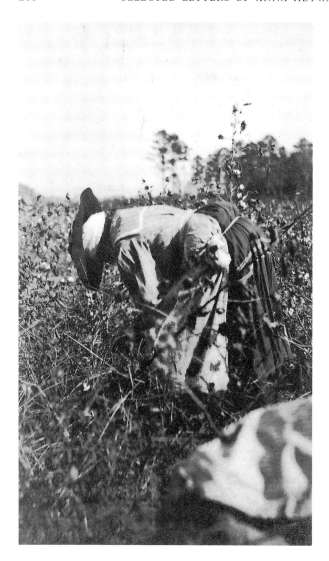

Cotton picking. Courtesy of South
Caroliniana Library, University of
South Carolina, Columbia

*From Chlotilde F. Crawford*
*The Print Club, 1614 Latimer Street, Philadelphia*
*April 7, 1938*

It gives me much pleasure to enclose a check for $75—the Mildred Boerick Prize—for the
best block print in the opinion of the Jury submitted to the Twelfth Annual Exhibition of
American Block Printers.*

* Taylor's linoleum block print *Harvesting Rice* (fig. 17) won the 1937 Boerick Prize. One of her
best-known prints, it was exhibited at the 1939 World's Fair in New York City and was published with
*July in Charleston* in the first edition of the Junior League of Charleston's cookbook, *Charleston
Receipts* (1950).

*30½ South Battery*
*April 30 [1949]*

To Margaret*

I agree with you in thinking it is a draw back not having the titles of my cuts listed or under each [image in *This Our Land*]. Some people have mistaken the Indigo cut for a rice cut. Also it should have an index. Perhaps if there is a second edition these may be put in. The prints with their velvety quality are far finer than the cuts in the book. I own the blocks (the prints) & they have been exhibited in the [Gibbes Art] Gallery & are for sale. I have sold a few but the book over shadows them now. In time the public will know they are for sale. The "Cutting Rice" is only in a half [sheet size] because the whole block would have had to be reduced to the size of the negro ploughing. It seemed to compose well even when cut in half. I set the whole print up as a trial balloon & the Brooklyn Museum took it. The American Federated Arts asked that it be one of 60 selected to send in turn. The Congressional Library took it & the Curator of the Carnegie Institute asked to have it for their show last fall. So it evidently is a fine print.

I wish you would get in touch with Katherine Heyward & Augusta Rembert & see if there is a good place [on the University of South Carolina campus] for a second exhibit for prints such as this series is. I will not consider the awful place in the Library near the art studio. Augusta & Catherine [*sic*] Rembert had a show lately. Where was it? I believe that the books & prints may sell well at least pay me for coming up [from Charleston]. How about the latter part of May? I leave tomorrow for New York to see Connie [Guion, M.D.] for I am not at all satisfied with my state of health & wish some advice on the subject. I plan to be north two weeks. No use to write me here for I am having the mail held until I return. Unless Connie puts me in the hospital again I will be visiting Mrs. Austin Sayre, Arden Lane, Essex Fells, N. Jersey. My address in N.Y. is Totham House, 138 E 38th St.

* The recipient was likely Margaret Babcock Meriwether (1895–1968), author and editor of works on South Carolina history and art. She was the wife of Robert Meriwether (1890–1958), the first director of the South Caroliniana Library. This letter is found in the Anna Heyward Taylor Artist's File, South Caroliniana Library.

Louis Lawson Jr. of the Pink House Gallery in Charleston organized a retrospective exhibition of Taylor's works from November 28 to December 10, 1950, at the Columbia Museum of Art and then at the Gibbes Art Gallery from December 19, 1950, through January 12, 1951. The *Columbia (S.C.) Record* described the exhibition and commented on its comprehensiveness. ✑

Included in the retrospective exhibition are six watercolors depicting various scenes and subjects in the South Carolina low country and in Mexico, two oils, one of which shows Hangmens Hill, Saint Thomas in the Virgin Islands, a wash entitled, "Grias Cauliflora" and a silk drapery decorated in the Japanese Batik manner. Outstanding in the collection are two large decorated folding screens. One, on a silvered background, has for its motif South Carolina birdlife, depicting Stuartia and Carolina paroquets. The other is of natural wood with a pattern of the cypress gardens and a heron.

Some of Miss Taylor's well-known linoleum block prints of Charleston and other low country scenes and subjects on exhibition are "Saint Michael's Gates," "The Sea Turtle" and several prints depicting various processes in the cultivation of rice. There is also a collection of wood blocks of native low country scenes, floral and animal life in the show.[1]

AFTER THE RETROSPECTIVES, Anna Heyward Taylor did not pursue any new projects. In her last five years, high blood pressure damaged her health. By then she had accumulated a wealth of friends all over the world, and many visited her in Charleston. Despite the paucity of letters that survive from her last years, she likely continued to write those geysers of observation and opinion that her friends and family had welcomed all her life. She continued to travel and so did her artwork. In March 1955 she received international recognition when ten of her lowcountry prints were exhibited in the Green Room of La Scala Opera House, Milan, Italy. Her prints and other memorabilia of Dubose Heyward and George Gershwin accompanied a performance of *Porgy and Bess* at that famous location. The Charleston Library Society owns a collection of photographs that depict Taylor's works hanging in place.[2]

When Taylor was seventy-five, she was delighted when her stock portfolio paid handsome-enough dividends to finance one last expedition, a cruise to the Caribbean islands, a place of inspiration and doubtless fond memories. On March 4, 1956, within two weeks of returning from her cruise, Anna Taylor died at her Charleston home, at the age of seventy-seven. Her funeral was held at Columbia's Trinity Cathedral on March 7, and she was interred in Elmwood Cemetery, surrounded in death by her mother, father, and brothers. Her epitaph reads, "Her work which is of enduring quality will remain to attest to her reputation as an artist and her generosity as a citizen."

In her last years Taylor donated some of her works to the Gibbes Museum of Art and the Columbia Museum of Art. In her will she made bequests of funds to those institutions to create an endowment to purchase graphic arts for their collections. Thanks to her endowment funds, the Columbia Museum has acquired works by Henri Toulouse-Lautrec, Goya, and Renoir, and the Gibbes has purchased works on paper by Charles Fraser, Charles W. Smith, William Henry Johnson, and Alfred Hutty.

An unsigned editorial comment in the *Charleston News and Courier* of March 7, 1956, seems a fitting way to conclude Anna's epistolary record of her own life. ❧

There are no soft fuzzy lines to Anna Heyward Taylor. She has a forceful personality, a straightforward, unwavering approach, to all things both personal and artistic. Whatever Anna Heyward Taylor looks at, she sees in a clear and unmistakable design.

All that is and has been the Lowcountry—the harvesting of rice on the Edisto, a flower woman under St. Michael's portico, palmettos on a sea island, the history-laden streets of this old city—are in Miss Anna's block prints.

1. *Columbia (S.C.) Record,* November 30, 1950, 2-D. A clipping is found in the Gibbes Museum of Art, Artist Files, Anna Heyward Taylor, folder 5, and is reproduced in Burgess, "Anna Heyward Taylor," 83.
2. Charleston Library Society, Picture File.

## SELECT BIBLIOGRAPHY

**Manuscript Collections**

Charleston Library Society, Charleston, South Carolina
  Photograph Files, Anna Heyward Taylor
Gibbes Museum of Art, Charleston, South Carolina
  Artist Files, Anna Heyward Taylor
  Alice Ravenel Huger Smith Collection
South Carolina Historical Society, Charleston, South Carolina
  Chalmers Swinton Murray Papers
  Vertical Files, 30-4, Anna Heyward Taylor
  Alice Ravenel Huger Smith Papers
South Caroliniana Library, University of South Carolina, Columbia
  Anna Heyward Taylor Collection
  Vertical Files, Artist Files, Anna Heyward Taylor

**Printed Primary Sources**

Beebe, William, G. Inness Hartley, and Paul G. Howes. *Tropical Wild Life in British Guiana: Zoological Contributions from the Tropical Research Station of the New York Zoological Society, with an Introduction by Colonel Theodore Roosevelt.* Vol. 1. New York: New York Zoological Society, 1917.
Bellamann, Henry. "The Works of Anna Heyward Taylor." *Columbia (S.C.) State,* December 21, 1930.
"Floral Designs in Textiles: Plant Motifs Based on Studies Made by Miss Anna Heyward Taylor at Kartabo, British Guiana." *Natural History: Journal of the American Museum of Natural History* 22 (March–April 1922): 175–78.
"From Guiana and Tehuantepec, Anna Heyward Taylor Brings Strong, Bold Paintings." *Charleston (S.C.) News and Courier,* March 26, 1939.
Junior League of Charleston. *Charleston Receipts.* Charleston, S.C.: Walker, Evans and Cogswell, 1950.
Murray, Chalmers S. *This Our Land: The Story of the Agricultural Society of South Carolina.* Illustrated by Anna Heyward Taylor. Charleston, S.C.: Carolina Art Association, 1949.
Poetry Society of South Carolina. *Yearbook 1929.* Charleston, S.C.: Poetry Society, 1929.
Smythe, Augustine T., and others. *The Carolina Low-Country.* New York: Macmillan, 1931.
Taylor, Anna Heyward. "British Guiana Flowers." *Christian Science Monitor,* January 17, 1921.
———. "British Guiana Jungles." *Christian Science Monitor,* December 22, 1920.

**Secondary Sources**

*American Art Today: New York World's Fair.* 1939. Repr., Poughkeepsie, N.Y.: Apollo, 1987.
Anderson, Elizabeth, and Gerald R. Kelly. *Miss Elizabeth: A Memoir.* Boston: Little, Brown, 1969.

Anonymous. "Two Southern Innovators in the American Woodblock Tradition: Alice Huger Smith and Anna Heyward Taylor." Undated, unpublished essay in Artist Files, Anna Heyward Taylor, folder 1, Gibbes Museum of Art, Charleston, S.C.

Atkinson, Scott D., and Nicolai Cikovsky Jr. *William Merritt Chase: Summers at Shinnecock, 1891–1902.* Washington, D.C.: National Gallery of Art, 1987.

Beebe, William. *Jungle Peace.* New York: Henry Holt, 1918.

Bowen, Valerie Suzanne. "Katherine Bayard Heyward, South Carolina Art Educator." Master's thesis, University of South Carolina, 1991.

Bridges, Robert, Kristina Olson, and Jane Snyder, eds. *Blanche Lazzell: The Life and Work of an American Modernist.* Morgantown: West Virginia University Press, 2004.

Bryant, Keith L. *William Merritt Chase: A Genteel Bohemian.* Columbia: University of Missouri Press, 1991.

Burgess, Lana Ann. "Anna Heyward Taylor: 'Her Work Which Is of Enduring Quality Will Remain to Attest to Her Reputation as an Artist and Her Generosity as a Citizen.'" Master's thesis, University of South Carolina, 1994.

Coke, Van Deren. *Nordfeldt, the Painter.* Albuquerque: University of New Mexico Press, 1972.

Davis, Gwen Shepherd. "The Charleston Etchers' Club and Early South Carolina Printmakers." Master's thesis, University of South Carolina, 1982.

Dennison, Mariea Caudill. "Art of the American South, 1915–1945: Picturing the Past, Portending Regionalism." Ph.D. diss., University of Illinois at Urbana-Champaign, 2000.

Edgar, Walter, and others, eds. *The South Carolina Encyclopedia.* Columbia: University of South Carolina Press, 2006.

Flint, Janet Altic. *Provincetown Printers: A Woodcut Tradition.* Washington, D.C.: Smithsonian Institution Press, 1983.

Gould, Carol Grant. *The Remarkable Life of William Beebe: Explorer and Naturalist.* Washington, D.C.: Island Press, 2004.

Hamilton, Elizabeth Verner. "Four Artists on One Block and How They Got Along; or, A Partial History of Atlantic Street, 1913–1936." *Carologue* 25 (Summer 2009): 15–19.

Hutchisson, James M., and Harlan Greene, eds. *Renaissance in Charleston: Art and Life in the Carolina Low Country, 1900–1940.* Athens: University of Georgia Press, 2003.

International Business Machines Corporation. *Contemporary Art of the United States.* New York, [1940].

Littleton, Taylor D. *The Color of Silver: William Spratling, His Life and Art.* Baton Rouge: Louisiana State University Press, 2000.

Mack, Angela D. *Coloring America: Regional Approaches to Wood-Block Printmaking.* Charleston, S.C.: Gibbes Museum of Art, 1993.

Mijer, Pieter. *Batiks and How to Make Them.* New York: Dodd, Mead, 1919.

Mühlberger, Richard. *Charles Webster Hawthorne.* Chesterfield, Mass.: Chameleon Books, 1999.

Ochs, Robert D. *The Columbia Art Association, 1915–1975: The Columbia Museum of Art, 1950–1975, Columbia, South Carolina; A History.* Columbia, S.C.: Columbia Museums of Art & Science, 1975.

Pisano, Ronald G. *A Leading Spirit in American Art: William Merritt Chase, 1849–1916.* Seattle, Wash.: Henry Gallery Association, 1983.

———. *The Students of William Merritt Chase.* New York: Heckscher Museum, 1973.

Roof, Katherine M. *The Life and Art of William Merritt Chase.* New York: Hacker Art Books, 1975.

Severens, Martha R. *Alice Ravenel Huger Smith: An Artist, a Place, and a Time.* Charleston, S.C.: Gibbes Museum of Art / Carolina Art Association, 1993.

————. *Anna Heyward Taylor: Printmaker.* Charleston, S.C.: Greenville County Museum of Art and Gibbes Art Gallery, 1987.

————. *The Charleston Renaissance.* Spartanburg, S.C.: Saraland Press, 1998.

Smith, Daniel E. H., and Alice Ravenel Huger Smith. *The Dwelling Houses of Charleston, South Carolina.* 1917. Repr., Charleston, S.C.: History Press, 2007.

Tarbell, Roberta K. *Marguerite Zorach: The Early Years, 1908–1920.* Washington, D.C.: Smithsonian Institution Press, 1973.

Wall, Pamela S. "The British Guiana Works of Anna Heyward Taylor." Unpublished essay, Gibbes Museum of Art, Charleston, S.C., 2007.

Yuhl, Stephanie Y. *A Golden Haze of Memory: The Making of Historic Charleston.* Chapel Hill: University of North Carolina Press, 2005.

Zorach, Marguerite Thompson. *Clever Fresno Girl: Travel Writings of Marguerite Thompson Zorach (1908–1915); Selected, Edited, and with an Essay by Efram L. Burk.* Newark: University of Delaware Press, 2009.

# INDEX

Anna Heyward Taylor (AHT) employed the racial terms of her era. The index contains entries for both African Americans and Negroes with cross references and subentries.

Egerton, Mrs. Walter, 97, 114

Egerton, Sir Walter, 96, 97

Einstein, Marian, 141

Eison, Mr., 52, 102

El Greco, Domenikos Theotokopoulos, 229, 255

Elizabeth I of England, 212, 226

Elki (a servant), 62

Elliott, Miss, 117

Elmore, Ellen T., letter from, 2

Ely, Miss, 38

Emerson, Alfred Edwards, 106, 153, 158–61

Emerson, Edith, 110

Emerson, Edwin, 110

Emerson, Gertrude. *See* Sen, Gertrude Emerson

Emerson, Margaret, 110

Emerson, Ralph Waldo, 204

Emerson, Winifred, 153, 158, 159, 169

Emery, Lloyd T., 87, 88–90, 158

Emmanuel, Umberto, 228

etching, xxx, xxxi, 37, 52, 62, 83, 84, 114, 116, 119, 214

Eurick, Mr., 88, 89

Ewart, Mrs., 31

Ewers, Mr., 101

Ewers, Mrs., 99, 101

exhibitions: of AHT's work, xxiii, xxiv, xxix–xxxiii, xxxiv, xxxvi–xxxix, xli, 106, 115, 154, 170, 171, 174, 206–8, 210, 215, 226, 256, 258, 260–62; of other artists's works, xxvi, xxvii, xxviii, xxx, xxxi, xxxiv, 7, 15, 30, 106, 112, 115, 127, 154, 210, 213, 233, 246, 259; "The Work of Anna Heyward Taylor," 216–17

Fair, Ray Taylor, xliii, 47, 70, 109, 154, 164, 175, 176, 200, 248

Fairchild, Arthur, 191, 192, 195

Faisal, Abdul Aziz Al Saud, King, 206

Falk, Mr., 36

Farrar, Miss, 12

Faulkner, William, xxxvii

fauna: AHT's depictions of, *following 34, pls. 11, 13, 14, 16, 19, 26, 27; following 106, figs. 1, 5, 6, 7, 8, 9, 14, 18, 21, 22, 23, 24, 26;* 262; Mexican, 231, 234, 248, 252; South American, xxvii, 86, 89, 97, 98, 102, 114, 153, 158, 170, 171; in South Carolina, xxxiv, 214, 258, 262. *See also* birds; insects; monkeys; snakes; turtles

Fenollosa, Ernest F., xxv, xxvii, 85, 214

Fiere. *See* Frére, Harold

Finlay, Mr., 151

Flat Rock, N.C., 2

flora and flowers: AHT's depictions of, xxix, xxx, xxxii, xxxv, xxxvi, xxxviii; *following 34, pls. 1, 2, 3, 4, 5, 6, 7, 8, 9, 10, 12, 13, 14, 15, 17, 18, 19, 20, 21, 23, 33, 34;* 101; *following 106, figs. 2, 3, 4, 22;* 118, 121, 127, 154, 156–63, 166, 167, 174, 196, 214, 215, 217, 226–31, 249, 261, 262; of British Guiana, xxvii, xxx, xxxii, 89–91, 94–97, 101, 102, 118, 121, 127, 153, 156–61, 164–67, 172–74, 208; Caribbean, 92, 156, 195; Japanese, 56, 58, 66, 72; lowcountry, xxxiv, xxxviii, 214, 219, 261, 262; mentioned, 18, 33, 49, 52, 80, 109, 112, 149, 171, 181, 183, 189, 198, 210, 211, 215, 229, 231, 233, 237, 246. *See also* drawing and sketching

Florence, Italy, xxiv, xxvi, xxxiii, 35, 43–47, 181–85

Floyd, J. F. M., 153, 163, 166–69

Flynn, Miss, 56, 61, 69, 105, 111

Fox, Jack, 107

Fox, Mr., 107

Fox, Mrs., 107

France, Anatole, 126

France and the French: African troops of, xxxi, 126; AHT in, xxxi, xxxiii, xxxiv, 51, 119, 124, 128, 131, 136, 137, 139, 147, 150, 175, 214; architecture of, 123, 125, 134, 137, 140; art of, 13, 19, 134, 214, 217; French Caribbean, xxxiv, 94, 102, 153, 155, 188, 194, 201, 221; immorality, 30, 124, 126, 128, 146; language, 43, 144, 195, 251, 255; mentioned, 11, 43, 44, 72, 76, 77, 88, 98, 99, 122, 126, 127, 131, 136, 137, 141–44, 146–48, 150, 204, 226, 227, 255. *See also* Paris; *individual artists by name*

Francis, Mr., 169, 170

Franz Joseph I of Austria, 77

Fraser, Charles, 33, 262

Frechette, Marie-Marguerite, letters from, 7, 8, 34, 127

Frére, Harold, 95, 98, 99

Frost, Mildred, 185

Furguson, Miss (in Mexico), 229

Furguson, Miss (in Scotland), 40

Furness, Horace H., 196

Furness, Horace H., Jr., 195, 196

Gadsden, Mrs., 34

Galileo Galilei, 46

Gandara, Dr., 228, 233

Gardiner, Hasu, 60, 105

Gardiner, John McD., 58, 64, 68